BOTANICALS

© 2008 Assouline Publishing
601 West 26th Street, 18th floor
New York, NY 10001, USA
Tel.: 212 989-6810 Fax: 212 647-0005
www.assouline.com

ISBN: 978 2 75940 269 4

The prints in this edition were reproduced from original editions of the following volumes:

Metamorphosis insectorum Surinamensium by Maria Sibylla Merian, held by the Joseph F. Cullman 3rd Library of Natural History, Smithsonian Institution Libraries (Washington, D.C.).

1730 Dutch edition of *Der Raupen wunderbare Verwandlung und sonderbare Blumen-Nahrung* entitled *Die europischen Insecten* by Maria Sibylla Merian held by the library of the Smithsonian's Cooper-Hewitt National Museum of Design (New York City).

New Illustration of the Sexual System of Carolus von Linnaeus by Robert Thornton (1807 edition, but with prints dated through 1810), held by the library of the Smithsonian's Cooper-Hewitt National Museum of Design (New York City).

Papillons and *Insectes* by E. A. Seguy, held by the library of the Smithsonian's Cooper-Hewitt National Museum of Design (New York City).

Lindenia: Iconographie des Orchidées by Jean Jules Linden held by the library of the Smithsonian's Cooper-Hewitt National Museum of Design (New York City).

Text and Images © Smithsonian Institution Libraries
E. A. Seguy photography by Matt Flynn

Smithsonian Institution Libraries

Printed in China

LESLIE K. OVERSTREET

CURATOR OF NATURAL-HISTORY RARE BOOKS, SMITHSONIAN INSTITUTION LIBRARIES

BOTANICALS

ASSOULINE

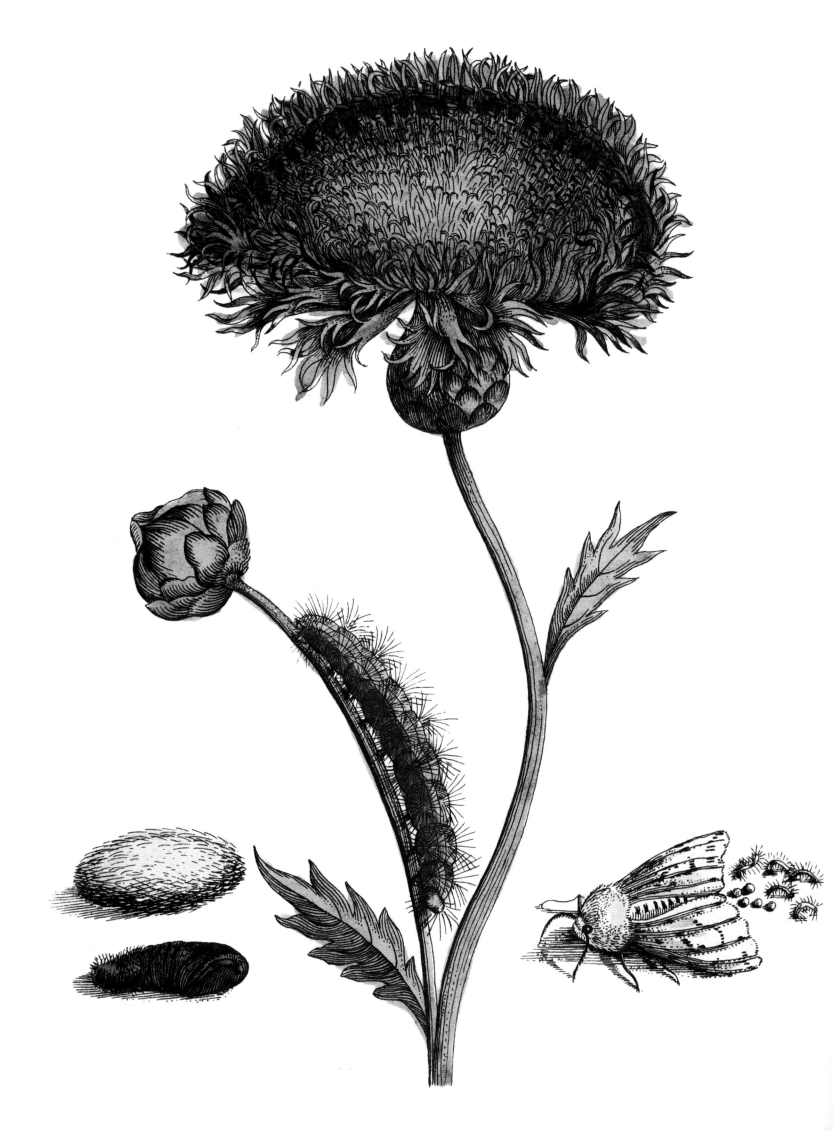

CONTENTS

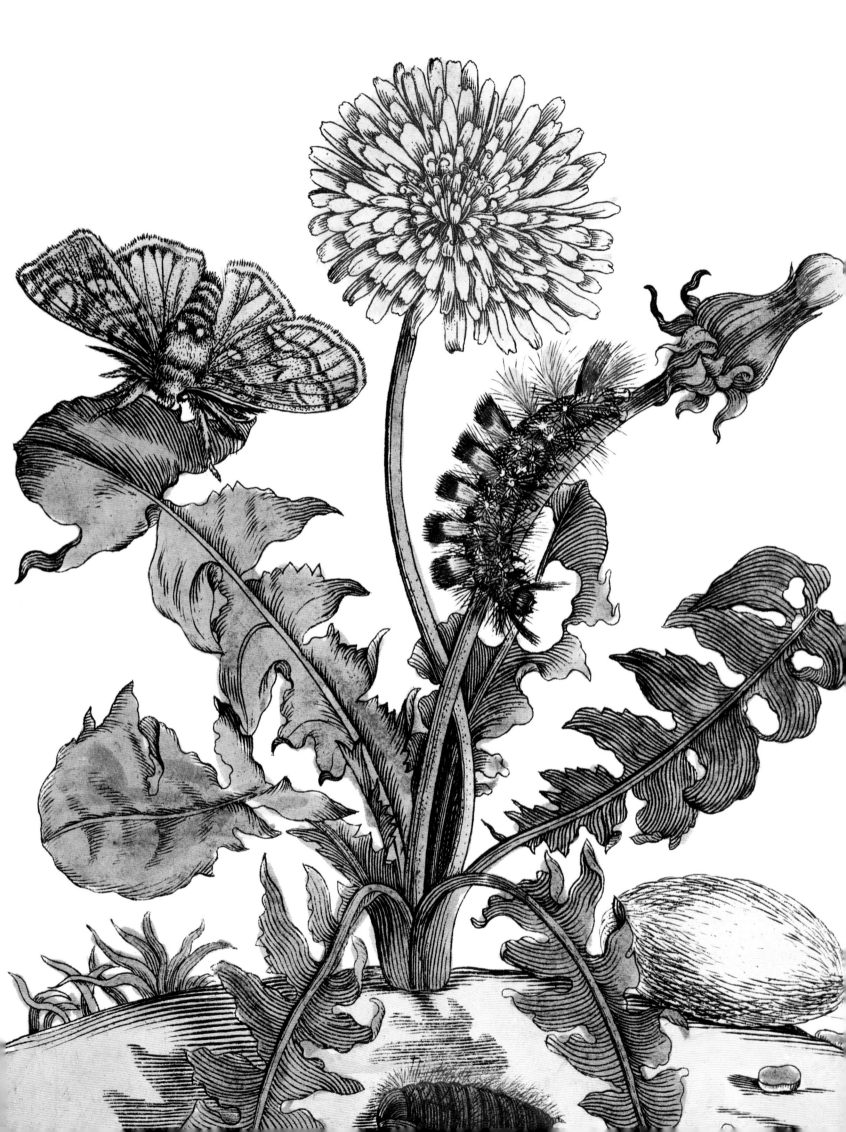

INTRODUCTION

During the course of its rich history, botanical and entomological illustration has graced the pages of medieval manuscript herbals, sixteenth-century encyclopedias, lavish baroque florilegia, taxonomic monographs from the eighteenth century to the present, and field guides that one can buy in bookstores today. Such works have embodied in visual form so many aspects of the Western cultural heritage—the religious allegorical mind-set of the European Middle Ages; the intellectual awakening of the Renaissance; the rise of modern scientific inquiry; and the development of printing technologies—that it would be impossible to summarize their nature and significance in a brief introduction. But it may be said, above all, that if a picture is worth a

thousand words, botanical and entomological illustrations reveal a natural world of diversity and beauty almost beyond mere verbal description. Although these images were originally intended primarily for practical purposes and usually accompanied scientific texts, the illustrations also serve to bring those texts to life, firing the readers' imaginations and standing on their own, then and now, as artistic delights.

Each of the four artist-authors whose works have been selected for this book stood alone in his or her day. They include a German woman who defied gender stereotypes and trained as an engraver in the late 1600s; an eccentric English physician who lived during the late-eighteenth and early-nineteenth centuries; an explorer and commercial horticulturist living in Belgium in the late 1800s; and a mysterious French entomologist of the 1920s. These four achieved their successes by rising above the conventions of their times. Yet each also represents significant aspects of their period and culture, and collectively they span the most important two centuries of natural-history discovery in modern science. Similarly, their illustrations reflect the development

of printed images during that period, from simple line engraving to more complex intaglio techniques used with color printing, such as mezzotint, aquatint, and stipple; and then to lithography and, finally, modern photographic-reproduction technologies.

This list of techniques suggests a primary difference between natural-history illustration and artistic works traditionally classified as fine art, namely that the former had to be capable of reproduction via the printing press. Illustrators were artists and often produced very fine art indeed, but their oil paintings and watercolors had to be transformed, usually by trained craftsmen, into carved woodcuts, engraved or etched onto copperplates, or drawn in grease lines on lithographic stones—the last is the only medium that allowed the artist to directly produce his or her own printable image.

Another distinction between natural-history illustration and fine art concerns their respective purposes: To simplify and generalize, the fine arts express or incorporate a larger, subjective vision, beyond that of simple representation; scientific illustration explicitly intends to represent reality in detail and with objective accuracy. Whether the

crudest medieval woodcut or the most meticulous hand-colored aquatint, botanical and entomological illustrations are intended to identify a particular species and distinguish it from others of its kind. The beauty such illustrations achieve lies in the plant or insect itself, their success (or failure), in the skill of the artist and the technical care taken to limn and color its features.

The botanical and entomological illustrations reproduced in this volume are among the most fascinating and sought-after artistic works of natural history ever produced. In this short introduction and in the chapters that follow, I have only hinted at the complex and remarkable stories behind their creation—the individuals whose inspiration and efforts brought them into being; the dangers of scientific exploration that brought specimens to Europe; the popular manias and financial risks that made some artist-authors rich while bankrupting others; and the practical realities of printing and selling the illustrations.

This last subject is particularly relevant, for it must be remembered that botanical and entomological prints are not only artistic and scientific treasures but also commercial products. In the centuries

before publishing houses were established to underwrite the costs (and reap the benefits, if any) of publication, the financial burden of producing a book—paying for the paper stock, the typesetters, the pressmen, and so on—was commonly borne by the author himself (or herself). A lucky few boasted wealthy patrons who bankrolled their projects. Others chose to sell their works outright to printers or booksellers. Illustrated books were especially expensive to finance: In addition to the costs of the text, illustrations required artists, engravers, copperplate or lithographic printers, and colorists. Considering these circumstances, it's not surprising that such books, as they became increasingly popular and scientifically important in the eighteenth and nineteenth centuries, were often sold by advance subscription so that a minimum market was guaranteed. In addition, because the prints were labor-intensive and time-consuming to produce, they were often published in parts over a period of years, to be gathered together and bound into volumes by the purchasers upon completion. These finished volumes could be difficult to attain. Some subscriptions lapsed, or their holders died before completion. Some subscribers completed their sets with prints and texts

from later editions. And some works were simply never completed. These and other peculiarities of the handpress period—roughly 1450 to 1800—make such books not only rare in our times but also often bibliographically complex.

Expensive to produce and printed in relatively small numbers, folio-plate books suffered a degree of normal attrition over the centuries. They were also broken up for their individual illustrations. As a result, they are now even more rare and valuable than ever to both working scientists and print collectors. Among the works represented in the following pages, for example—bearing in mind that exact numbers are hard to determine—the first edition of Maria Sibylla Merian's *Metamorphosis insectorum Surinamensium (Metamorphosis of Surinamese Insects)*, published in Amsterdam in 1705, is held by only a few dozen libraries worldwide. Later editions increase that number significantly, but it is still on a par with limited-edition printmaking in modern times.

As with fine-art prints, variation among impressions, states, issues, and editions exists in botanical and entomological illustrations and can be extremely difficult to sort out. Once engraved or etched, a copper

plate can be used to make prints for years, and although the crispness of line and general quality of the image tended to deteriorate after many impressions, a number of artist-authors or their heirs (or the printers and booksellers to whom the plates might be sold) did so. To confuse matters further, even among the prints originally produced for a first edition, the vagaries of hand-coloring—intaglio processes cannot be fully colored in the press—could result in differences from one copy to another, slight if the colorists were careful and the artist-author vigilant, but sometimes quite noticeable. The latter is especially likely if the prints were purchased in black-and-white (a choice frequently offered, at a lower price), and colored by the owner or by a print dealer at a later date rather than having "original color" for which the original artist-author had vouched.

The degree of variation among copies and editions is important to their scientific usefulness, in which representational accuracy is crucial. The exact shape of a leaf, the specific pattern of a beetle's spots, the precise hue of a bird's feathers or a butterfly's scales are defining characteristics used to identify a species and distinguish it from others

in its genus. Natural-history illustrators faced many obstacles in getting these attributes right, the biggest of which was the fact that the artists usually had never seen the animal, insect, or plant alive in its natural context. (This is one reason for the convention of presenting a single figure against a blank background. Others include the desire to focus attention solely on the attributes of the specimen under study and the added cost of the artist's and craftsman's time and labor.) Illustrators commonly worked in the cities of Europe, drawing from dead—even rotting—specimens whose forms and colors may have changed significantly during the months-long ocean voyages that brought them back from the Americas or the Indies to Amsterdam, Paris, or London. Live animals were famously rare, and even plants didn't often survive the journey when freshwater became scarce and couldn't be spared by the crew. In addition, the lack of knowledge about the insects' and plants' environmental and cultivation requirements often doomed the specimens.

It is for this reason that such high value has been placed on the illustrations of certain artist-naturalists, such as Maria Sibylla Merian, both in their own time and today. Merian and a few adventurous others

traveled to remote areas of the globe, where they lived for years, often in deprivation and ill-health, observing and sketching plants, insects, and animals in their native environments, and collecting specimens for later detailed studies. The texts accompanying their illustrations provide important documentation about behavior, habitat, and ecological relationships, as well as practical uses and indigenous lore. Another of this book's subjects, Jean Jules Linden, spent more than eight years in the wilds of Central and South America and devoted the rest of his career to assiduously replicating, from his personal experience, the various environments in which different species of orchids thrive.

The astounding diversity and breathtaking beauty of the natural world—from seemingly inconsequential insects to the rarest of exotic blooms—inspired each of the four naturalists whose works appear in this book to undertake perilous journeys, financial risks, and laborious projects of which few others even dreamed. Whether they were rewarded for their efforts or ruined as you shall see, their works survive today and provide us with the greatest of riches: a heightened awareness of and appreciation for the plants and insects with whom we share this earth.

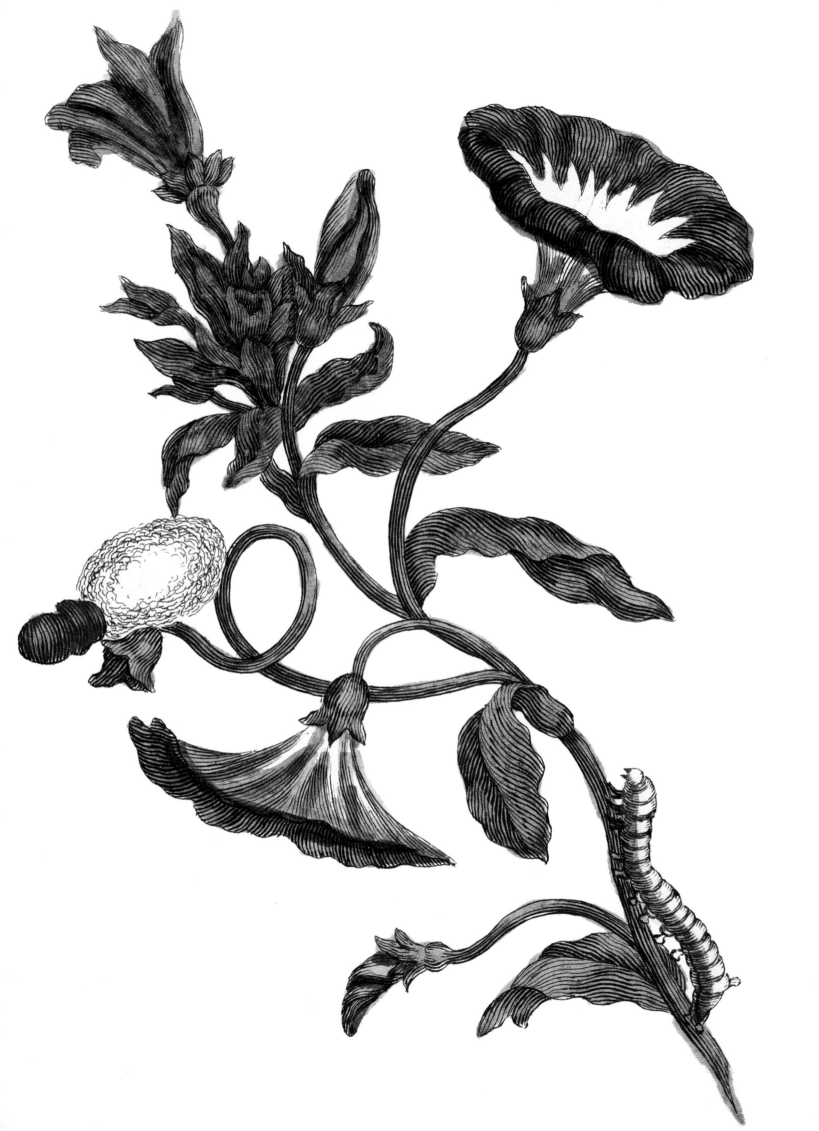

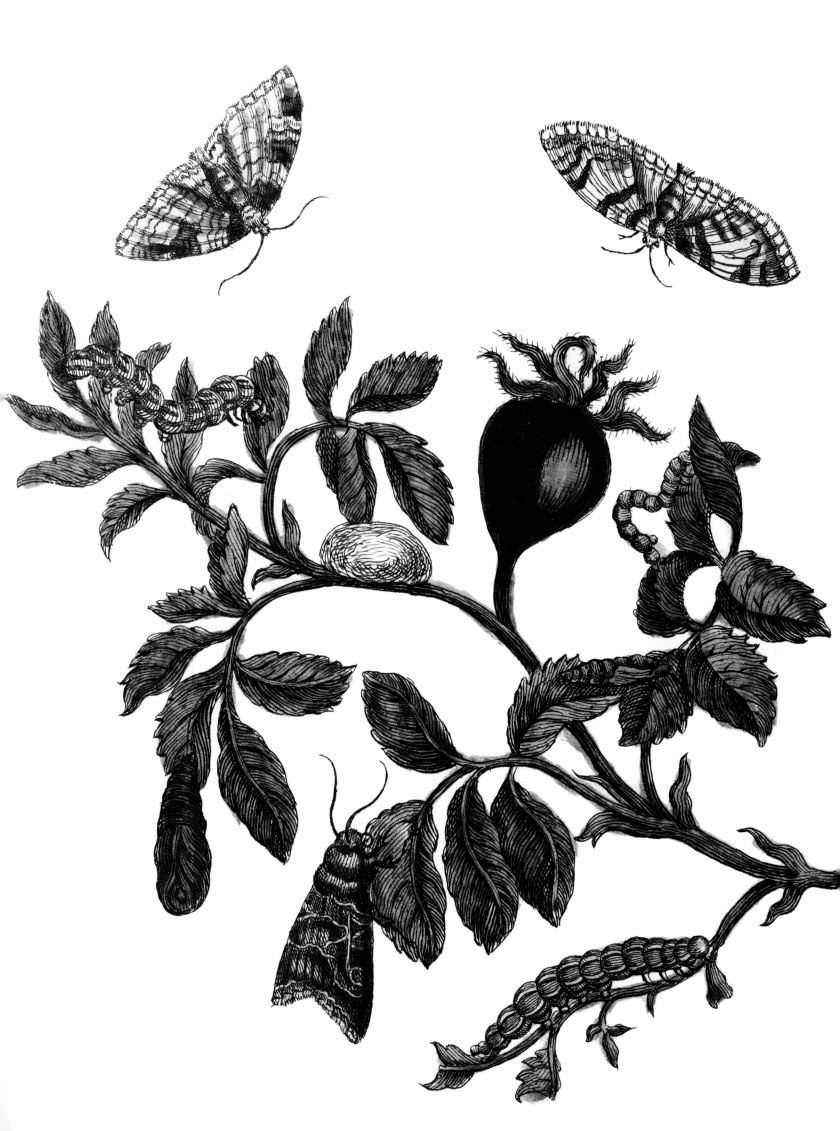

PLANTS AND BUTTERFLIES

MARIA SIBYLLA MERIAN (1647–1717)

Scientific study in seventeenth-century Germany, as elsewhere in Europe, was a man's world. The few highly qualified female entrants to the field remained outsiders and were largely barred from formal training. Yet some women prevailed, staking their independence—and future fame—on science. Among them was Maria Sibylla Merian. Born in Germany in 1647, Merian was the daughter of the renowned engraver Matthäeus Merian the Elder and, after his death, the step-daughter of artist Jacob Marrell. Her mother was related to the de Bry family, which was famous for its publishing enterprises, especially of illustrated works on European voyages to newly "discovered" lands and their human, plant, and animal inhabitants. As a result, Merian

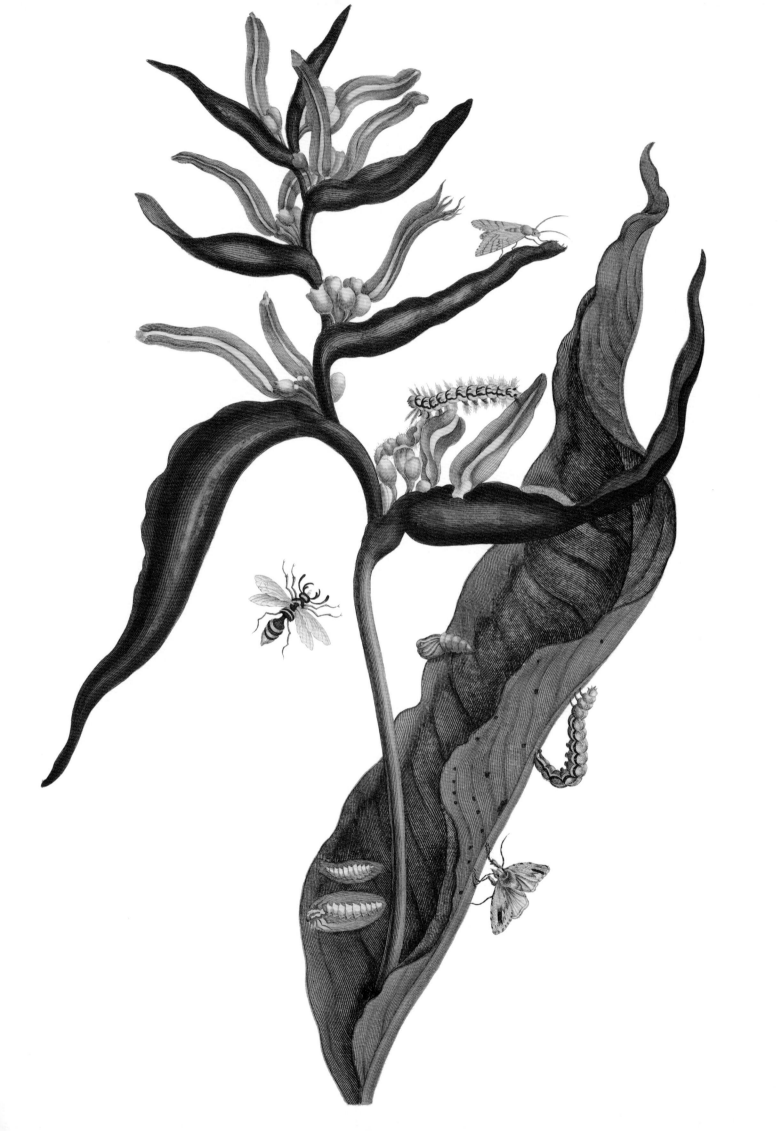

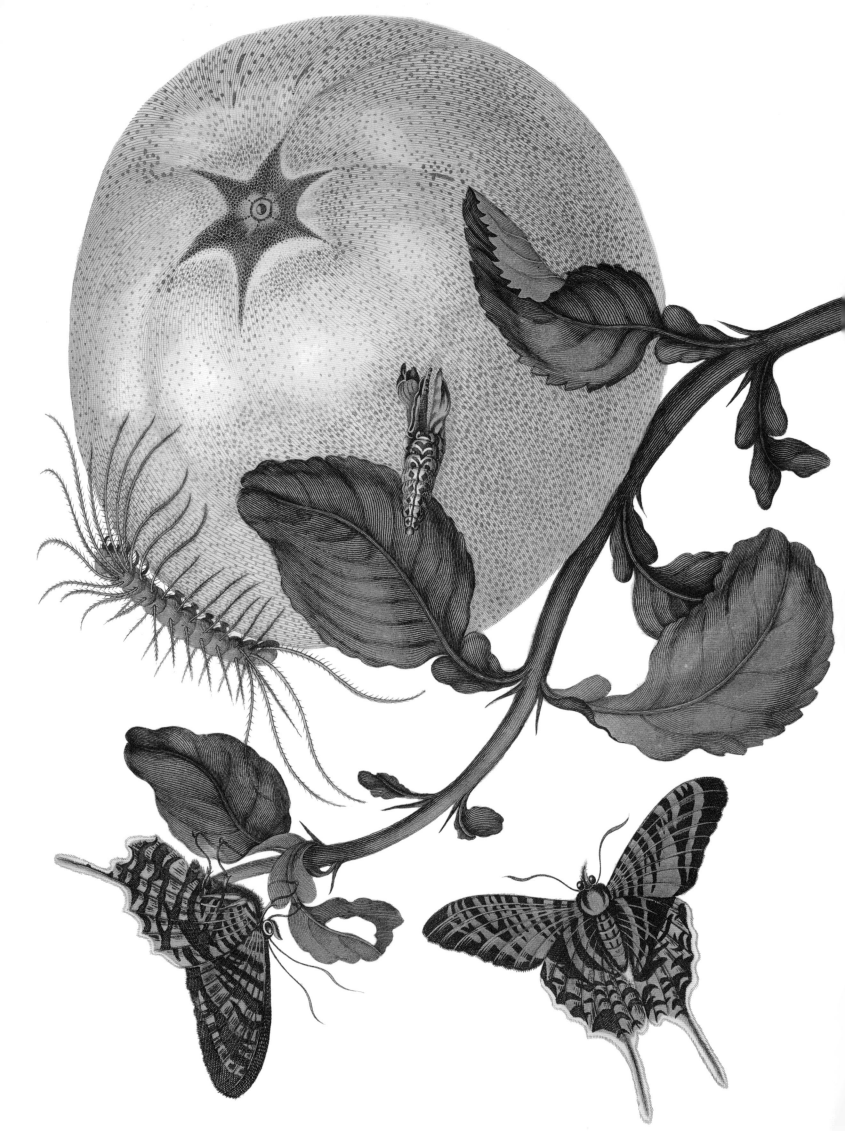

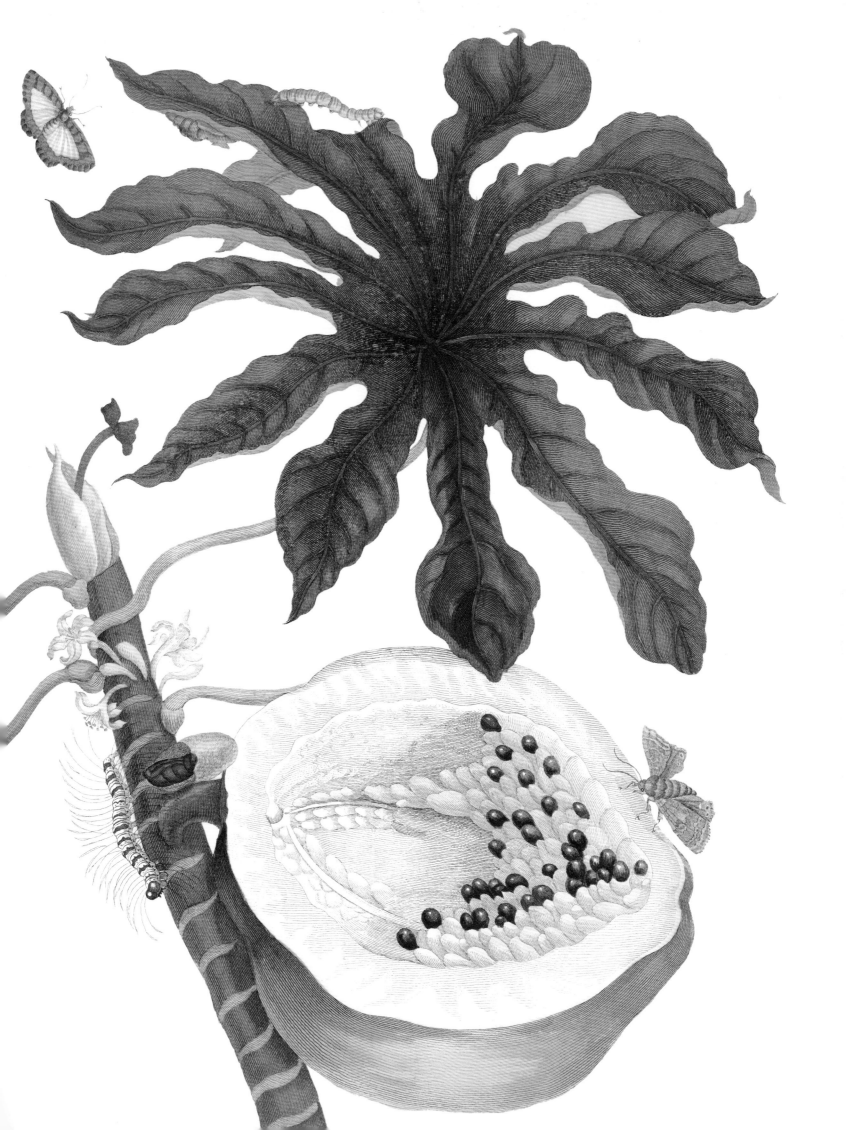

grew up in a busy milieu of baroque still-life painting and natural-history book illustration and was taught drawing and engraving along with her brother. This in itself was uncommon for a young girl of her time, but even more unusually she developed an interest in studying insects, especially butterflies and moths, that would remain an unflagging fascination for the rest of her life. Through her youth and into adulthood she caught them, reared them, and drew them, observing their metamorphoses from egg to caterpillar to chrysalis to adult.

At the age of eighteen, Merian married artist Johann Andreas Graff and embarked on motherhood and the management of a household. But neither her own interests nor the family's financial situation encouraged a conventional life, and amidst the daily domestic duties she continued to study and to draw. She taught art to other women, despite severe gender-based restrictions and regulations by the artists' guild. She also engraved floral designs for embroidery patterns, published as *Neues Blumenbuch* (*New Flowers Book*) in Nuremberg between the years 1675 and 1680.

At about the same time, she began engraving one hundred of her drawings of European insects, published under the title *Der Raupen wunderbare Verwandlung und sonderbare Blumen-Nahrung* (*The Wondrous Transformations of Caterpillars and Their Particular Flower Foods*). Part 1 was published in Frankfurt am Main in 1679; Part 2, in Nuremburg in 1683. The book attracted scientific attention to Merian, for although the fact of metamorphosis had been known since ancient times, the specifics of the process and the connections between the various life stages were still largely unstudied. It was commonly thought, for example, that the larval forms of insects, which resembled worms, arose spontaneously from mud or putrefying meat. And while bees and butterflies may have been well regarded for their usefulness in pollination and as inspiring symbols, insects in general were still a subject of considerable ignorance and aversion in the late seventeenth century. Only one other book up to that time had depicted their metamorphoses (Johannes Goedart's *Metamorphosis naturalis*, published in Middelburg, in the Netherlands, between 1662–1669), so Merian's studies were an important addition to the number of

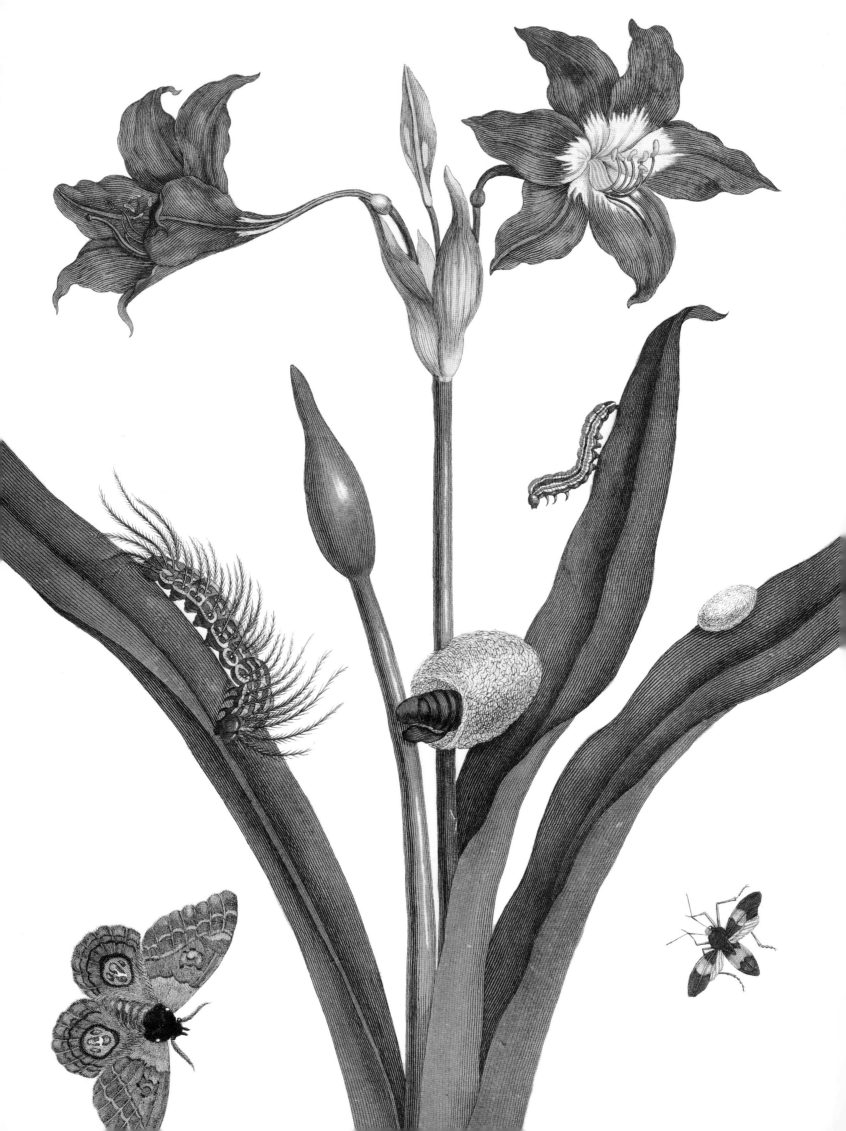

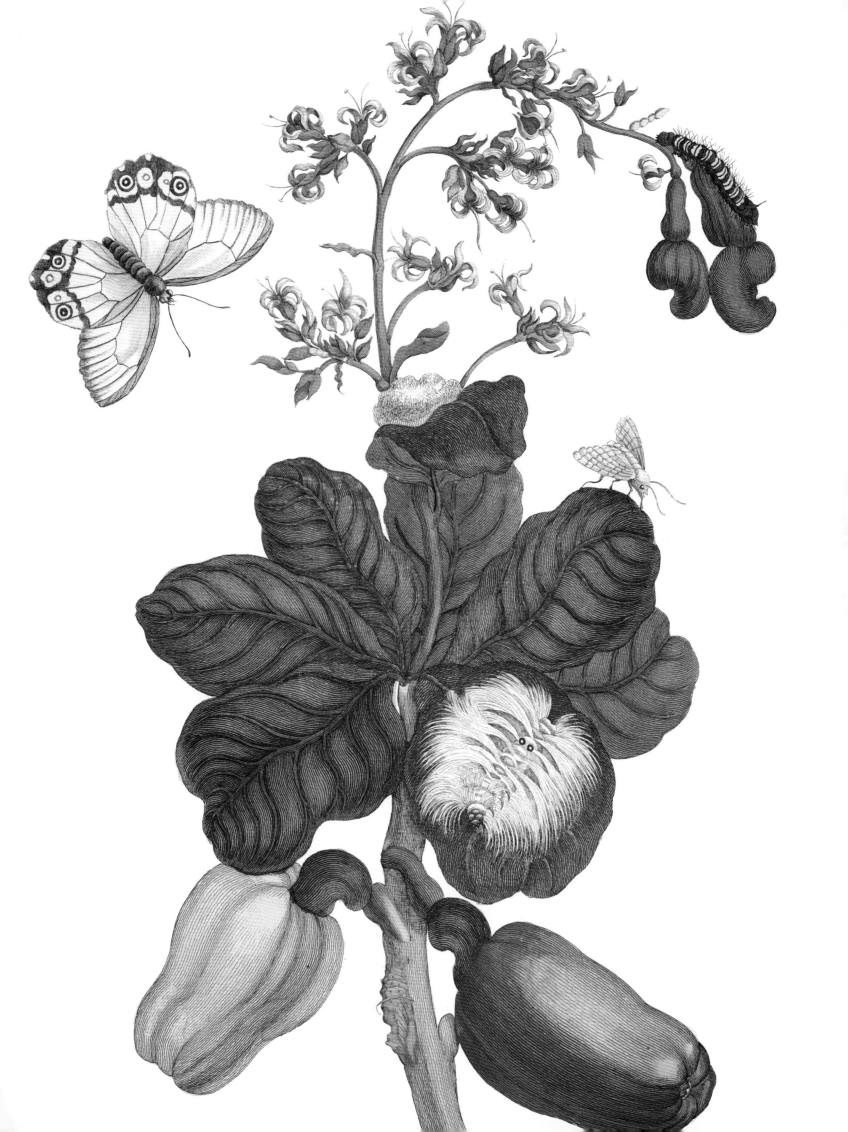

species whose full life cycles were known. Significantly, *Der Raupen wunderbare Verwandlung* was the first book to include illustrations of insects along with their host plants, on which either the larval (caterpillar) or adult form depended for nourishment.

This achievement presaged yet further independence, and in 1685 the thirty-eight-year-old Merian separated from her husband and left with her mother and two daughters to join a religious community in the Netherlands. In the late seventeenth century, this small, northern country was at the height of a golden age of prosperity, thanks to maritime explorations, colonial expansion, and the trade networks of the Dutch East and West India companies. Correspondingly, the country had become a leading intellectual center where science and the arts flourished in universities and printing houses that were famous throughout Europe. Interest was focused particularly on natural-history subjects—and specifically on the peoples, plants, and animals of remote parts of the world. Owning private cabinets of curiosities, formerly a collecting hobby limited to the aristocracy or to obscure specialists, was now widespread.

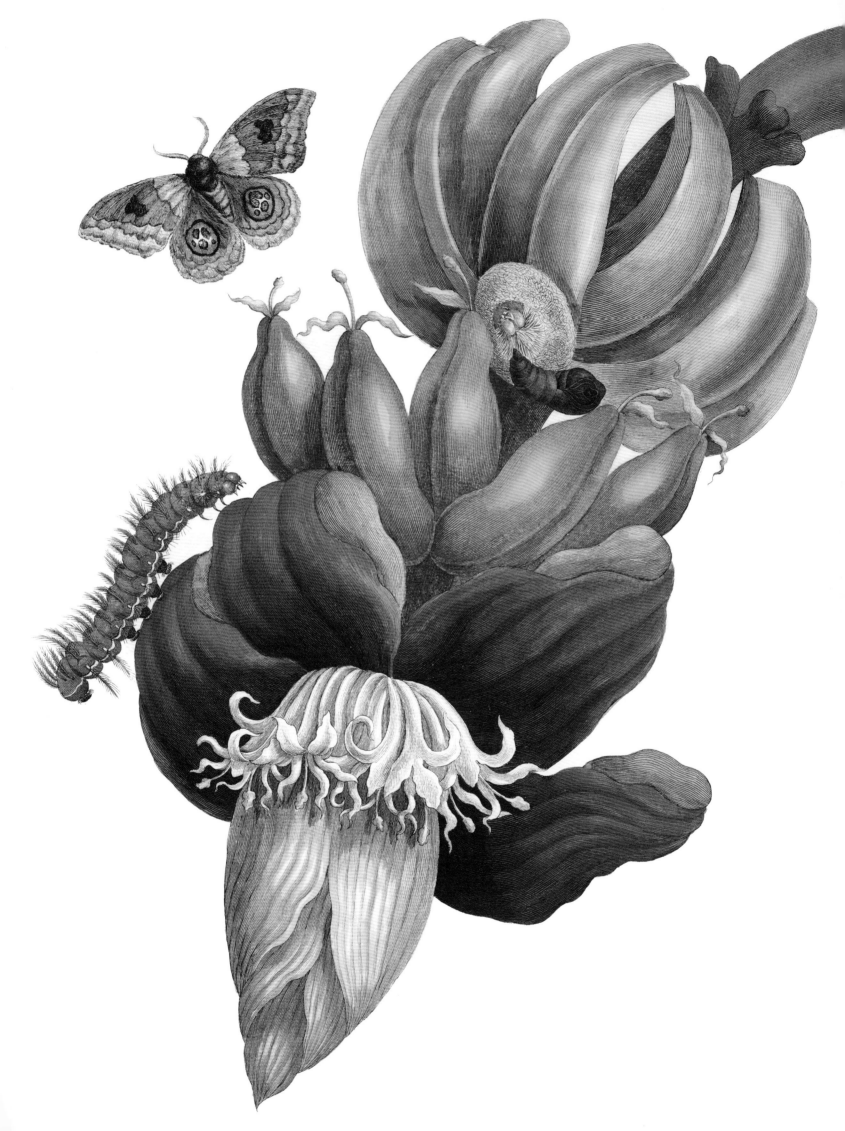

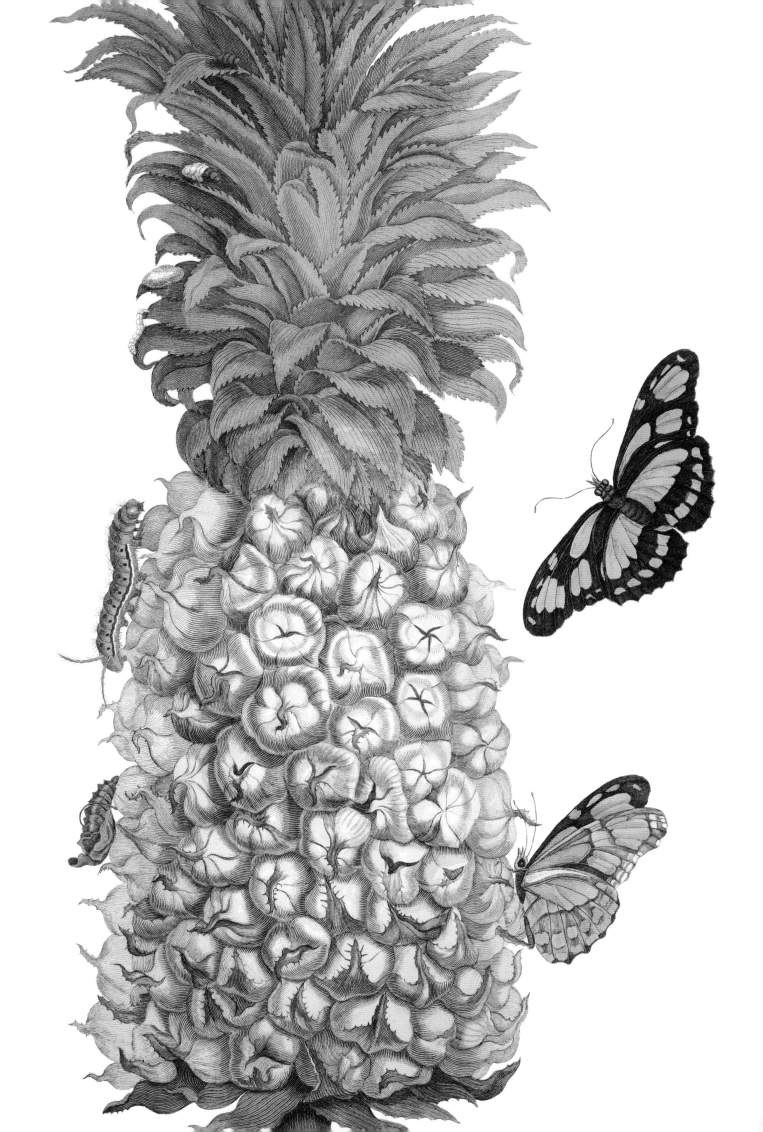

One such collection belonged to Cornelis van Sommelsdijk, the landowner who hosted the religious community in which Merian and her family lived. Through van Sommelsdijk, Merian also became acquainted with other collections, including those of the botanist and anatomist Frederik Ruysch and the merchant Levin Vincent. Intrigued—or perhaps frustrated—by the fact that the spectacular butterflies and insects in the cases were present only in their adult forms, with nothing known of their life histories, she made the extraordinary decision to travel to South America to study them herself.

Merian sold her collections of insects and her paintings to fund the journey, and at the age of fifty-two—an elderly woman in those days—she embarked in 1699 on a two-month voyage across the Atlantic to the Dutch colony of Surinam (later Dutch Guiana, and today the Republic of Suriname), accompanied only by her younger daughter. She lived for two years on private plantations carved from the jungle wilderness, observing, sketching, and collecting, before a serious illness forced her to return to Amsterdam.

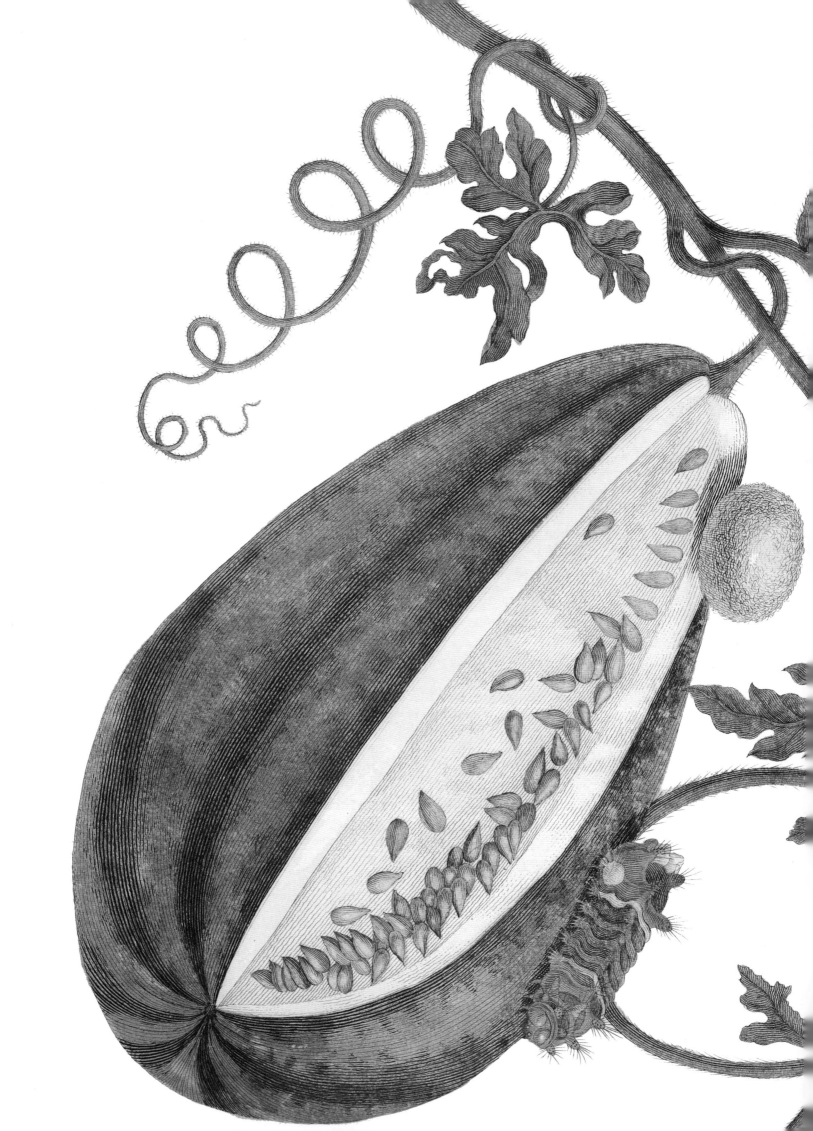

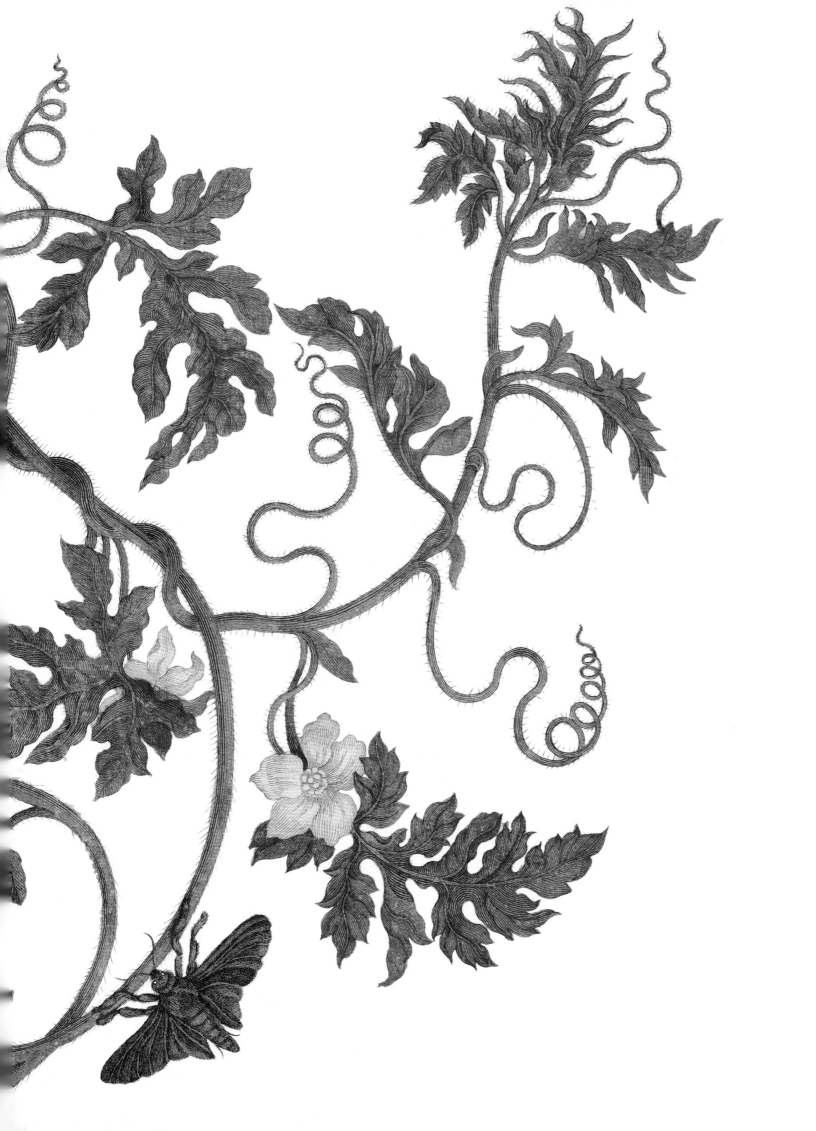

To support herself thereafter she had sixty of her finished drawings engraved and published in a folio format with explanatory text (in either Latin or Dutch). She sold *Metamorphosis insectorum Surinamensium/ Of te verandering der Surinaamsche insecten* (*The Transformation of Surinam Insects*), published in Amsterdam in 1705, by subscription at various prices. The most expensive editions were colored by Merian and her daughters, an unusual approach at the time but a distinction that was considered a major artistic advantage.

The book was an unprecedented achievement in natural history. Virtually every one of the tropical plants, fruits, insects, and other animals that she depicted had never before been illustrated in print. Equally unusual, as in her previous works, each insect was illustrated in all the various stages of its life cycle and in relation to a host plant upon which it depended for nourishment. The accompanying text describes her first-hand observations and includes notes on the plants and fruits by Caspar Commelin, a prominent botanist of the day.

The magnificent book was valued by scientists and collectors alike, and Merian was able to make a meager living from it, as well as from

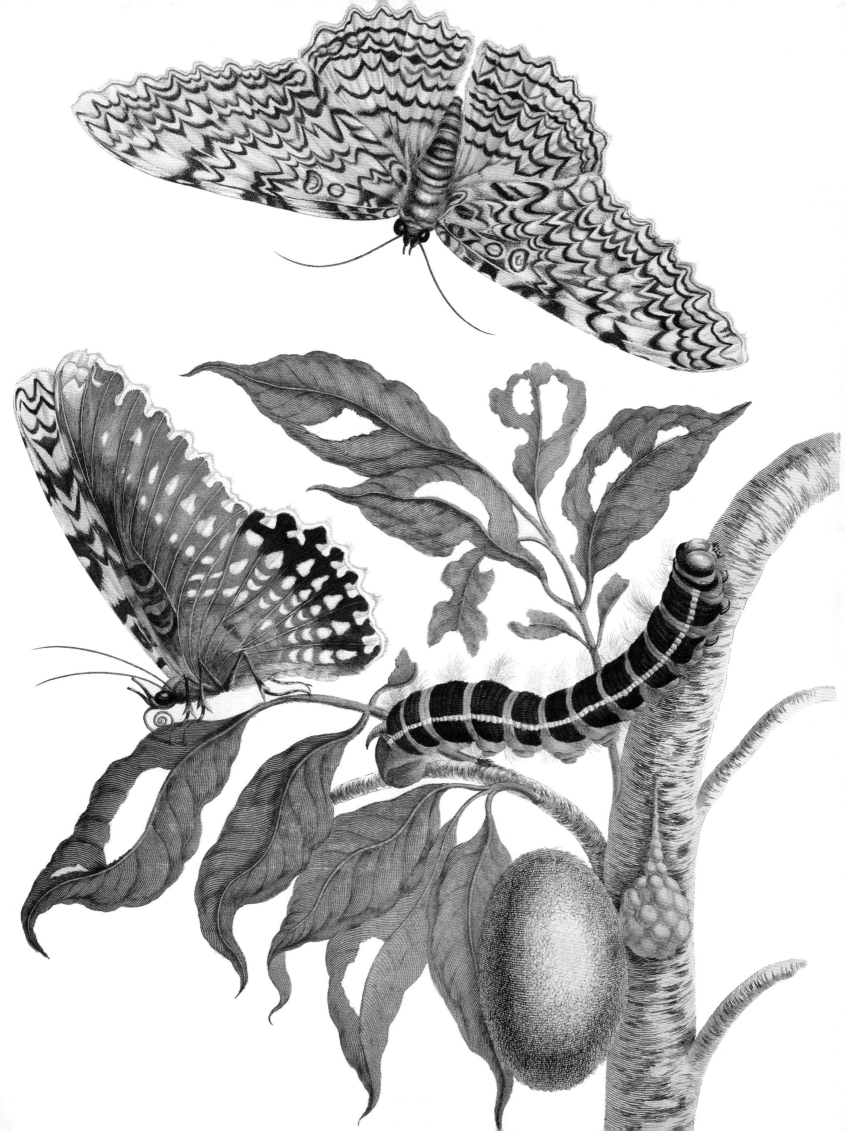

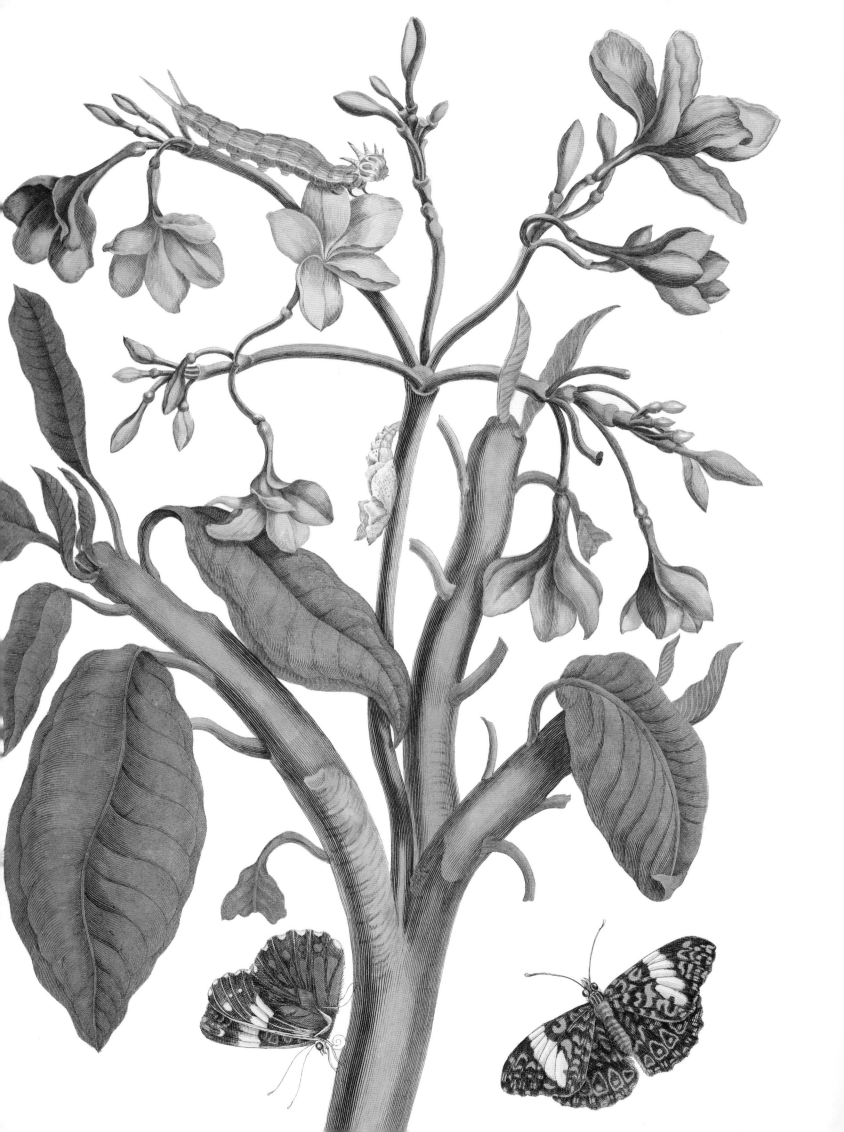

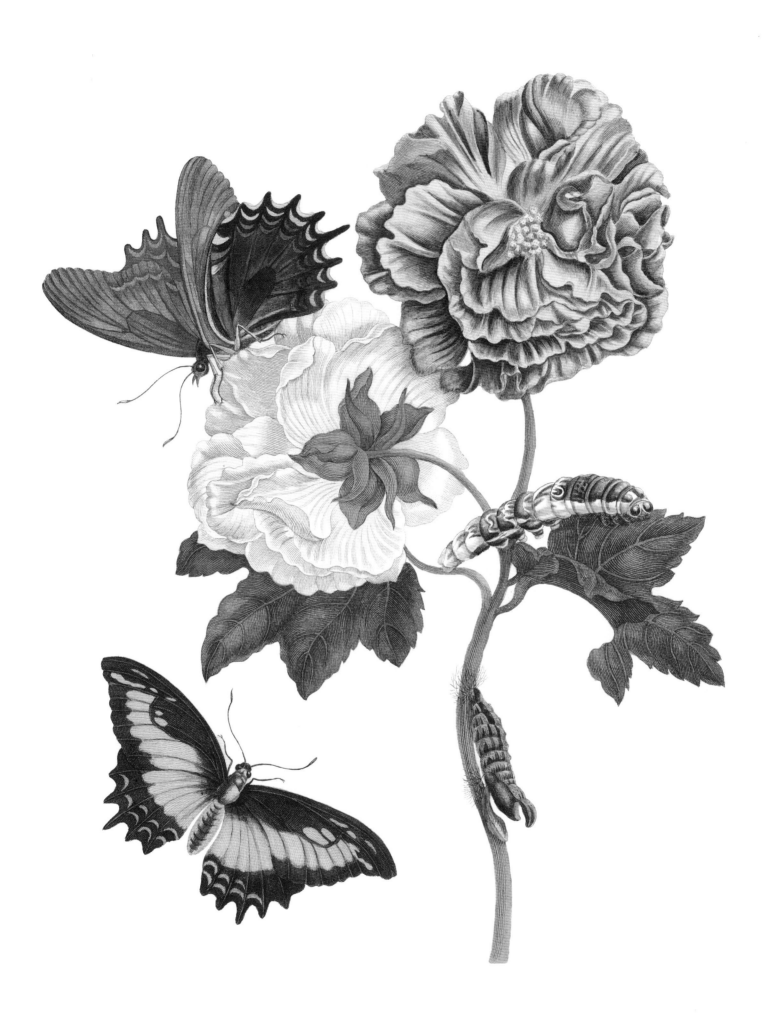

the sale of her original drawings and engraving proofs and counter-proofs. (In addition, she undertook a commission to provide illustrations for Georg Rumphius's *D'Amboinsche Rariteitkamer,* a book on East Indian seashells published in Amsterdam, 1705.) Among those who admired her work was Tsar Peter the Great of Russia who, during a visit to Western Europe, bought several hundred of her watercolor drawings; they reside today in the Russian Academy of Sciences, in Moscow (published in facsimile as the *Leningrader Aquarelle,* in Lucerne, Switzerland, 1974).

Merian died in 1717, at the age of sixty-nine. Her daughters subsequently sold the copper plates for the illustrations in both the *Raupen* and the *Metamorphosis,* and these plates were used for subsequent editions of the books in various European languages during the next several decades. The German *Der Raupen wunderbare Verwandlung und sonderbare Blumen-Nahrung,* with fifty additional prints, was republished in Dutch, Latin, and French five times between 1713 and 1771. The *Metamorphosis* had an even more complicated publishing history. The original Latin and Dutch texts of 1705 were transformed,

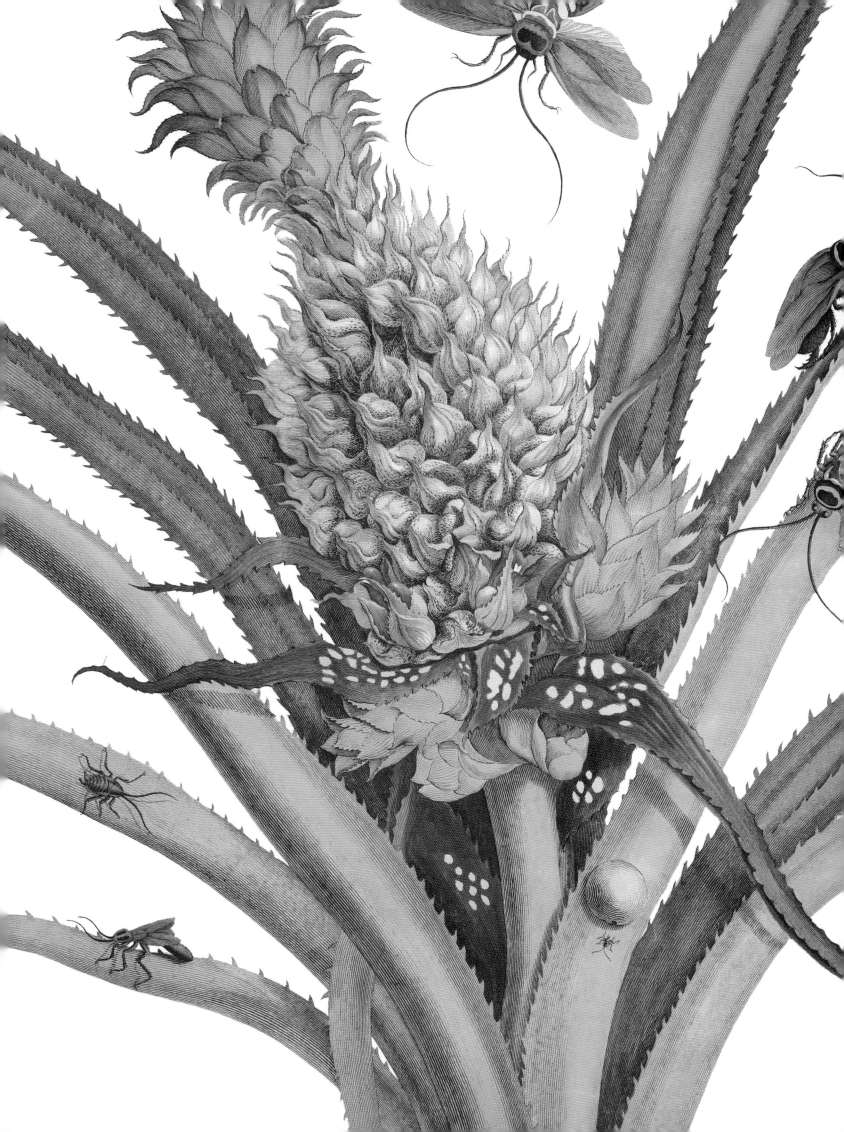

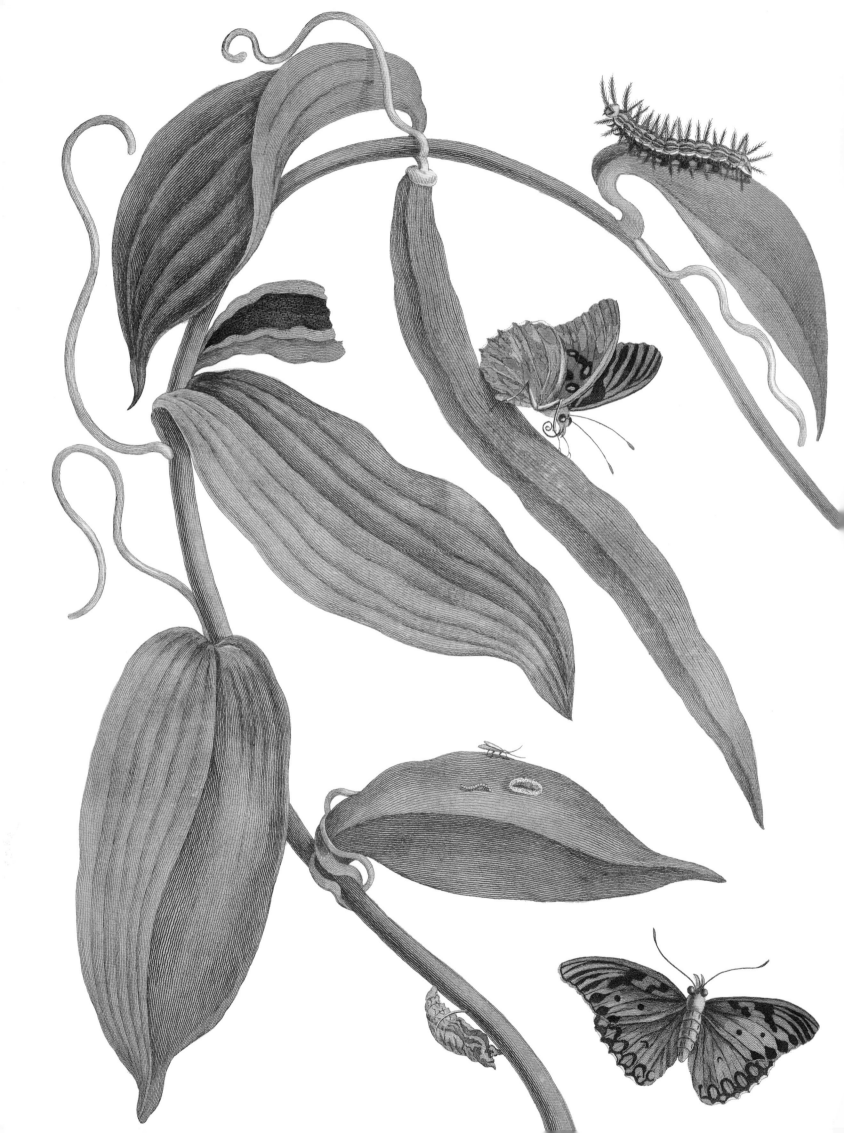

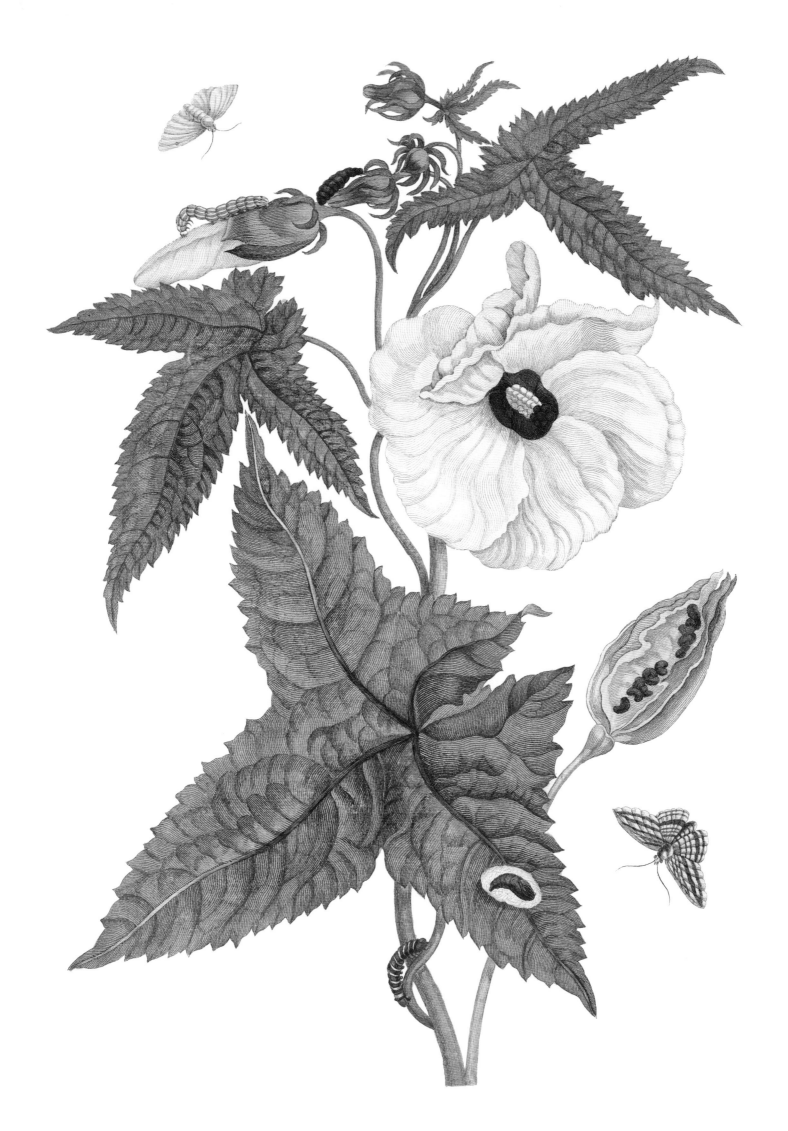

with twelve additional prints for a total of seventy-two, into eight further editions under alternate titles in Latin, Dutch, and French between 1719 and 1771.

Although later entomologists found a few errors and misidentifications in Merian's work, it still stands as an astonishing achievement, both artistically and scientifically. The founder of modern zoological classification and binomial nomenclature, Carl Linnaeus, cited the *Metamorphosis* and the *Raupen* (in its 1730 French version) for more than a hundred insects and plants to which he gave scientific names in his *Species Plantarum*, published in Stockholm in 1753, and his *Systema Naturae* (tenth edition), published in Stockholm, 1758–1759. Both he and other naturalists have named species of plants, butterflies, and beetles in Merian's honor, giving her well-deserved scientific immortality.

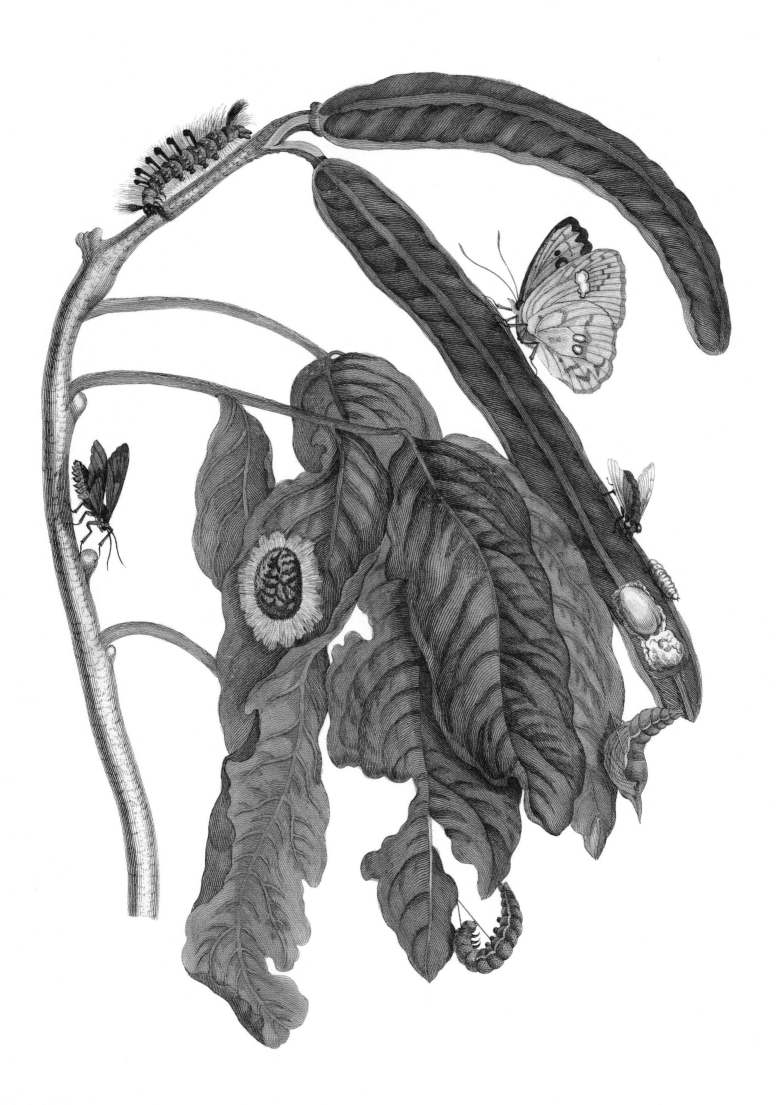

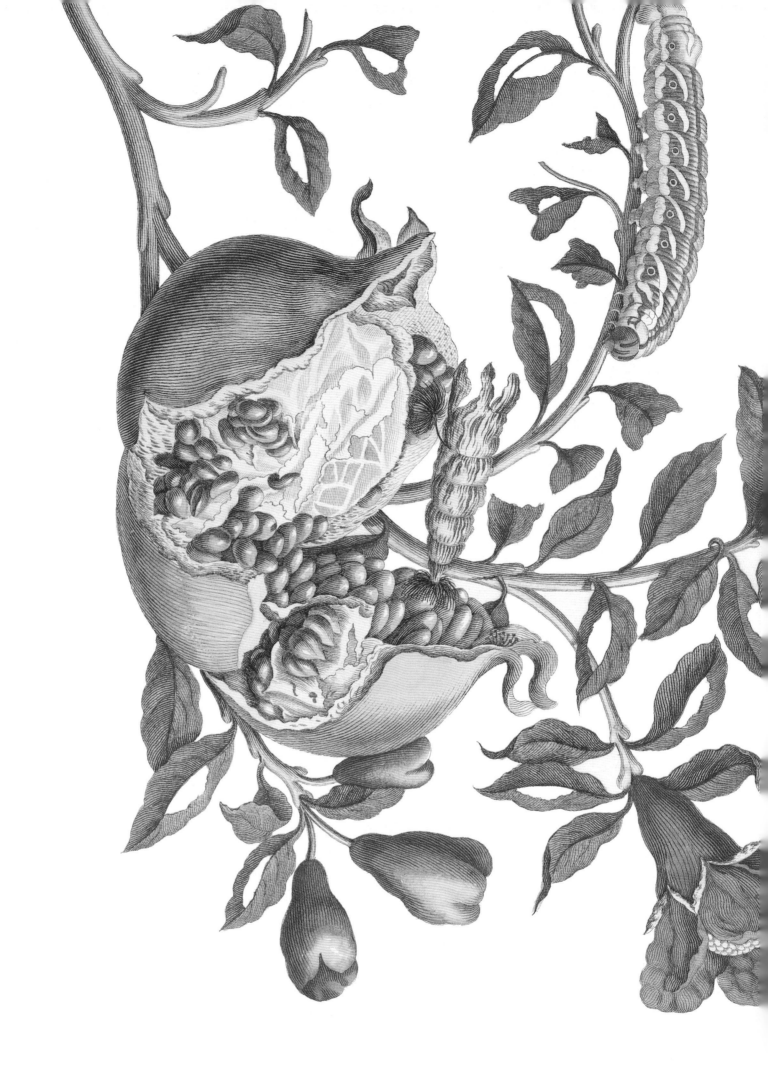

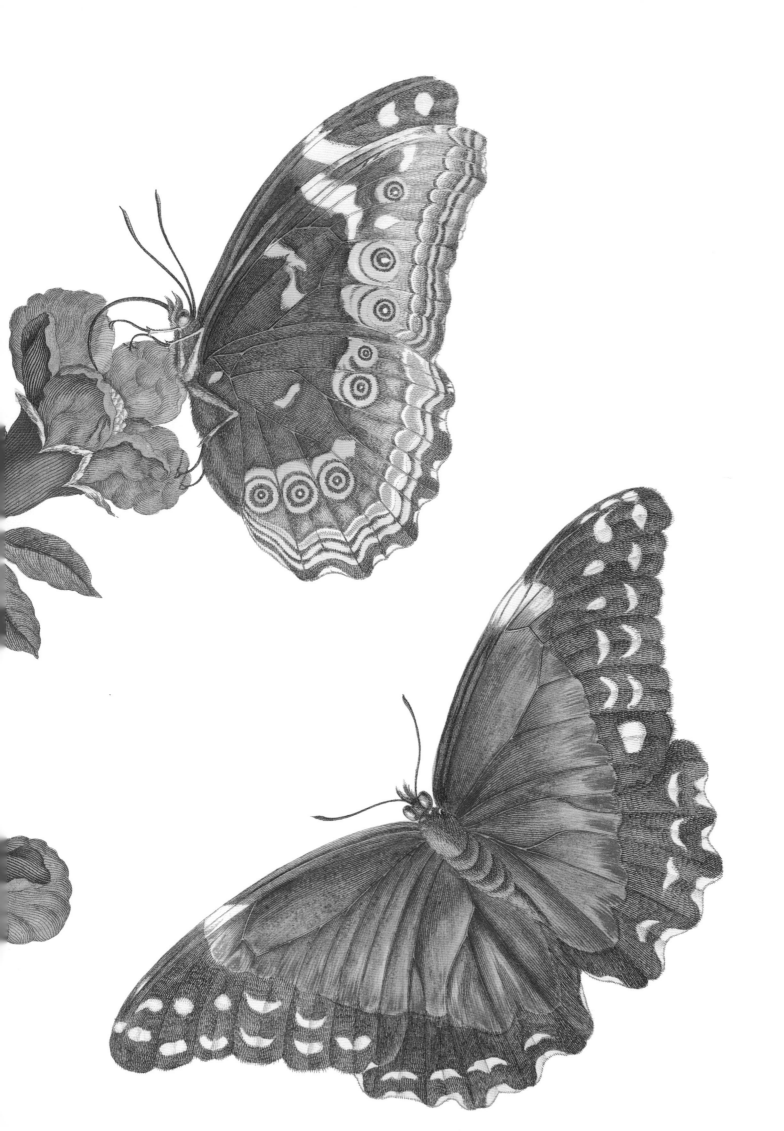

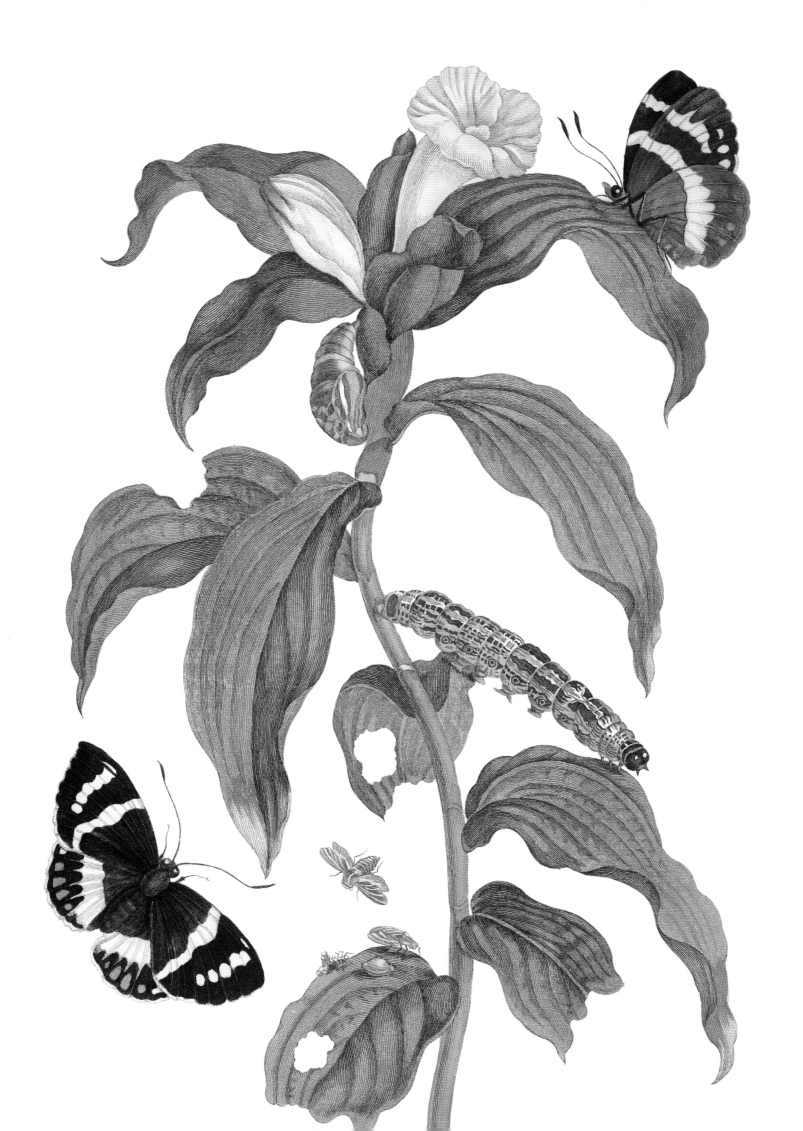

"What the caterpillar calls the end of the world, the Master calls a butterfly."

RICHARD BACH

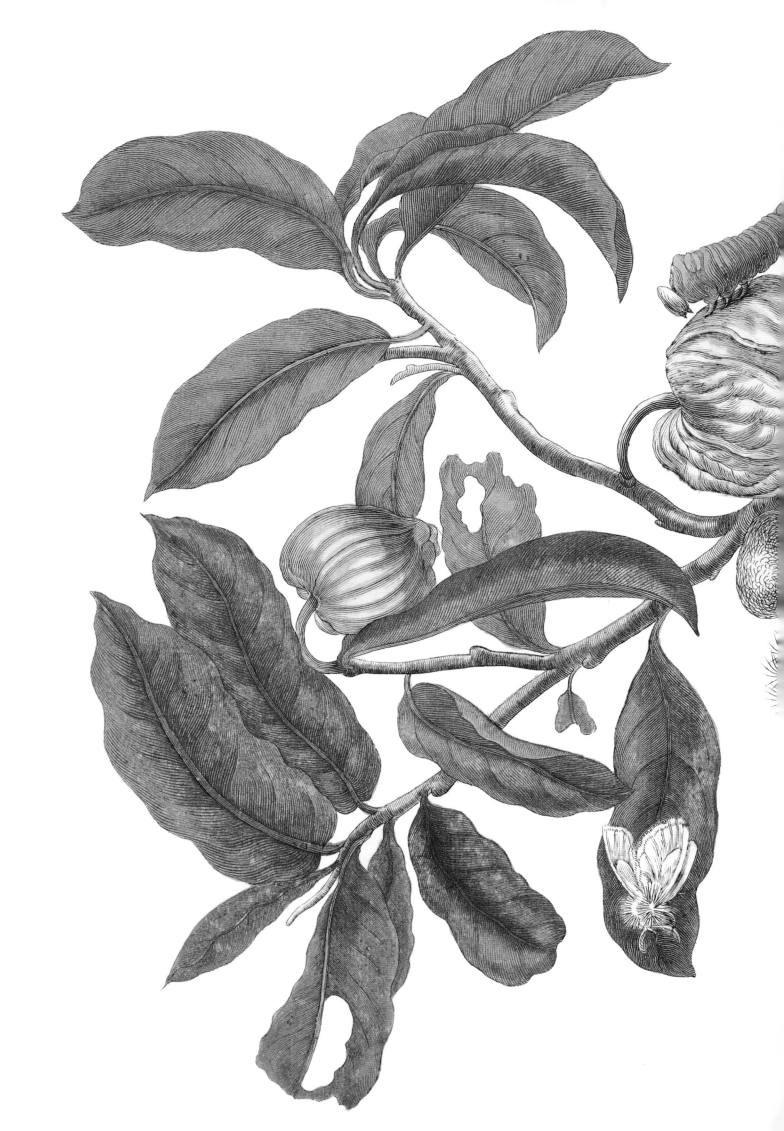

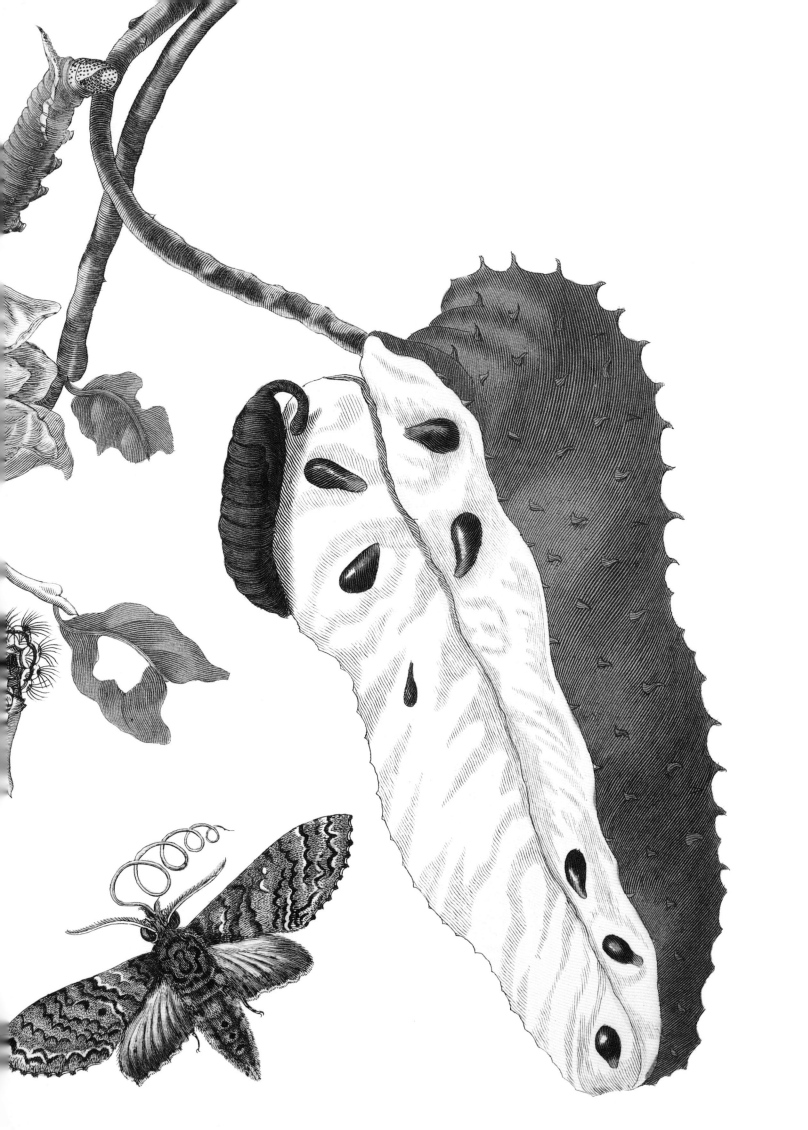

"I trust in Nature for the stable laws
Of beauty and utility. Spring shall plant
And Autumn garner to the end of time.
I trust in God,—the right shall be the right
And other than the wrong, while he endures.
I trust in my own soul, that can perceive
The outward and the inward,—Nature's good
And God's."

ROBERT BROWNING

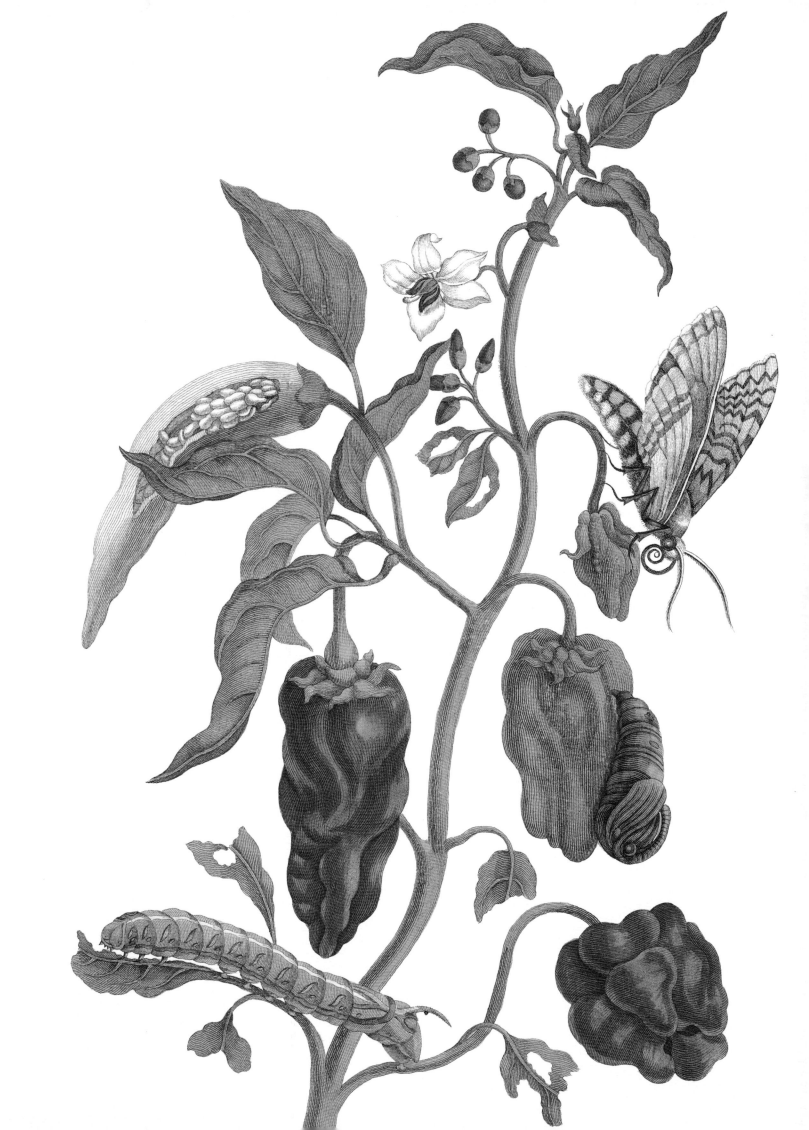

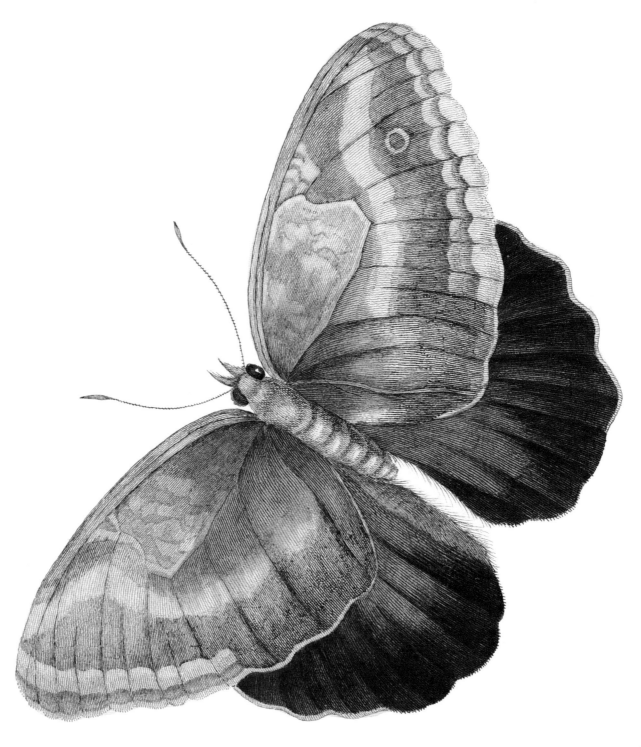

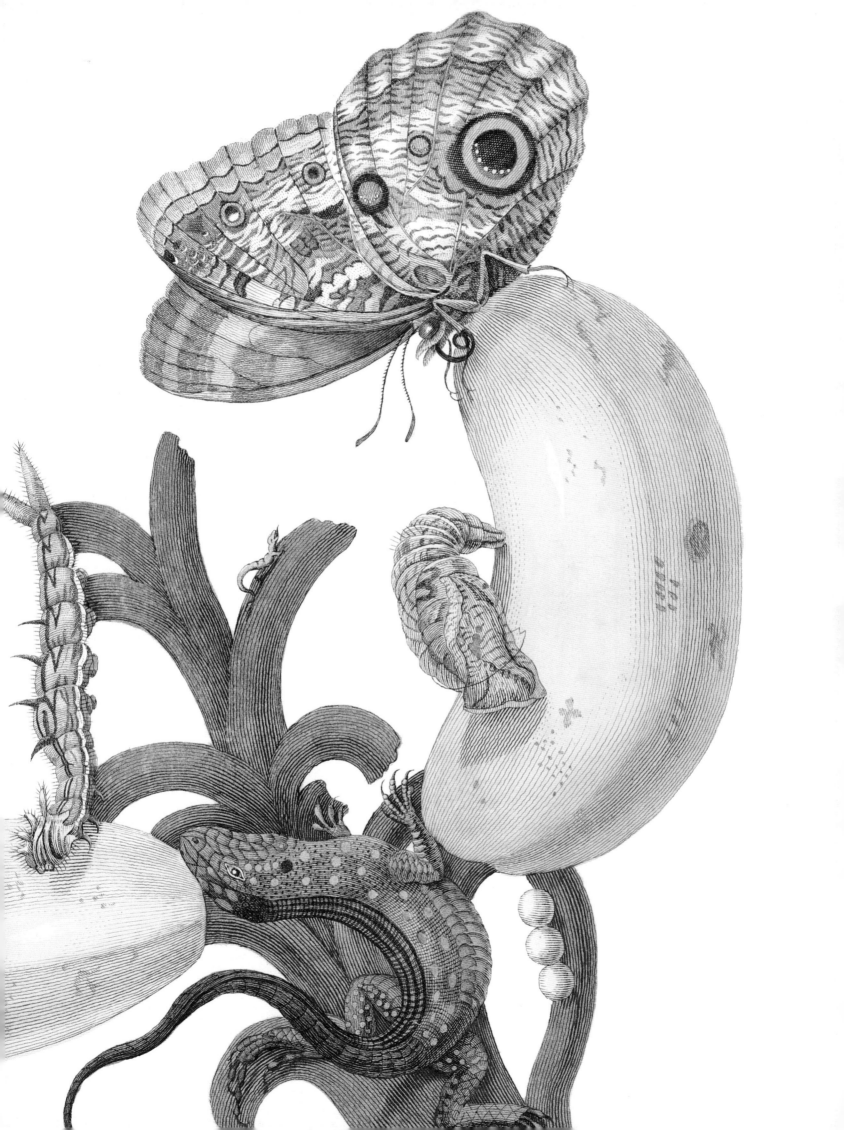

"And 'tis my faith that every flower Enjoys the air it breathes."

WILLIAM WORDSWORTH
LINES WRITTEN IN EARLY SPRING

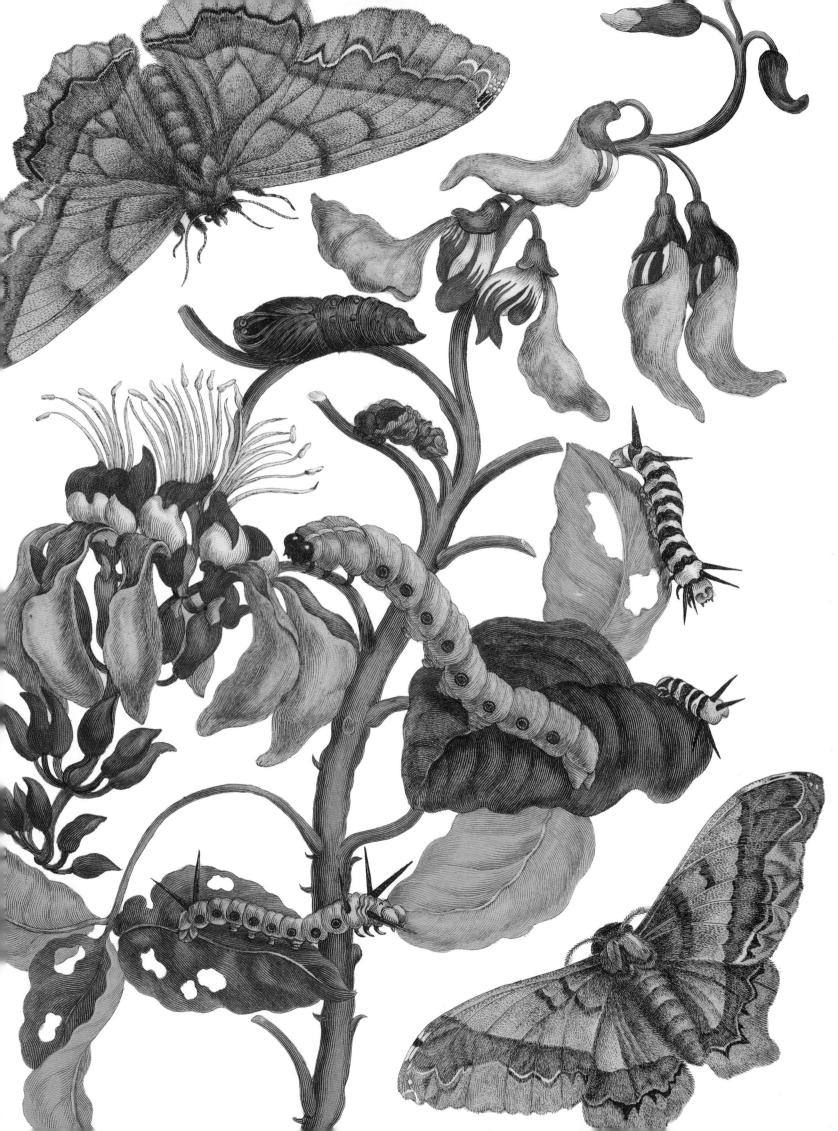

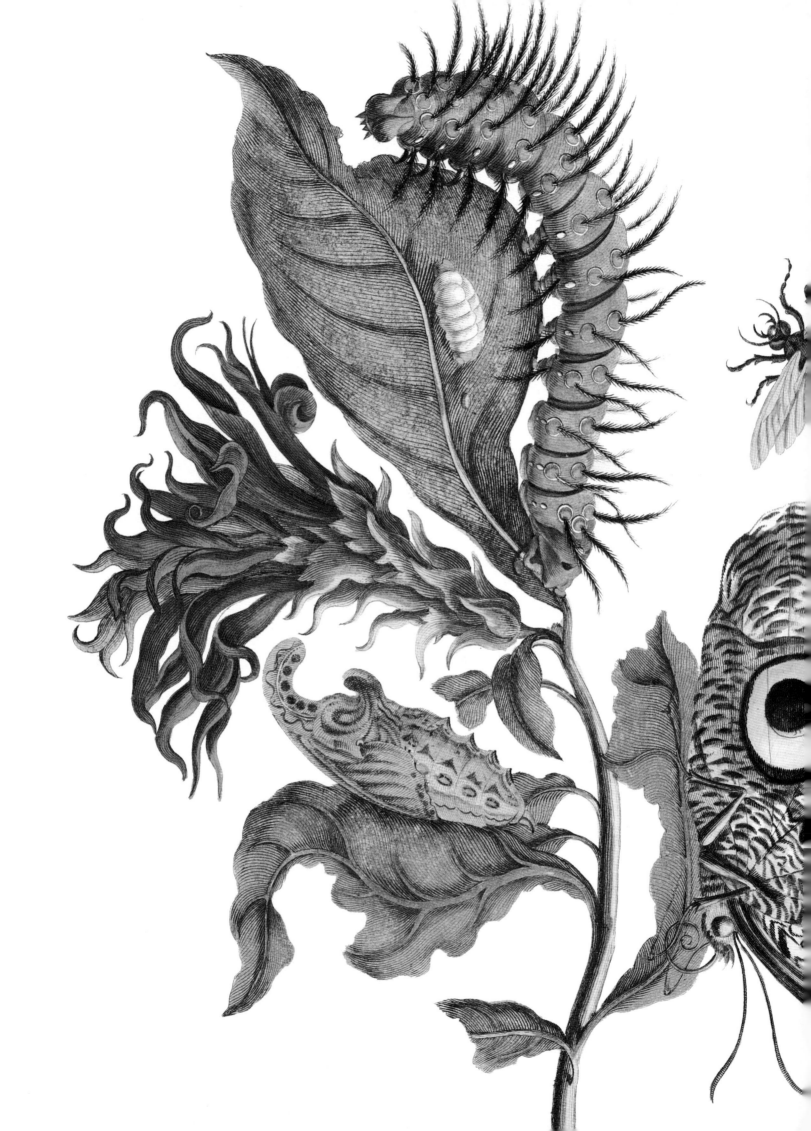

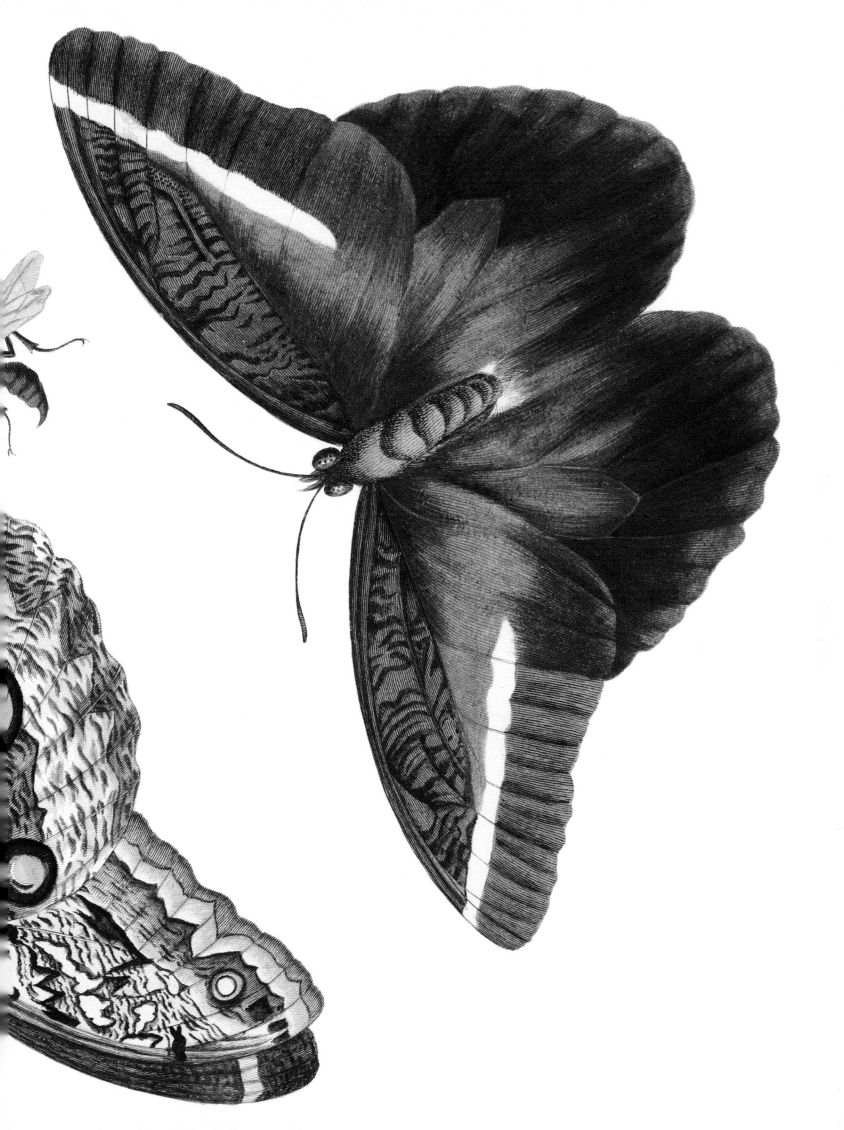

"There are not frogs wherever there is water; but wherever there are frogs, water will be found."

GOETHE, *SPRUCHE IN PROSA*

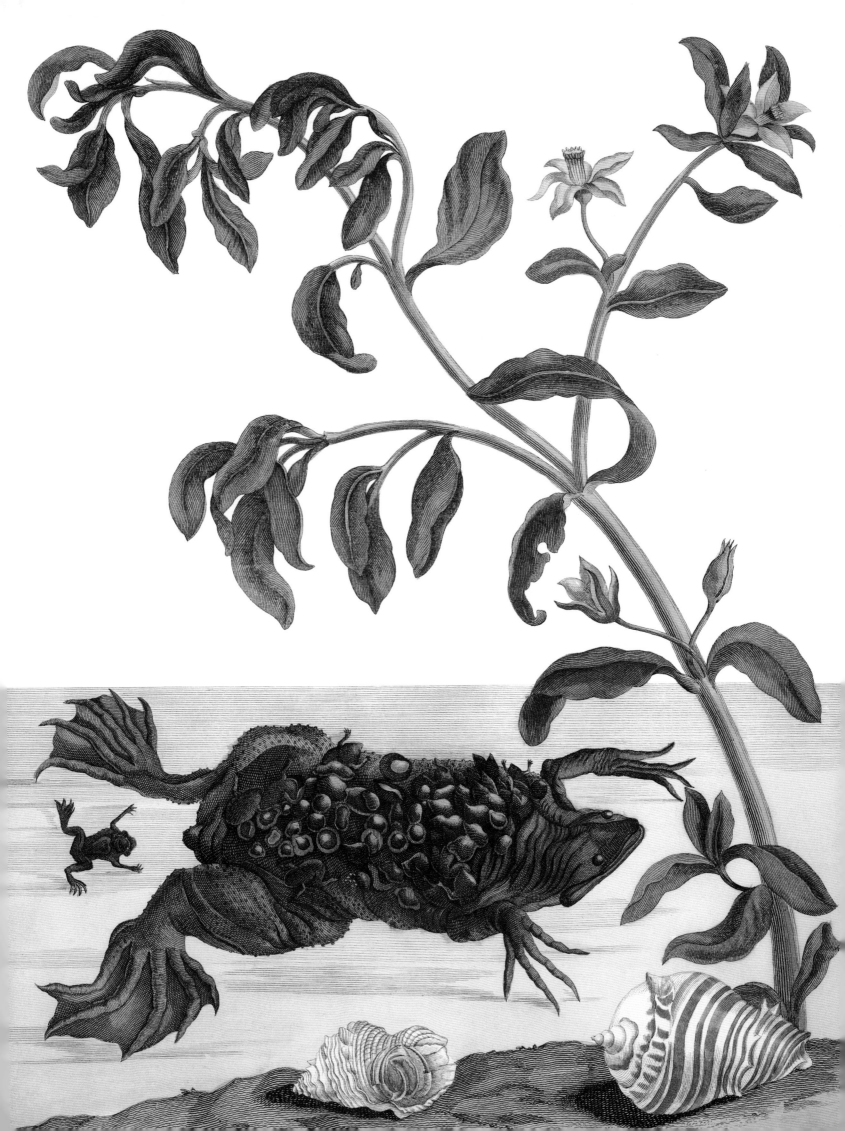

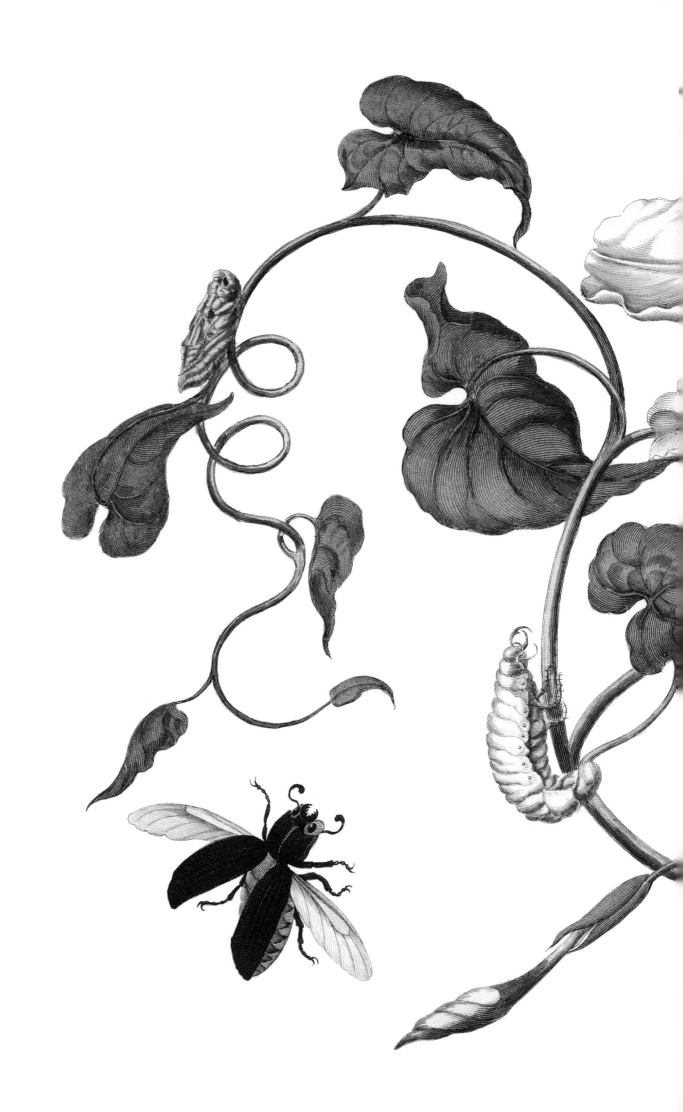

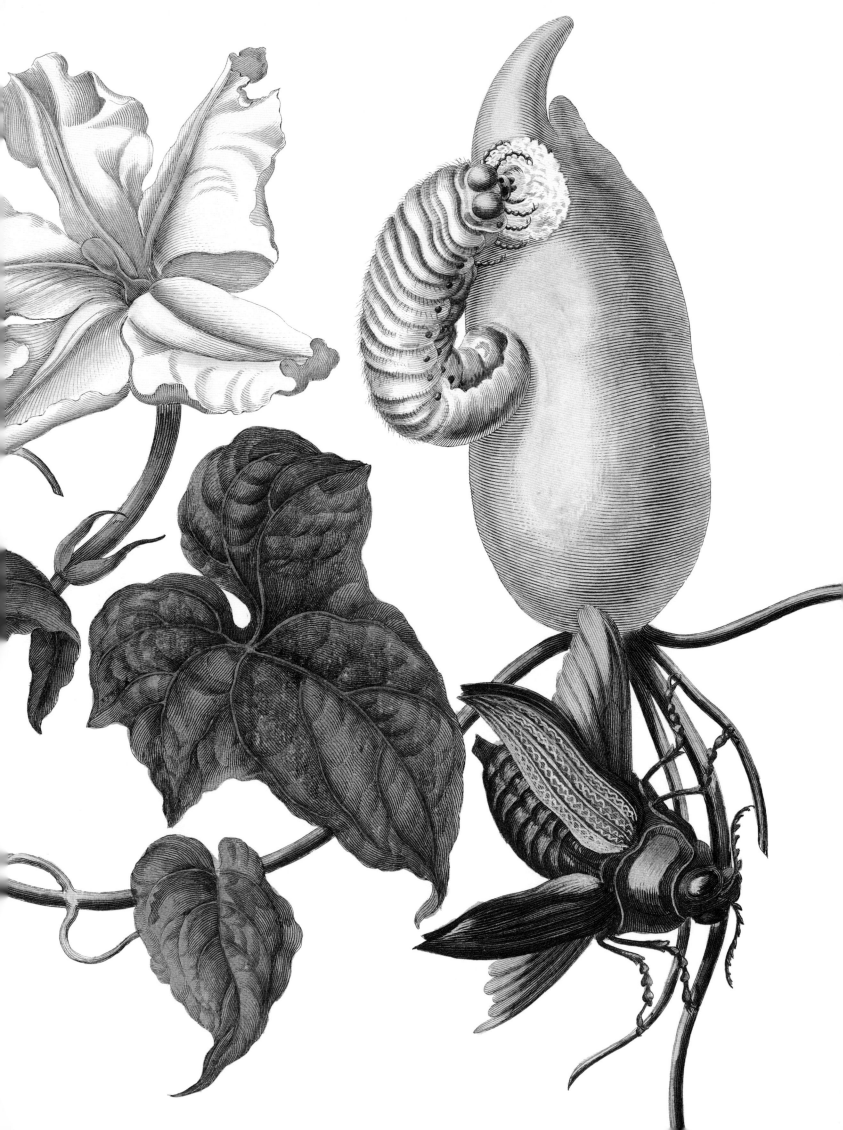

"Violets! —deep-blue violets!

April's loveliest coronets!

There are no flowers grow in the vale,

Kissed by the dew, wooed by the gale,—

None by the dew of the twilight wet,

So sweet as the deep-blue violet."

LETITIA ELIZABETH LANDON, *THE VIOLET*

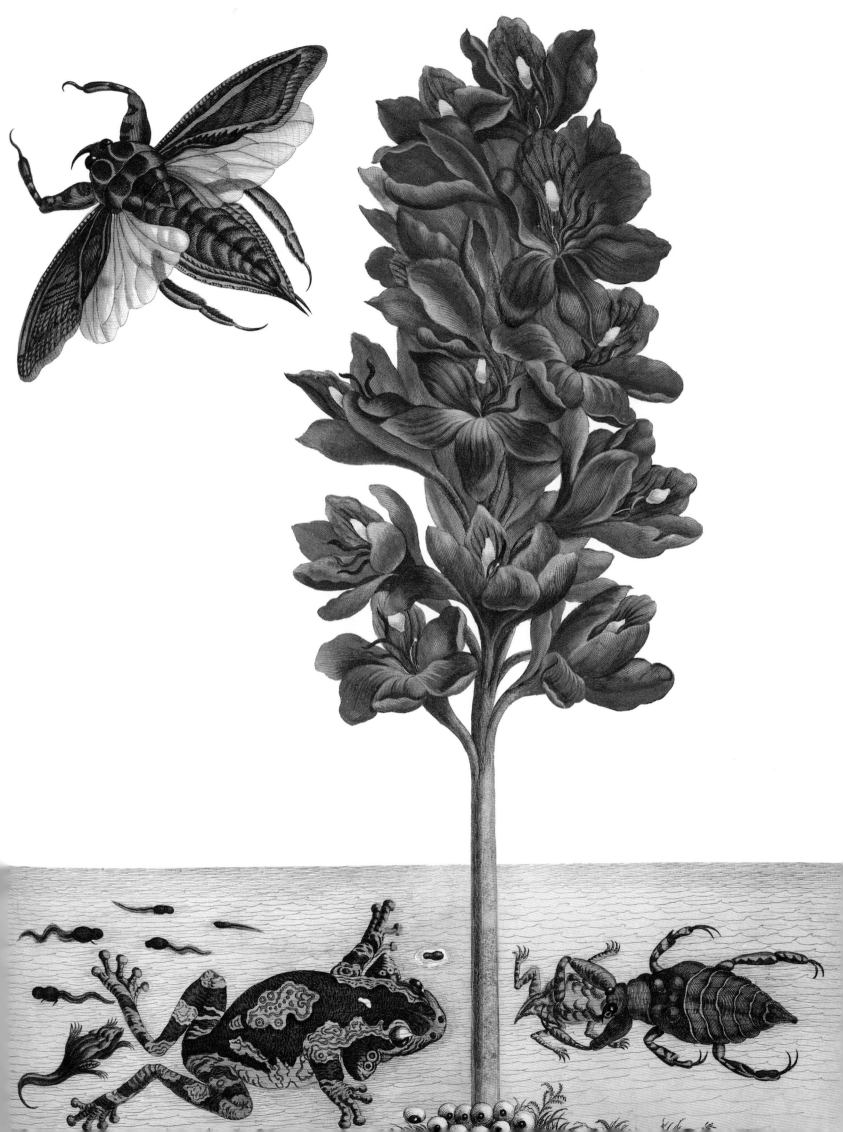

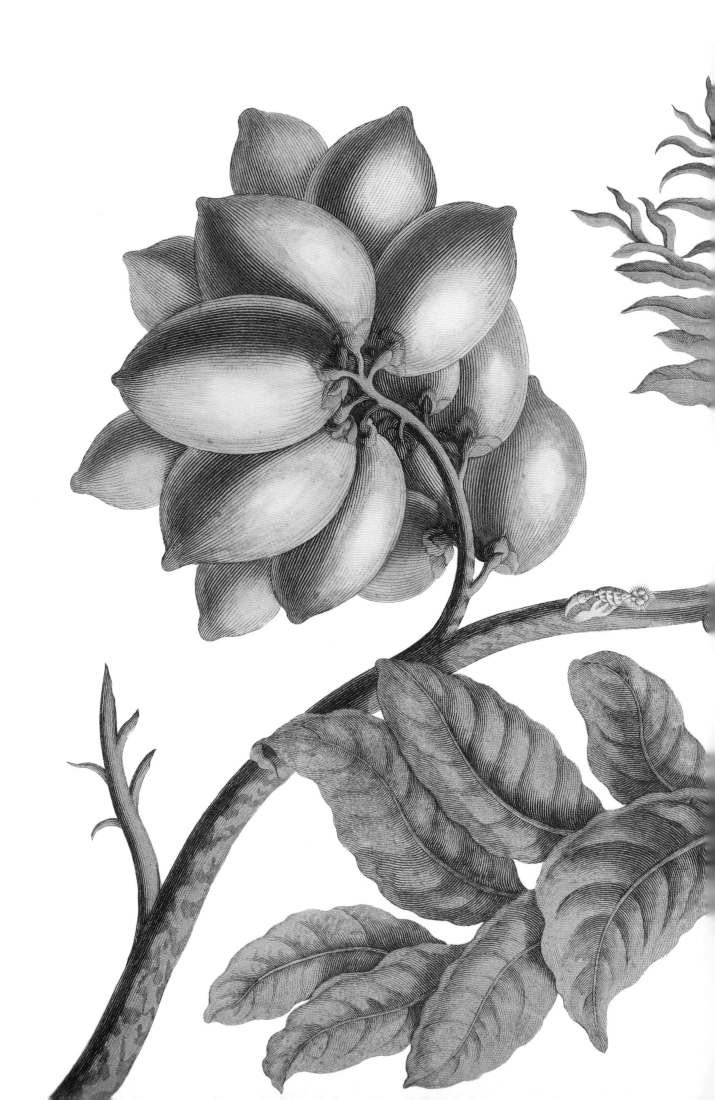

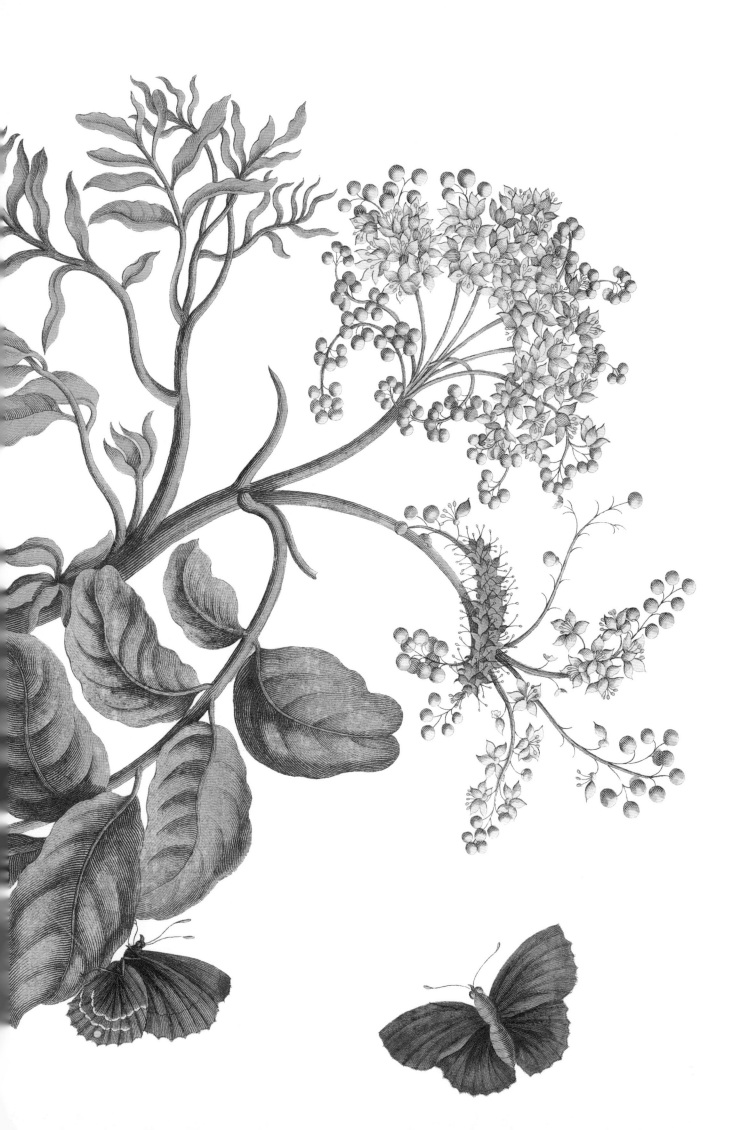

66 And because the breath of flowers is far sweeter in the air (where it comes and goes, like the warbling of music) than in the hand, therefore nothing is more fit for that delight than to know what be the flowers and plants that do best perfume the air. **99**

FRANCIS BACON

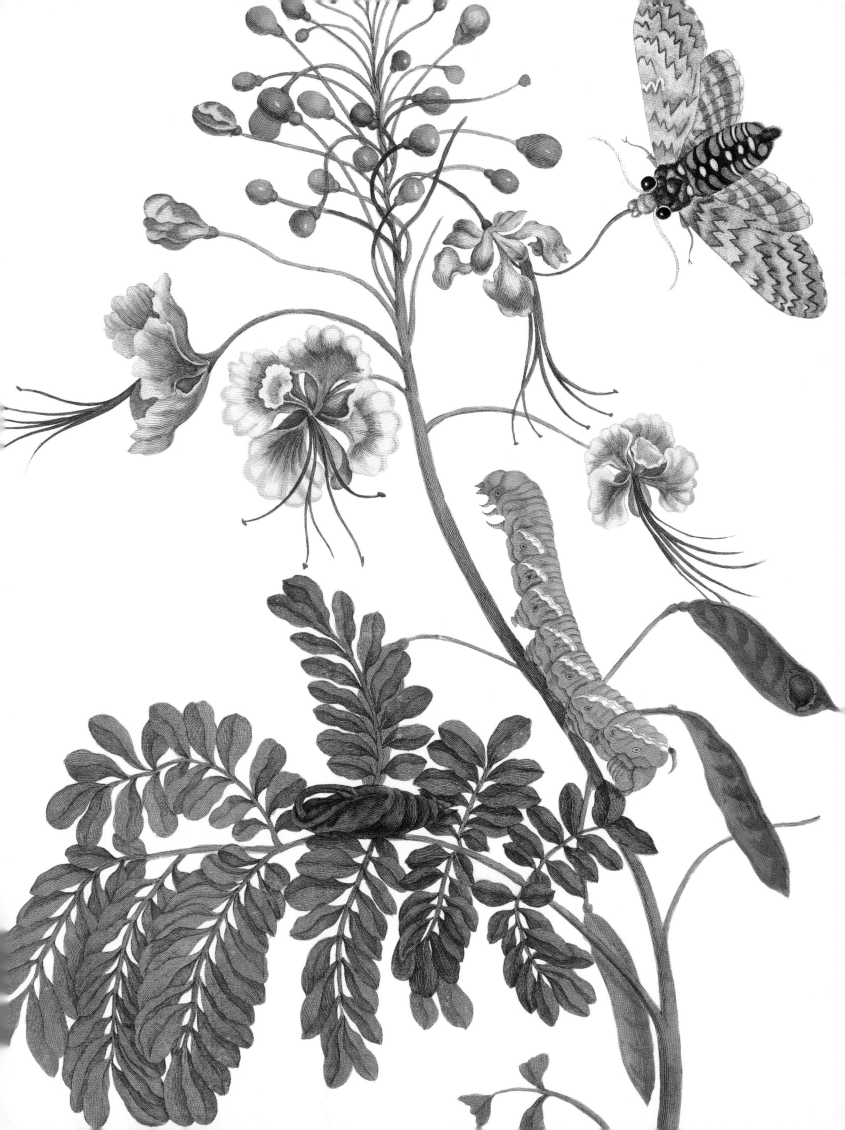

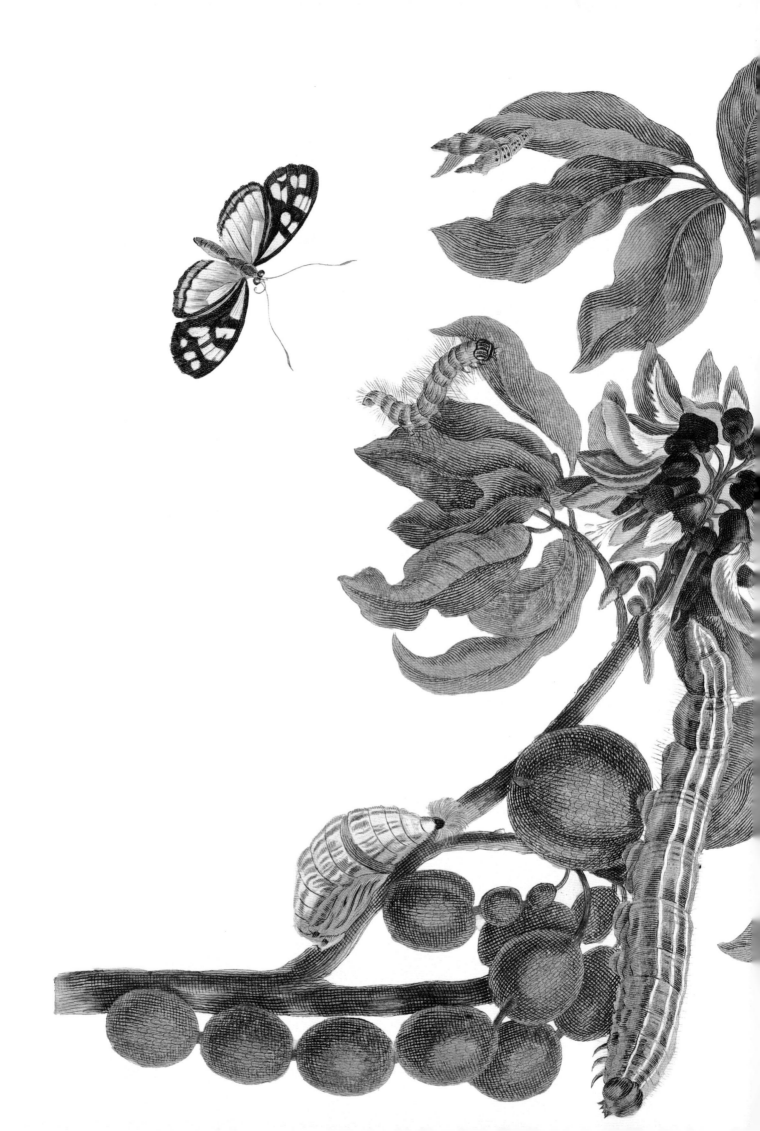

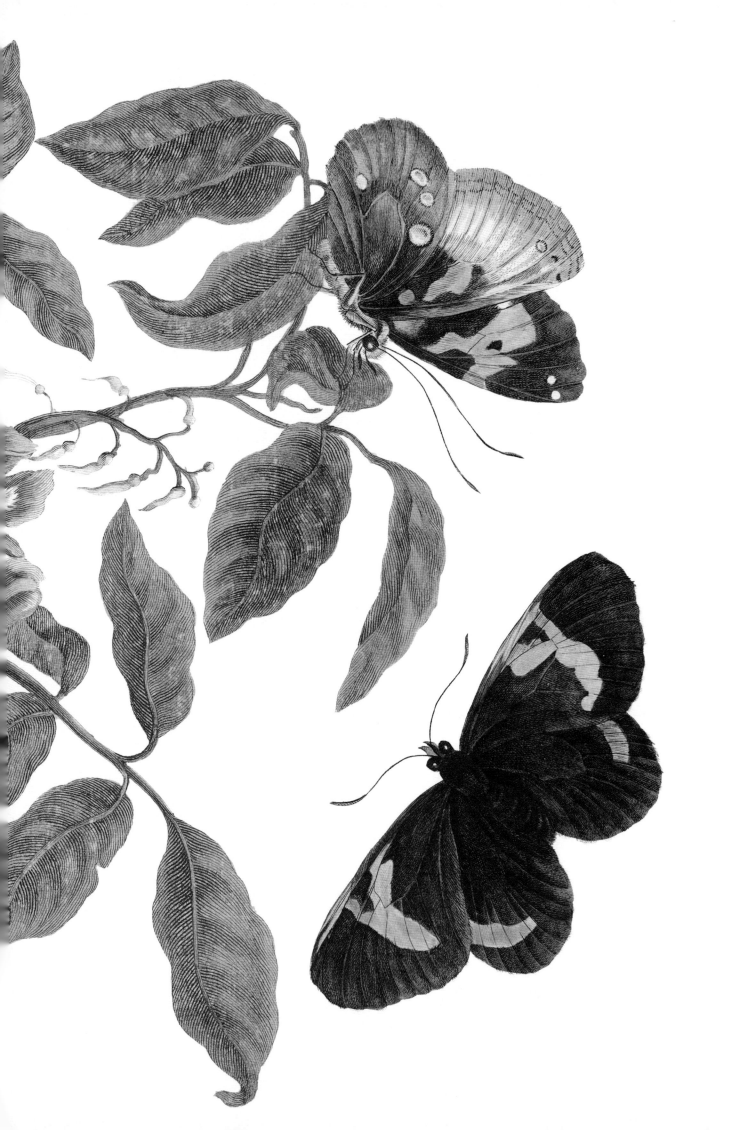

"It is blue-butterfly day here in spring,
And with these sky-flakes down in flurry on flurry
There is more unmixed color on the wing
Than flowers will show for days unless they hurry.

But these are flowers that fly and all but sing:
And now from having ridden out desire
They lie closed over in the wind and cling
Where wheels have freshly sliced the April mire."

ROBERT FROST, *BLUE-BUTTERFLY DAY*

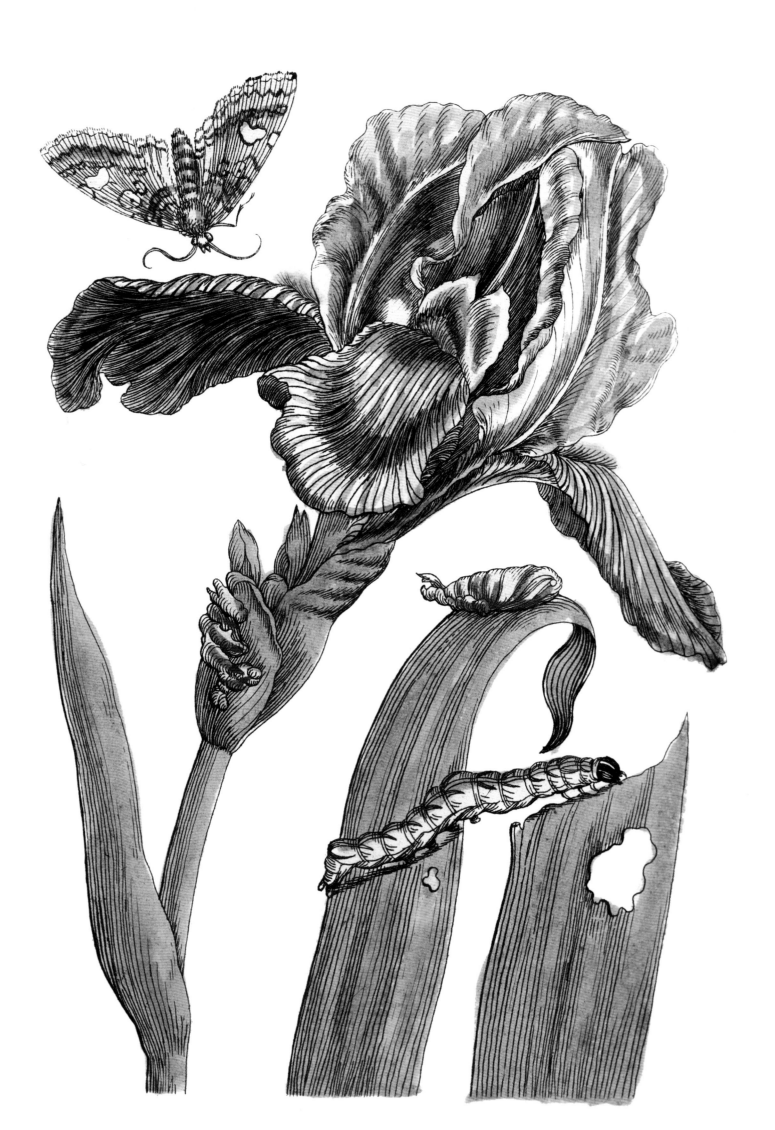

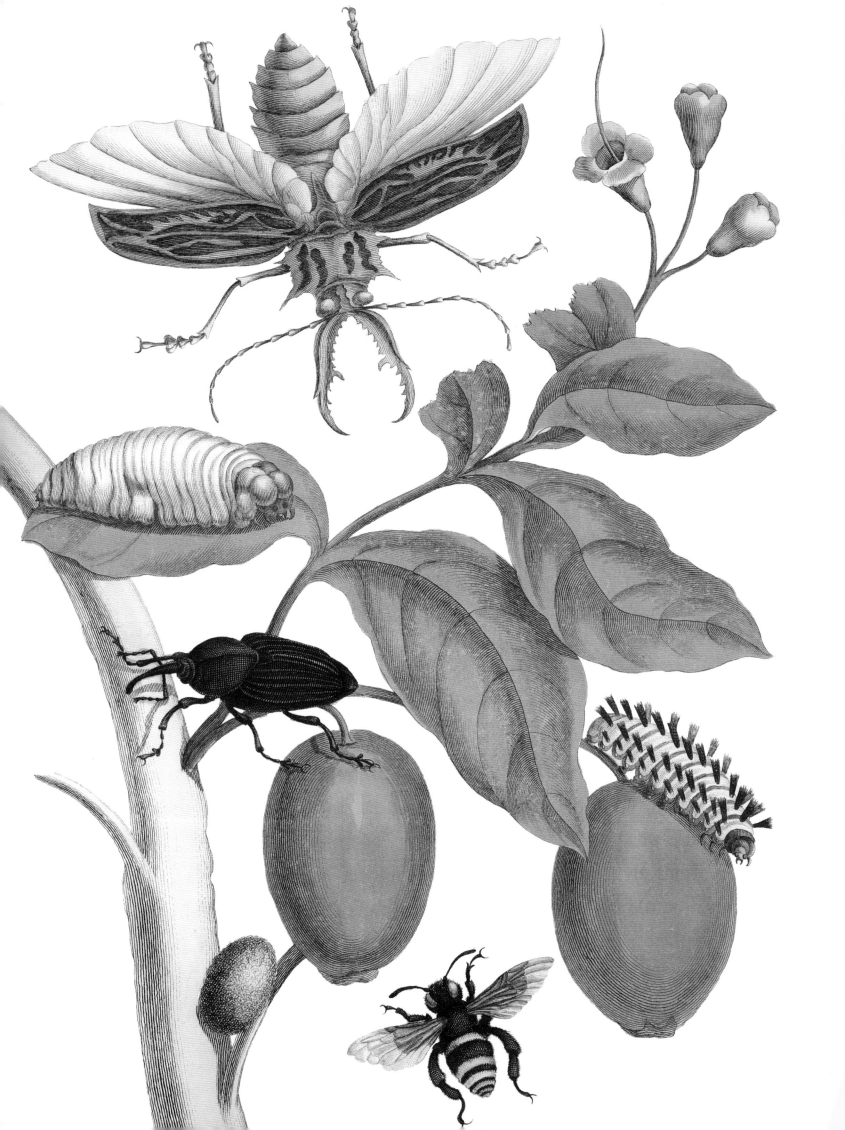

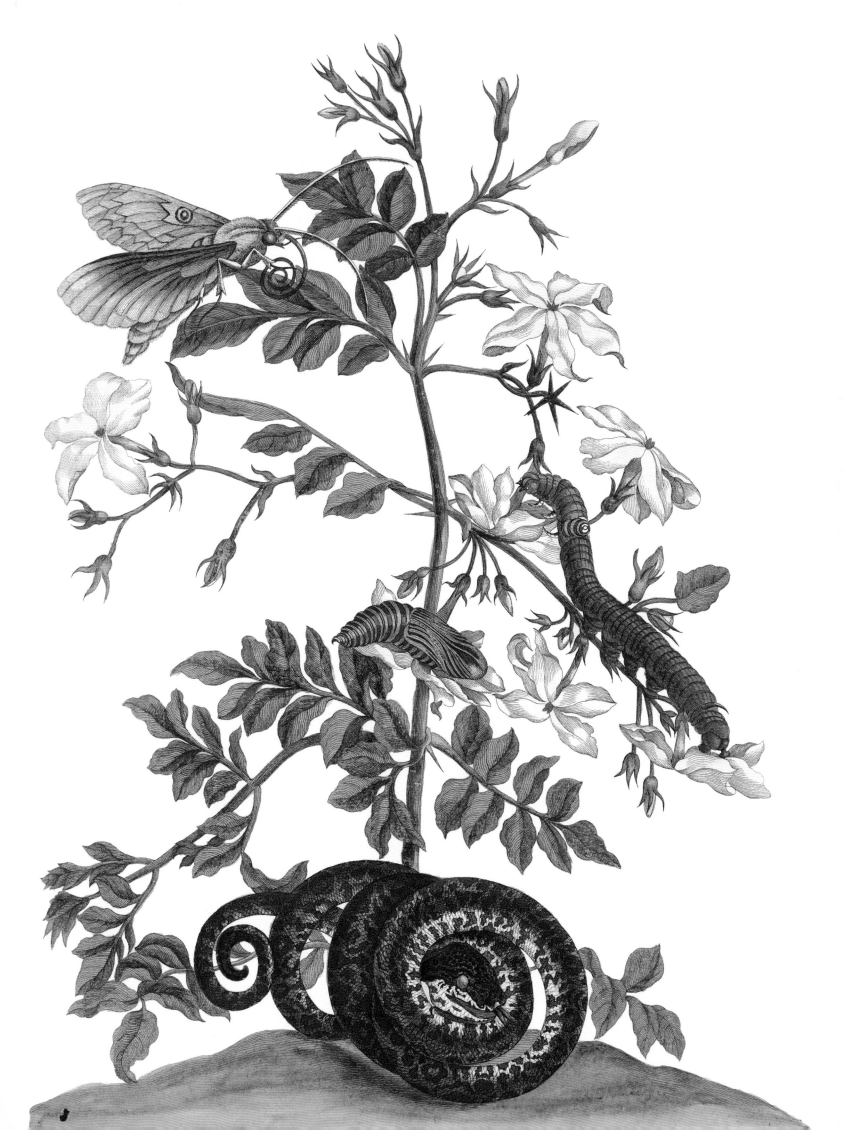

"We must remain as close to the flowers, the grass, and the butterflies as the child is who is not yet so much taller than they are."

FRIEDRICH NIETZCHE

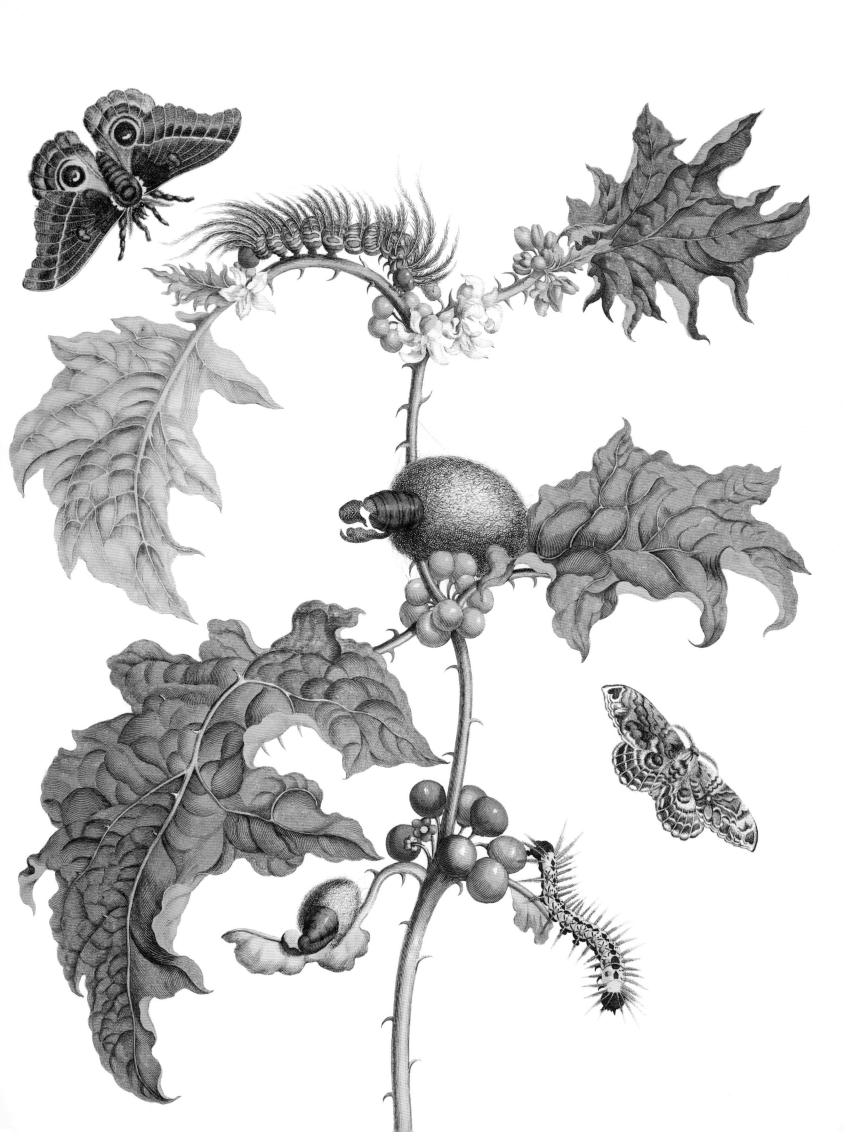

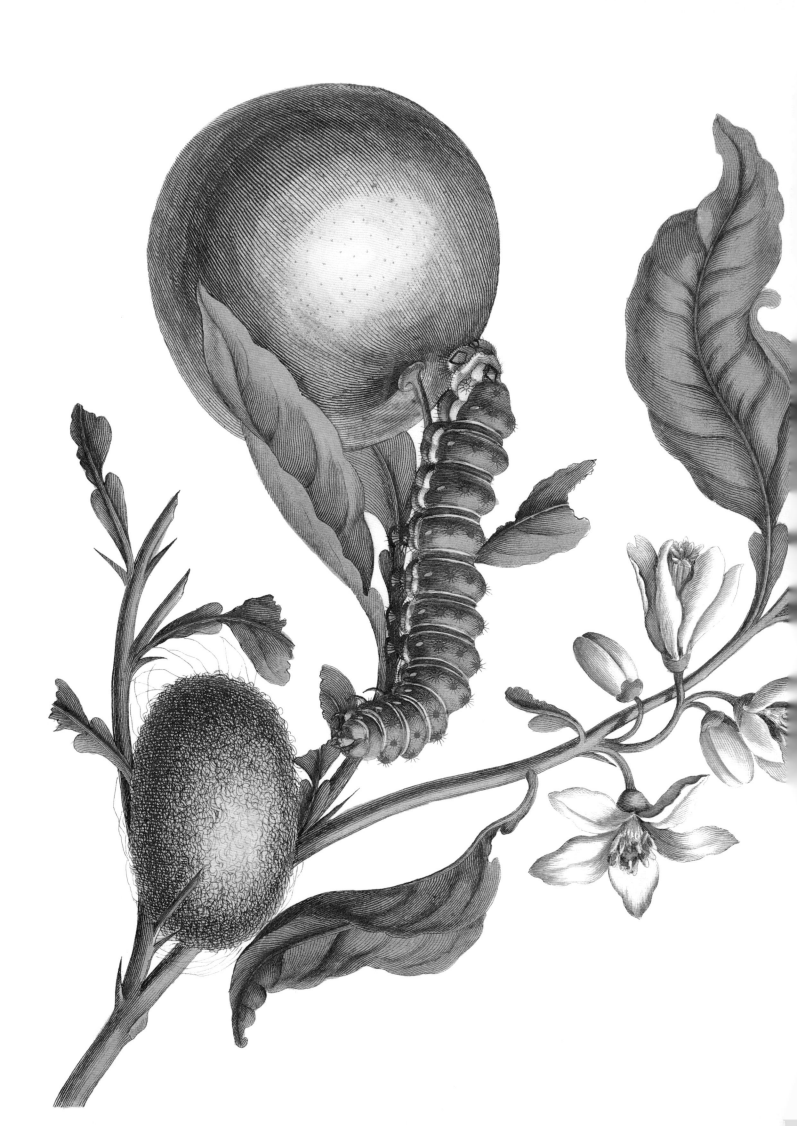

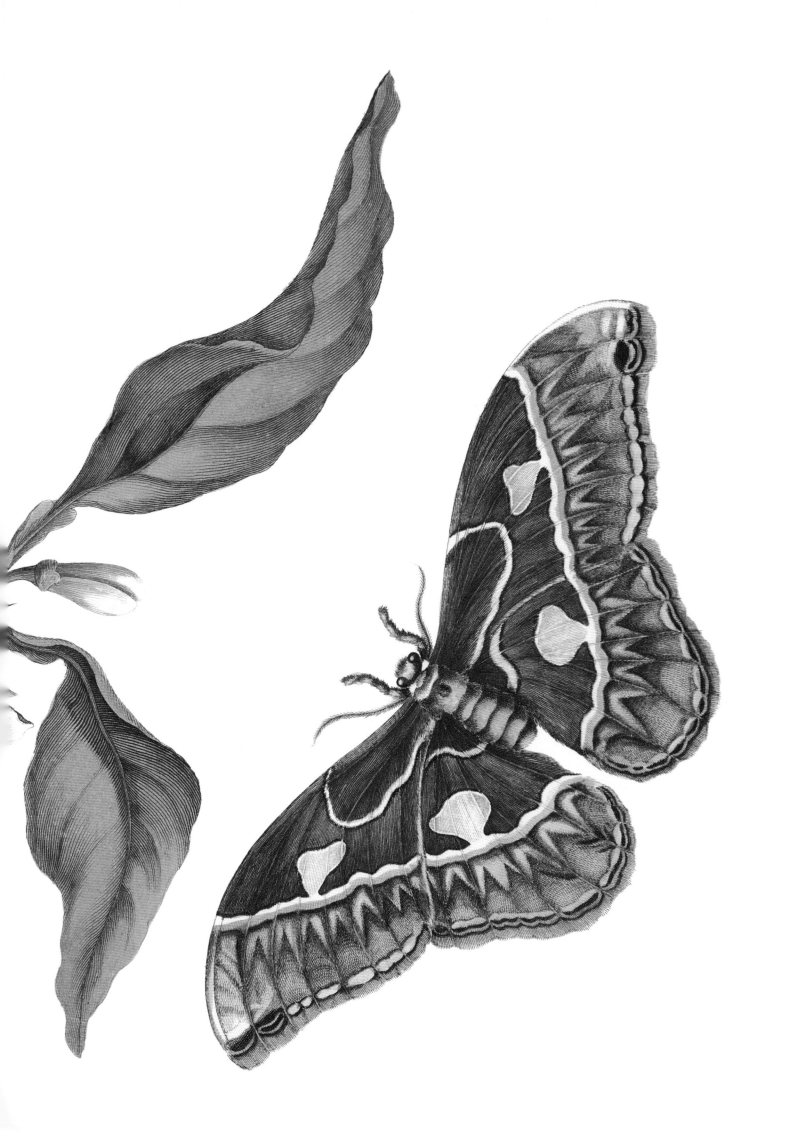

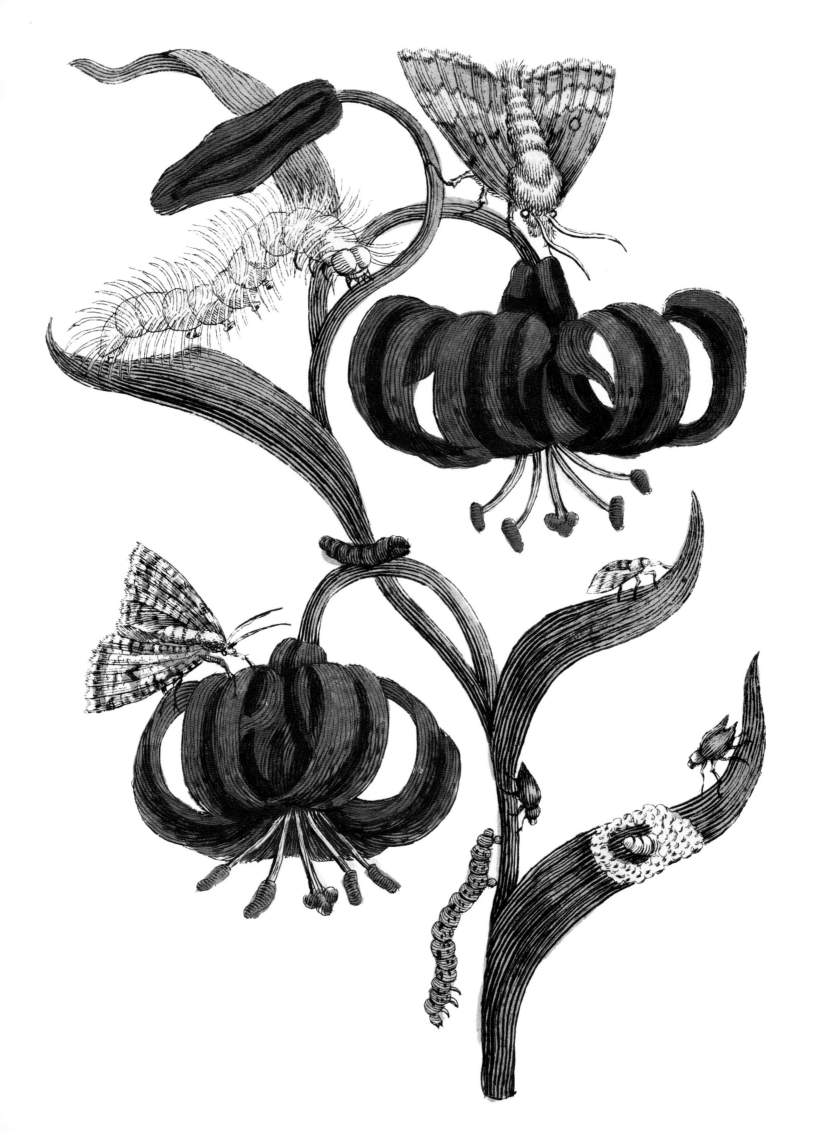

" Flowers laugh before thee upon their beds

And fragrance in thy footing treads;

Thou dost preserve the stars from wrong;

And the most ancient heavens, through thee,

are fresh and strong. "

WILLIAM WORDSWORTH

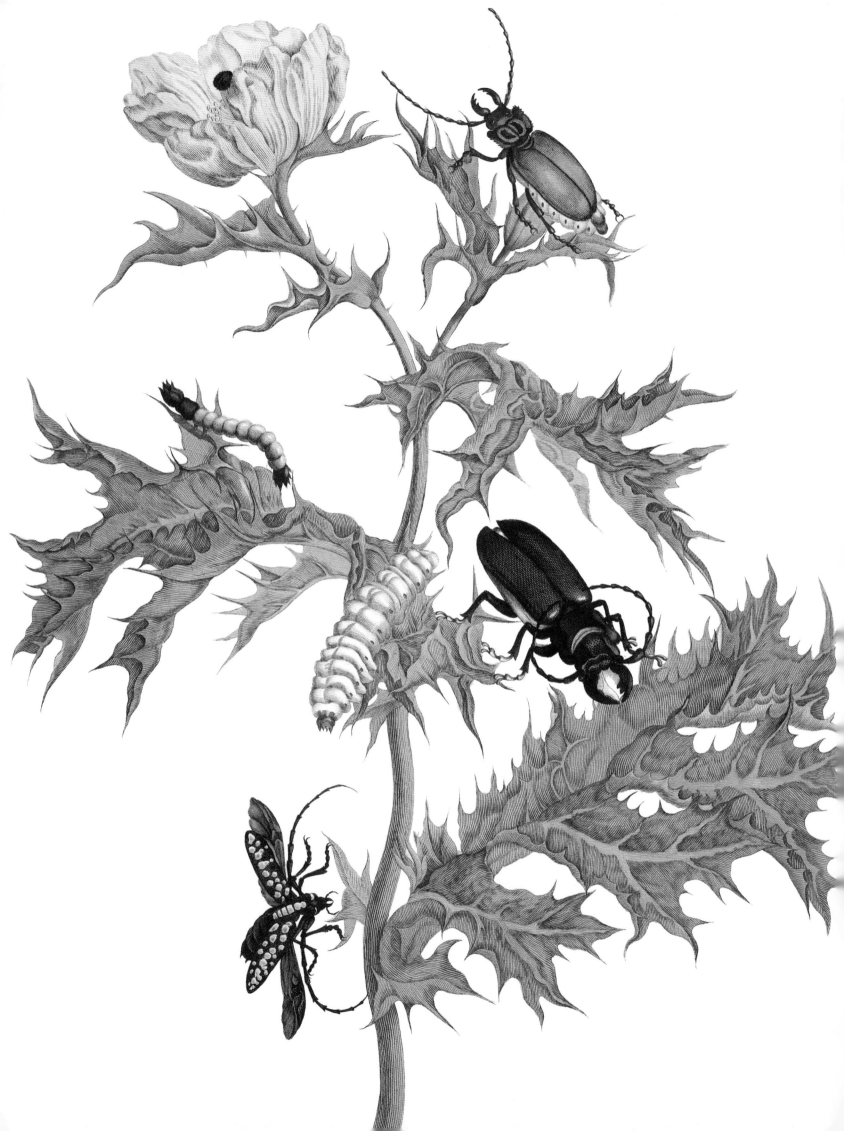

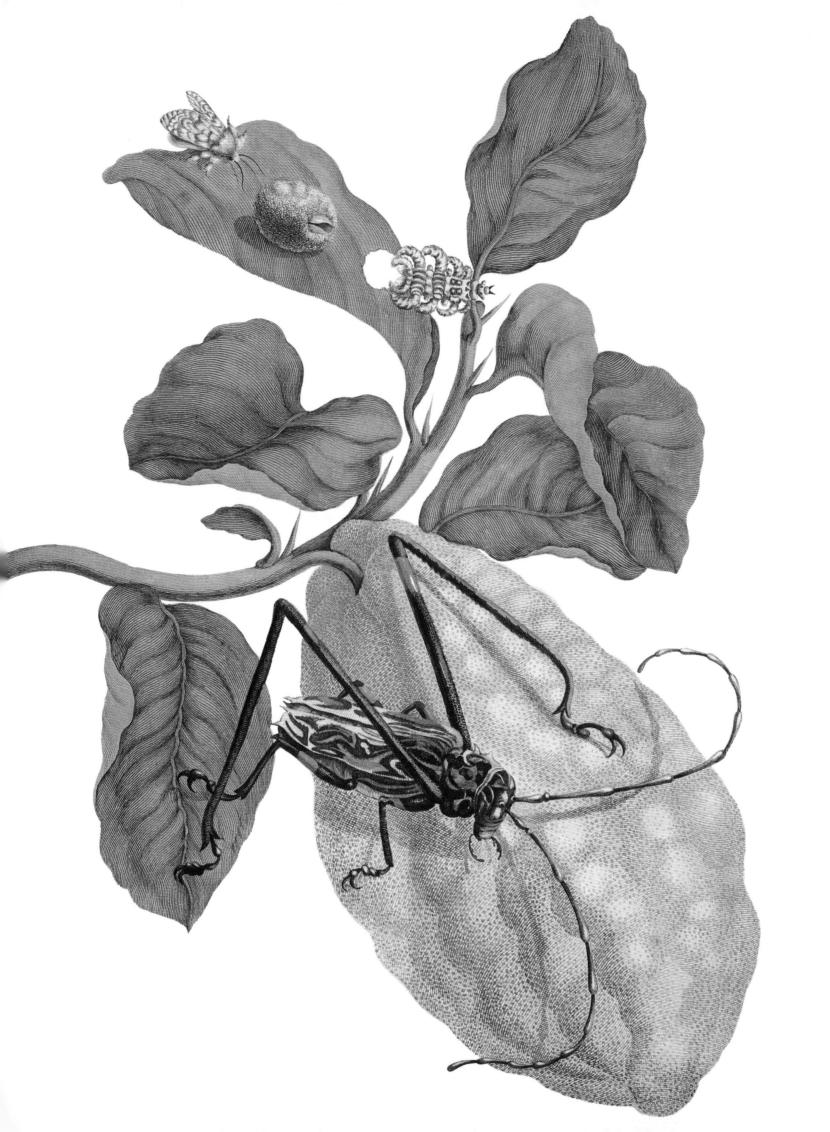

"Love has its own instinct, finding the way to the heart, as the feeblest insect finds the way to its flower, with a will which nothing can dismay nor turn aside."

HONORÉ DE BALZAC

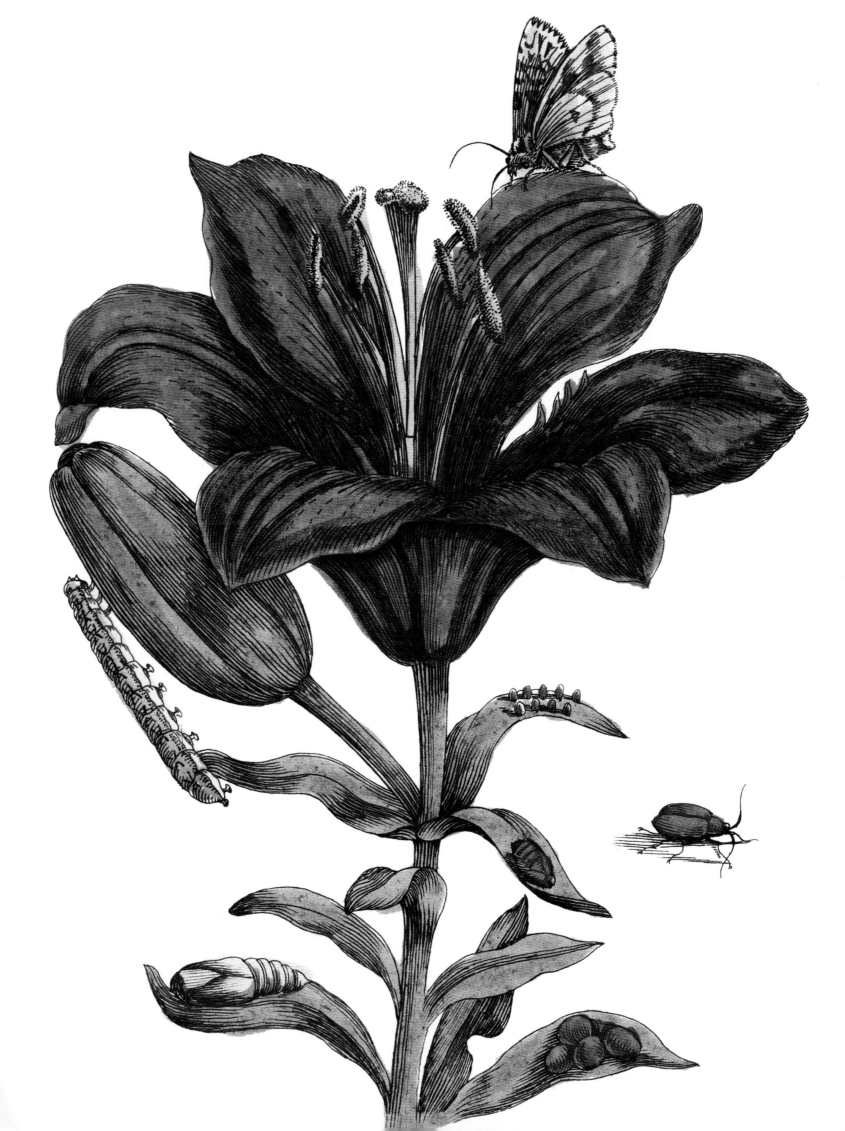

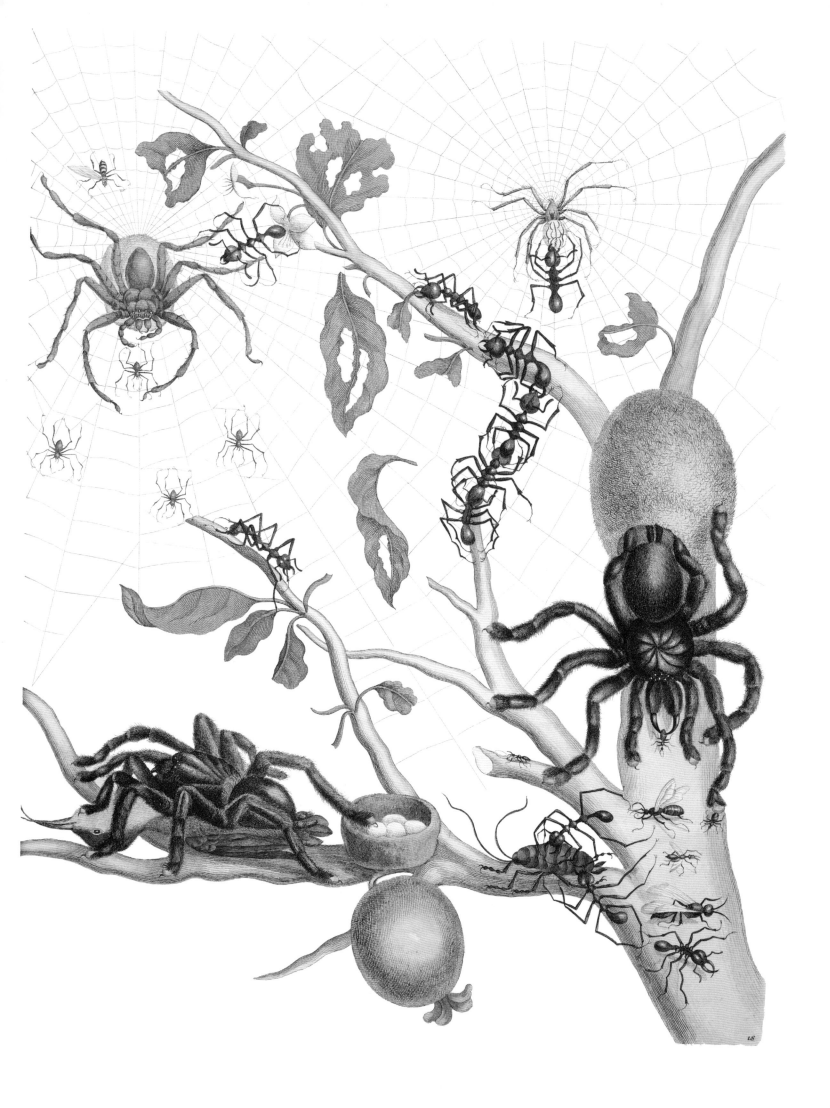

"A thing of beauty is a joy forever:
Its loveliness increases; it will never pass
into nothingness ..."

JOHN KEATS, *ENDYMION*

"Flowers are Love's truest language."

PARK BENJAMAIN

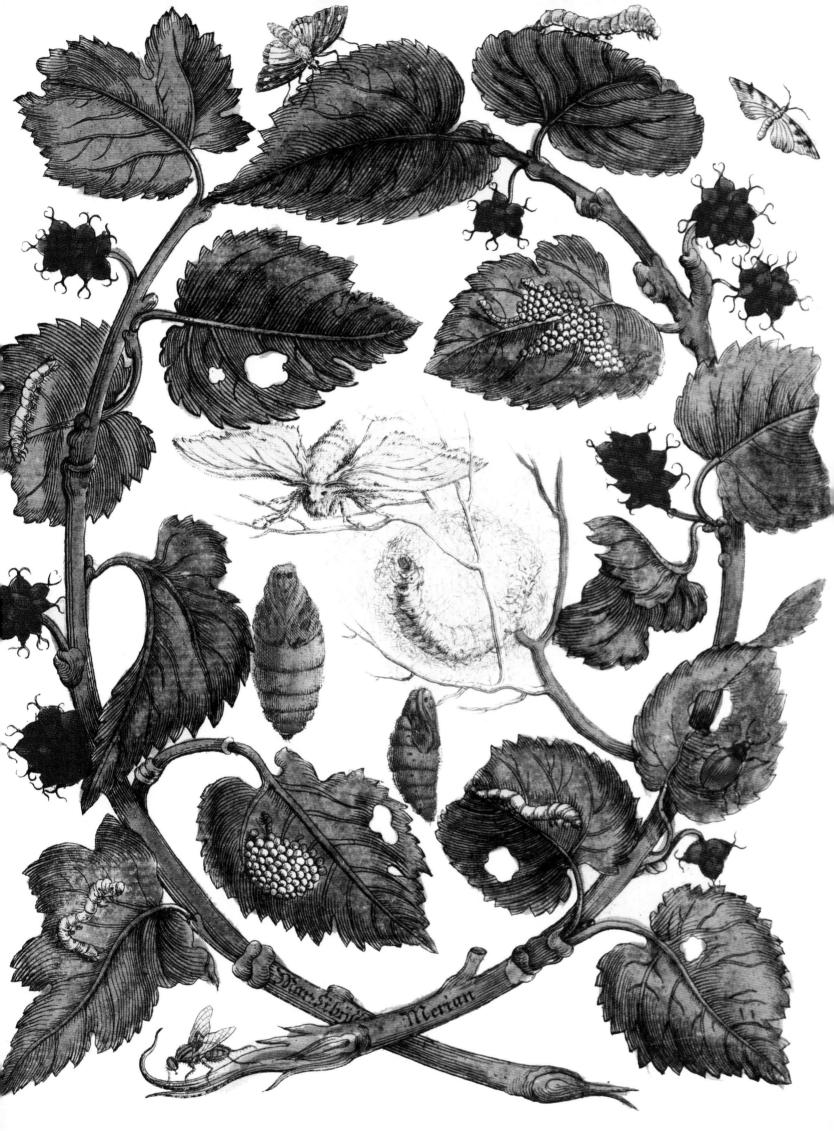

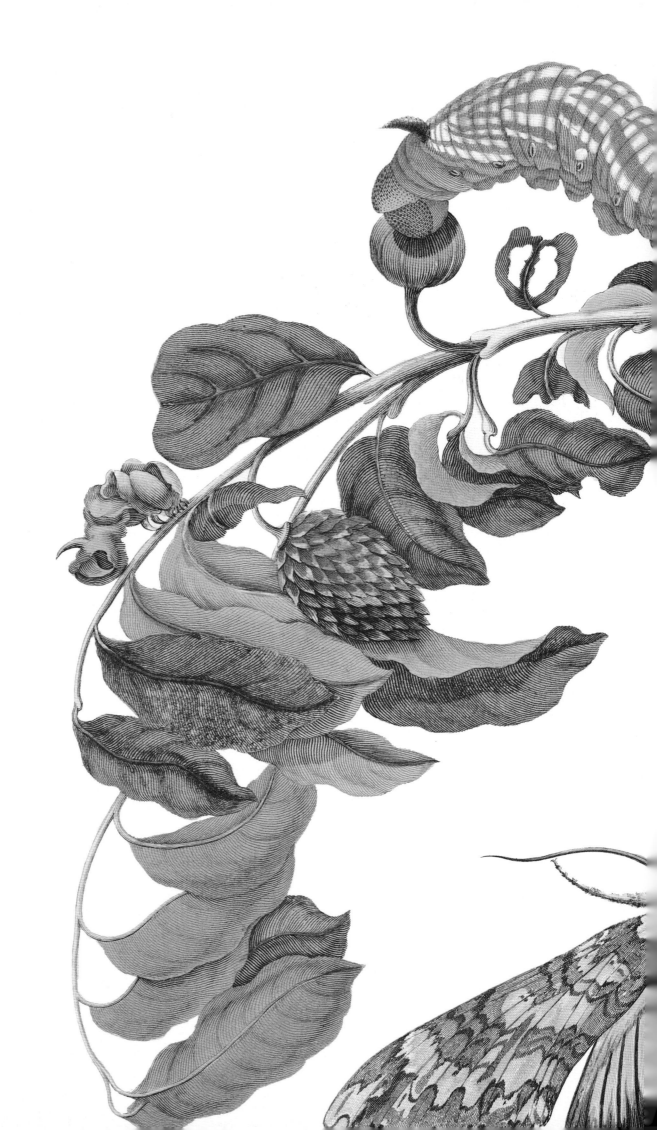

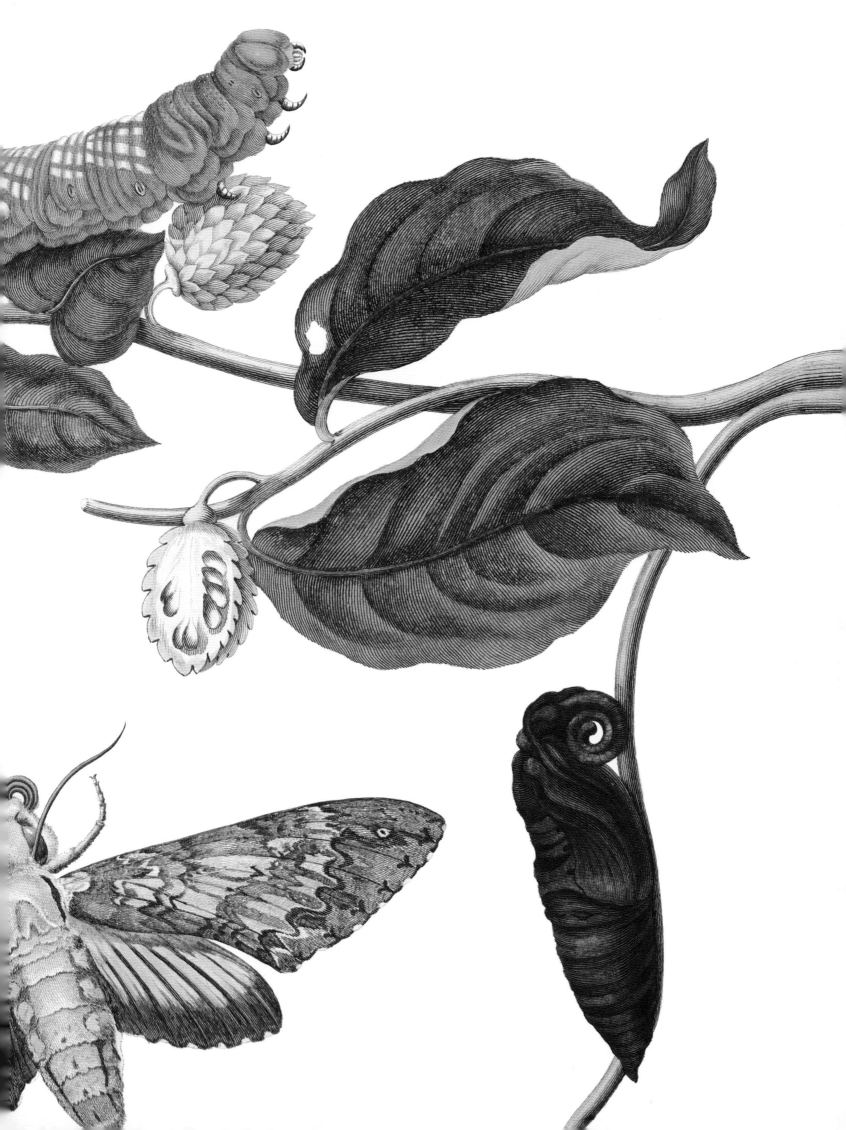

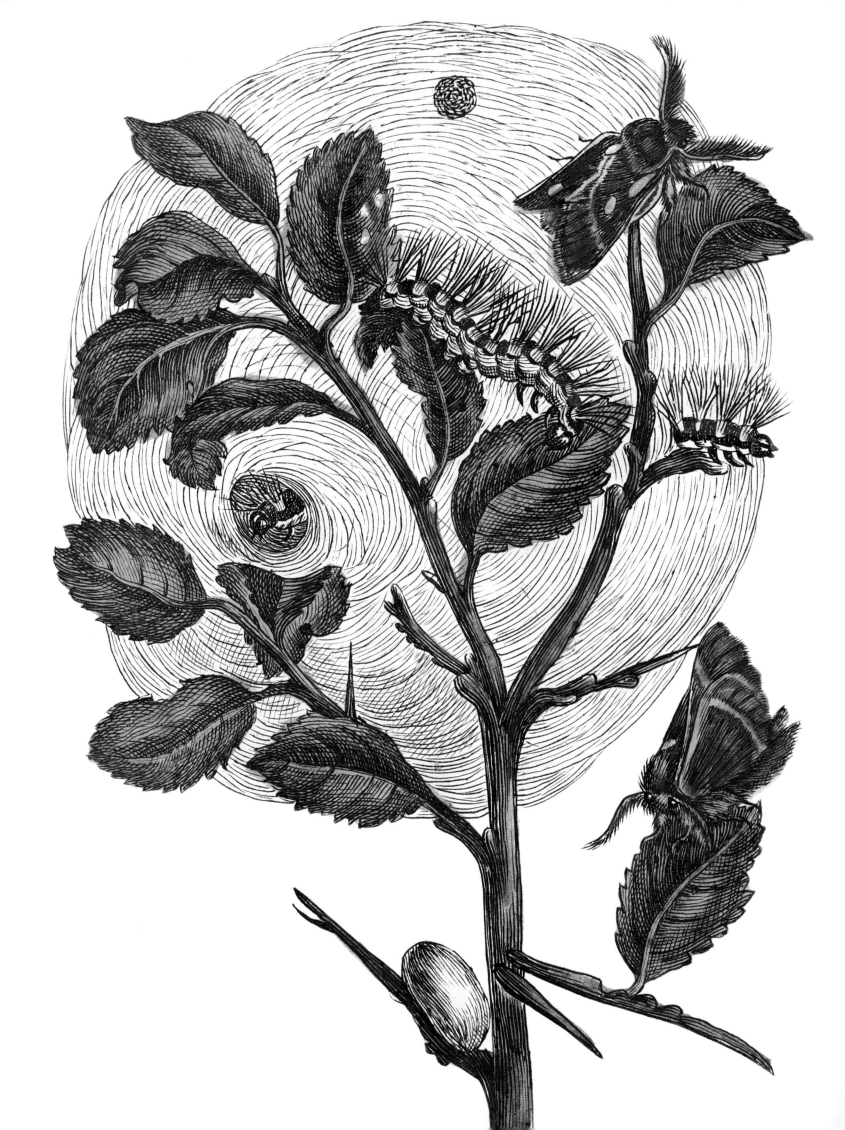

"And all about her wheeled and shone Butterflies all gold."

JOHN DAVIDSON, *BUTTERFLIES*

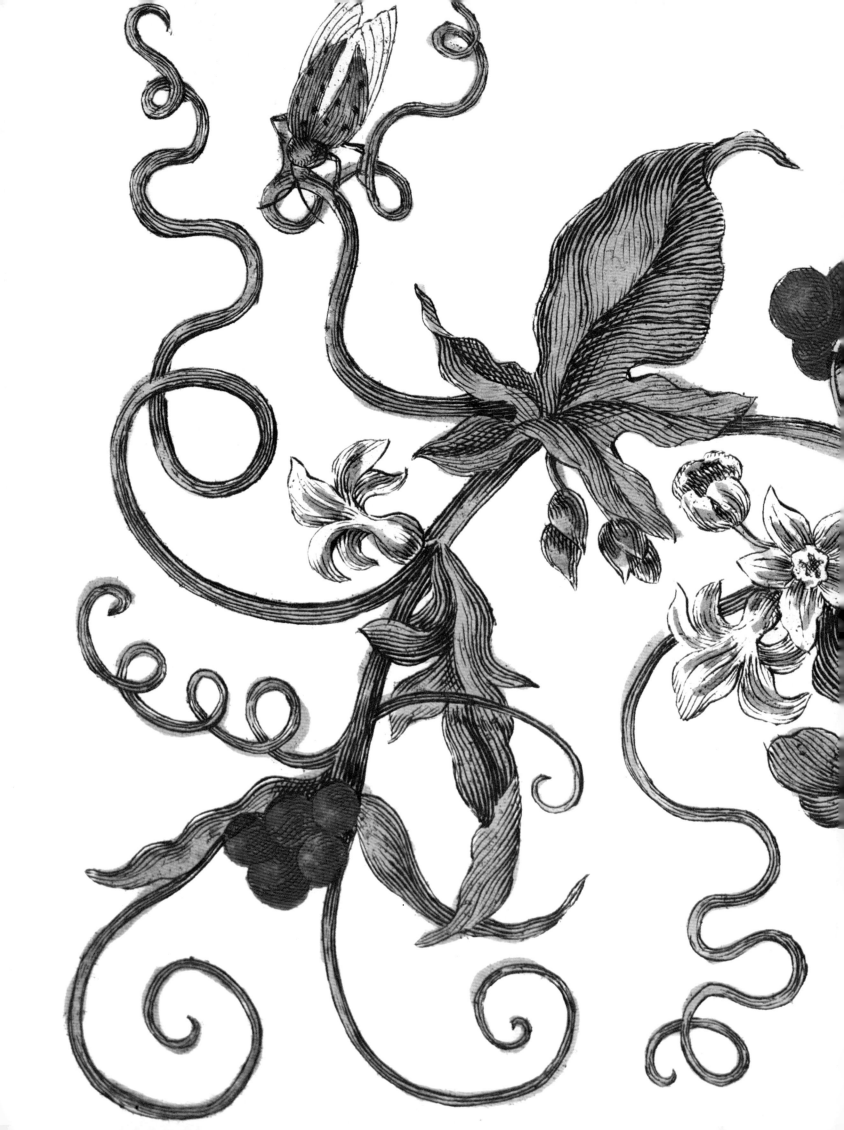

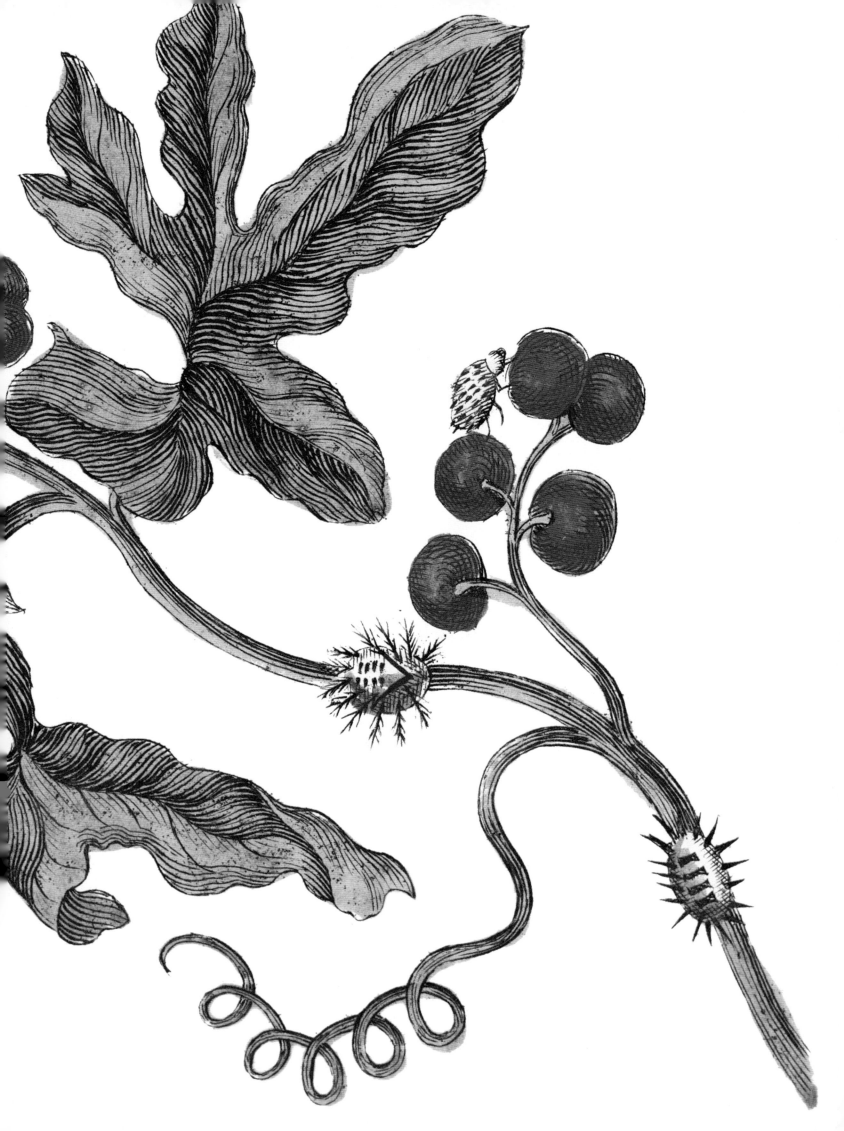

"We are Lilies fair,
The flower of virgin light;
Nature held us forth, and said,
"Lo! My thoughts of white."

LEIGH HUNT, *LILIES*

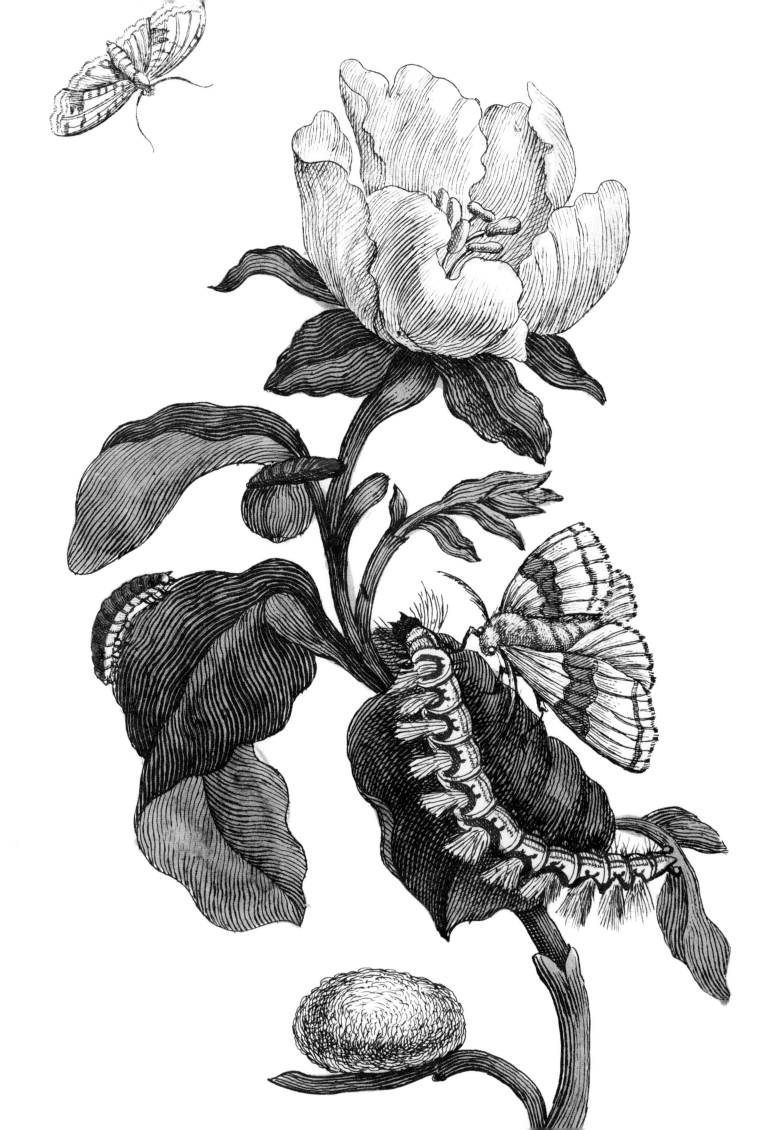

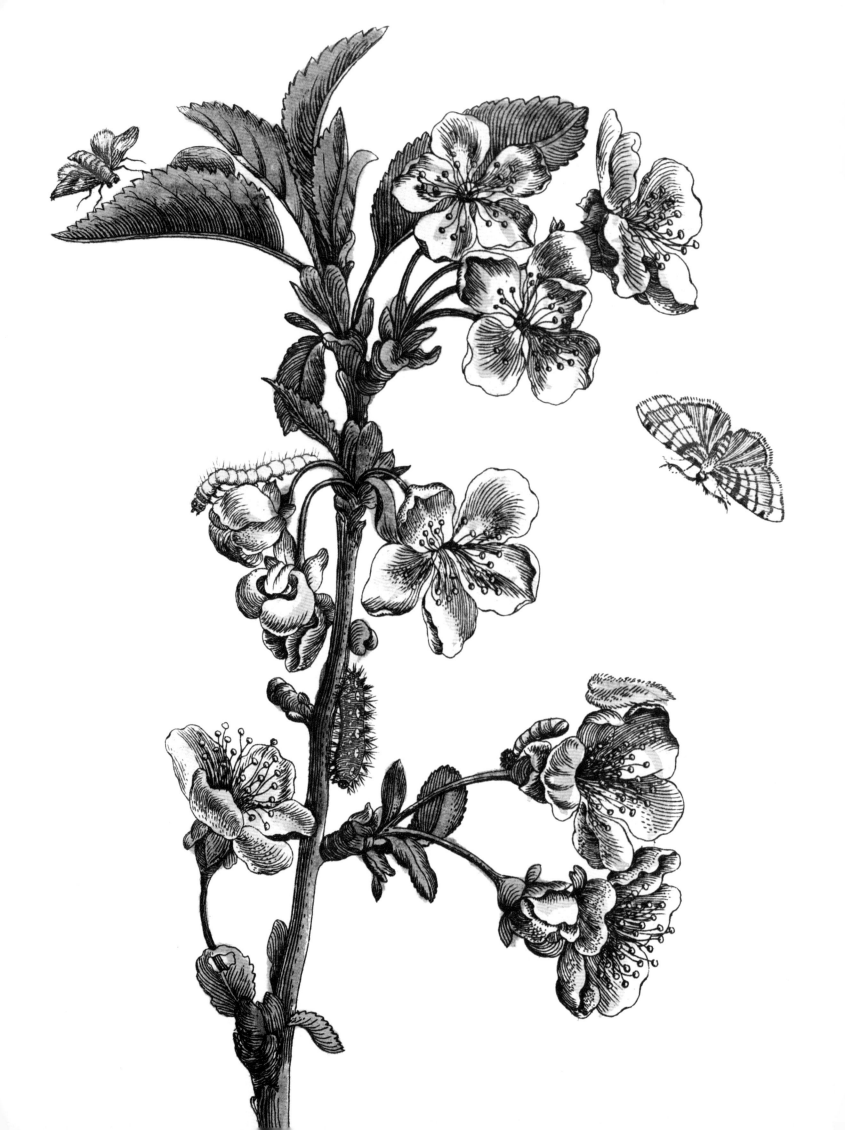

"There will be butterflies
There will be summer skies
And flowers upthrust,
When all that Caesar bids,
And all the pyramids
Are dust."

HANIEL LONG, *BUTTERFLIES*

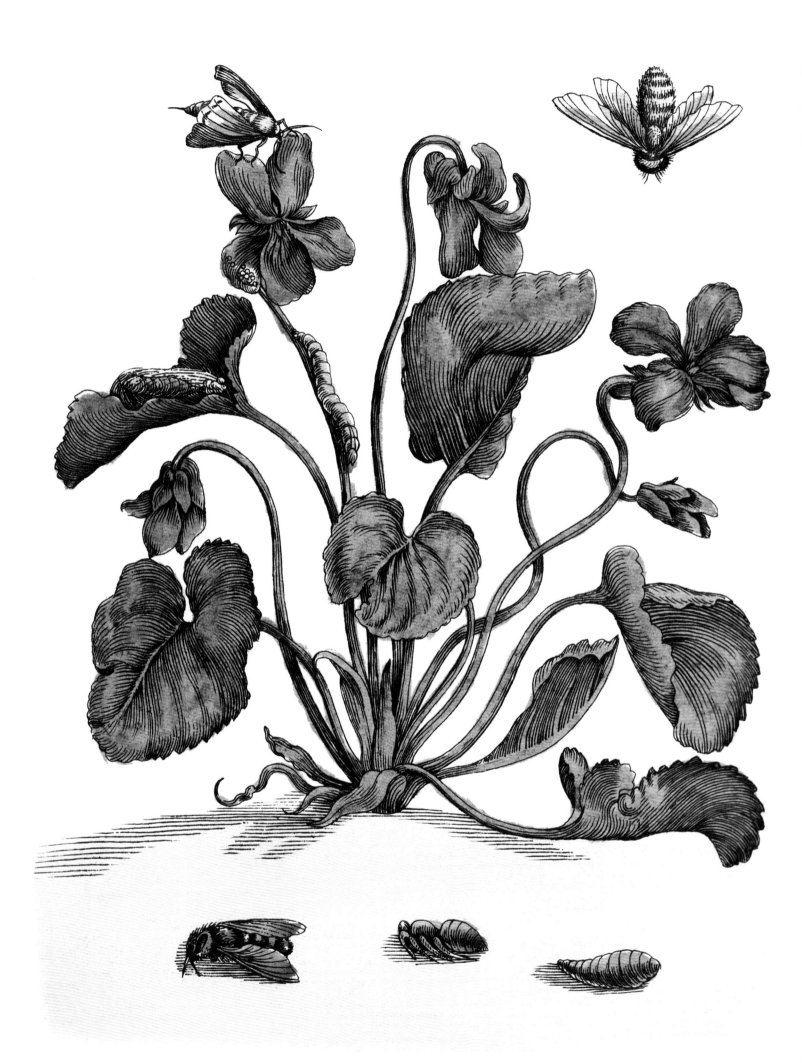

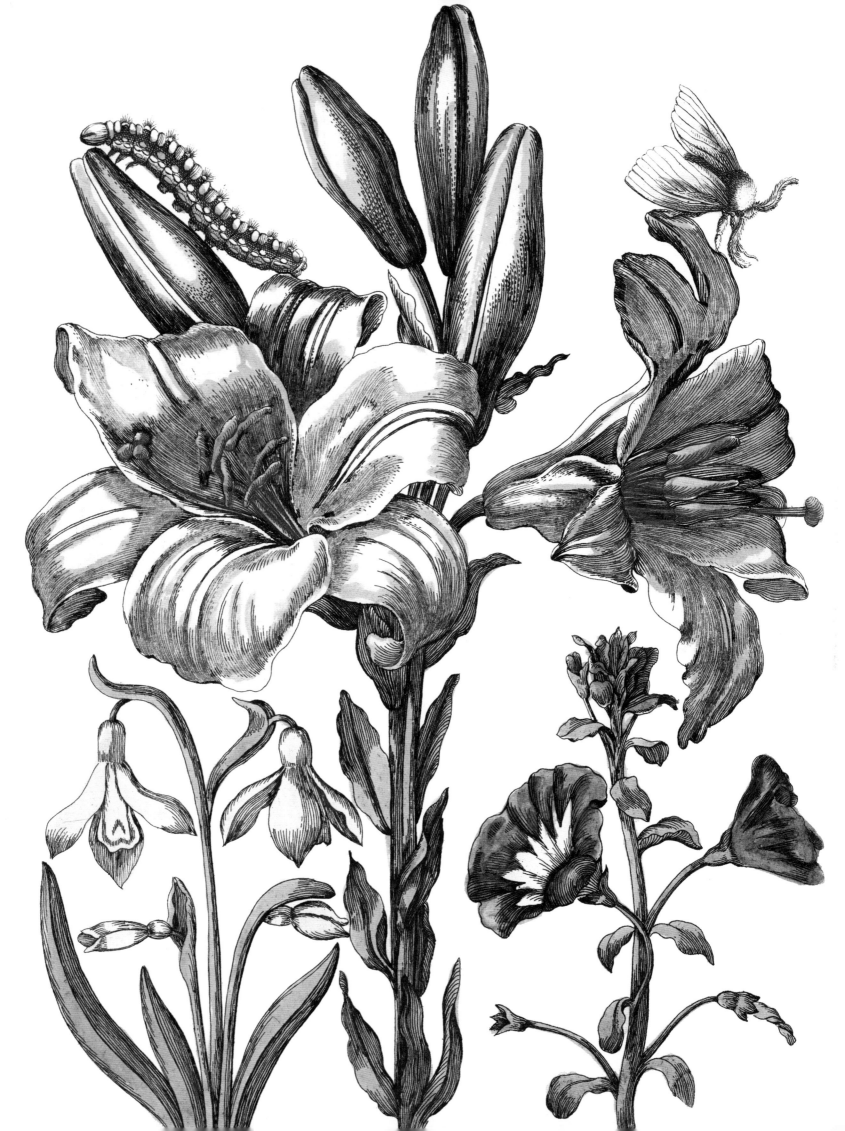

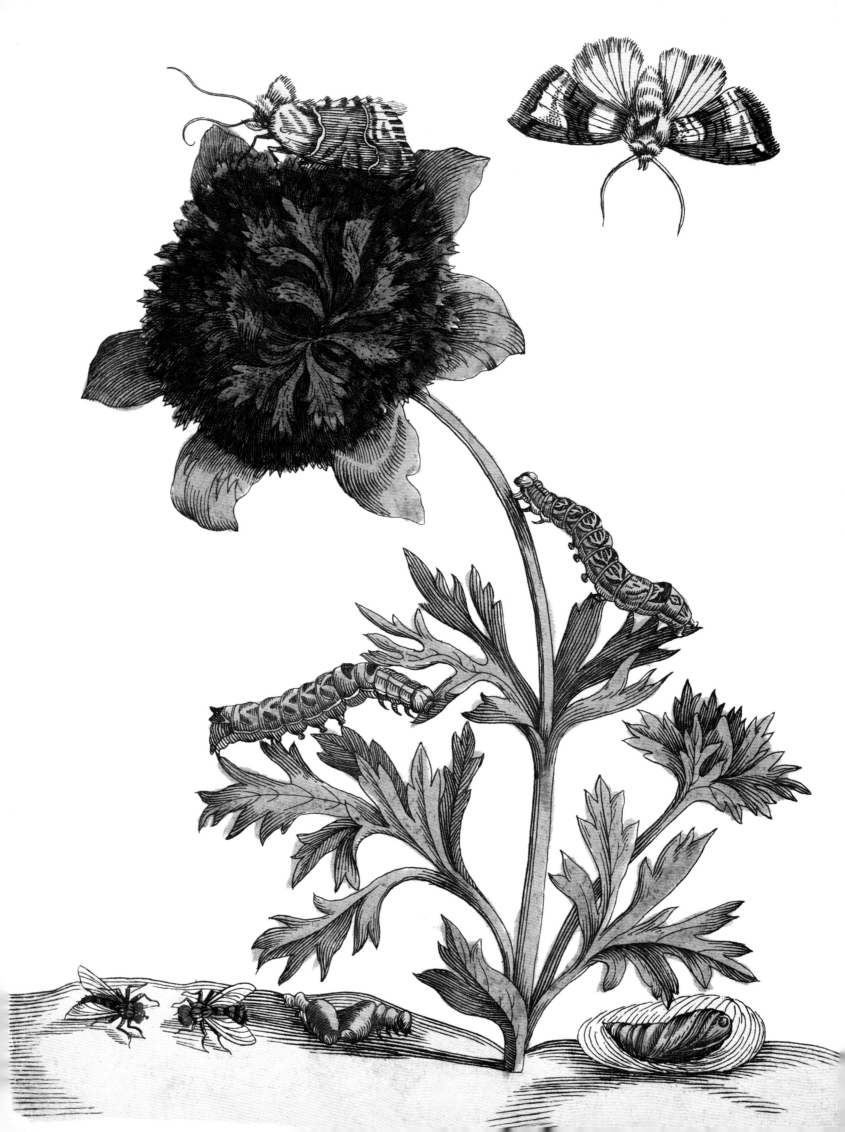

"Little flower—but *if* I could understand,
What you are, root and all, and all in all,
I should know what God and man is."

LORD ALFRED TENNYSON

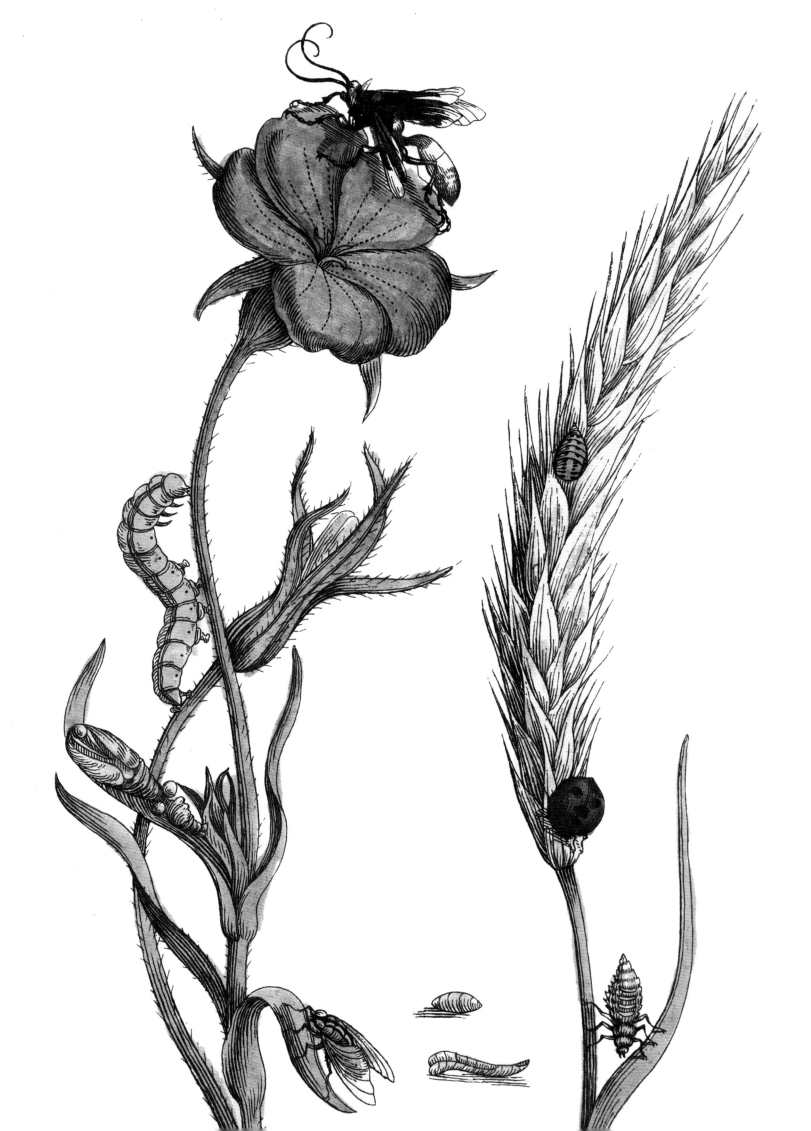

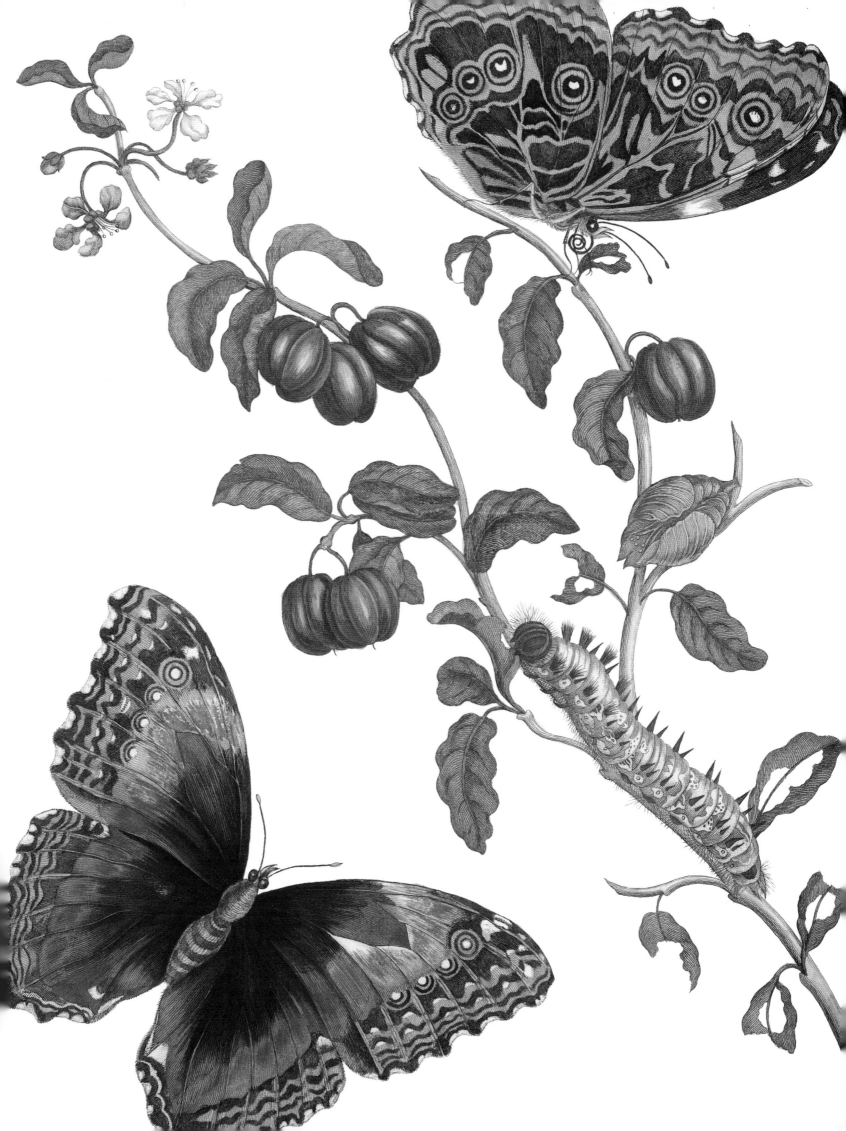

> **To see a world in a grain of sand**
> **And a heaven in a wildflower,**
> **Hold infinity in the palm of your hand**
> **And eternity in an hour.**

WILLIAM BLAKE

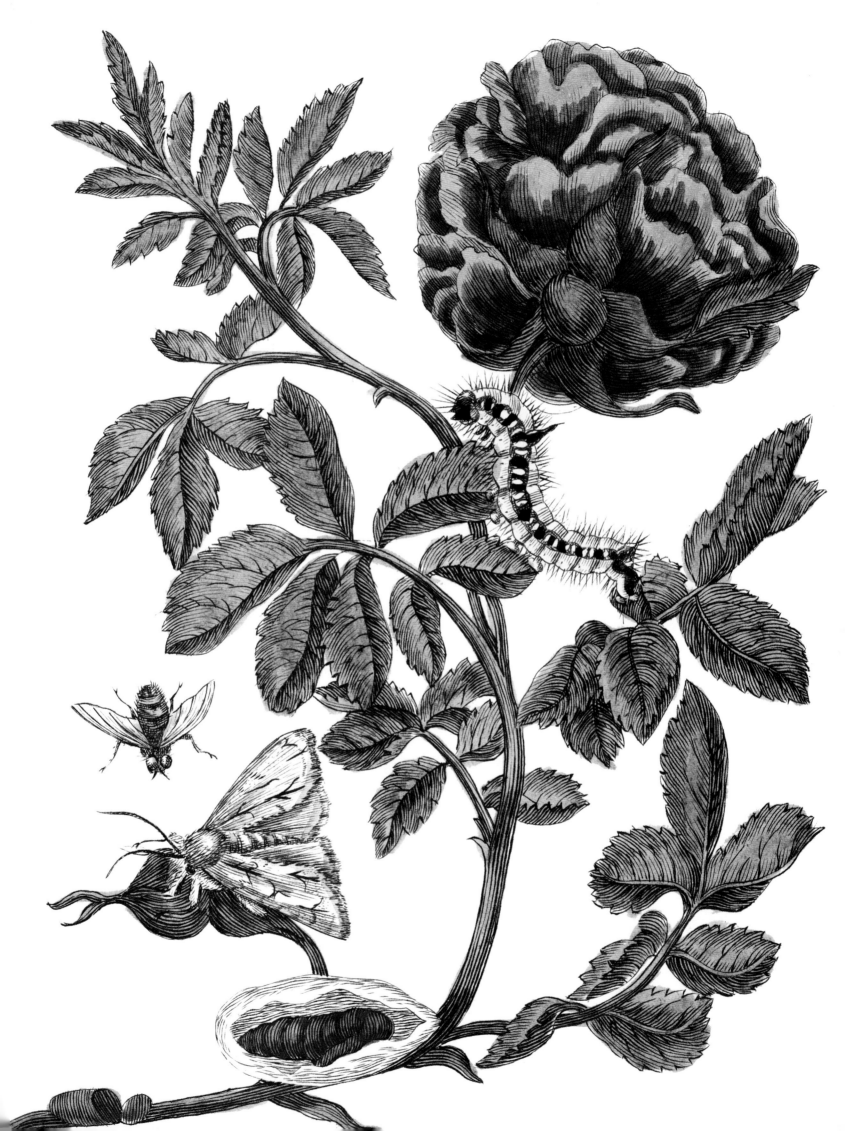

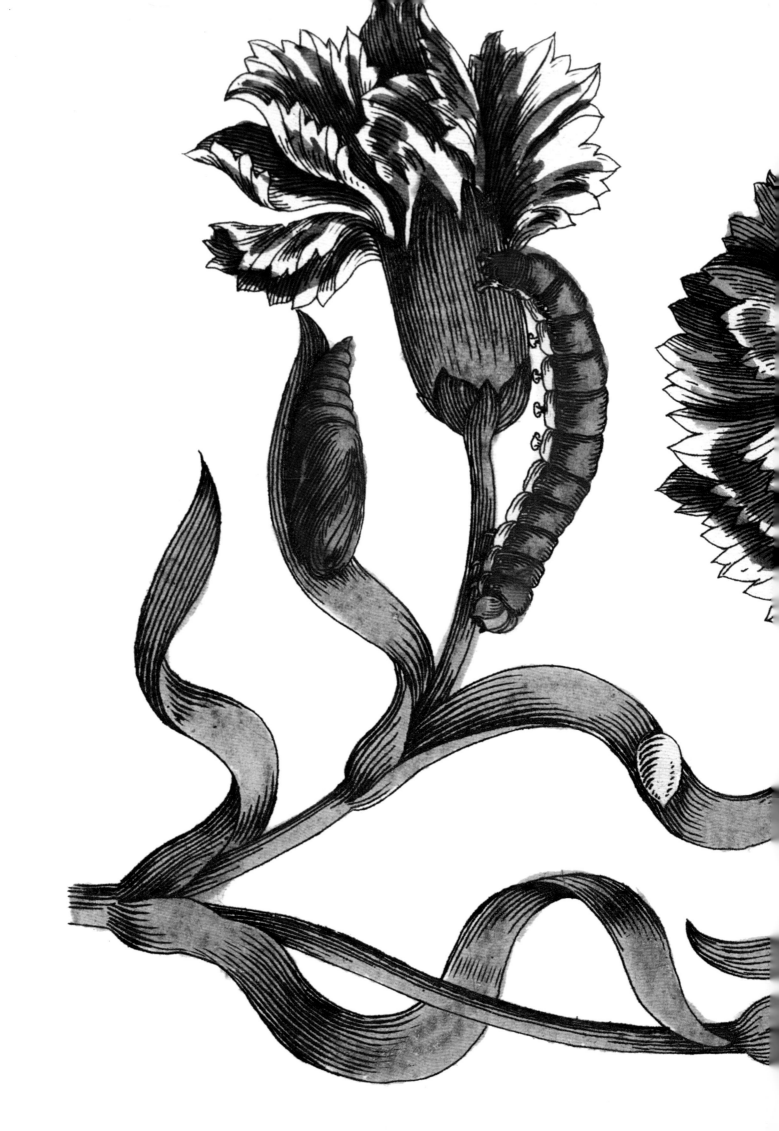

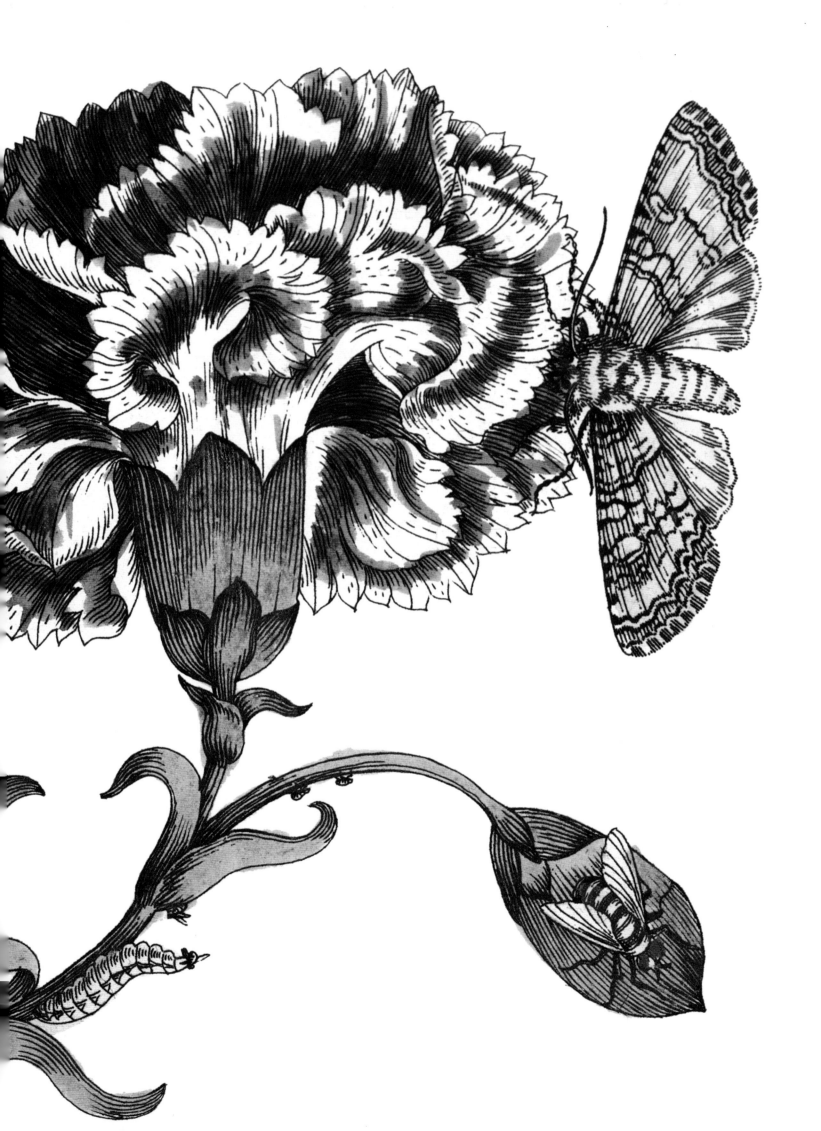

"When daisies pied and violets blue
And lady-smocks all silver-white
And cuckoo-buds of yellow hue
Do paint the meadows with delight."

SHAKESPEARE, *LOVE'S LABOUR'S LOST*

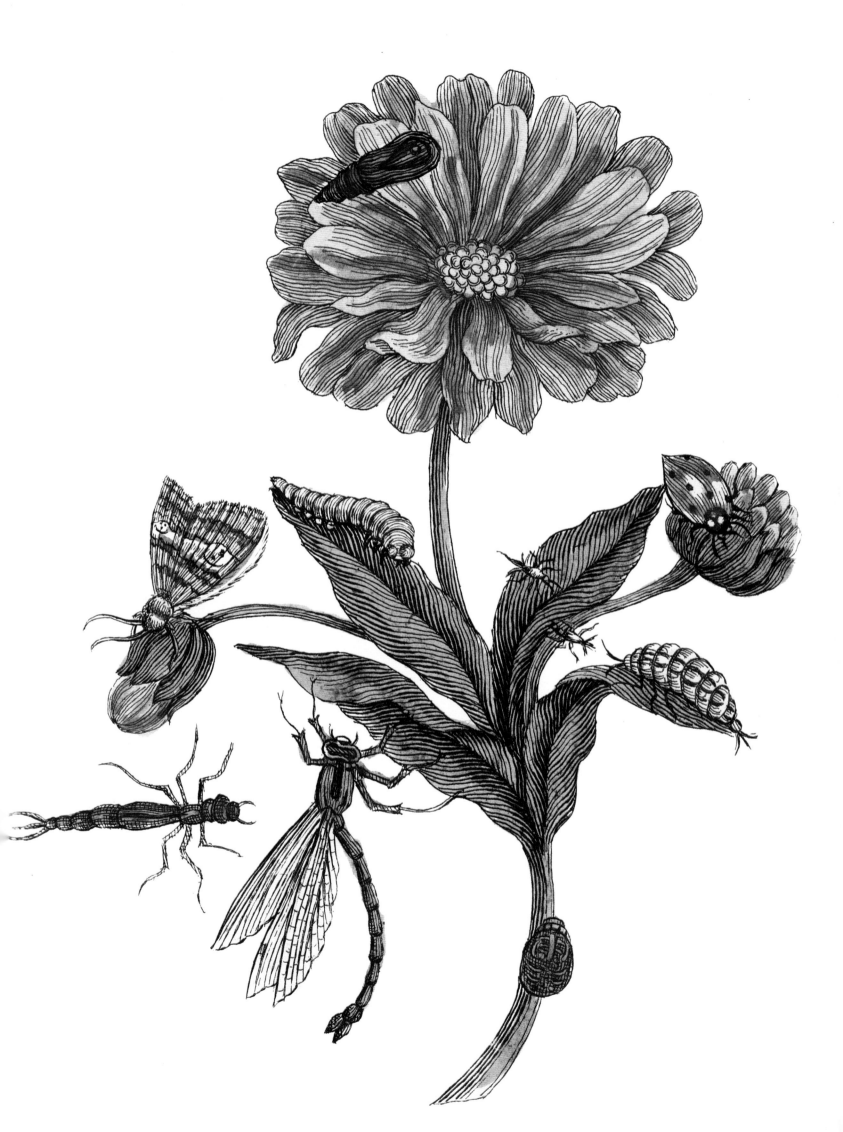

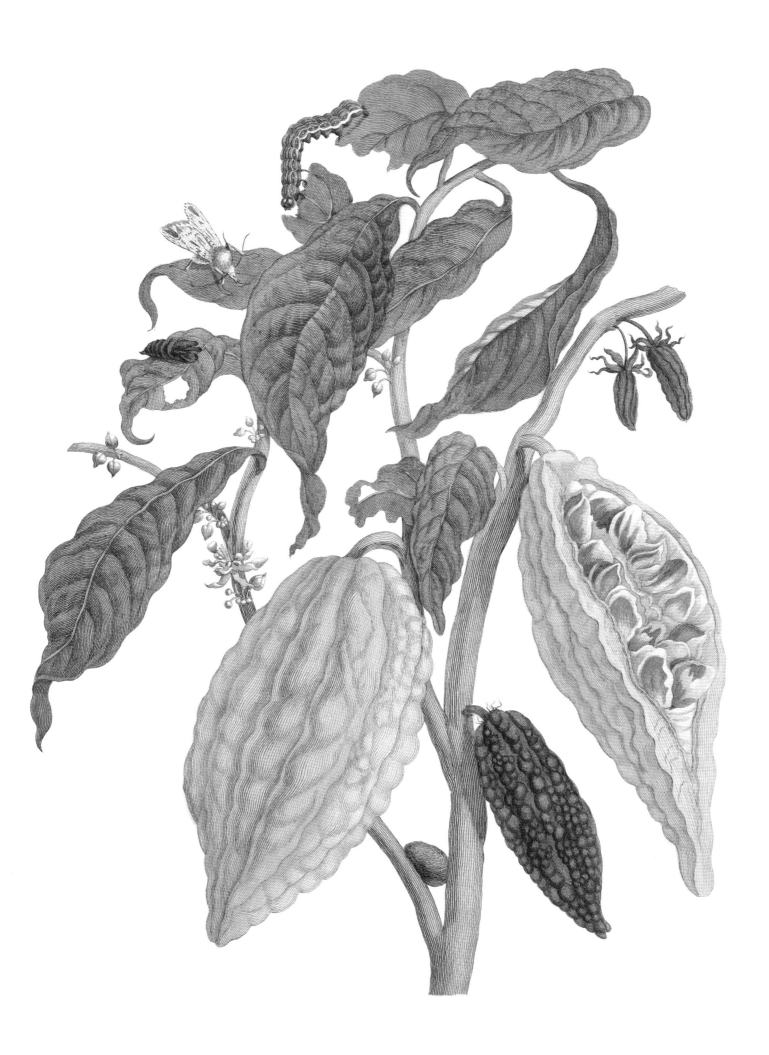

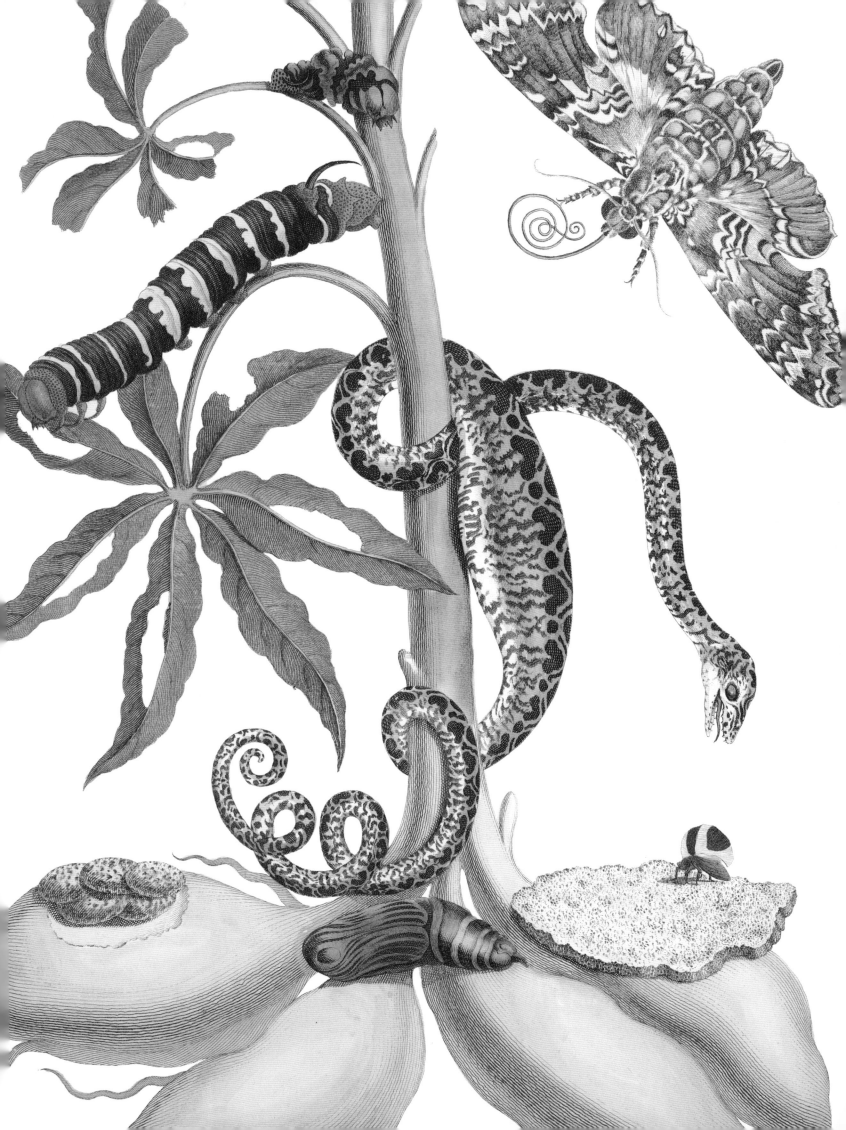

66 Genius detects through the fly, through the caterpillar, through the grub, through the egg, the constant individual; through countless individuals the fixed species; through many species the genus; through all genera the steadfast type; through all the kingdoms of organized life the eternal unity. Nature is a mutable cloud which is always and never the same. 99

RALPH WALDO EMERSON

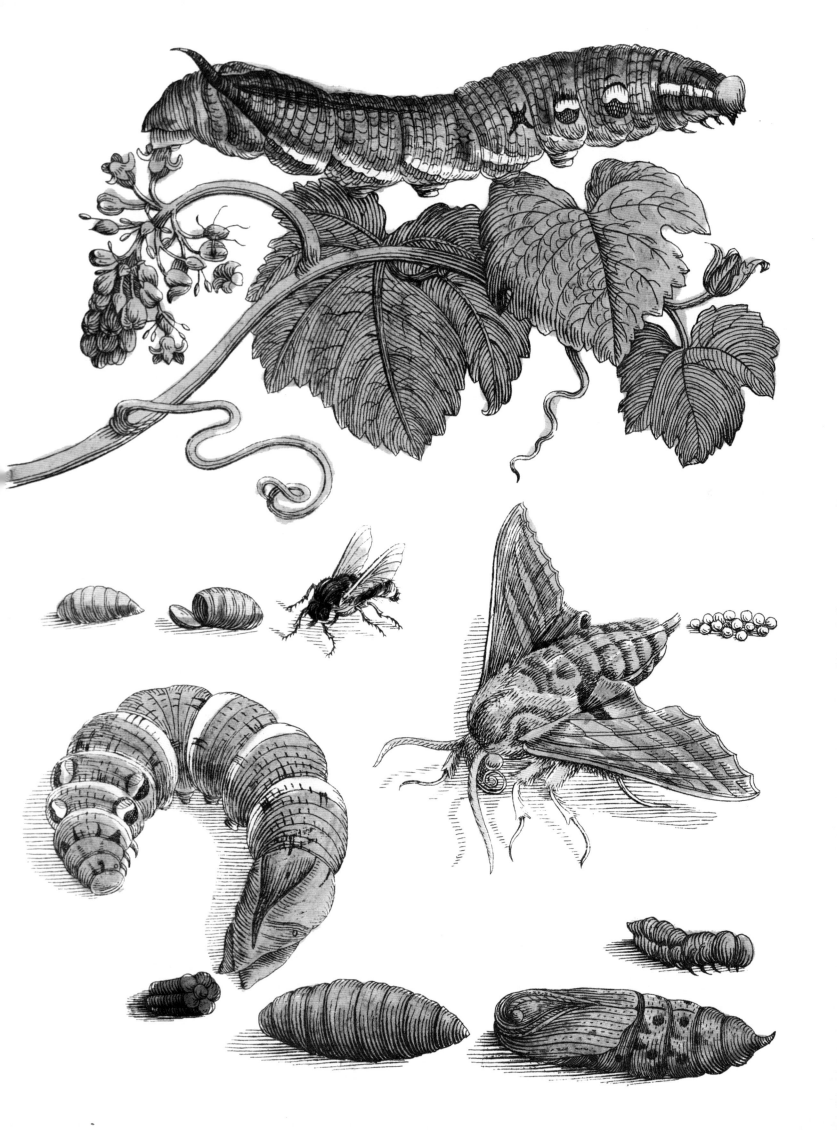

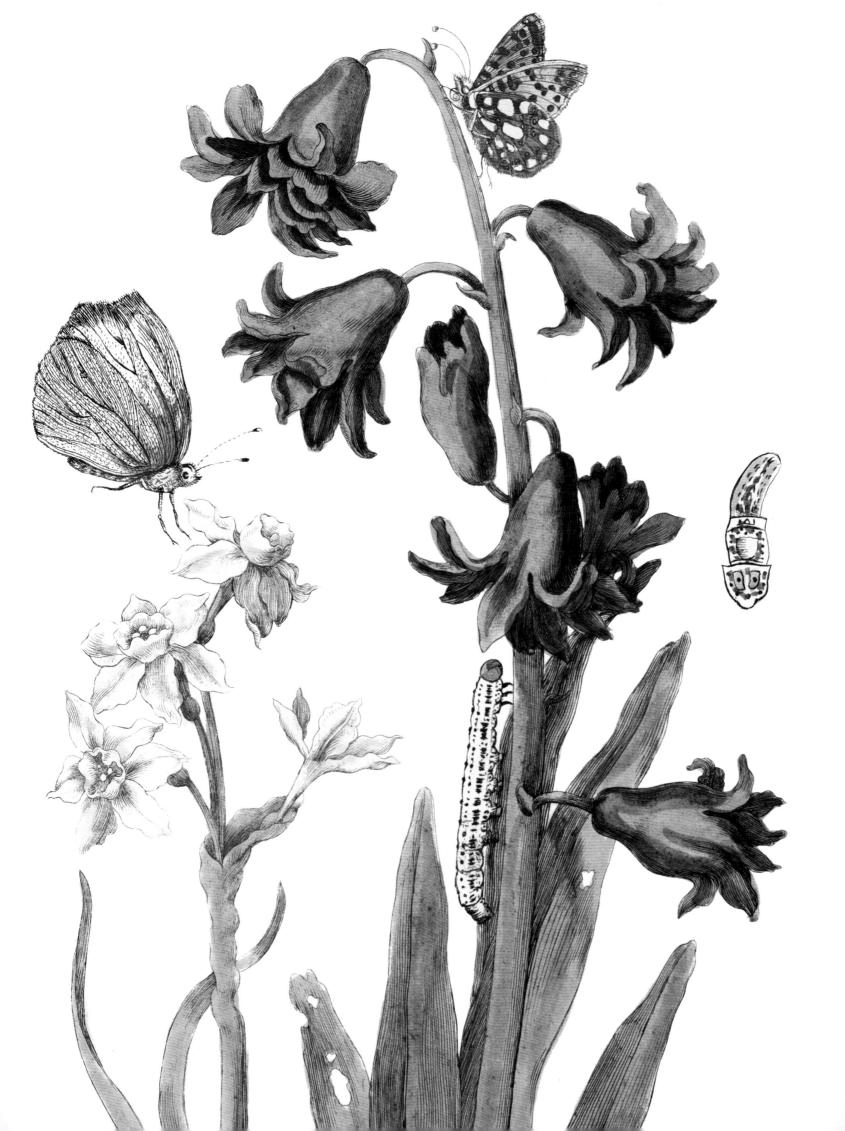

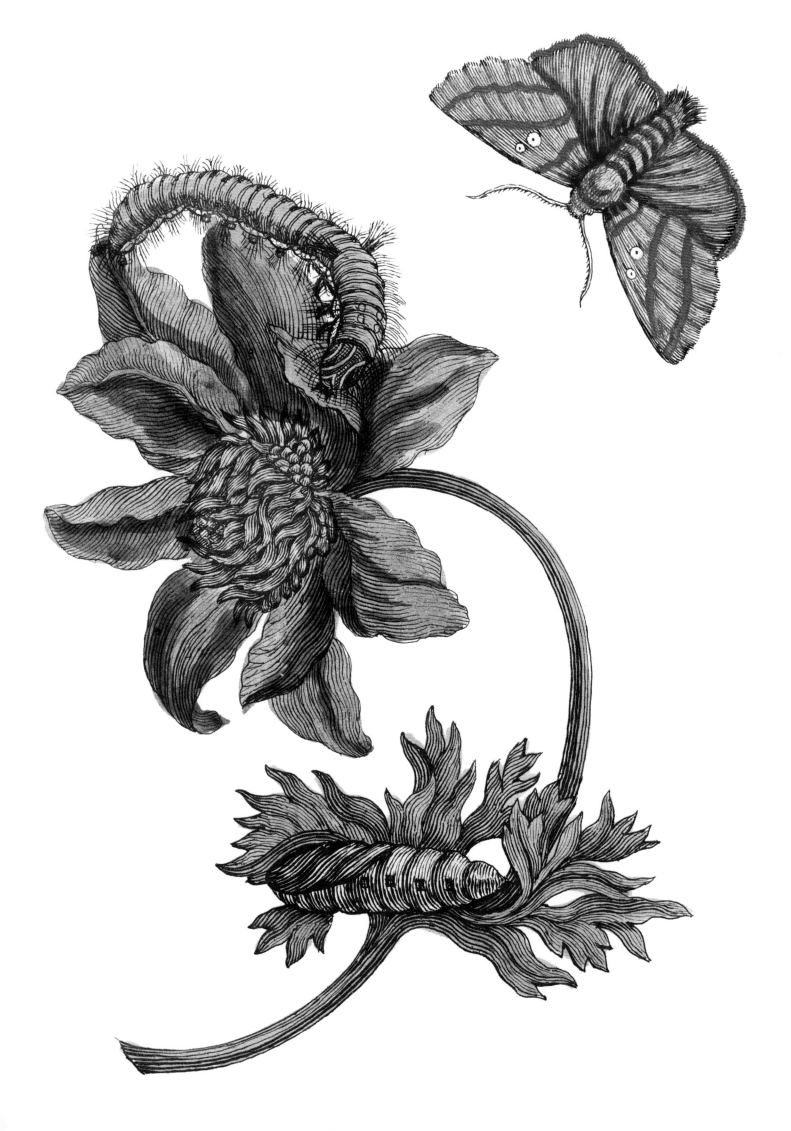

"The flower of the sweetest smell is shy and lowly."

WILLIAM WORDSWORTH

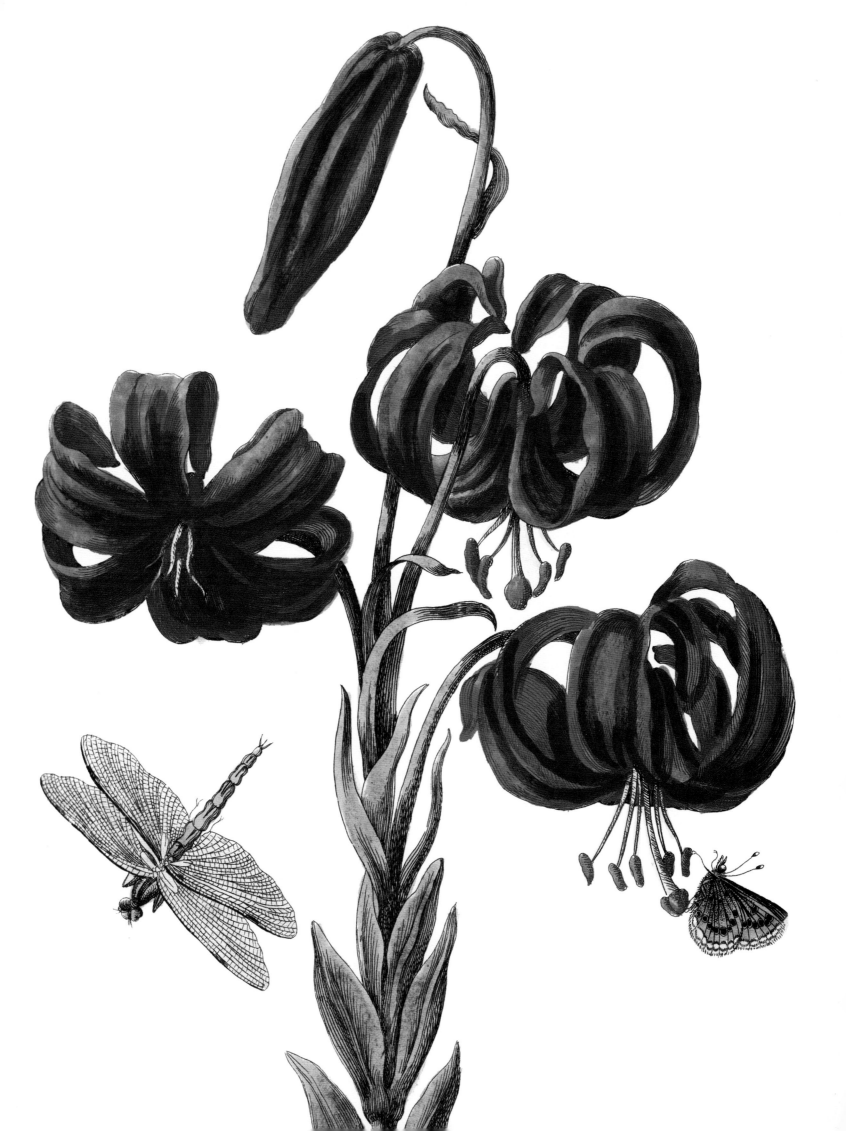

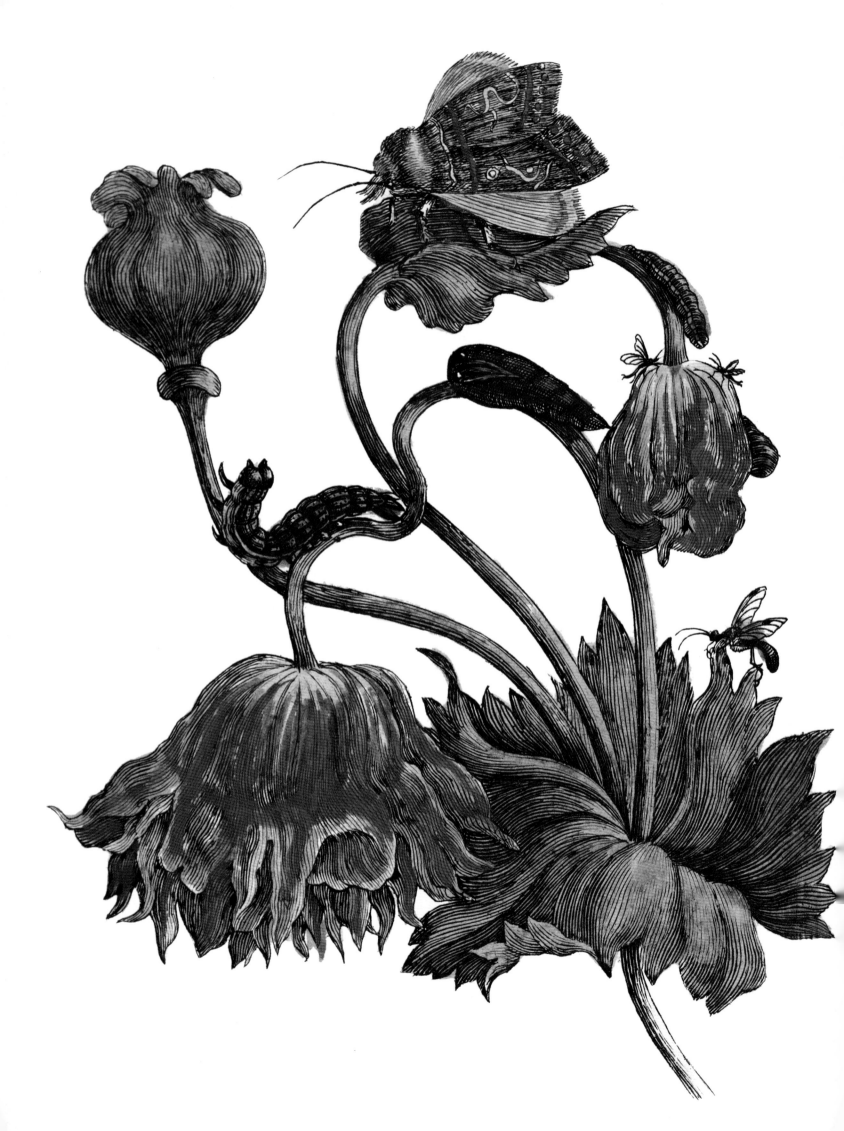

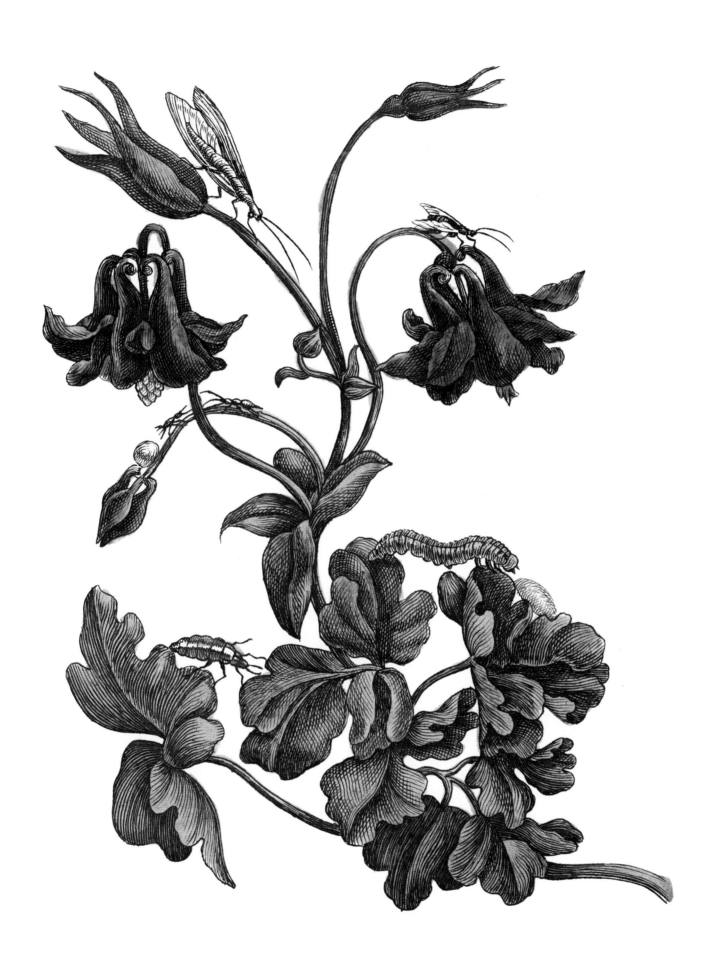

"The pedigree of honey does not concern the bee, a clover, anytime, to him, is aristocracy."

EMILY DICKINSON

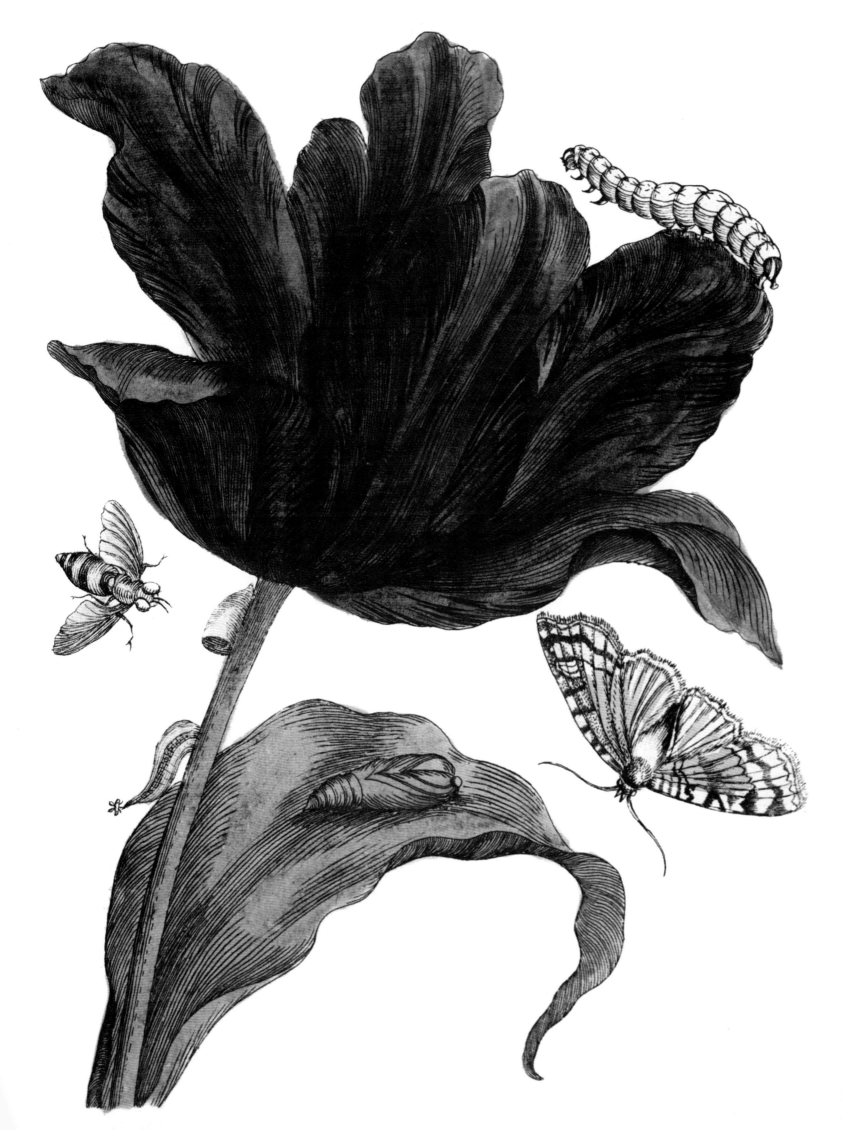

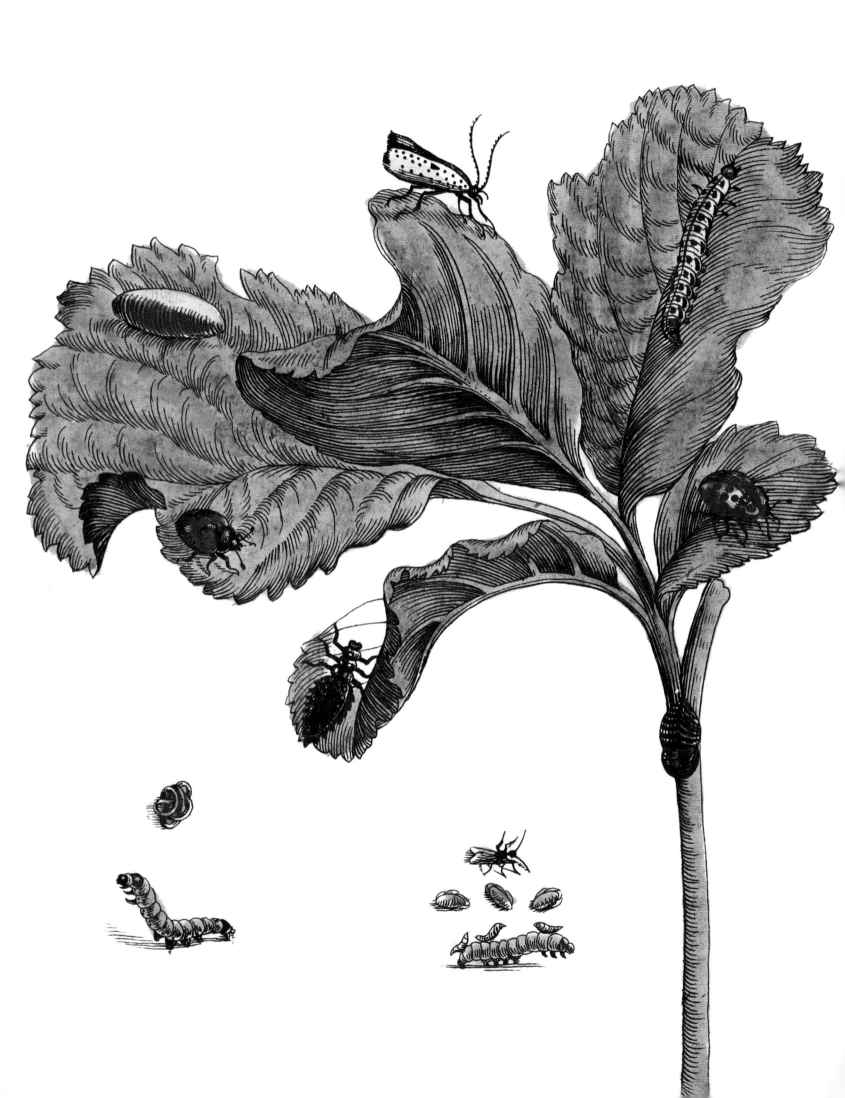

"The spider as an artist
Has never been employed …
Neglected son of genius,
I take thee by the hand."

EMILY DICKINSON

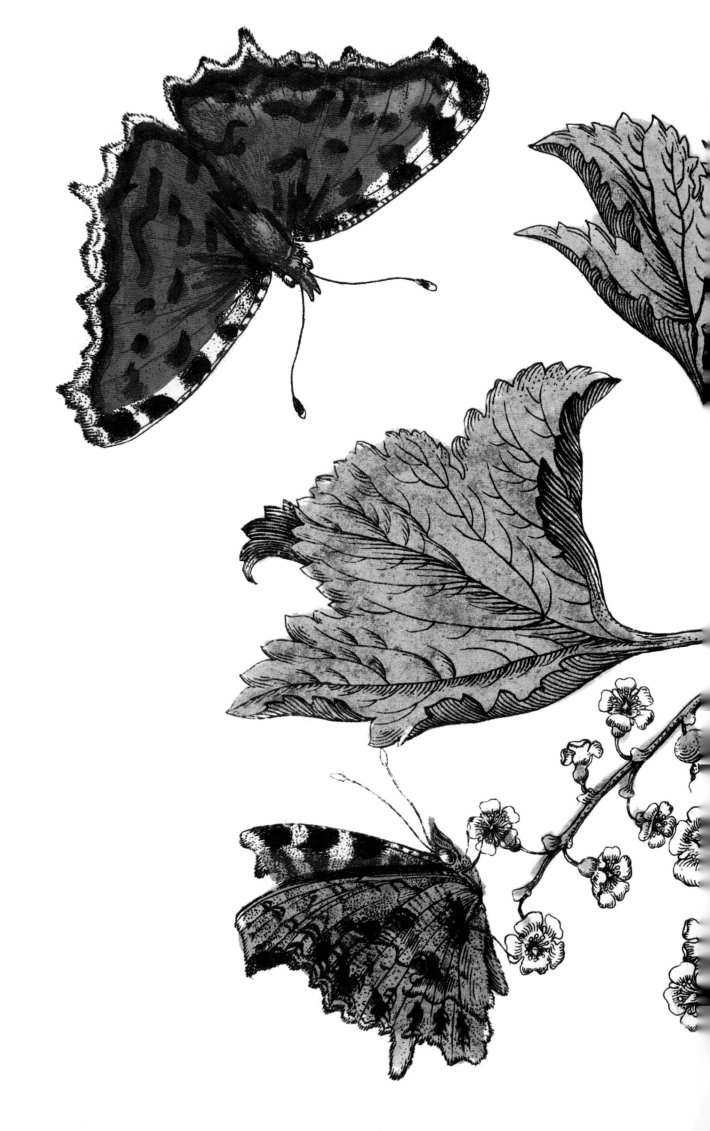

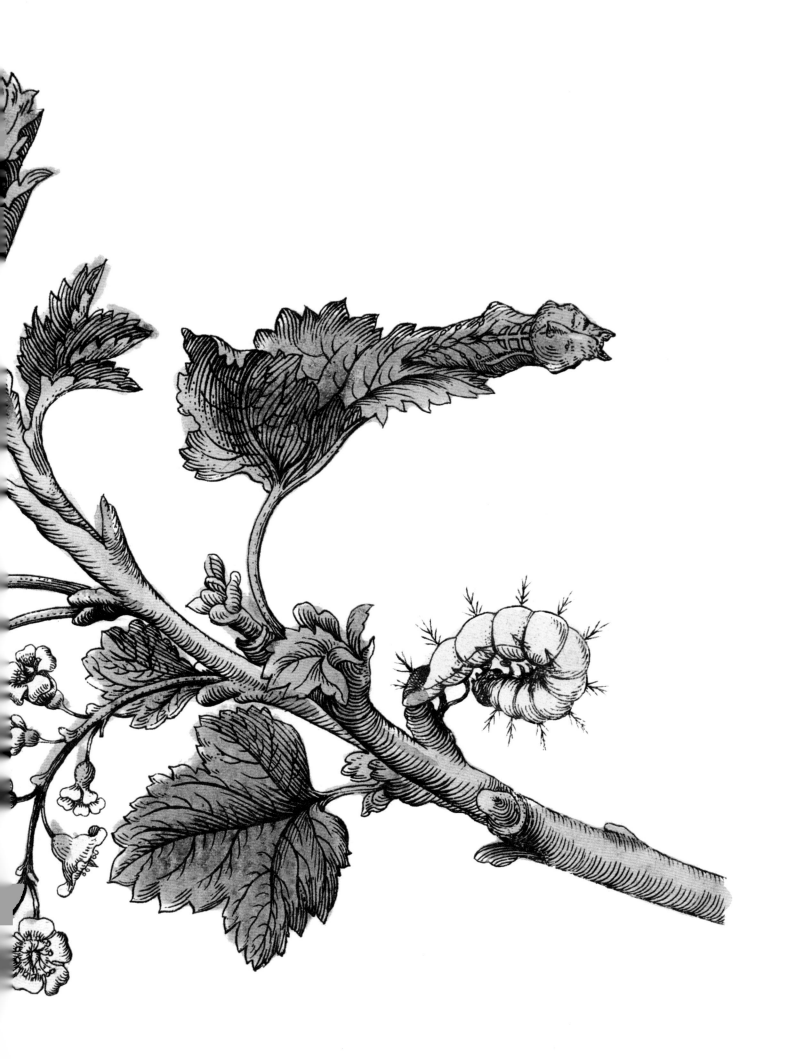

"The moth's kiss first!
Kiss me as if you made believe
You were not sure, this eve,
How my face, your flower, had pursed
Its petals up; so, here and there
You brush it, till I grow aware
Who wants me, and wide ope I burst."

ROBERT BROWNING

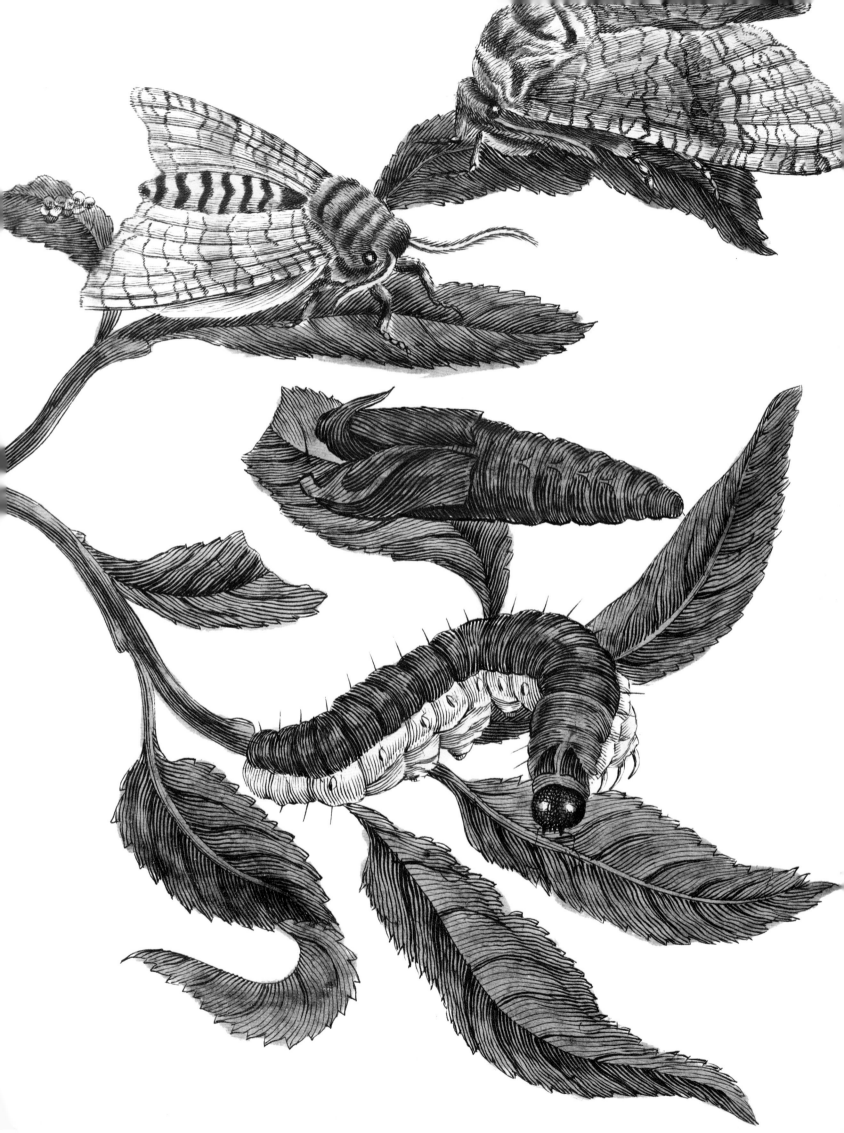

" Gorgeous flowerets in the sunlight shining,
Blossoms flaunting in the eye of day,
Tremulous leave, with soft and silver lining
Buds that open only to decay. "

HENRY LONGFELLOW, *FLOWERS*

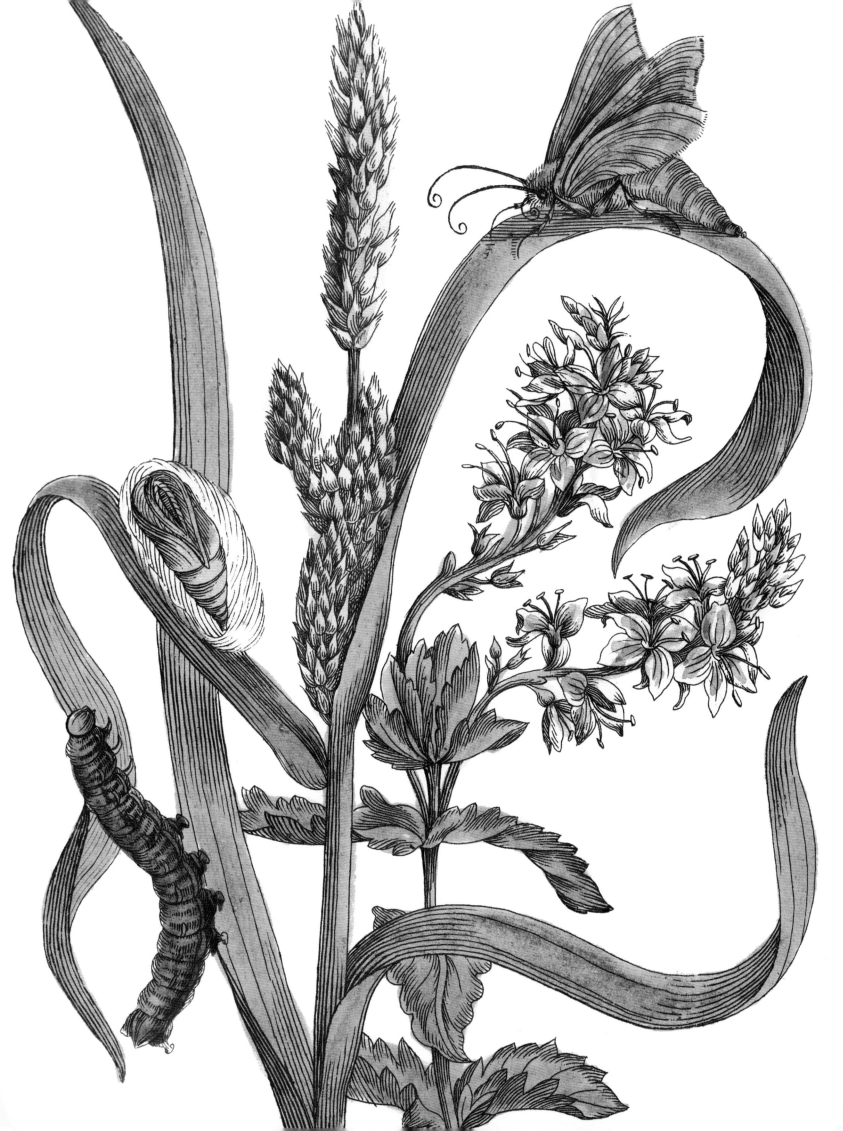

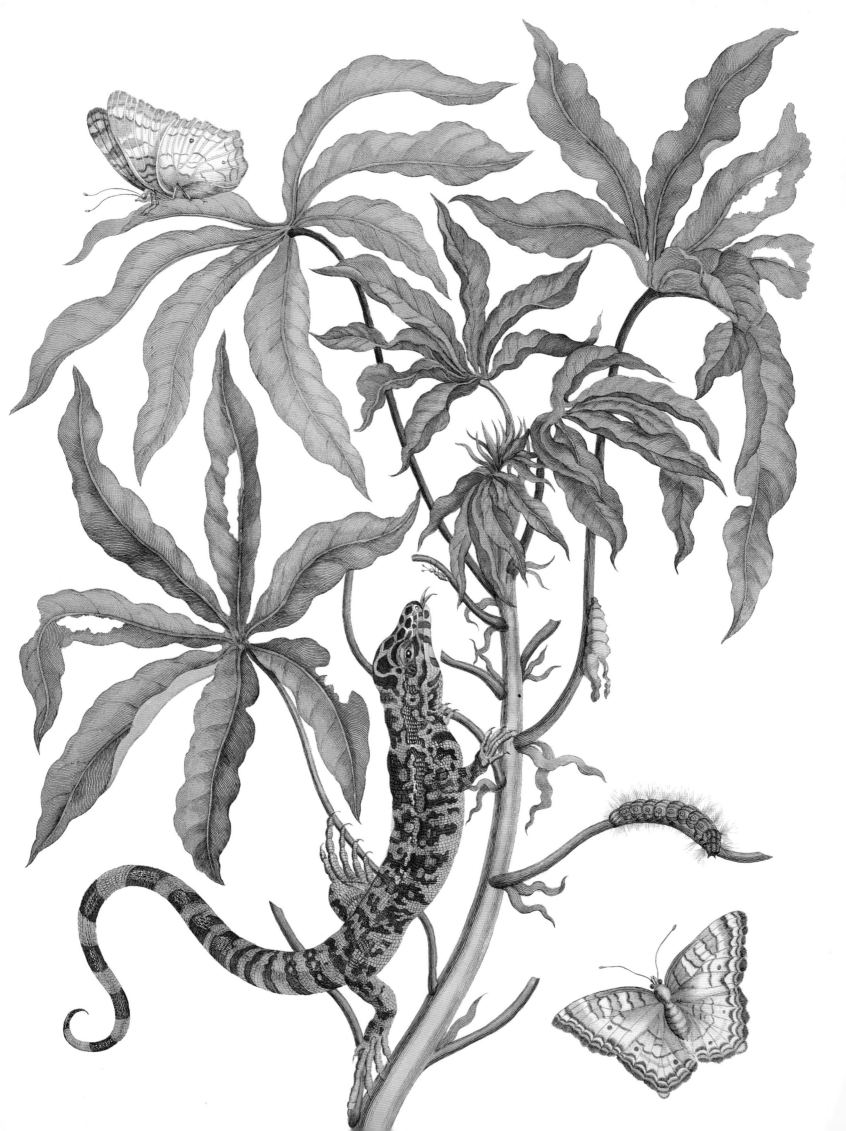

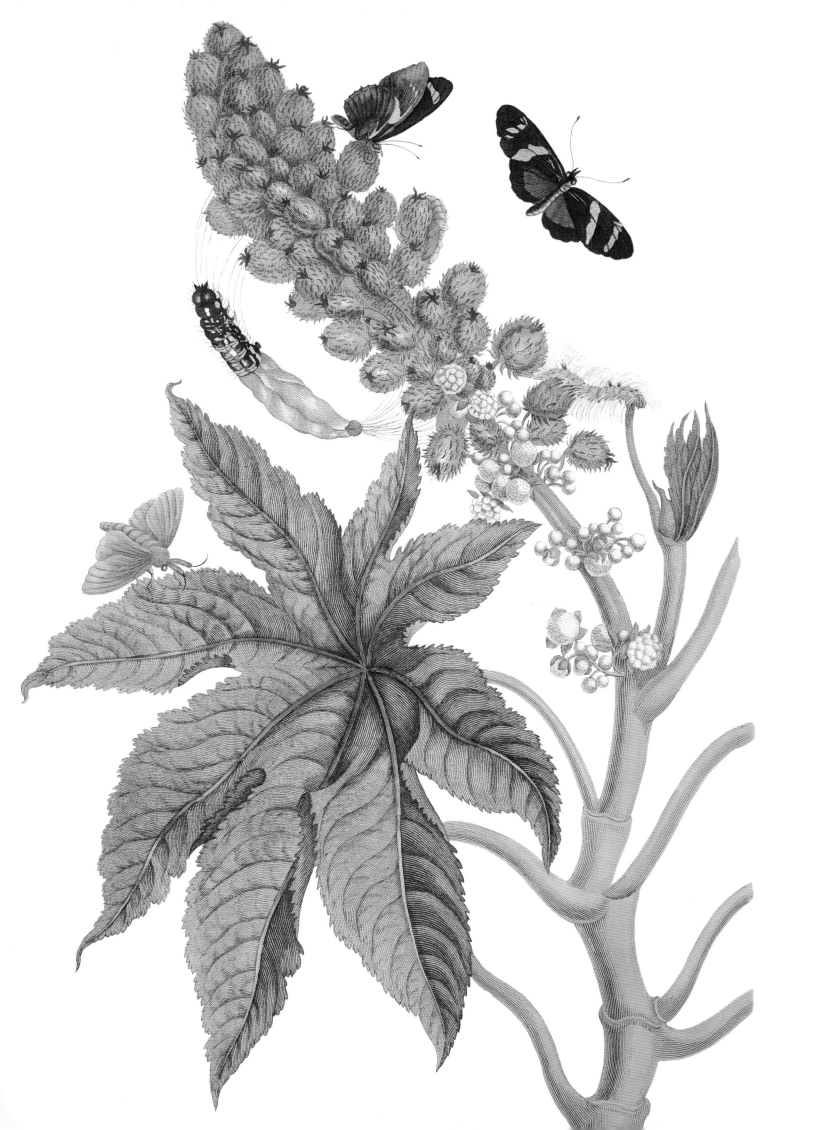

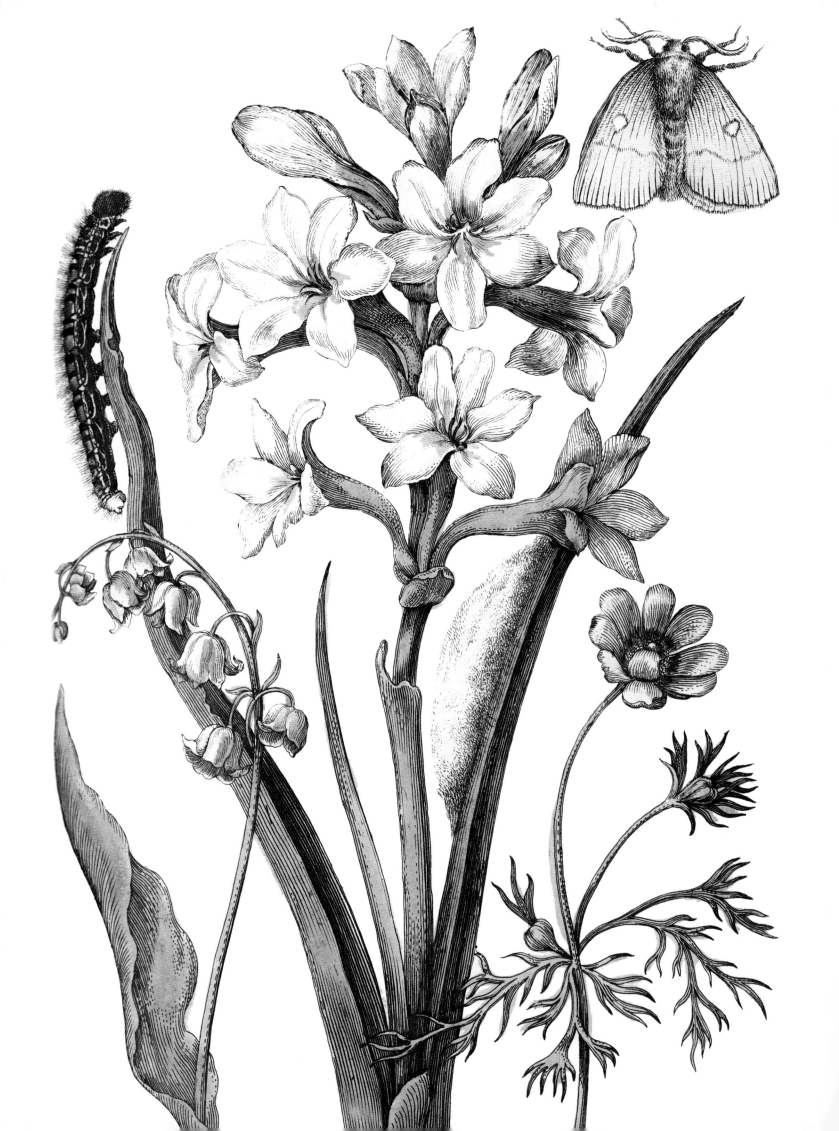

66 To create a little flower is the labor of ages. 99

WILLIAM BLAKE

"His talent was as natural as the pattern that was made by the dust on a butterfly's wings. At one time he understood it no more than the butterfly did and he did not know when it was brushed or marred. Later he became conscious of his damaged wings and of their construction and he learned to think and could not fly any more because the love of flight was gone and he could only remember when it had been effortless."

ERNEST HEMINGWAY, *A MOVEABLE FEAST*

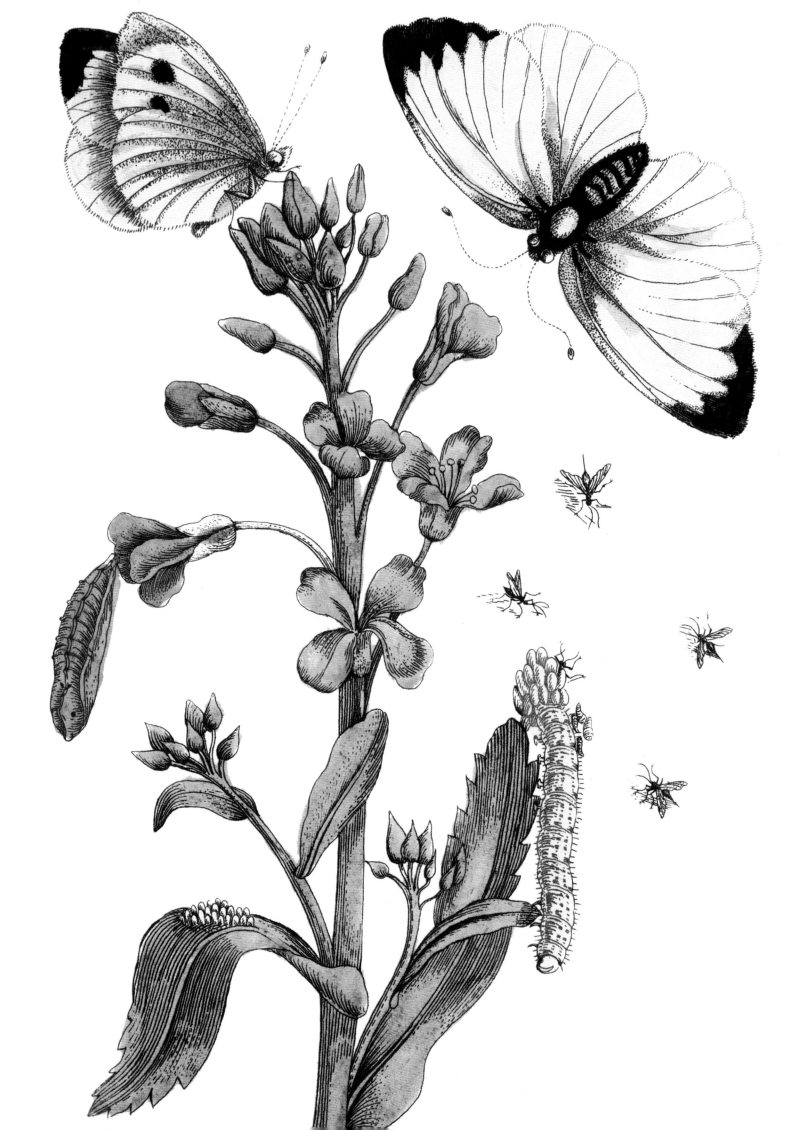

" Flowers are the sweetest things God ever made and forgot to put a soul into. **"**

HENRY WARD BEECHER

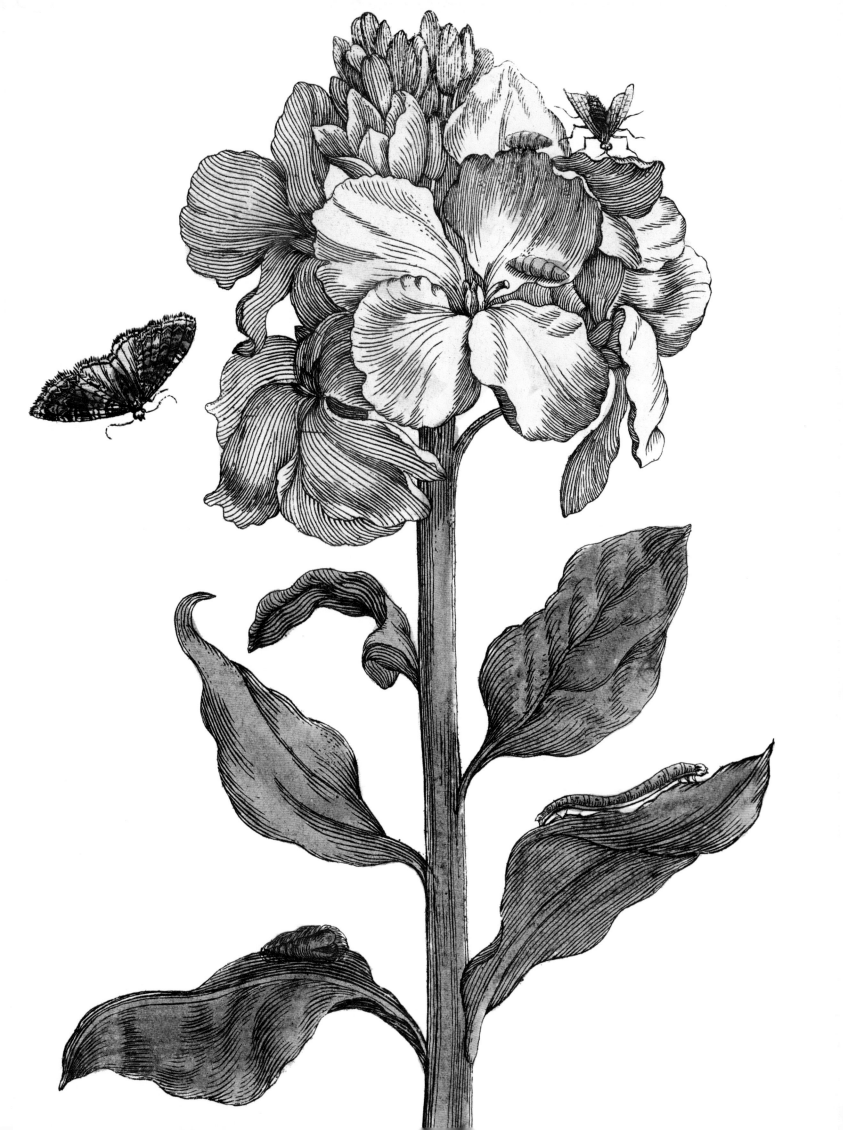

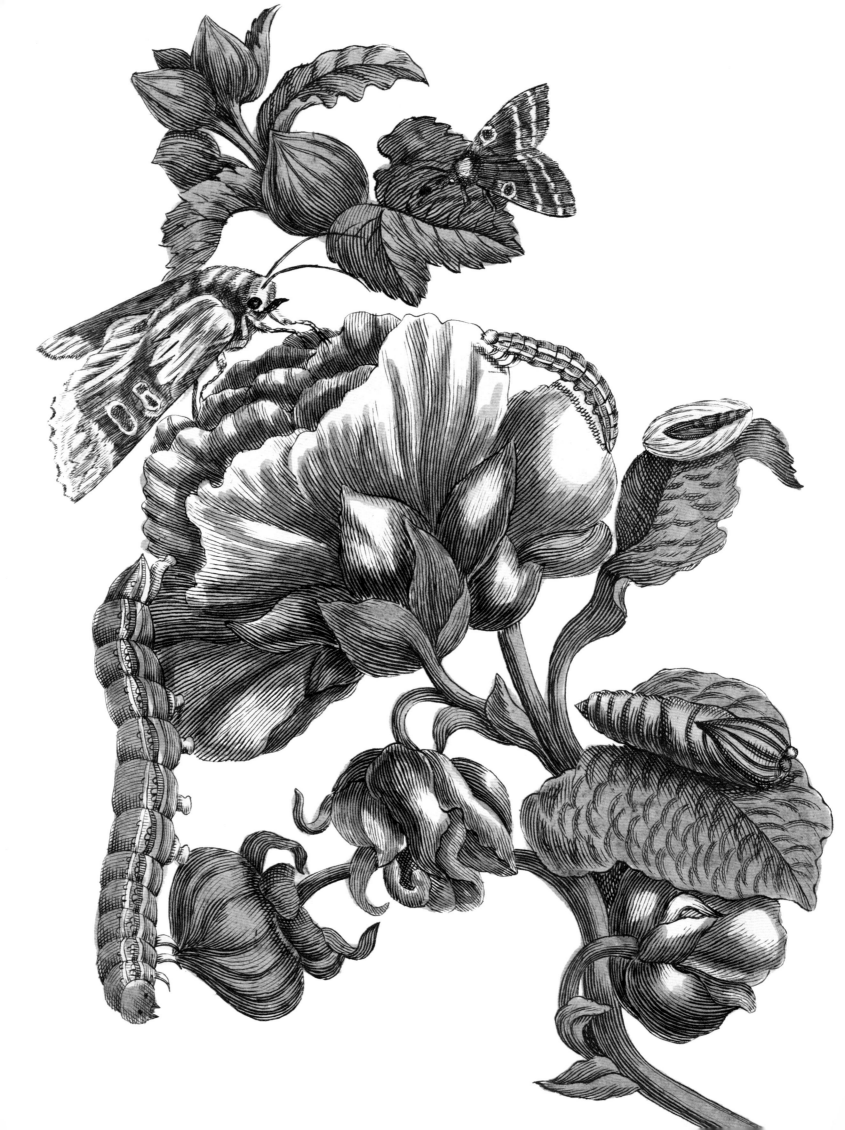

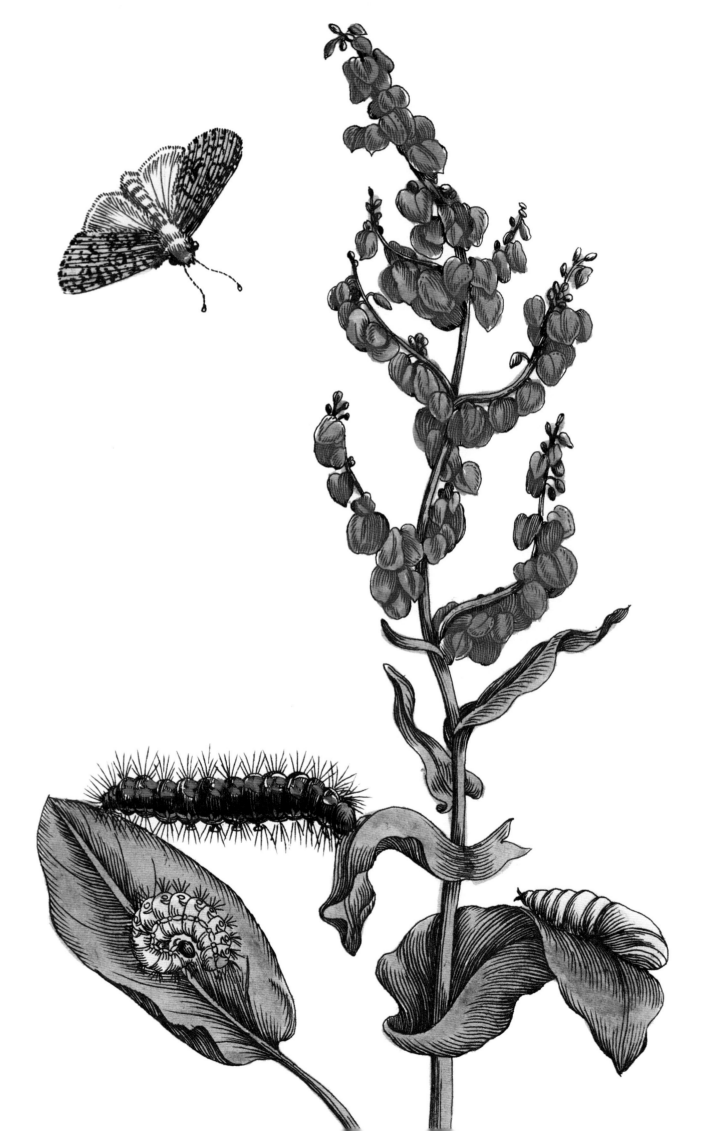

"Nature will bear the closest inspection. She invites us to lay our eye level with her smallest leaf, and take an insect view of its plain."

HENRY DAVID THOREAU

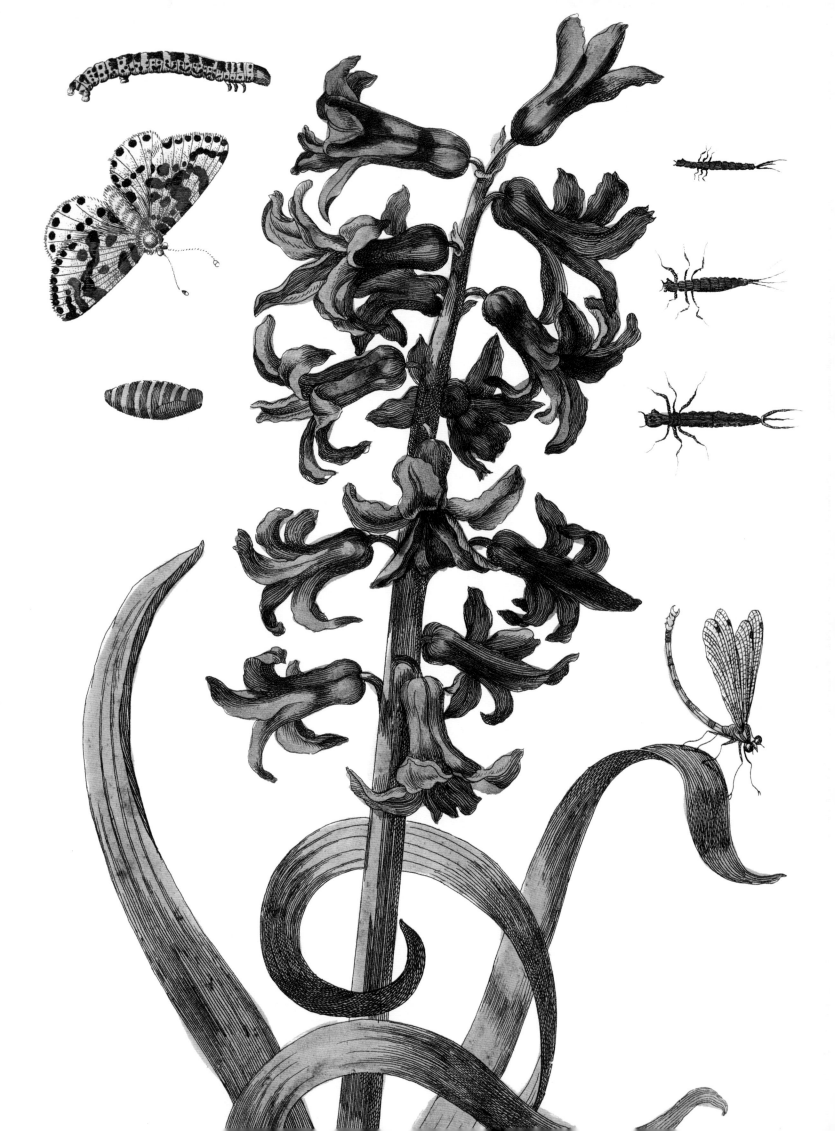

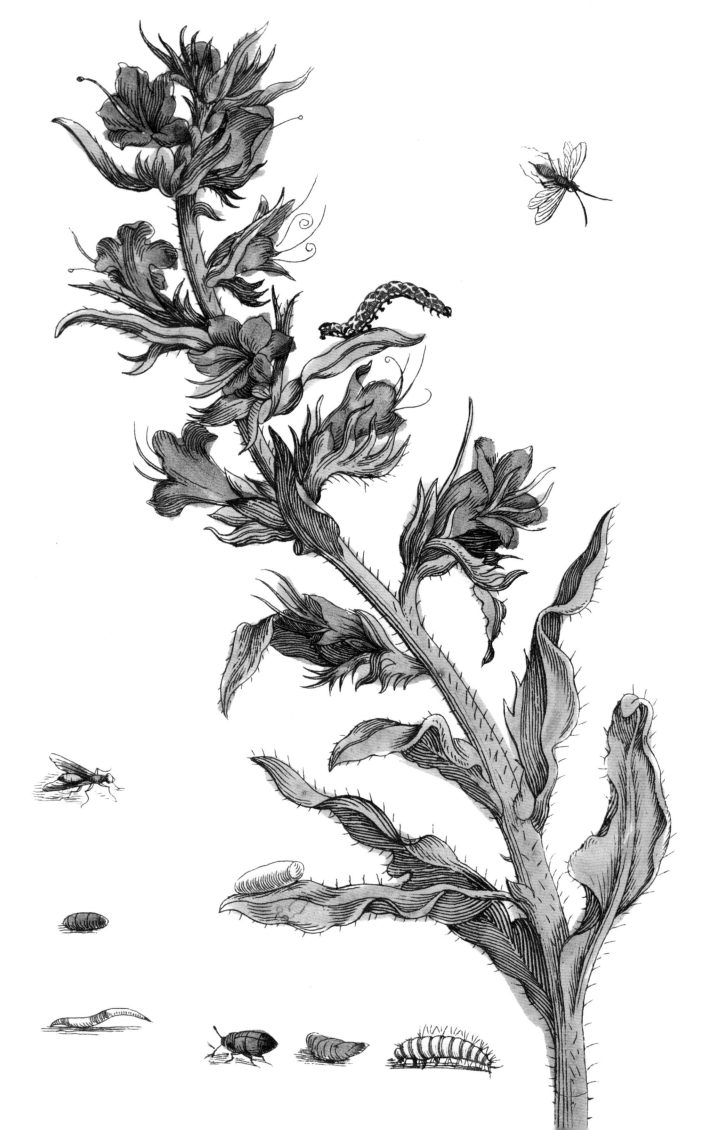

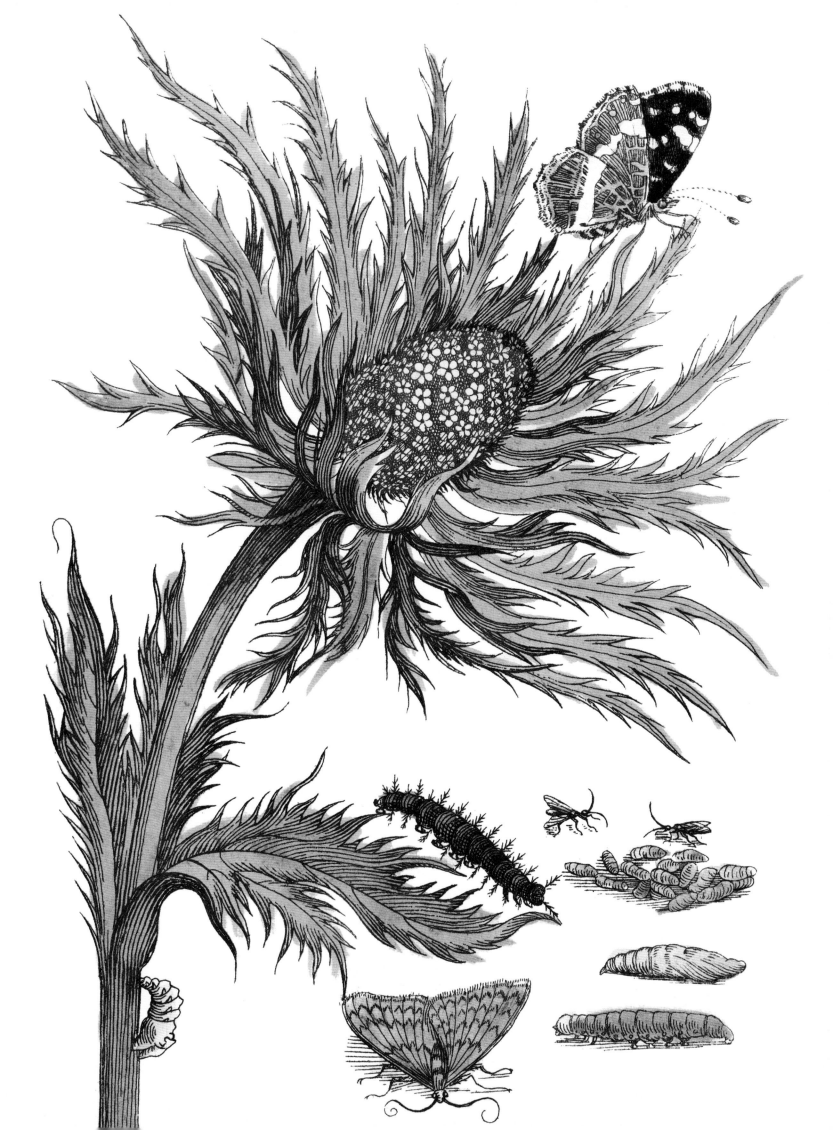

"Rose, thou art the sweetest flower
That ever drank the amber shower;
Rose, thou art the fondest child
Of dimpled Spring, the wood-nymph wiled."

THOMAS MOORE, *ODES OF ANACREON*

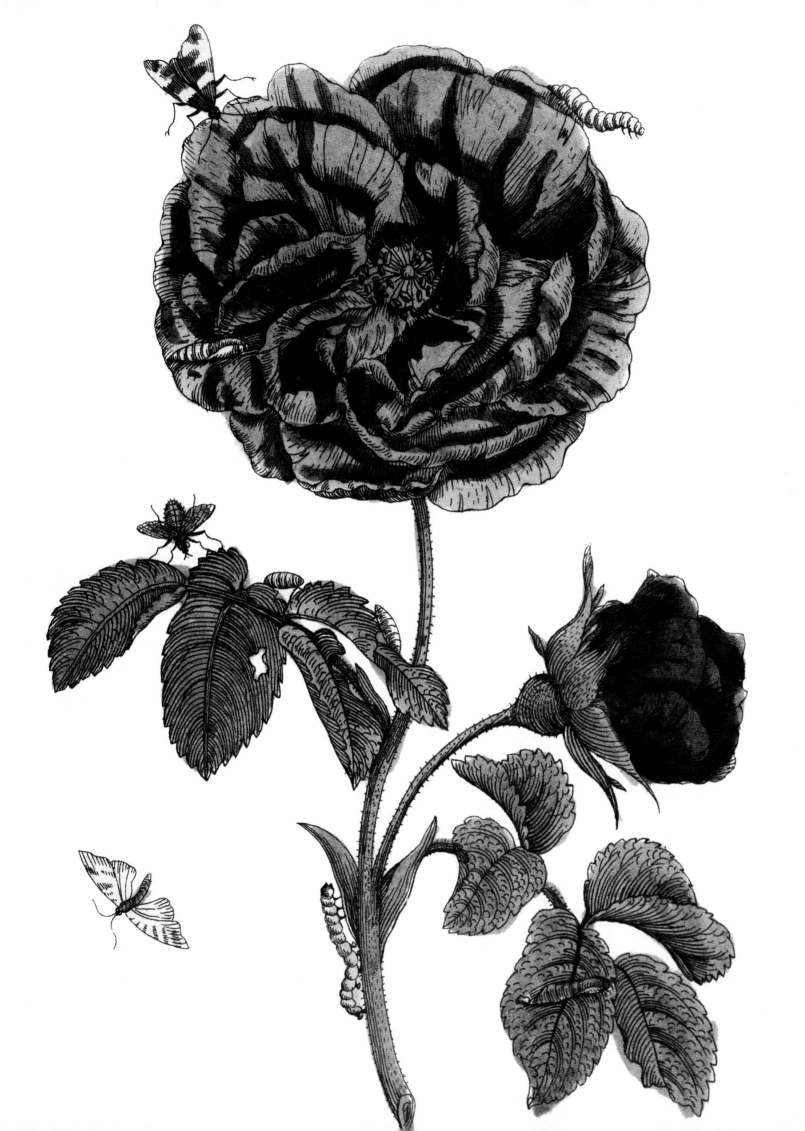

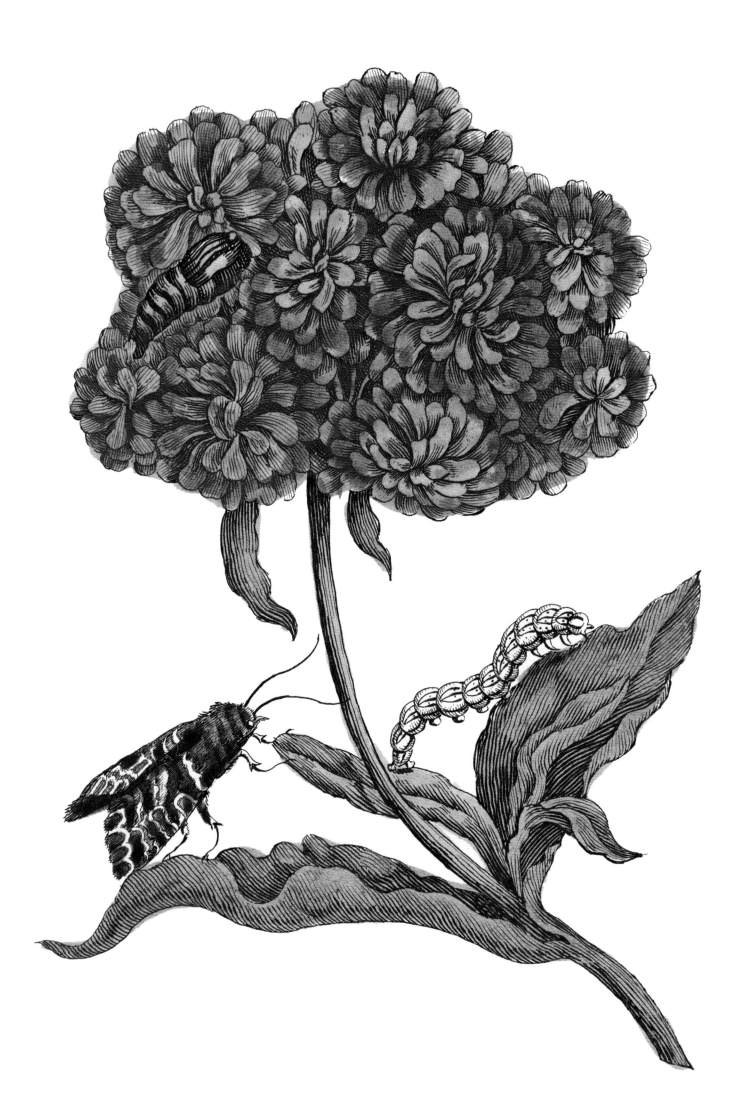

"To strew thy green with flowers: the yellows, blues, The purple violets, and marigolds."

WILLIAM SHAKESPEARE, *PERICLES*

"Ye field flowers! the gardens eclipse you, 'tis true;

Yet, wildings of nature! I dote upon you,

For ye waft me to summers of old,

When the earth teem'd around me with fairy delight,

And when daisies and buttercups gladden'd my sight,

Like treasures of silver and gold."

THOMAS CAMPBELL, *FIELD FLOWERS*

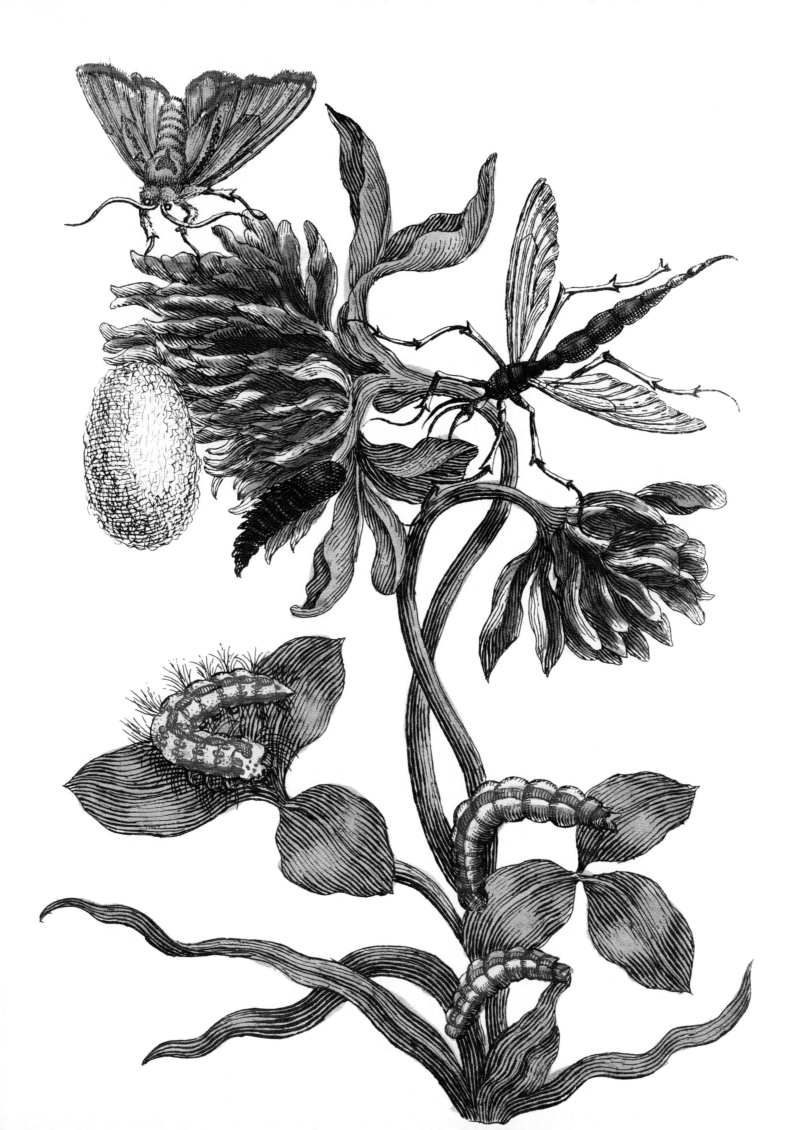

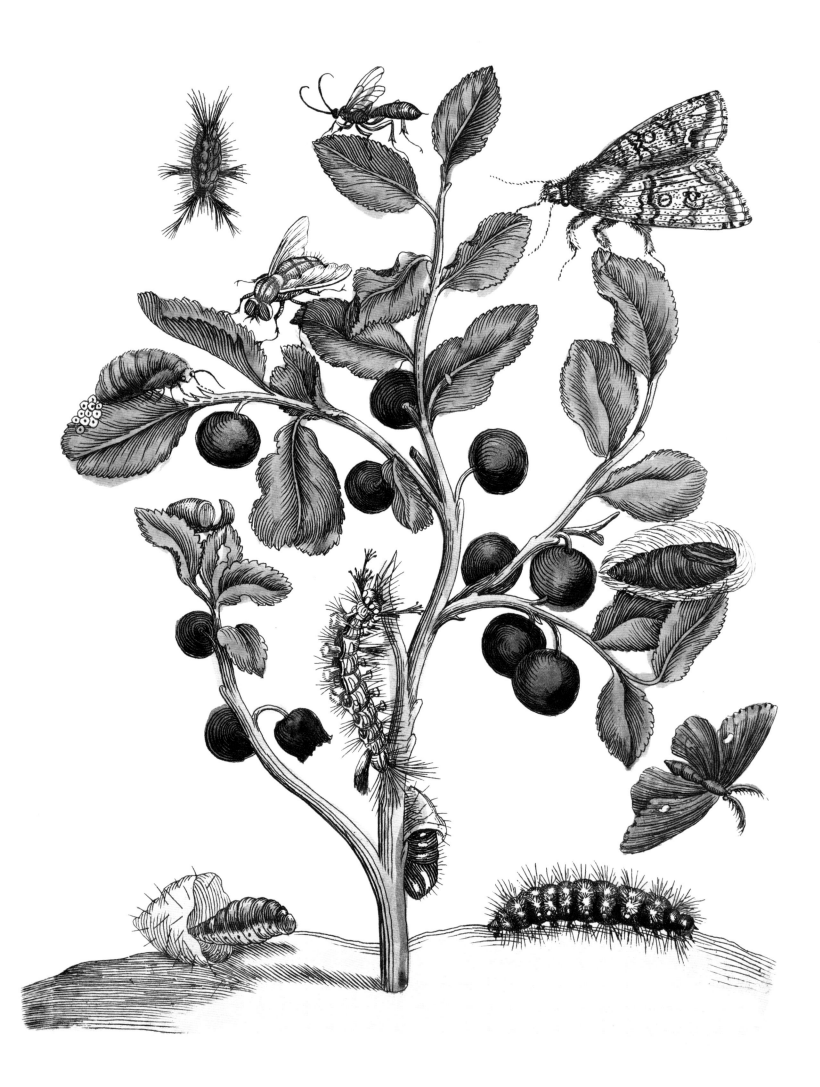

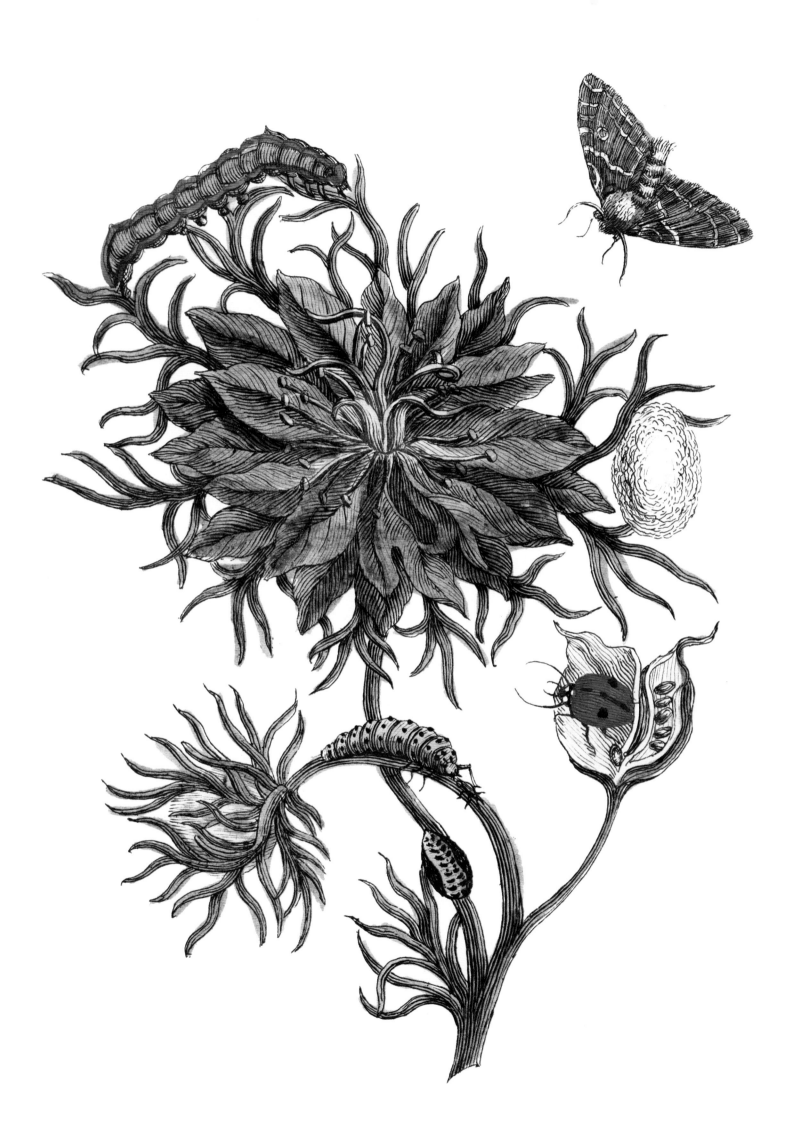

"High rise the cloud-capp'd hills where Kalmia glows
With dazzling beauty, 'mid a waste of snows,
O'er the wild scene SHE casts a smiling eye,
The earth her bed, the skies her canopy.—
Thus from the north, in undulating streams,
Glance after glance, the polar radiance gleams,
Or, in expanding glare, at noon of night,
Fills the red zenith with unbounded light.
Quick fly the timid herd in wild amaze,
While arms unseen clash dreadful 'mid the blaze.
Th' affrighted shepherd to his cot retires,
Nor dares to gaze upon the quiv-ring fires:
The crouching dogs their master's feet surround,
And, fix'd by fear, lie torpid on the ground:
Loud shrieks the screaming owl, and flits away,
Scar'd by the luster of unlook'd-for day:
E'en the grim wolf his nightly prey forsakes,
And silent in his gloomy cavern quakes,
Till skies serene their starry groupes display,
And each terrific phantom dies away."

DR. SHAW

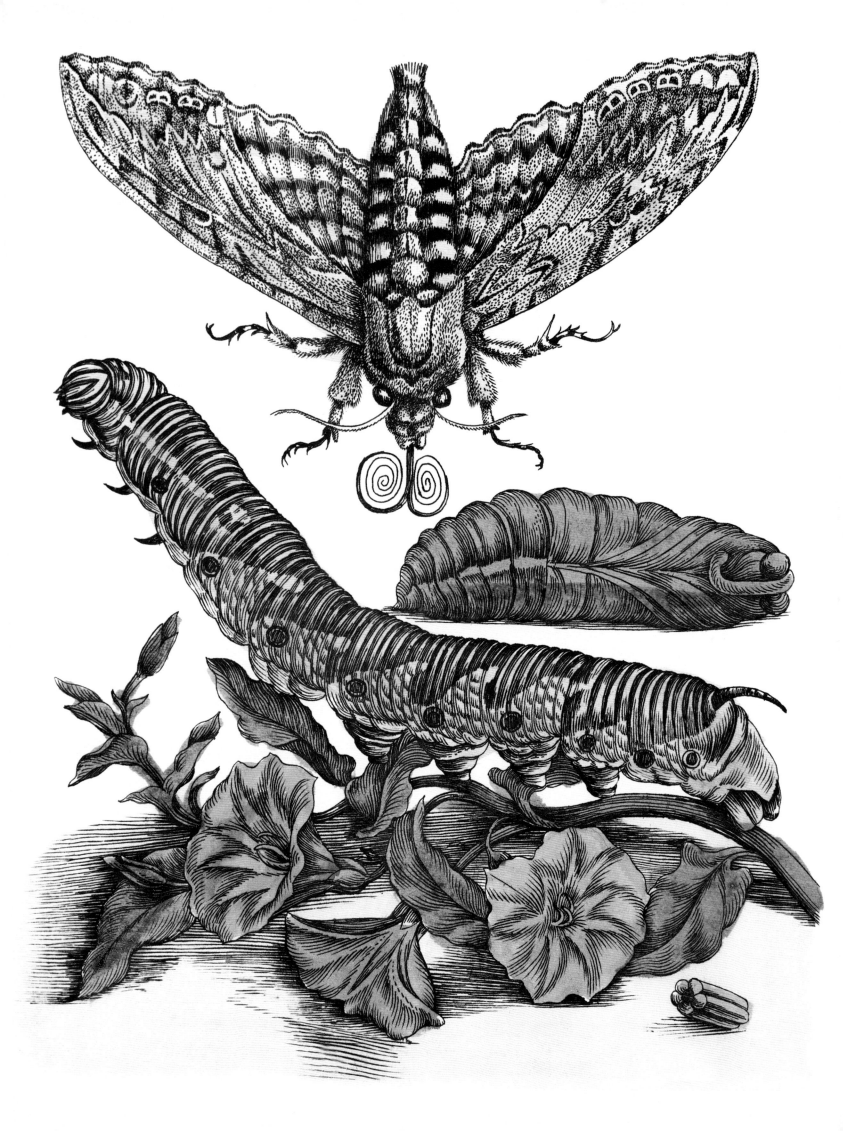

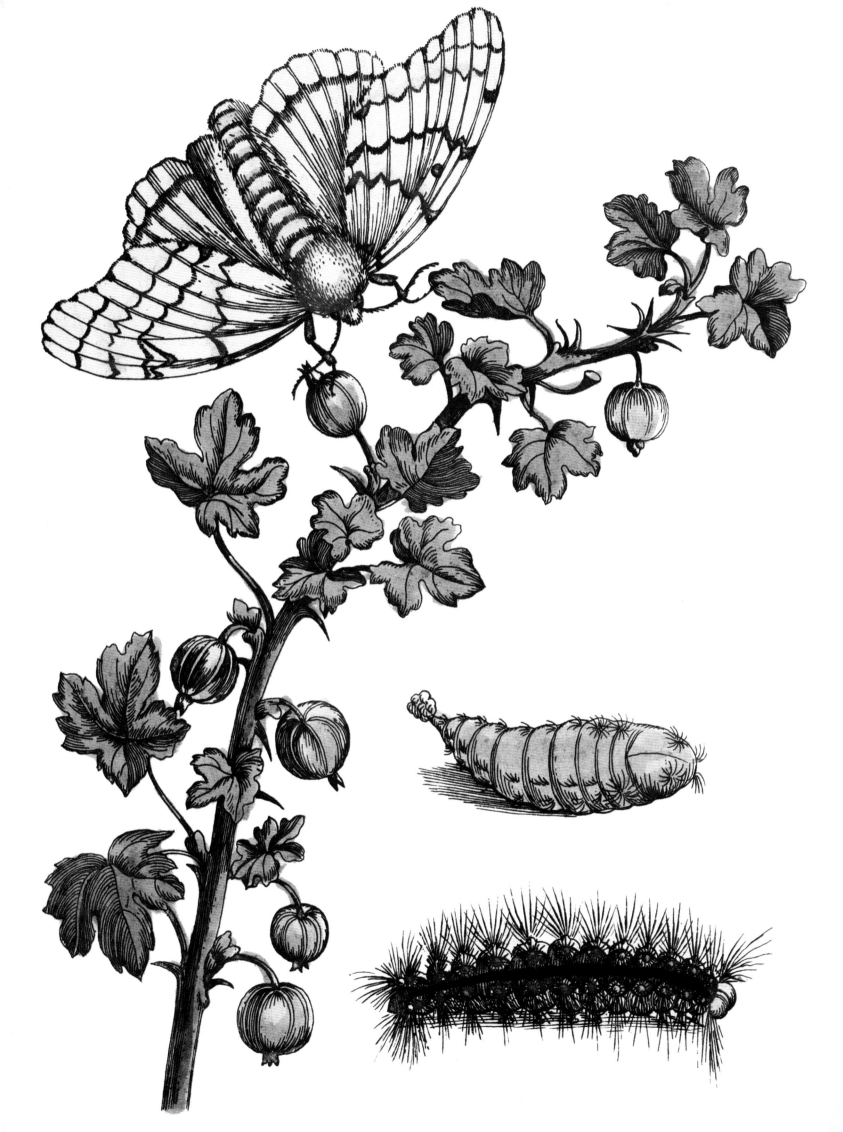

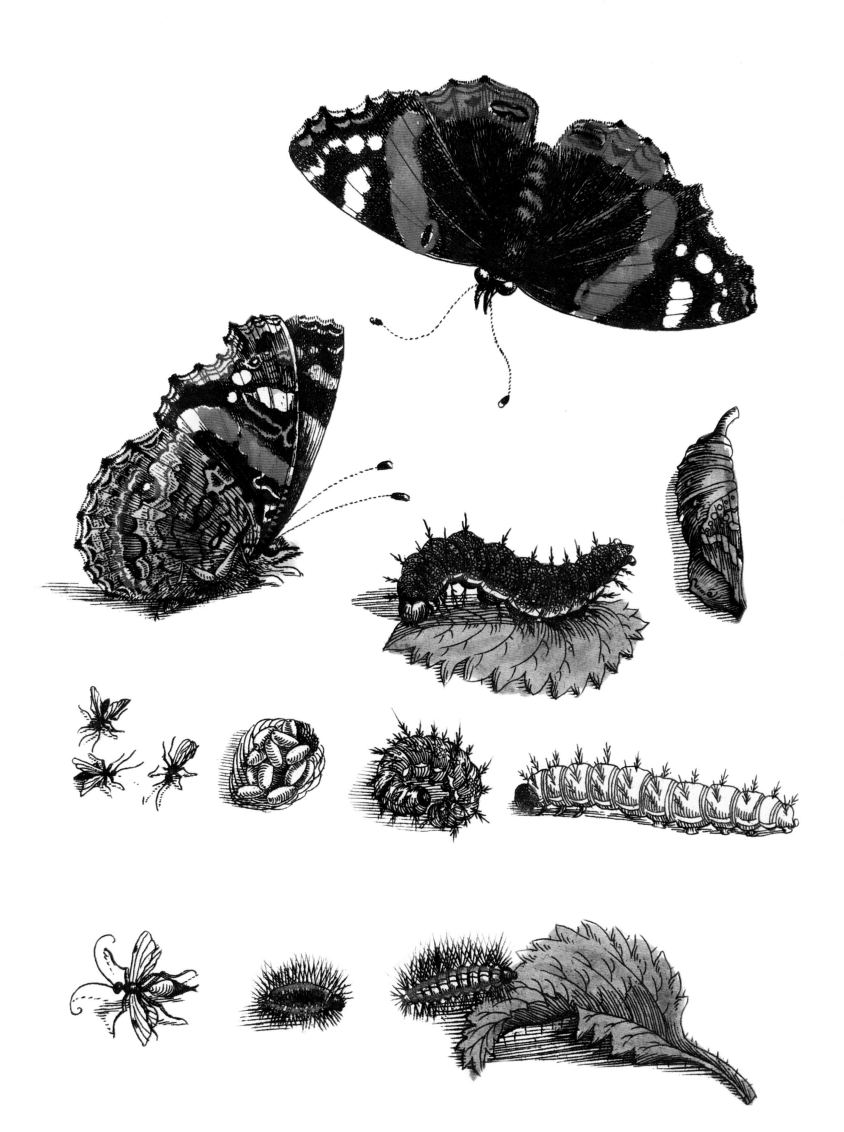

"In Easter lands they talk in flowers,
And they tell in a garland their loves and cares;
Each blossom that blooms in their garden bowers,
On its leaves a mystic language bears."

J.G. PERCIVAL, *THE LANGUAGE OF FLOWERS*

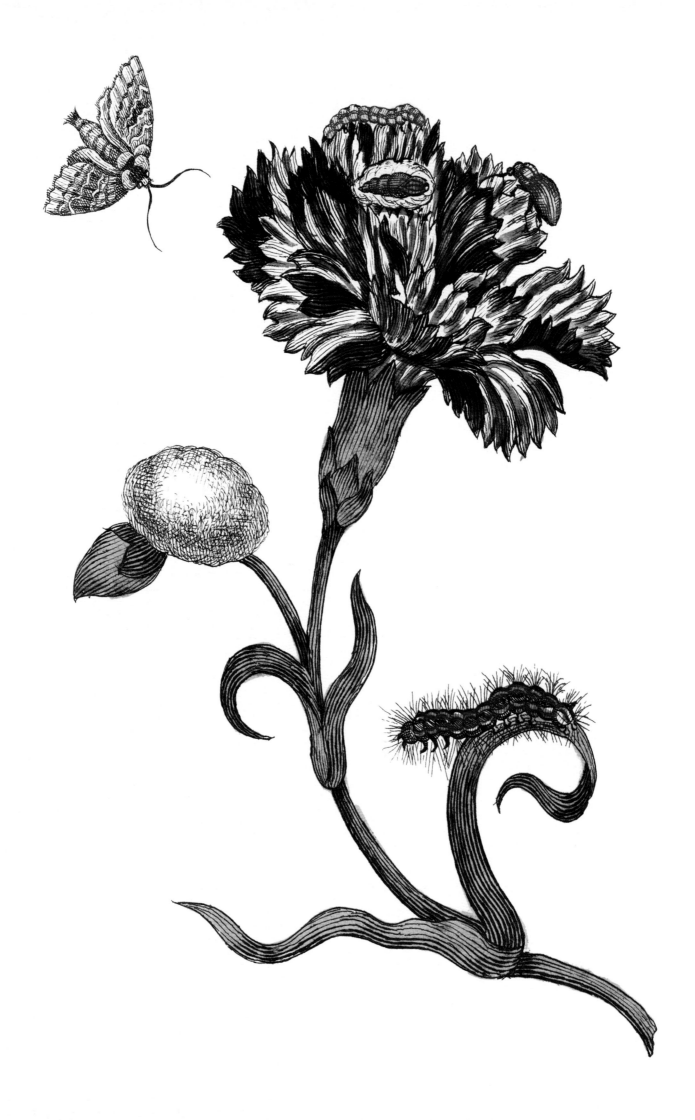

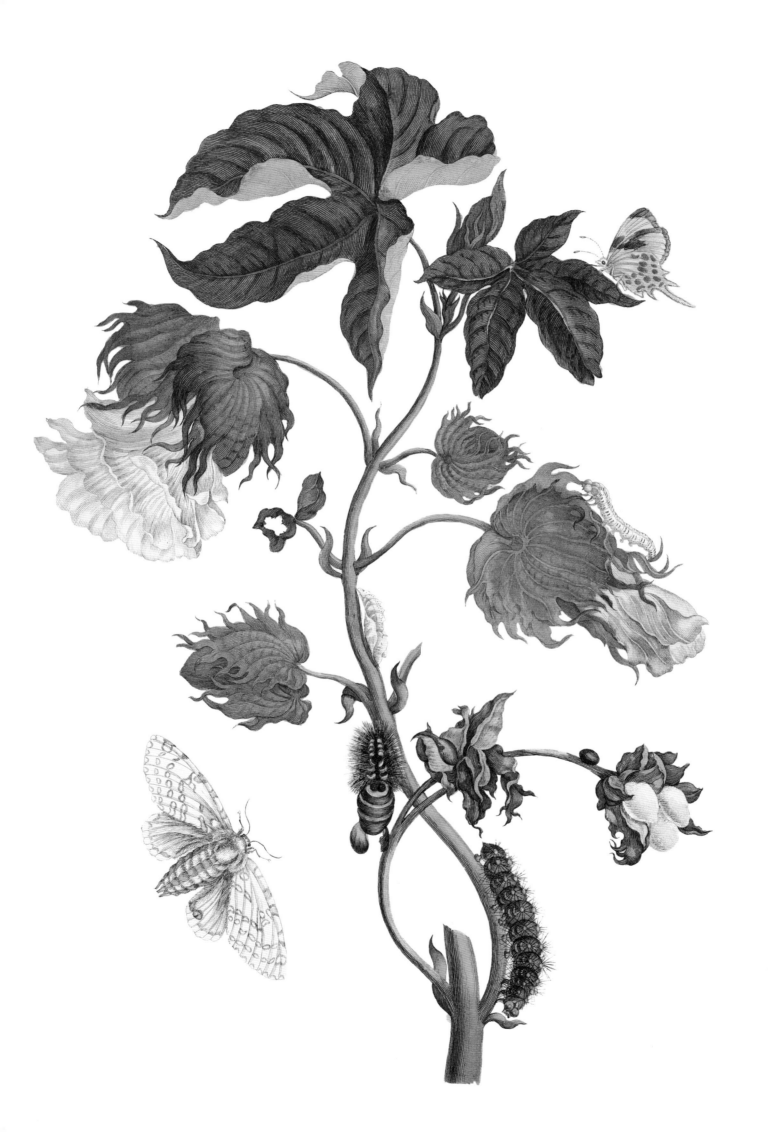

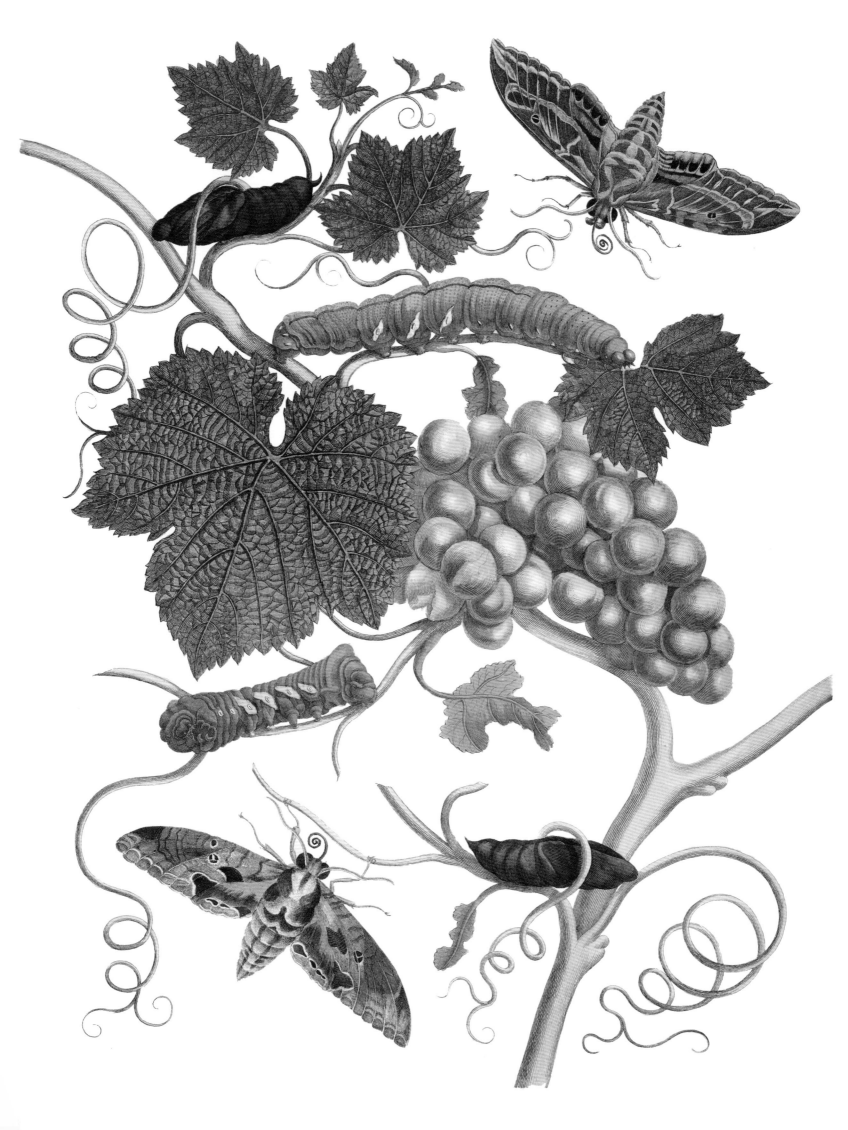

"Love is both Creator's and Saviour's gospel to mankind; a volume bound in rose-leaves, clasped with violets, and by the beaks of humming-birds printed with peach-juice on the leaves of lilies.**"**

HERMAN MELVILLE

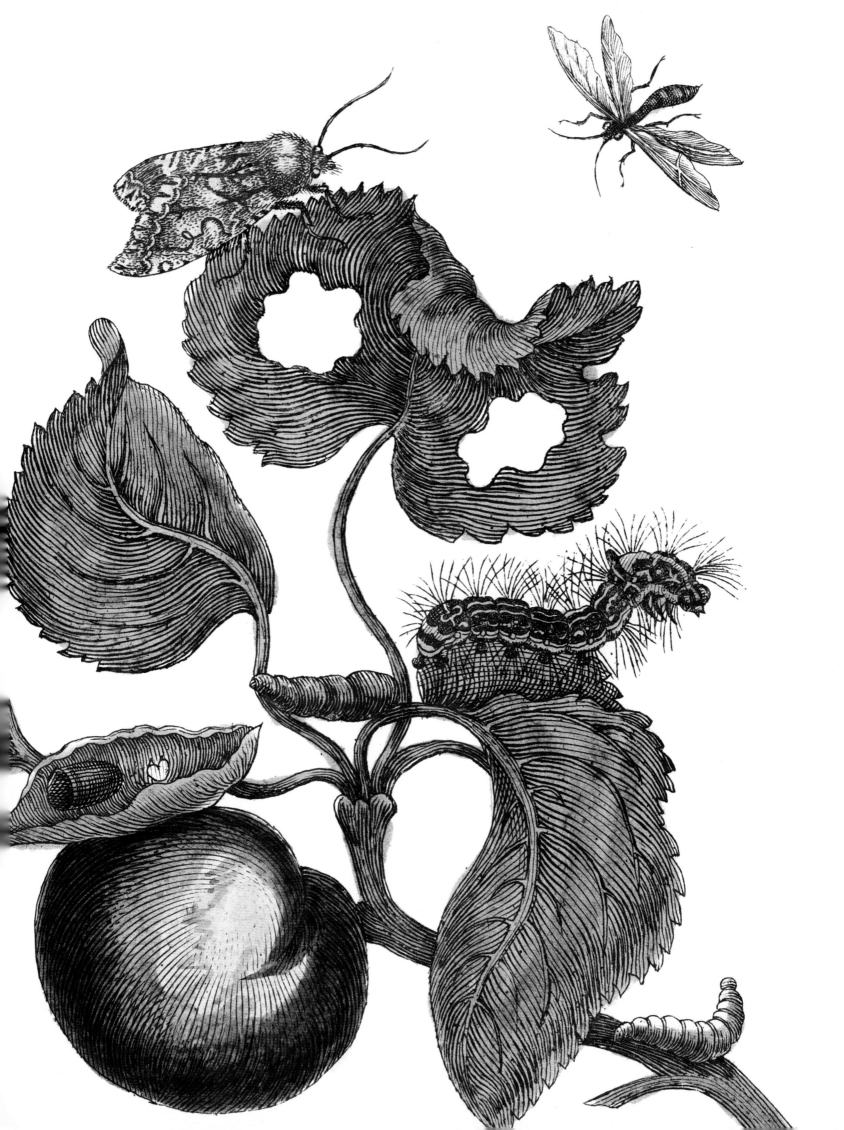

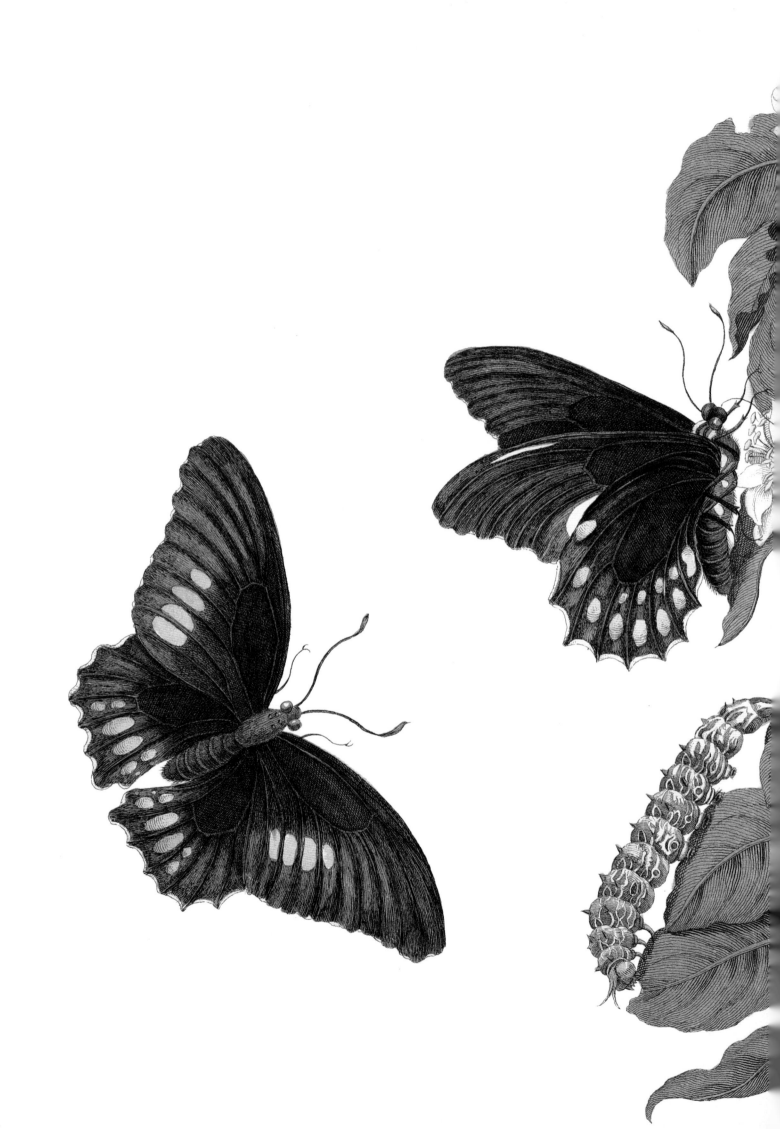

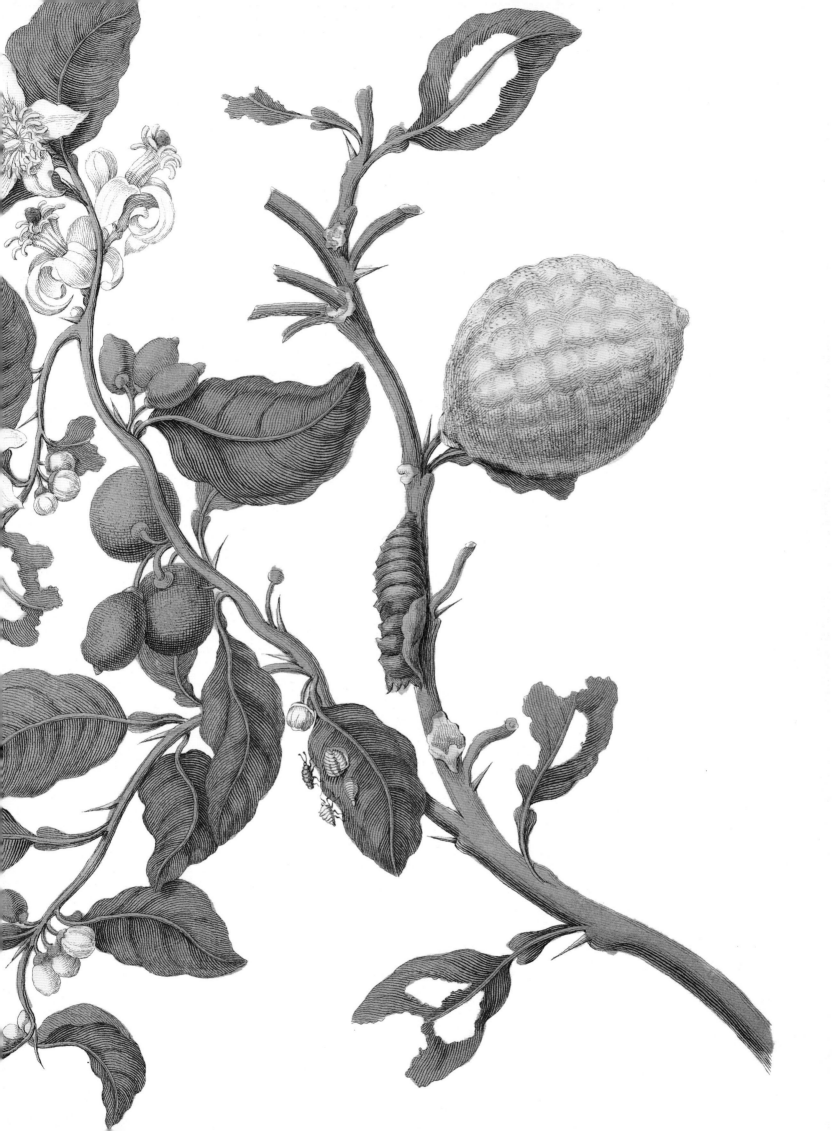

BUTTERFLIES AND INSECTS

E. A. SEGUY (1890?–1985?)

With the work of E. A. Seguy, we move from scientific illustration to the realm of the decorative arts. Rather than classify species, he sought to glorify selected exotic creatures in which he found artistic inspiration. Imaginatively employing floral and zoological motifs, Seguy's early designs in *Les fleurs et leurs applications decoratives* (*Flowers and Their Decorative Applications*) and *Textiles*, published in Paris in 1902 and 1910, respectively, are wonderful examples of the art nouveau style that swept through Europe in the decades around the turn of the century. The movement's influence extended to textiles, wallpaper, and other materials both manufactured and hand-crafted featuring the naturalistic shapes, flowing curves, and graceful movements of growing plants. Art

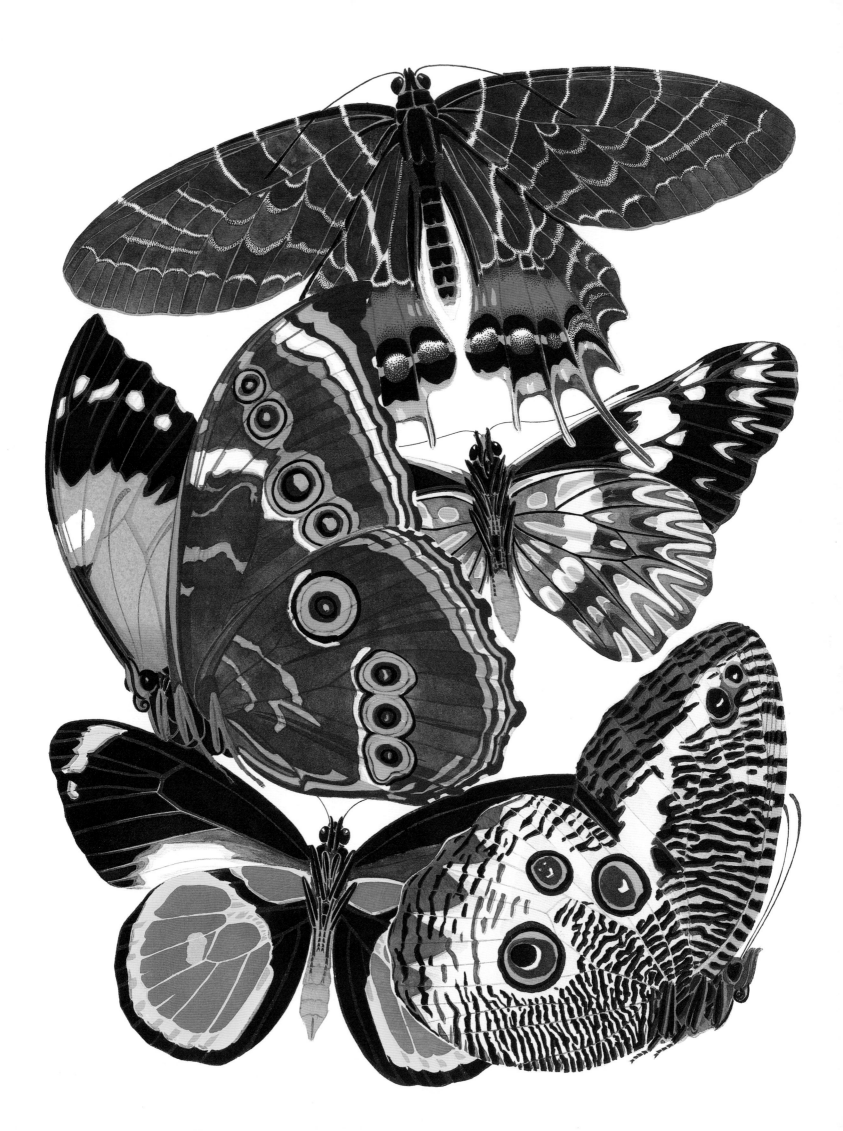

nouveau motifs persisted throughout his subsequent works, including *Floréal dessins et coloris nouveaux (Floral Designs and New Colorings)* and *Bouquets et frondaisons (Bouquets and Foliage)*, both published in Paris, dates unknown, and *Suggestions pour étoffes et tapis (Suggestions for Textiles and Carpets)*, published in Paris in 1923; his last known work was *Prismes (Prisms)*, published in Paris in 1930, inspired by the natural forms of crystals. Each of these was published in a format of twenty prints in a portfolio (each print on a separate sheet, loose in a folder or box), with some works consisting of two portfolios, forty prints.

Seguy's best-known publications, *Papillons (Butterflies)* and *Insectes (Insects)* both published in Paris (dates unknown), again consist of twenty richly colored prints each, ranging from magnified, scientifically precise depictions of butterflies and other insects to highly schematized patterns based on their abstracted forms. Almost hallucinatory in their intricacy and intense color schemes, the extraordinary designs juxtapose a lingering love of natural forms and patterns with the newer, antithetical aesthetic of art deco.

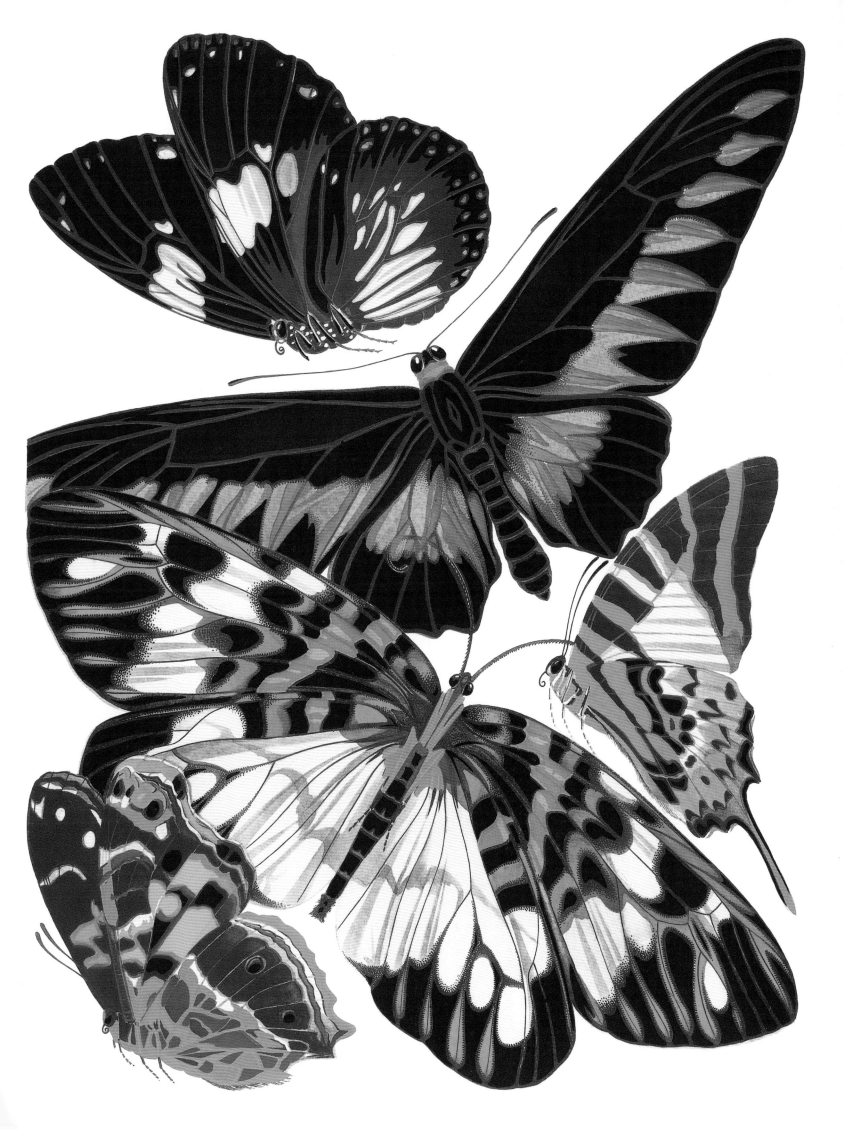

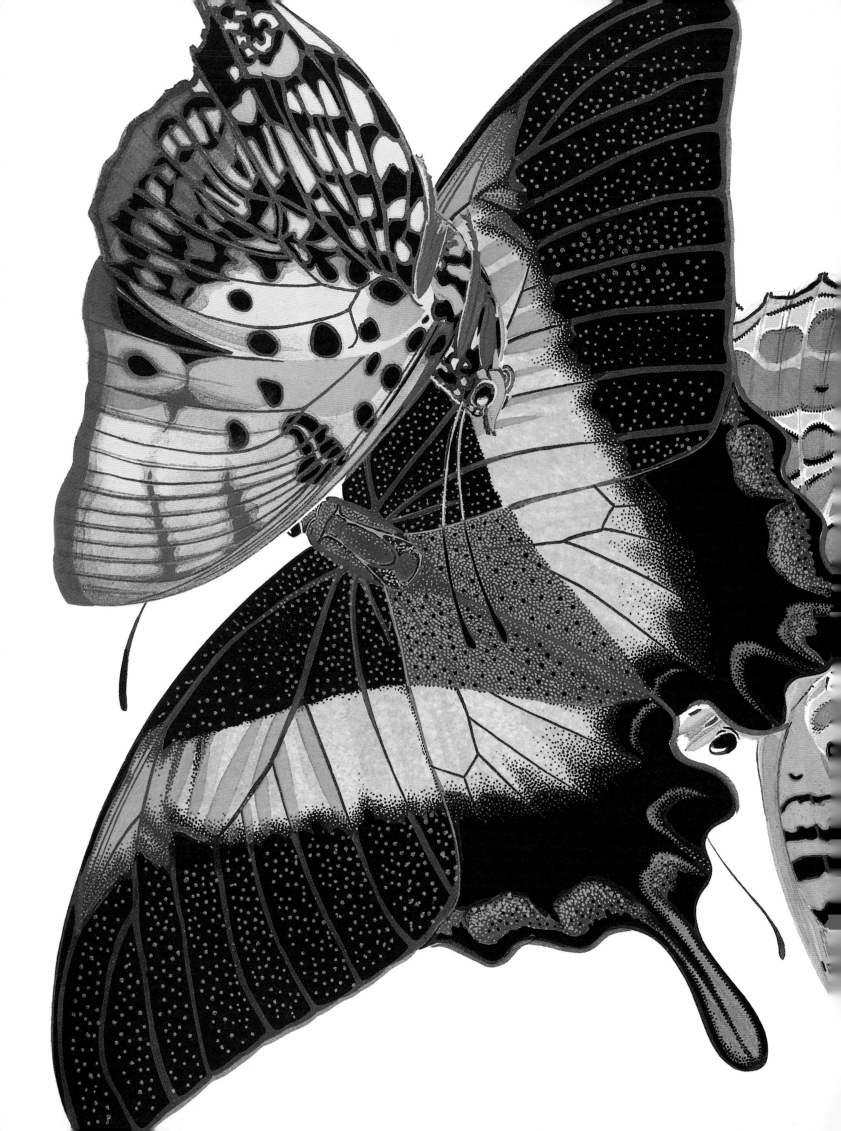

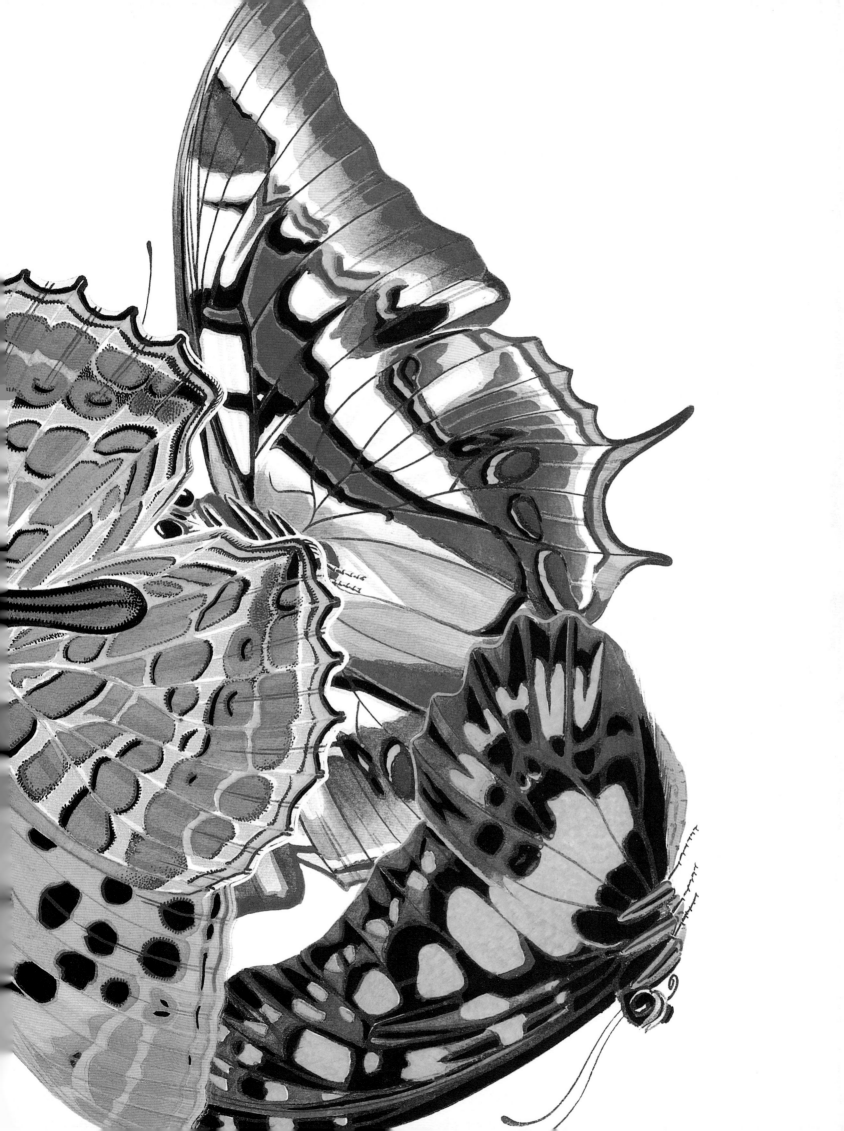

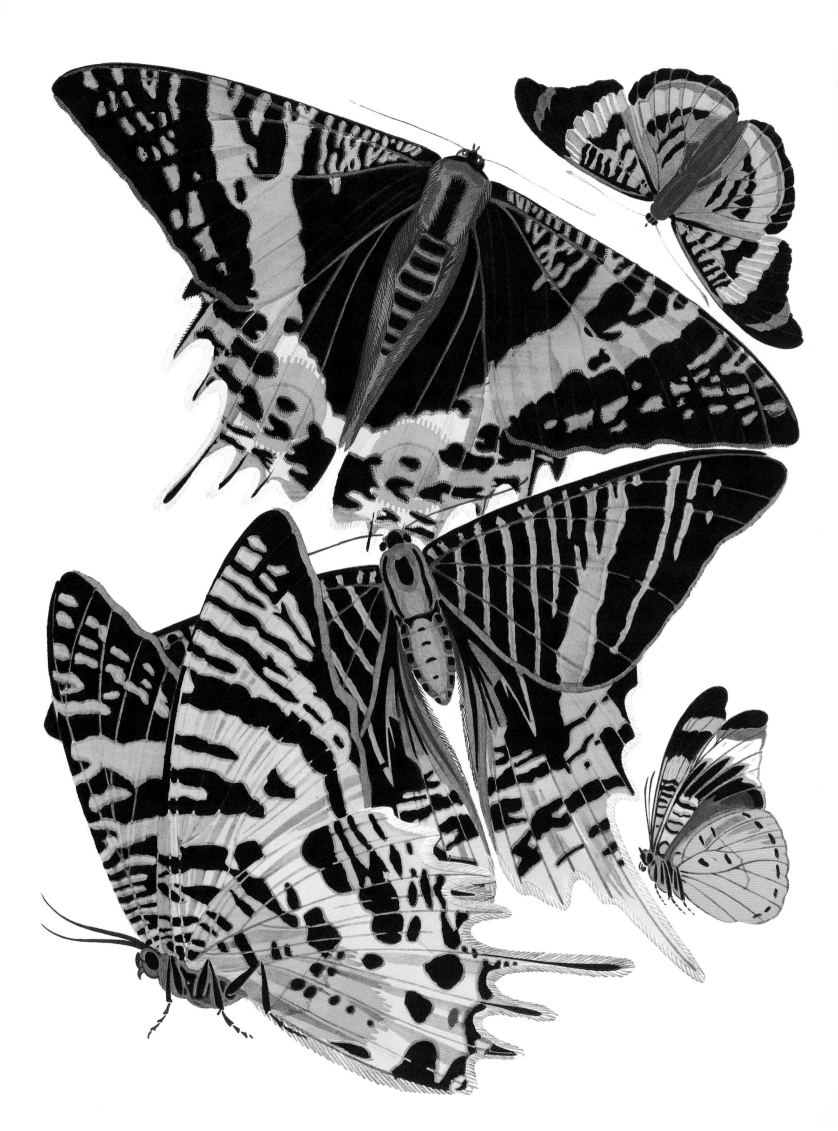

This popular art movement coalesced in the 1920s and '30s following the Exposition Universelle (Universal Exposition) of 1900 in Paris and, more significantly, the Exposition Internationale des Arts Décoratifs et Industriels Modernes (International Exposition of Modern Industrial and Decorative Arts) in Paris in 1925. Initially called style moderne, it was an eclectic and elegant, yet solid and massy, style that combined abstraction and simplification (streamlined functionality) with geometric shapes and intense colors (primitive and exotic visual motifs) and a fascination and experimentation with modern materials (the potential of technology and industry). Art deco made its most publicly visible impression on architecture—the grand railroad stations and office buildings of the 1930s—but all of the decorative arts were influenced, including fashion and jewelry, furniture and interior decoration, fabrics and textiles, glassware, and silverware, among others.

The abstract, geometric patterns and wild colors of Seguy's prints were produced with the pochoir technique, in which intricately cut stencils for hand-coloring were overlaid on (in his case) a printed

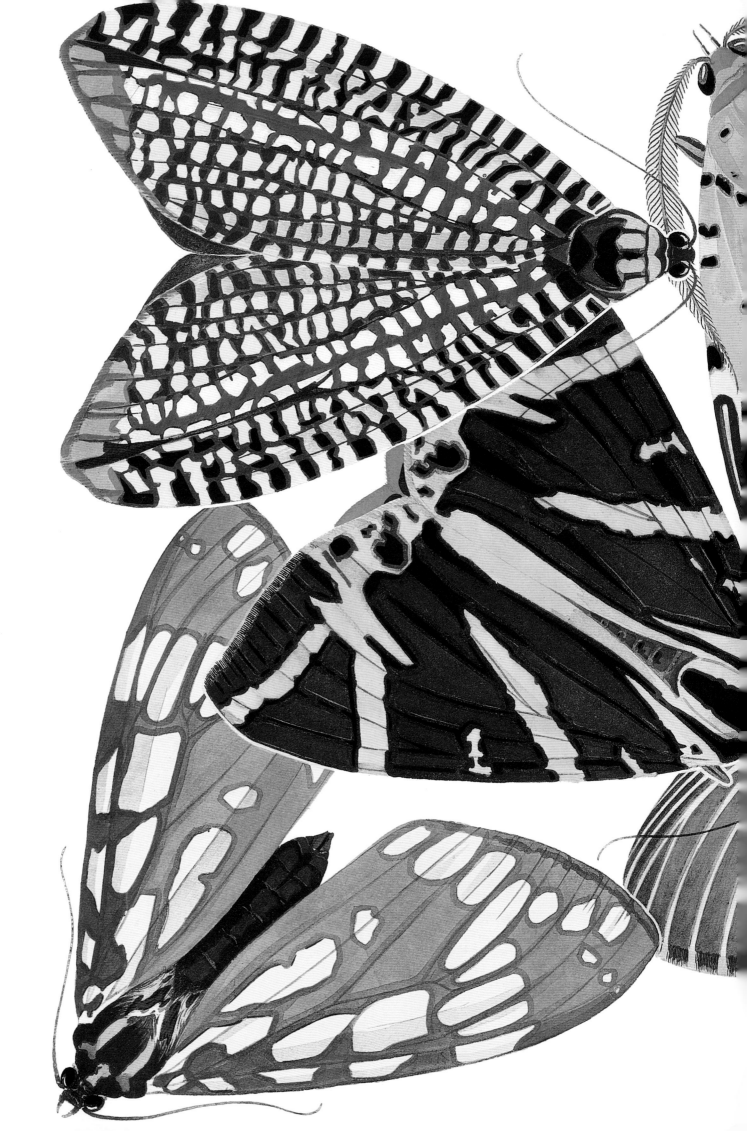

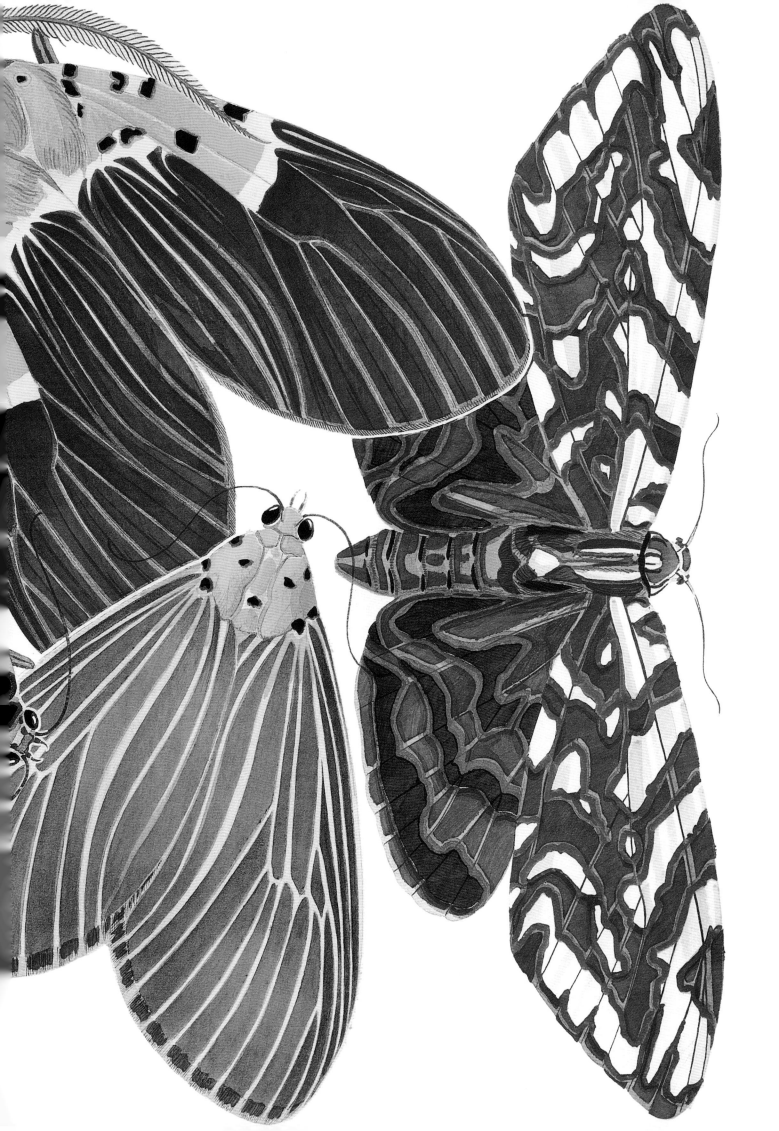

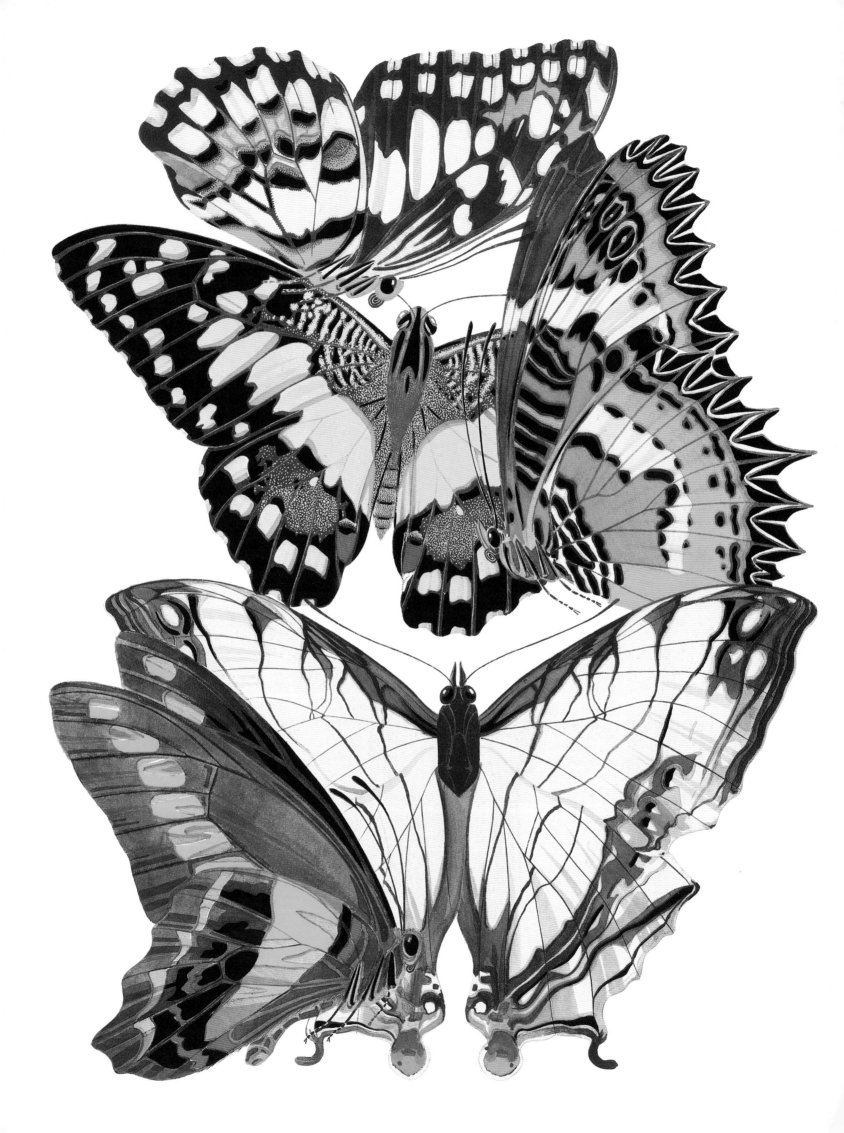

photogravure image. Though labor-intensive and therefore expensive, this was a popular technique for producing illustrations in books and periodicals, especially fashion magazines, in the early decades of the twentieth century, most notably in Paris. In itself a technology exemplifying art deco through its use of aluminum and zinc—and later celluloid and other plastics—for the stencil forms, the pochoir process allowed considerable scope for varying color treatments and graphic textures.

The identity of E. A. Seguy is a mystery to this day. His dates of birth and death—and even his full name—are not known. He is sometimes called Émile-Allain Seguy but without a cited authority. In other instances, he is linked with a French entomologist named Eugène Séguy (c. 1890–1985) who was associated with the Muséum Nationale d'Histoire Naturelle in Paris from 1919 forward. Although a connection between the two has never been definitively estab-lished, the entomologist's scientific illustrations of *diptera* (flies) suggest a possible relationship; on the other hand, he signed them "E. Seguy" rather than "E. A. Seguy," and the artist's earliest known

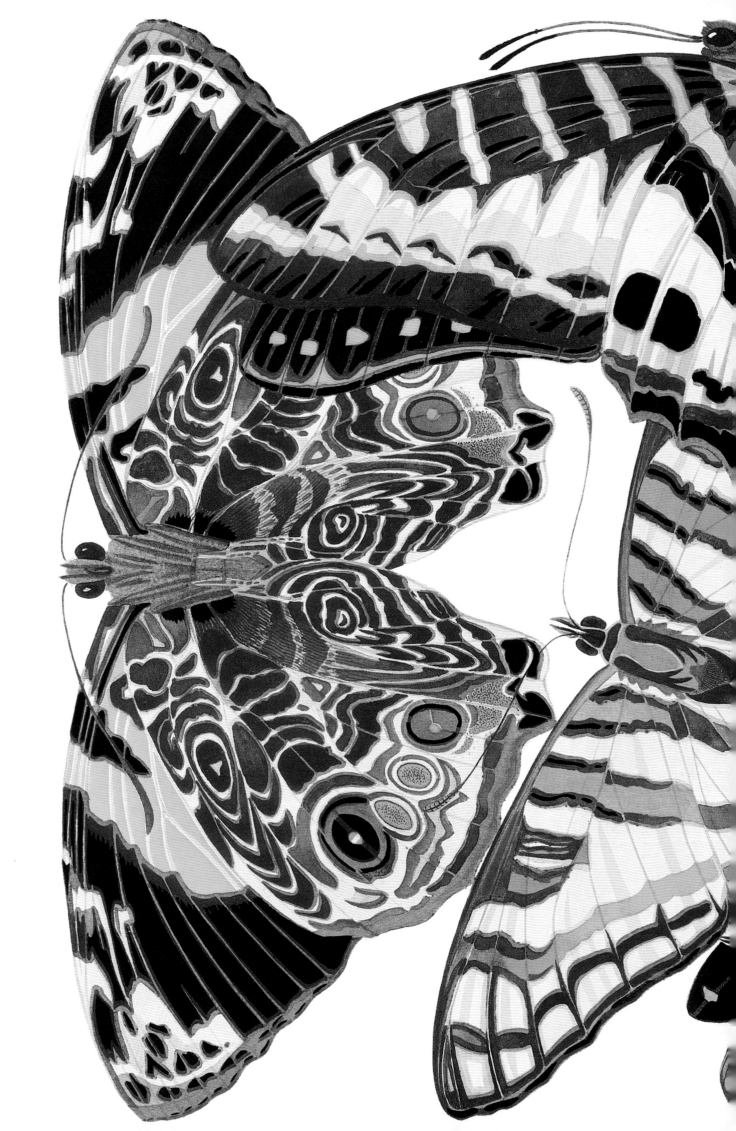

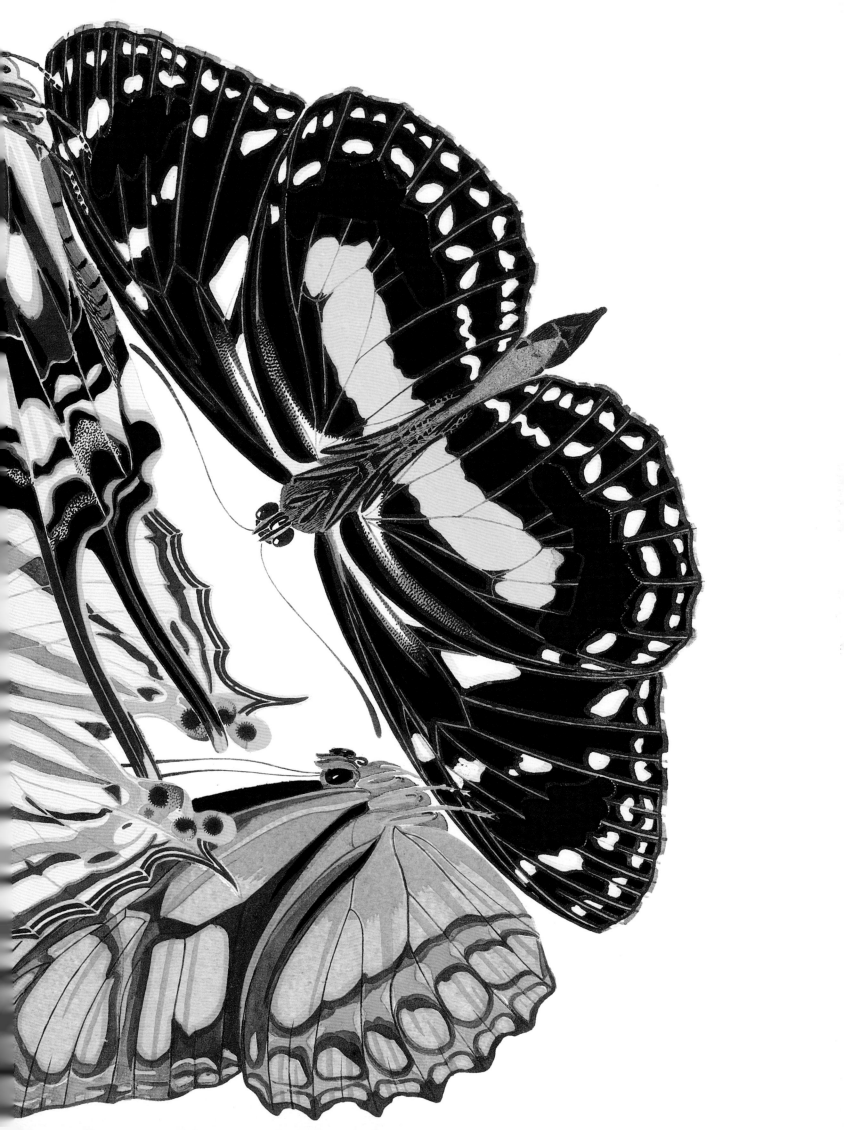

work is from 1902, when the entomologist would have been only twelve or so. Whatever the connection (father and son? brothers? cousins? or even a daughter or sister, demurely hiding her gender?), it is easy to believe that both shared a love of and an appreciation for "un monde somptueux de formes et de couleurs" (a sumptuous world of forms and colors) [*Papillons*, preface], which we can now experience with them in these prints.

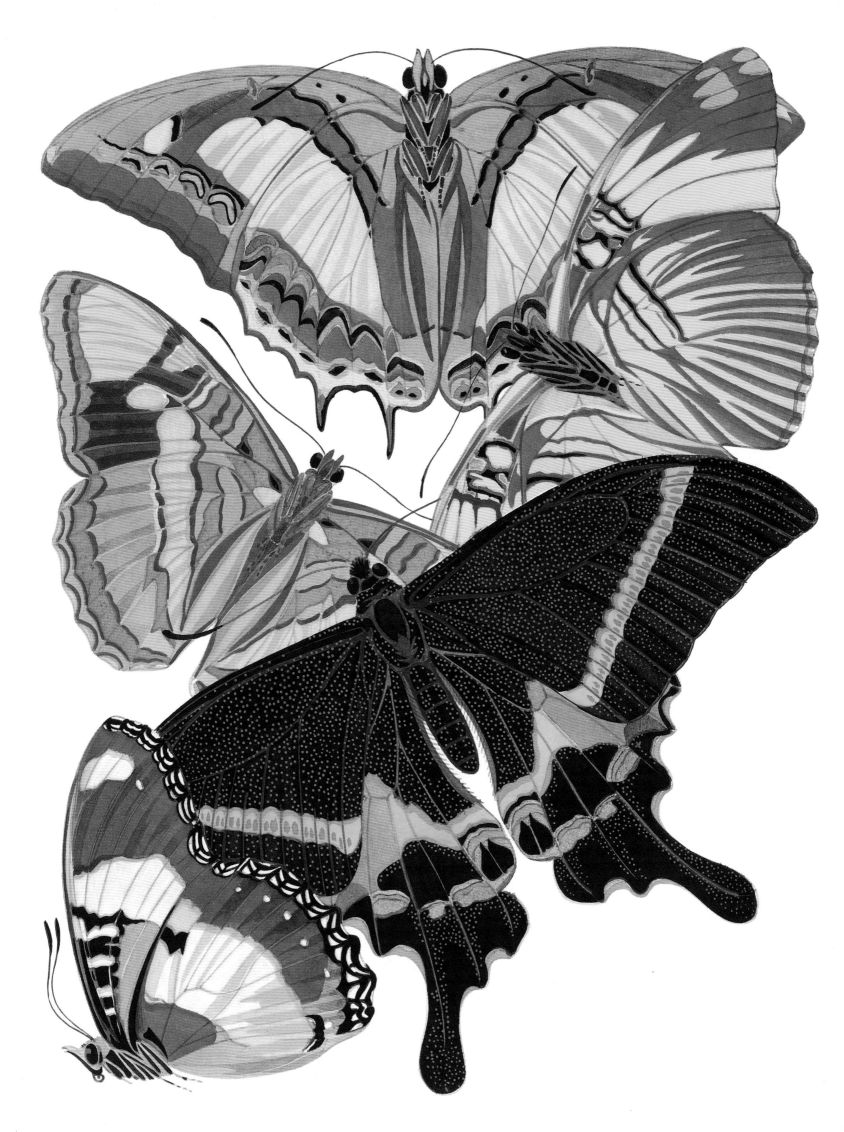

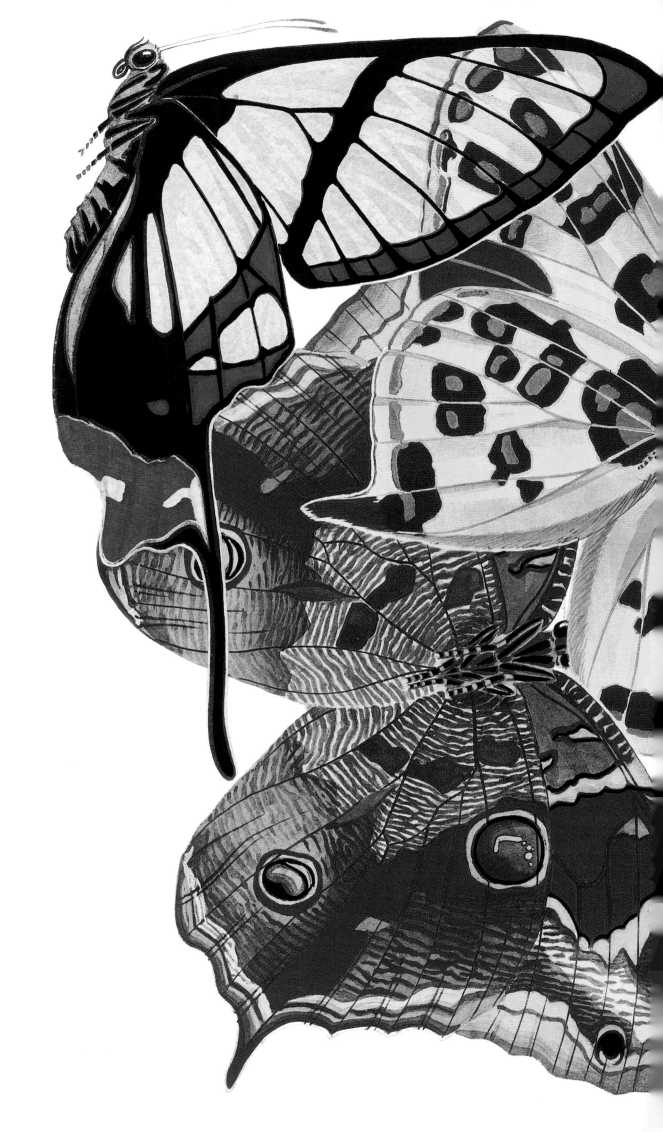

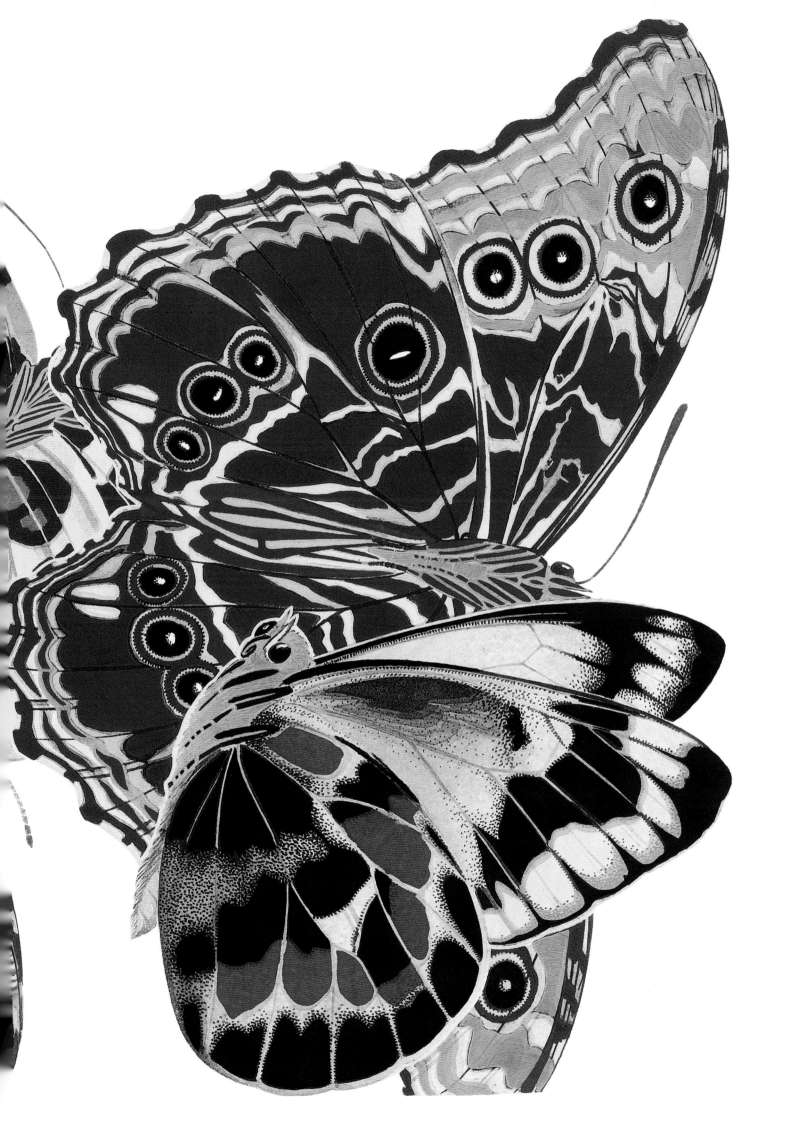

66 The butterfly is a flying flower,
The flower a tethered butterfly. 99
PONCE DENIS ÉCOUCHARD LEBRUN

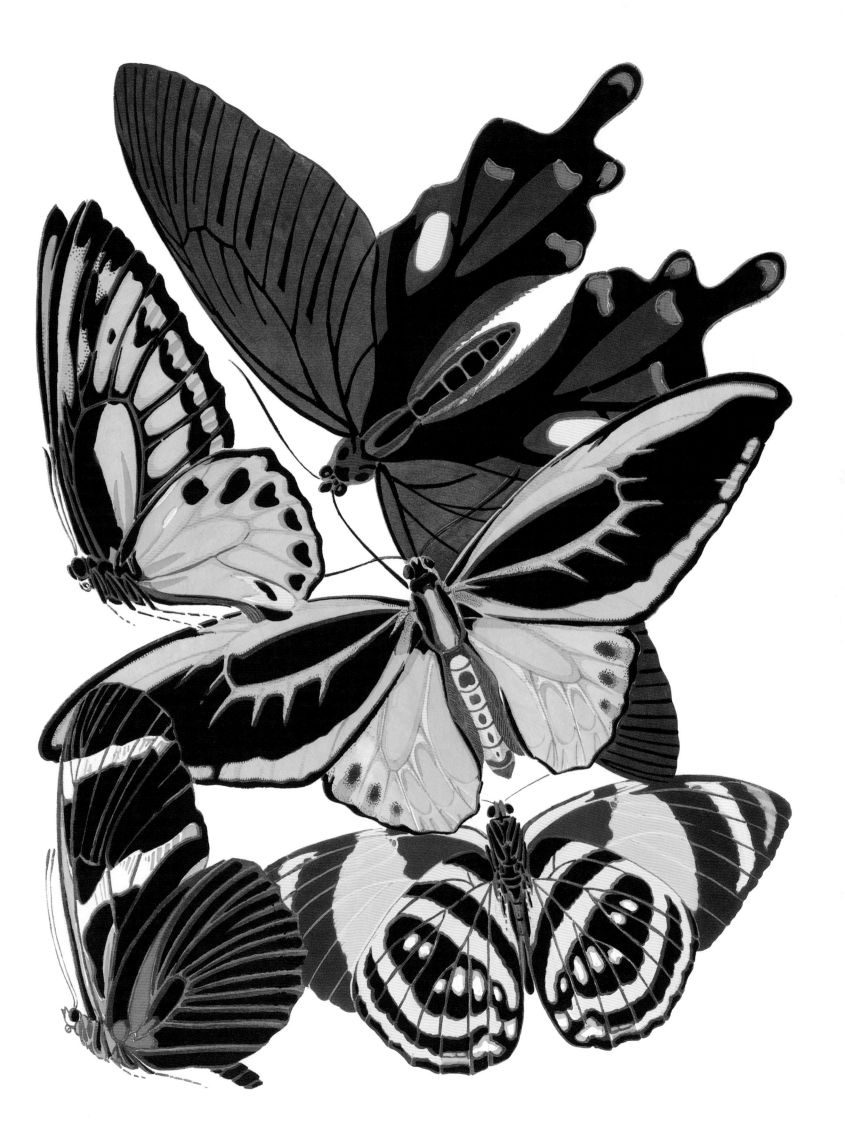

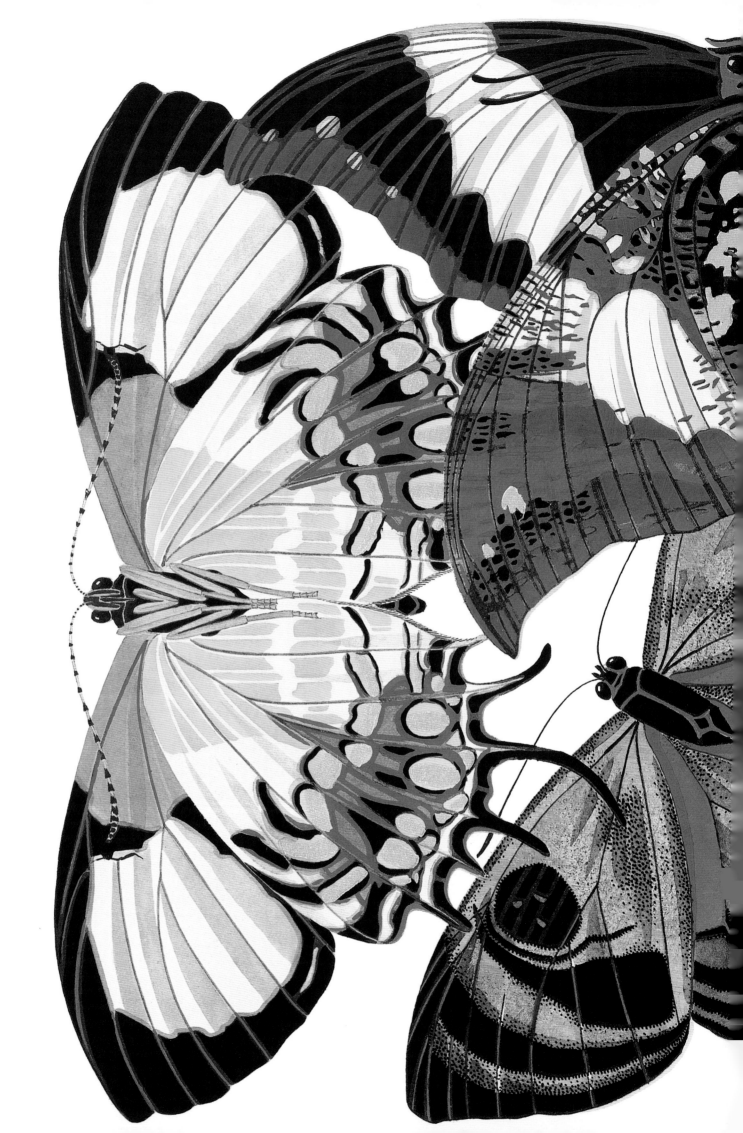

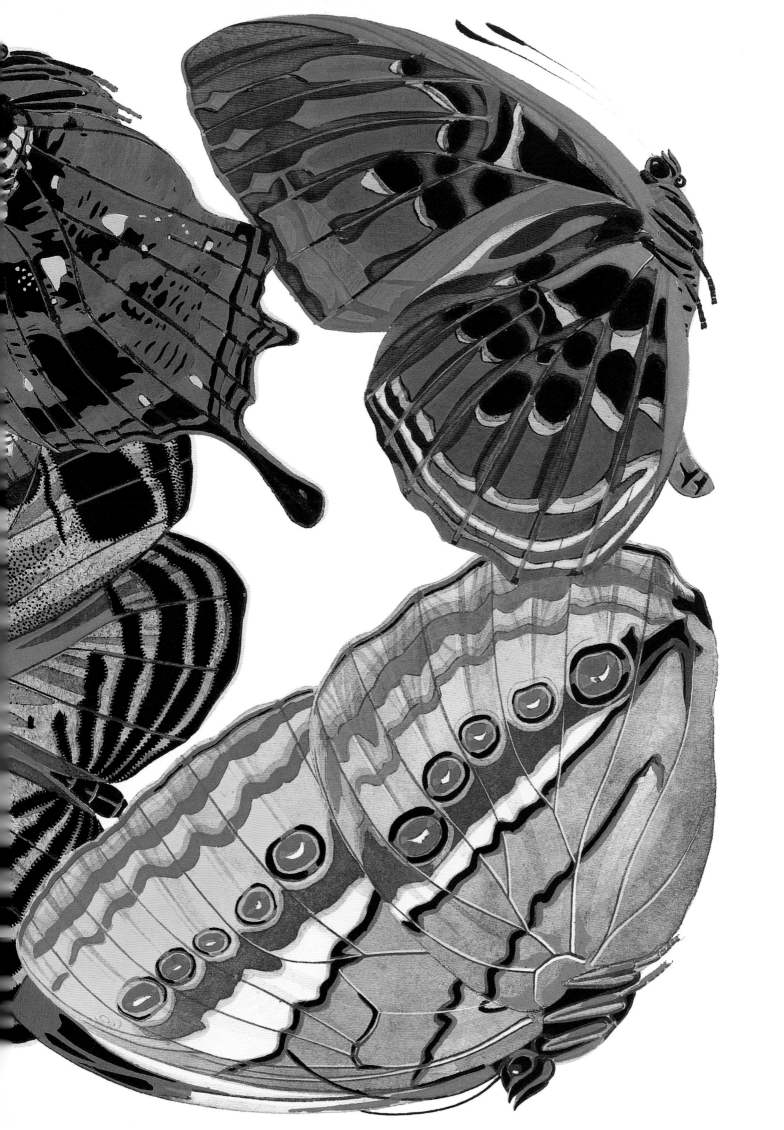

"This was your butterfly, you see—
His fine wings made him vain:
The caterpillars crawl, but he
Passed them in rich disdain.—
My pretty boy says, 'Let him be
Only a worm again!'"

SARAH M. B. PIATT, *AFTER WINGS*

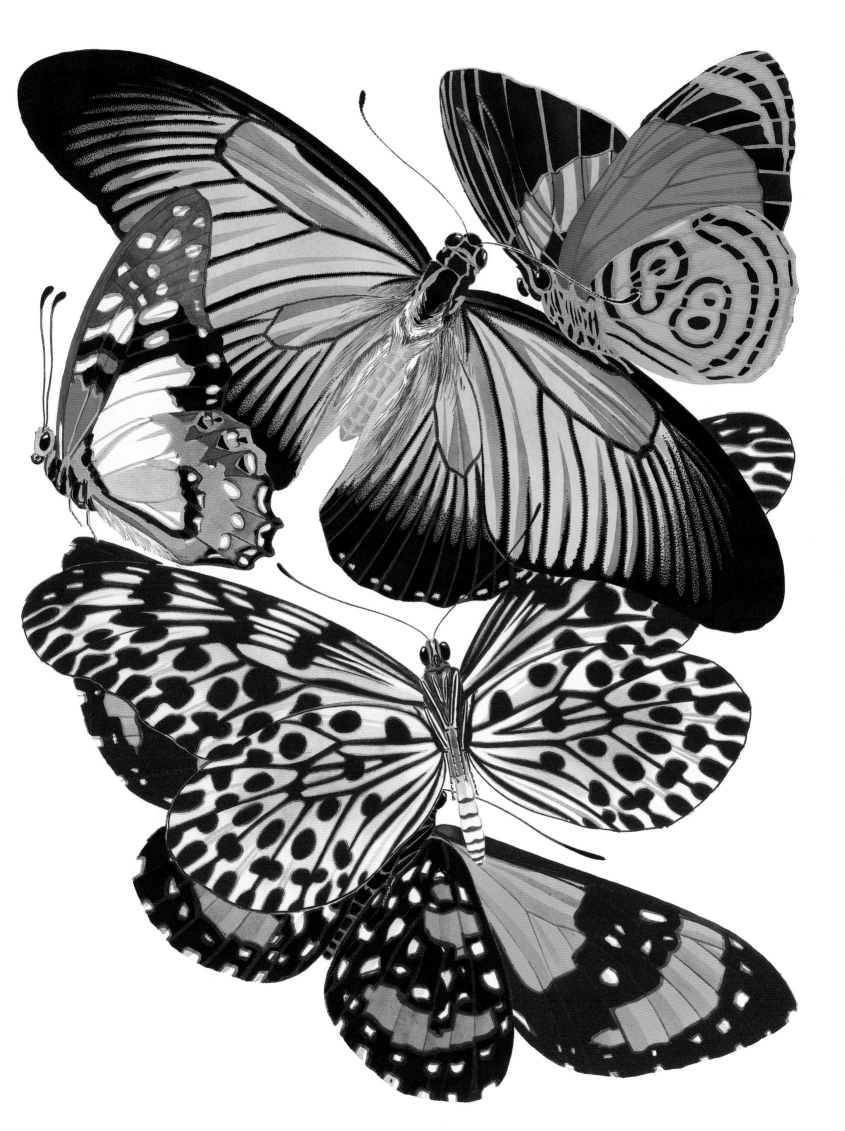

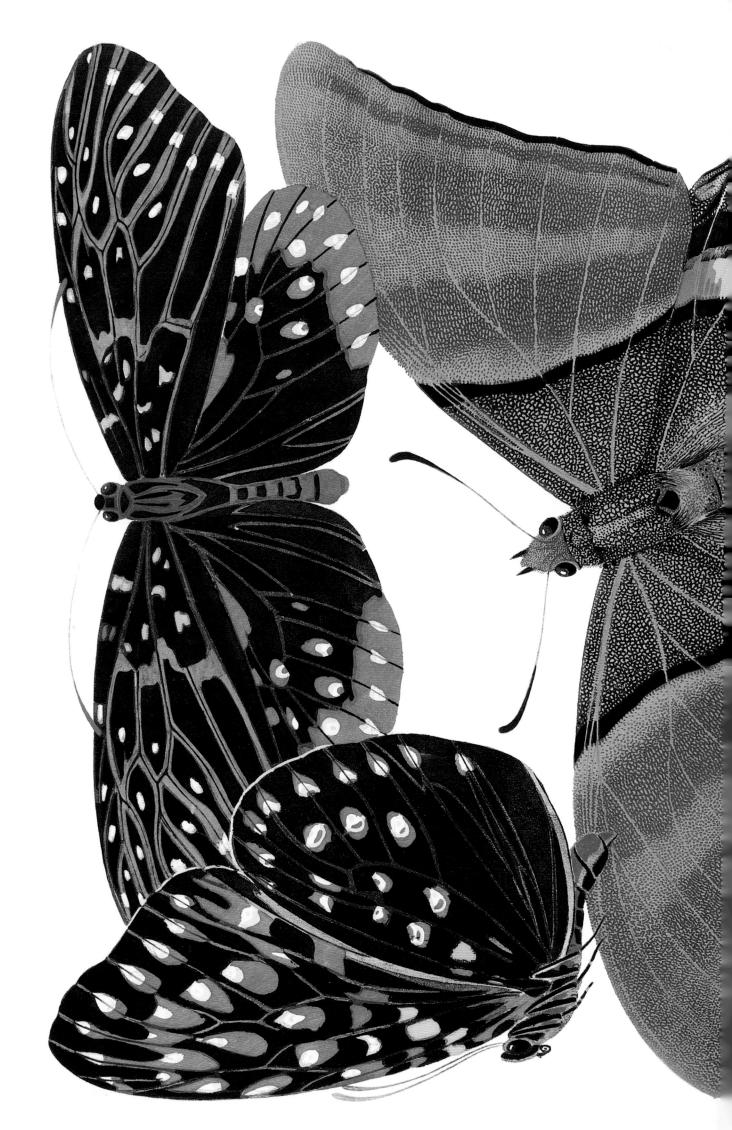

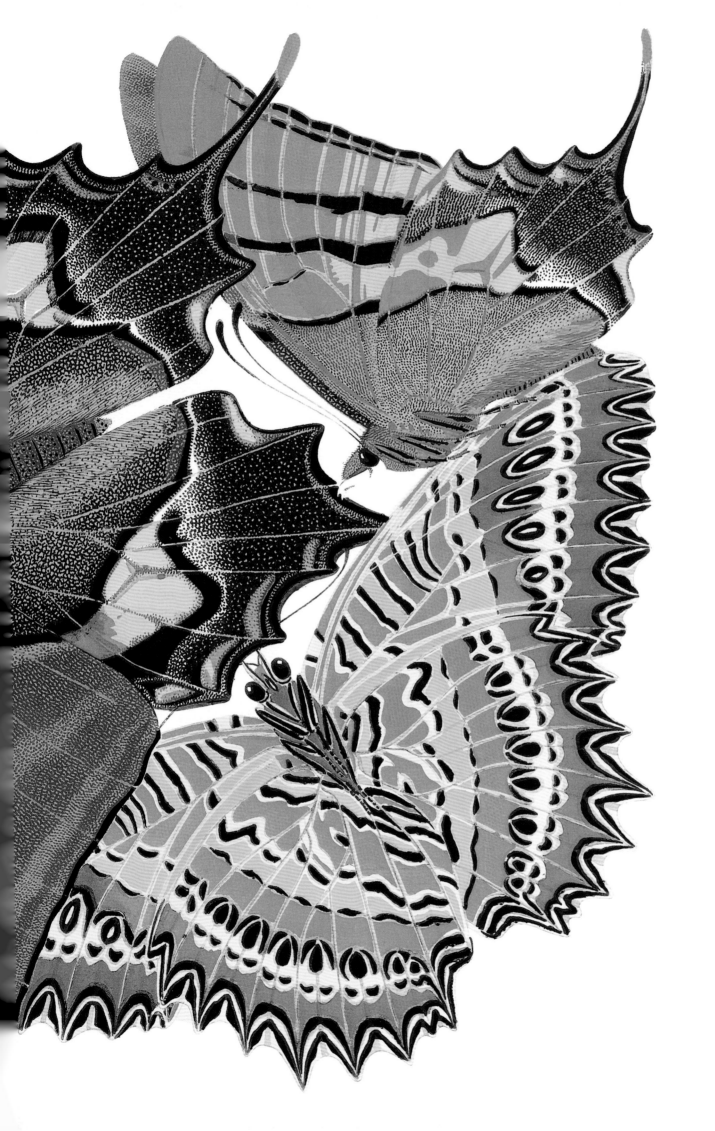

66 I'd be a butterfly born in a bower,
Where roses and lilies and violets meet. 99

THOMAS HAYNES BAYLY

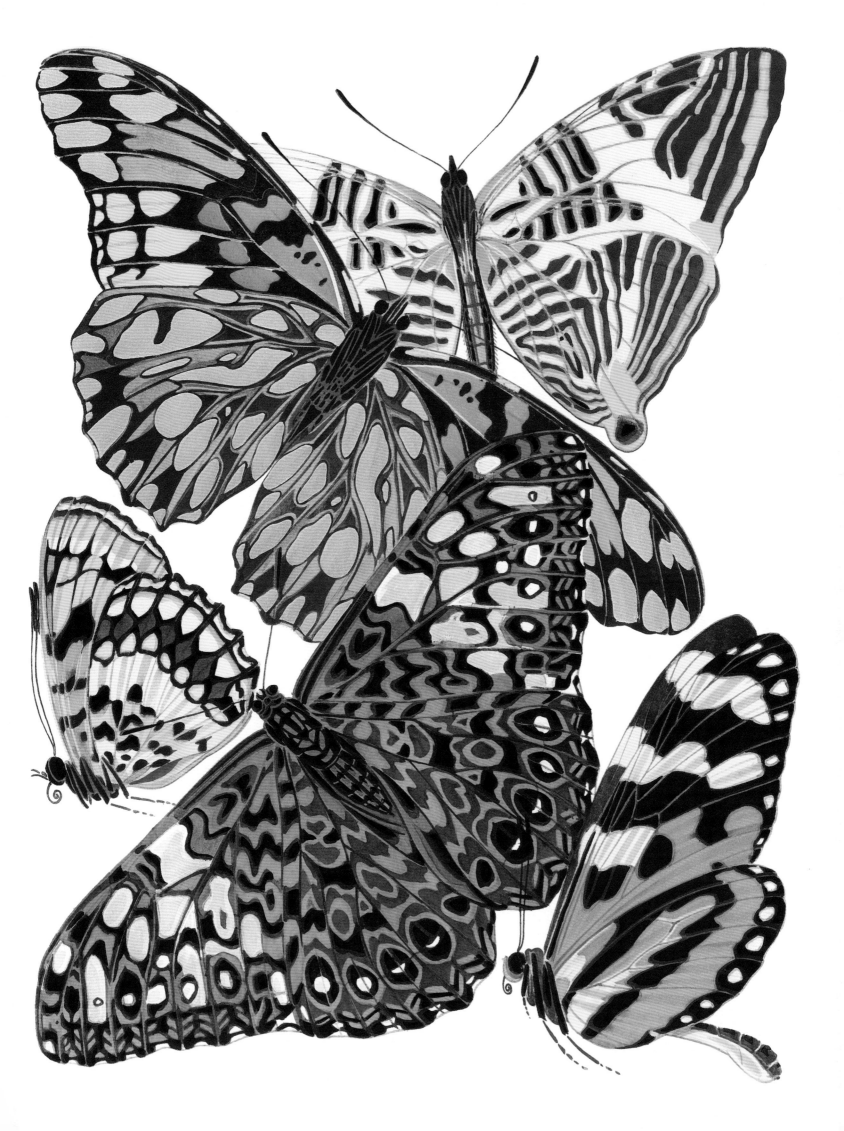

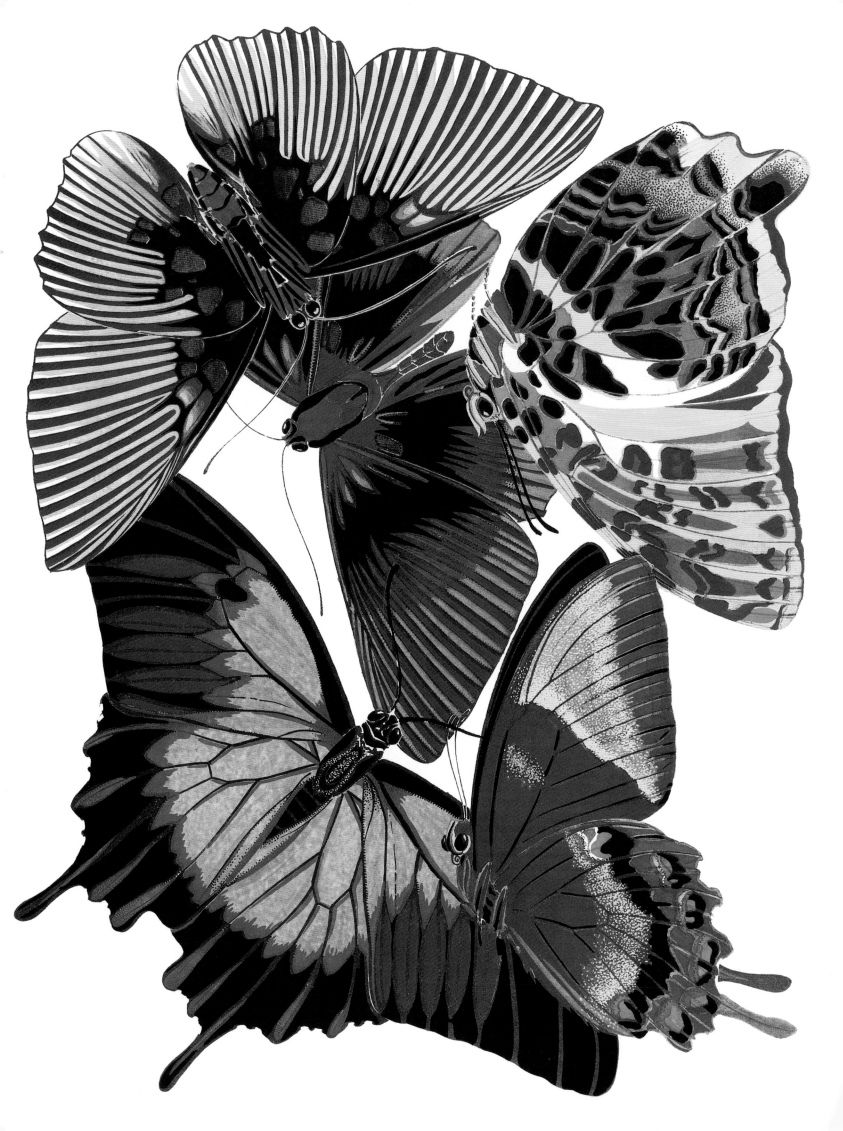

"Thou spark of life that wavest wings of gold,
Thou sonless wanderer mid the songful birds,
With Nature's secrets in thy tints unrolled …
Thou winged blossom, liberated thing, …
But thou art Nature's freeman."

T. W. HIGGINSON, *ODE TO A BUTTERFLY*

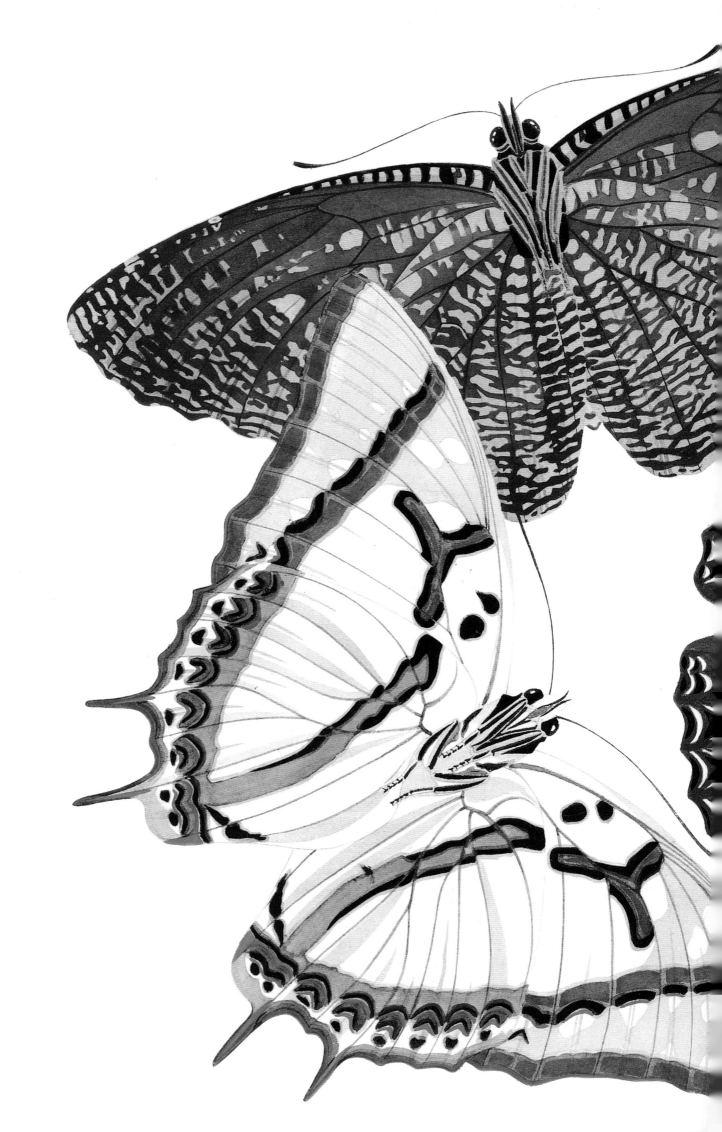

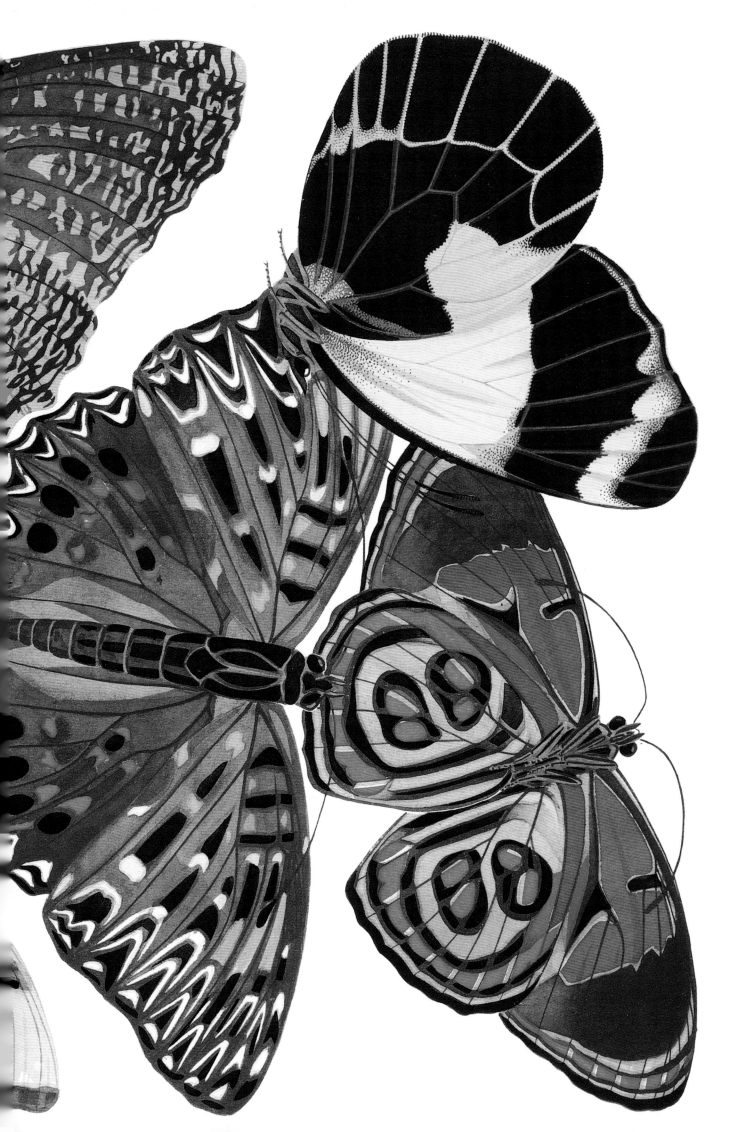

"When April winds
Grew soft, the maple burst into a flush
Of scarlet flowers. The tulip tree, high up,
Opened, in airs of June, her multiple
Of golden chalices to humming birds
And silken-wing'd insects of the sky."

WILLIAM CULLEN BRYANT

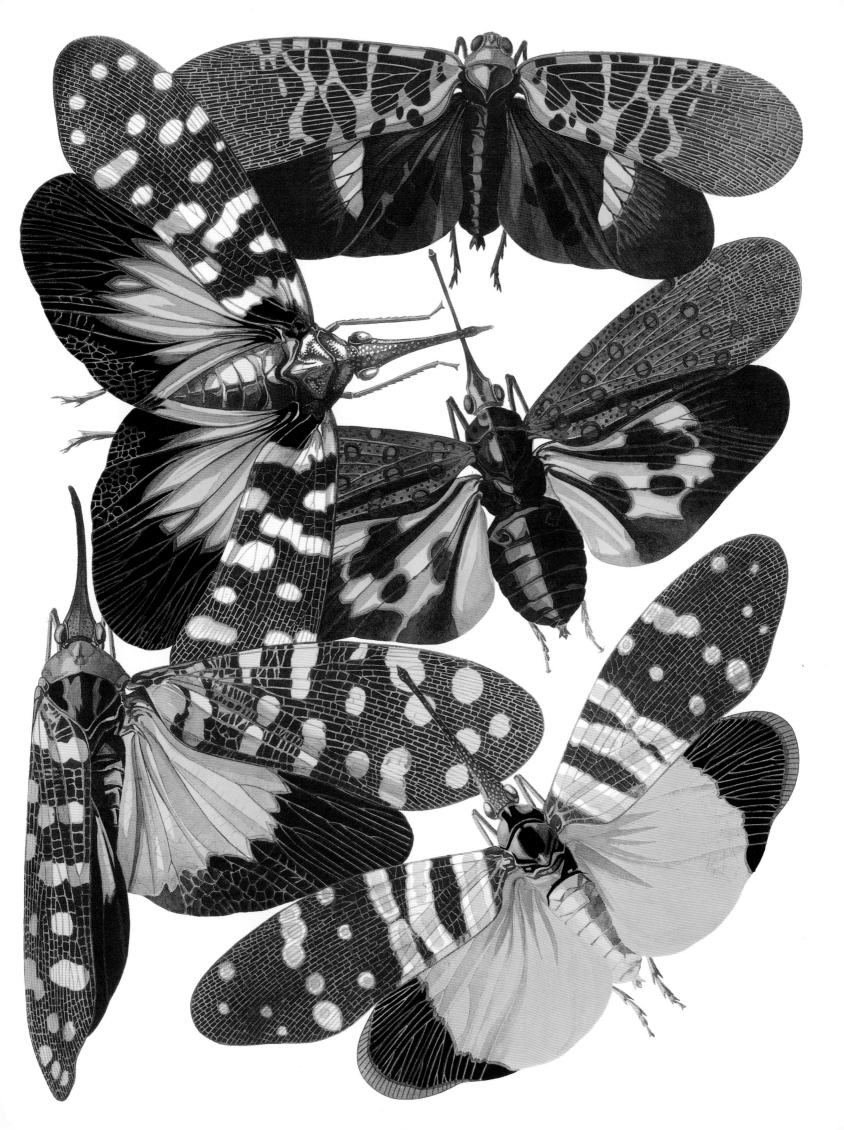

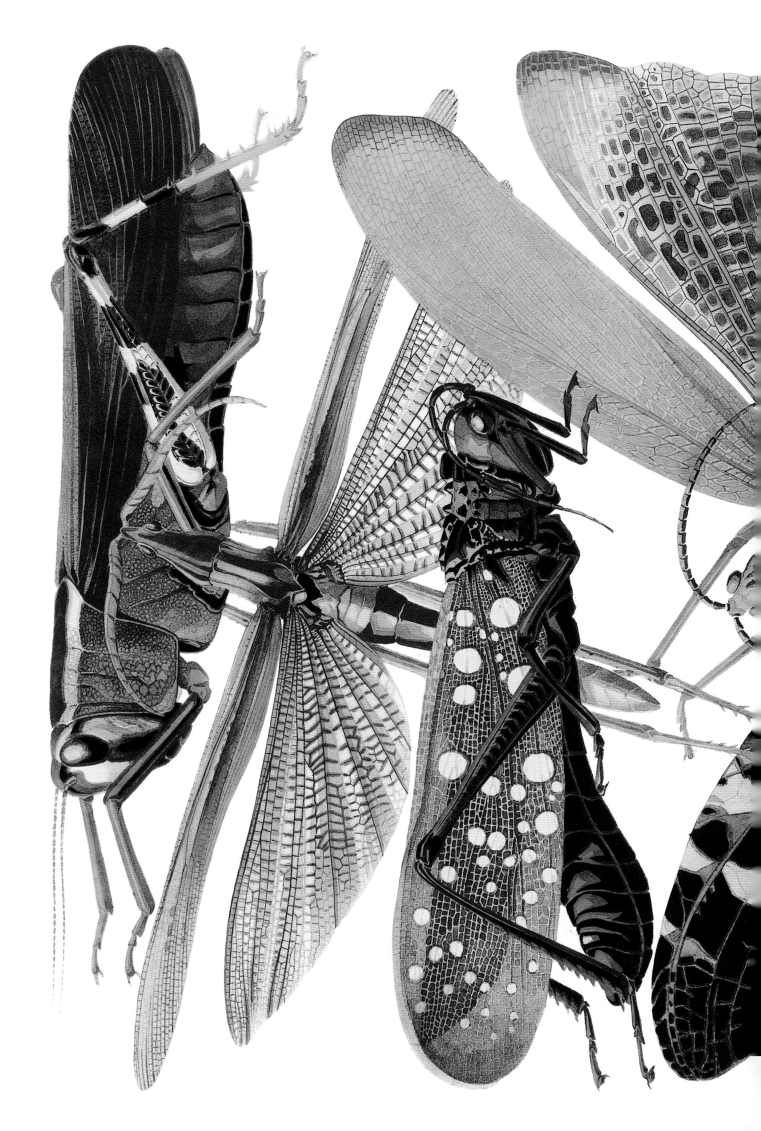

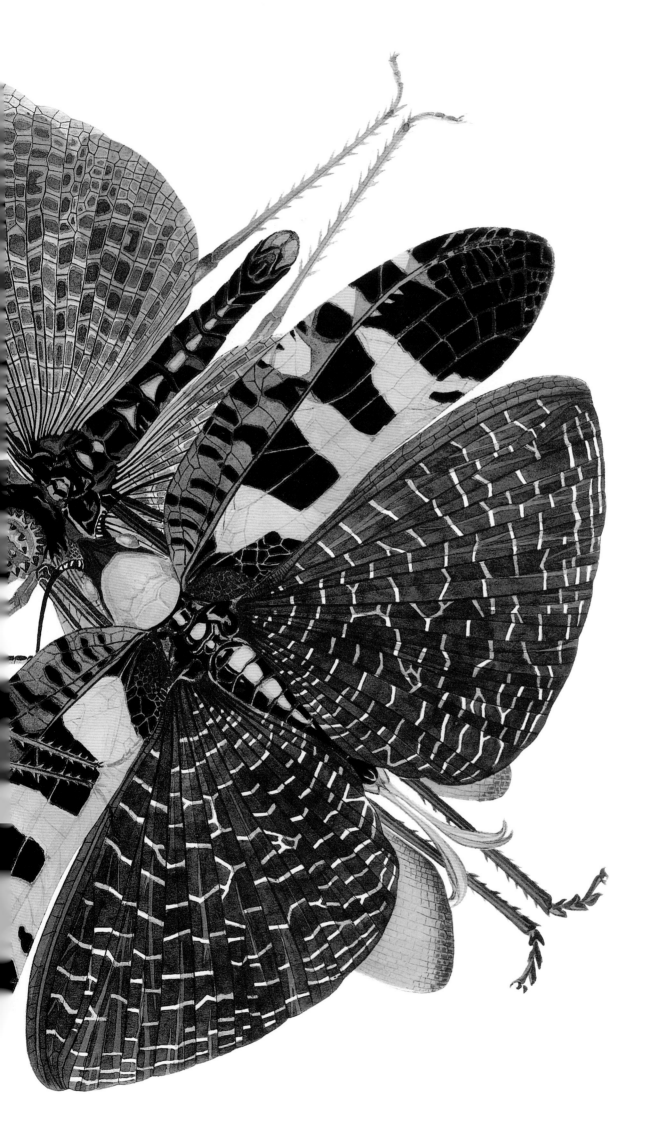

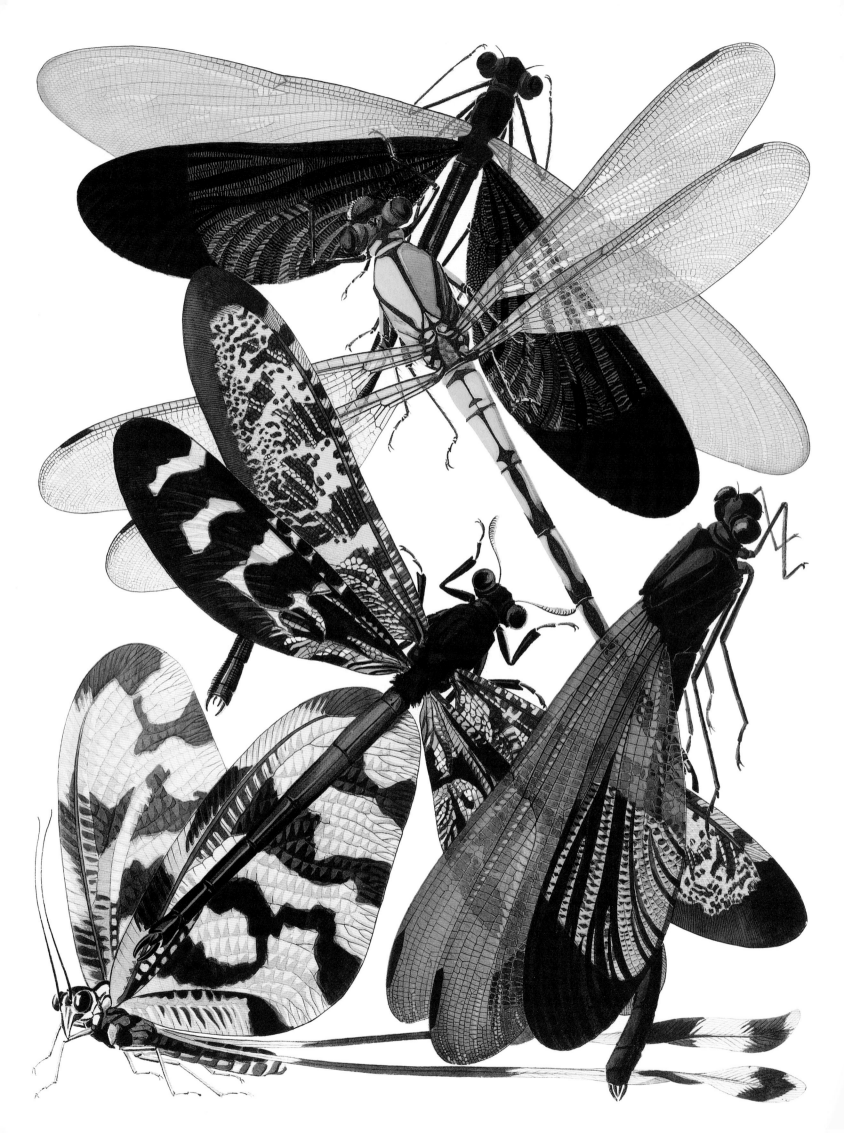

66 Clouds of insects danced and buzzed in the golden autumn light, and the air was full of the piping of the song-birds. Long, glinting dragonflies shot across the path, or hung tremulous with gauzy wings and gleaming bodies. 99

SIR ARTHUR CONAN DOYLE

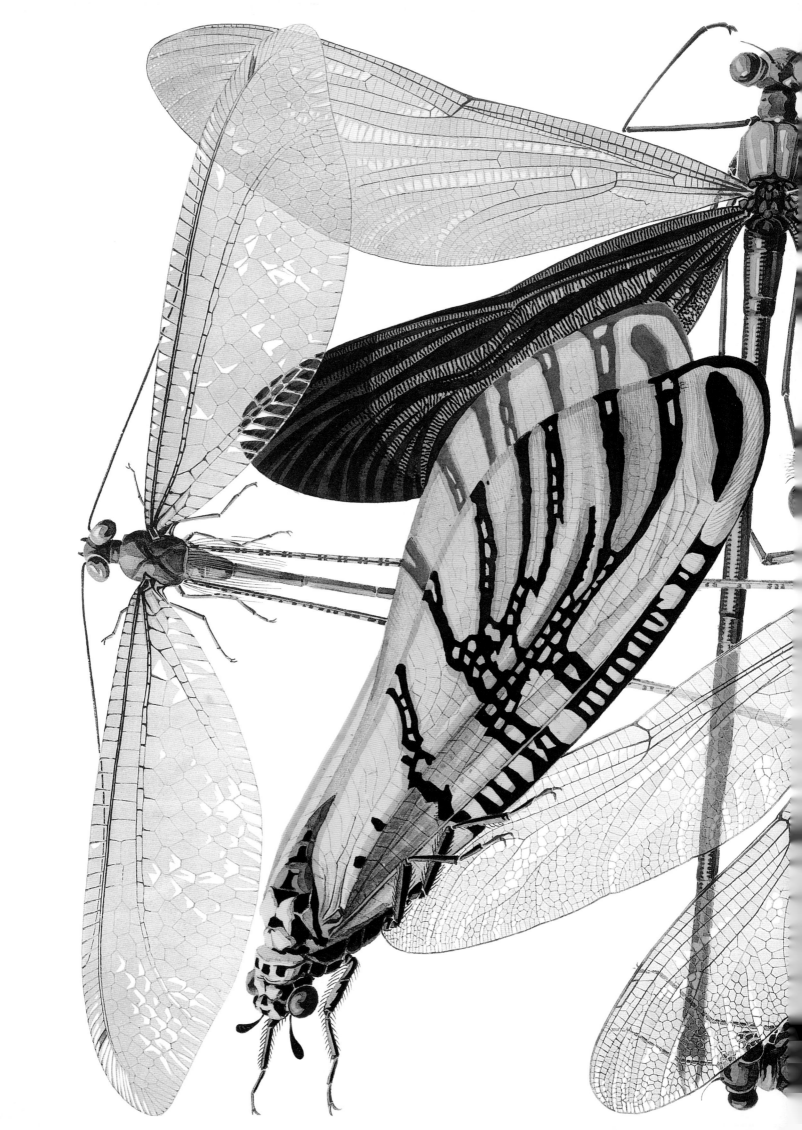

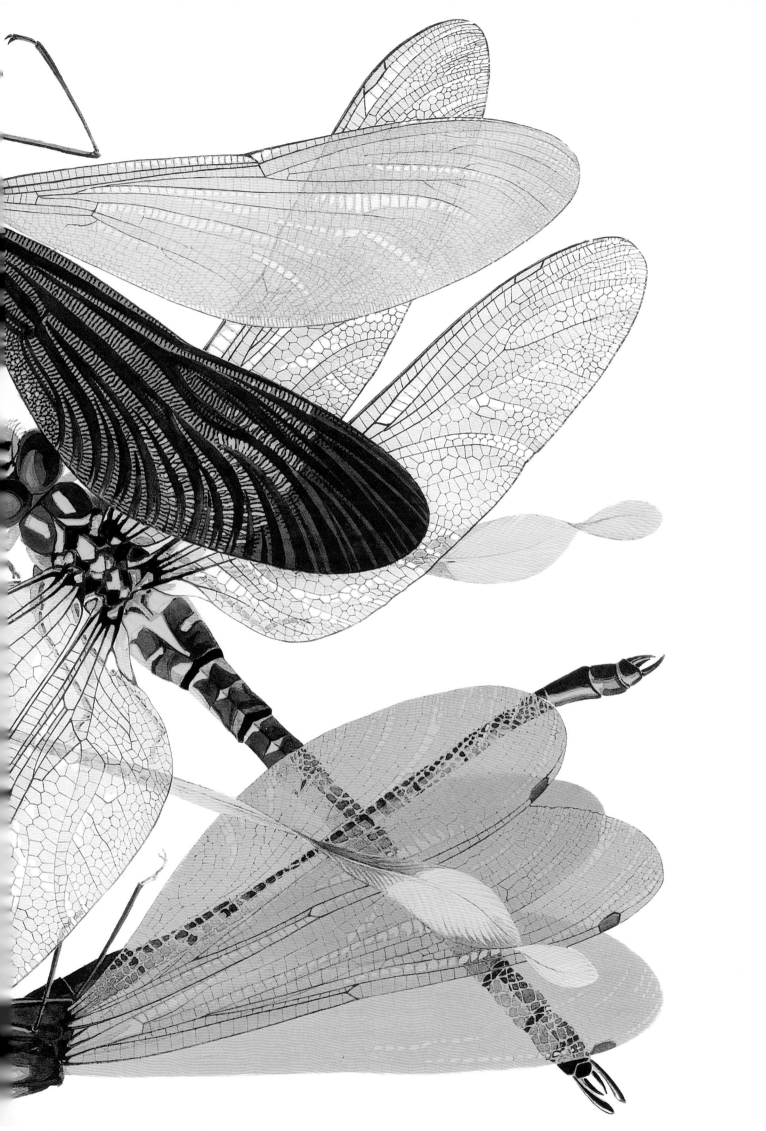

"I've watched you now a full half-hour;
Self-poised upon that yellow flower
And, little Butterfly! Indeed
I know not if you sleep or feed.
How motionless!—not frozen seas
More motionless! and then
What joy awaits you, when the breeze
Hath found you out among the trees,
And calls you forth again!"

WILLIAM WORDSWORTH

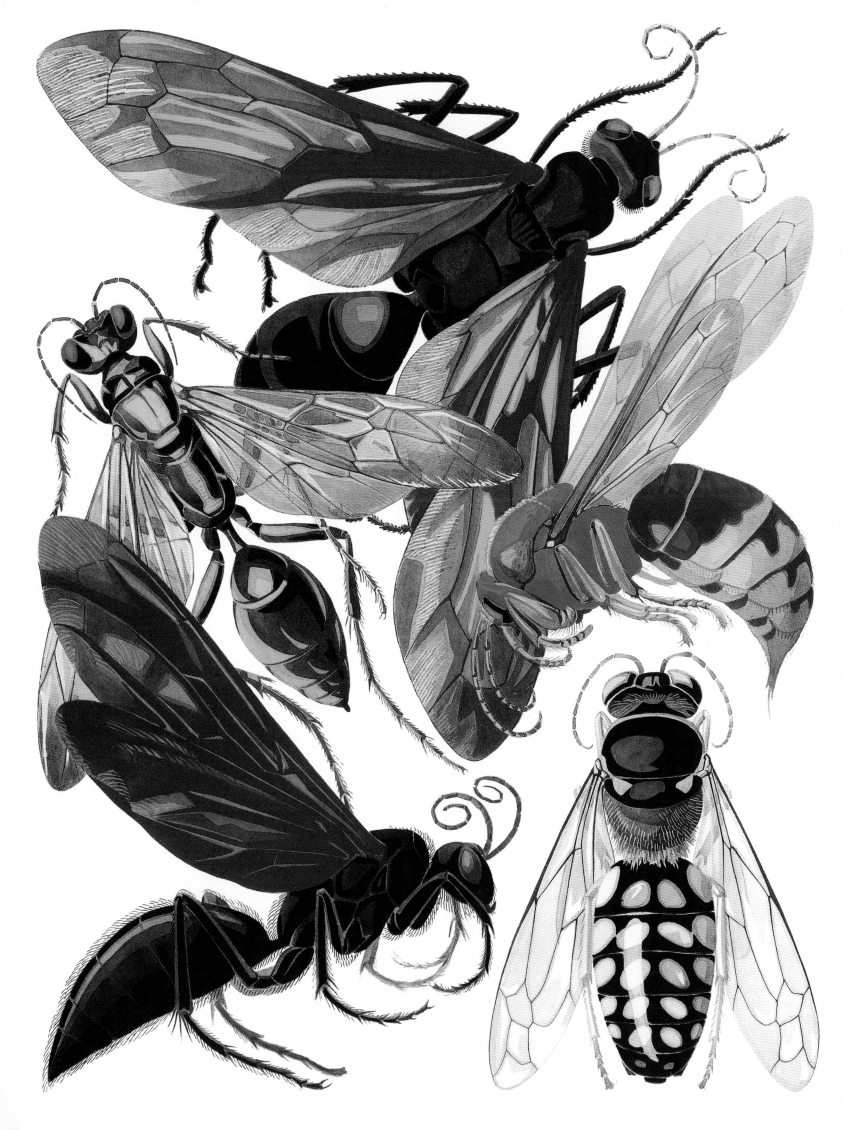

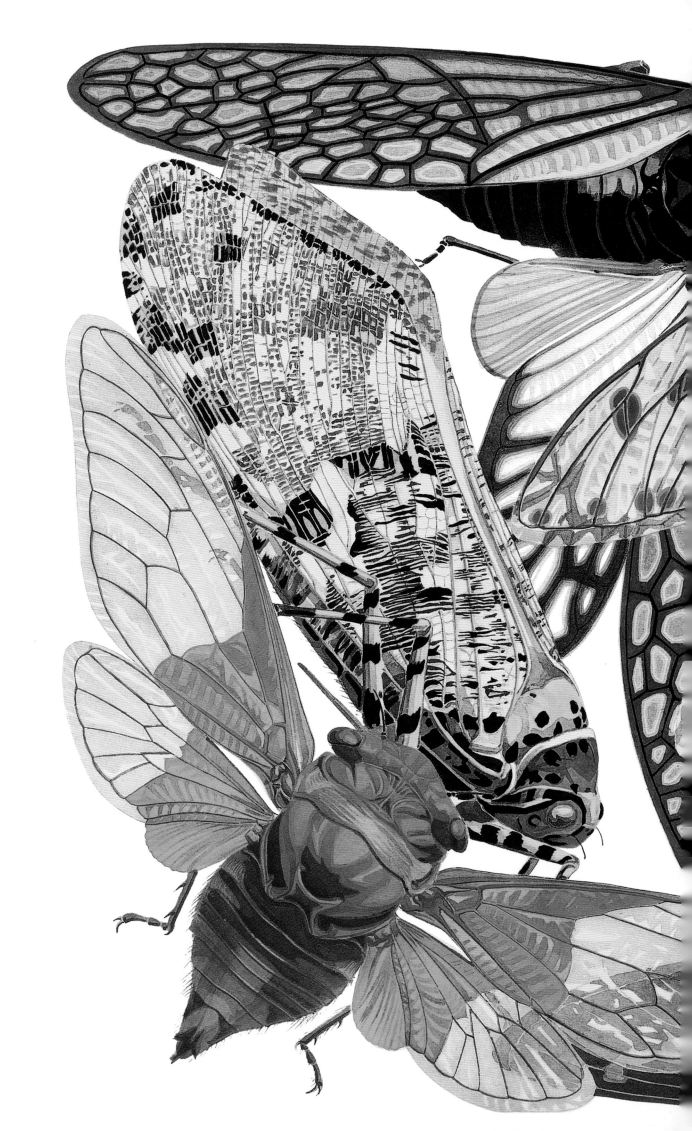

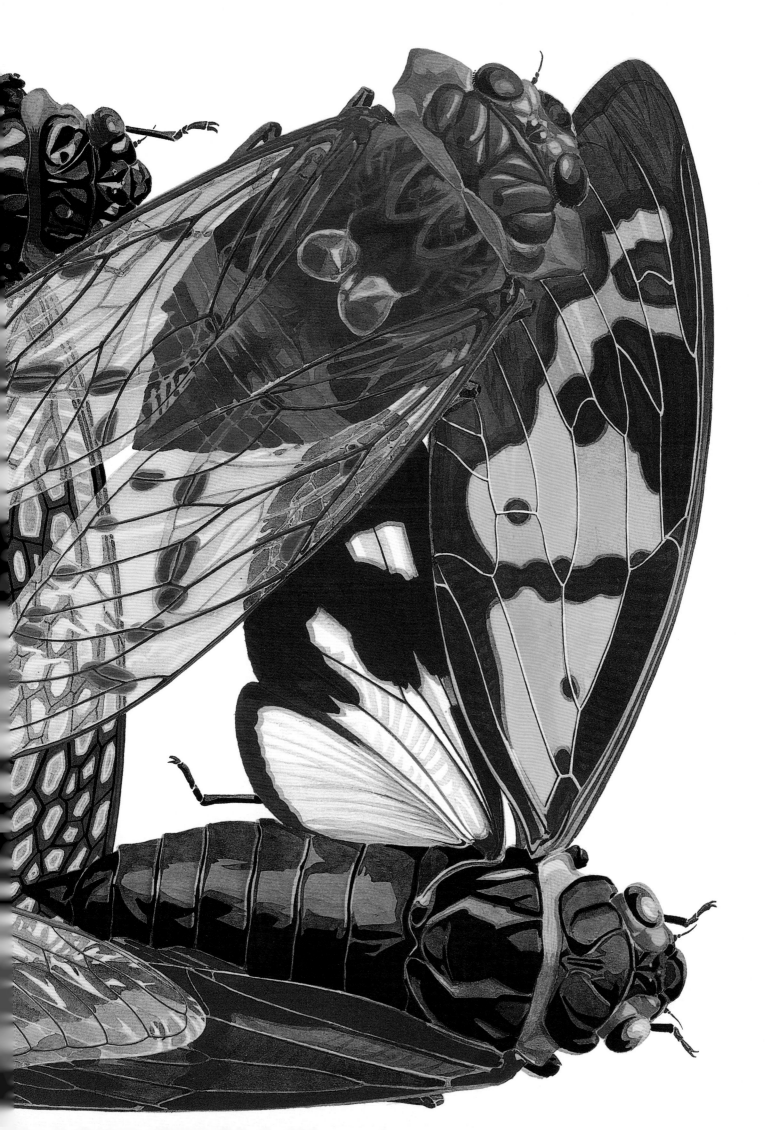

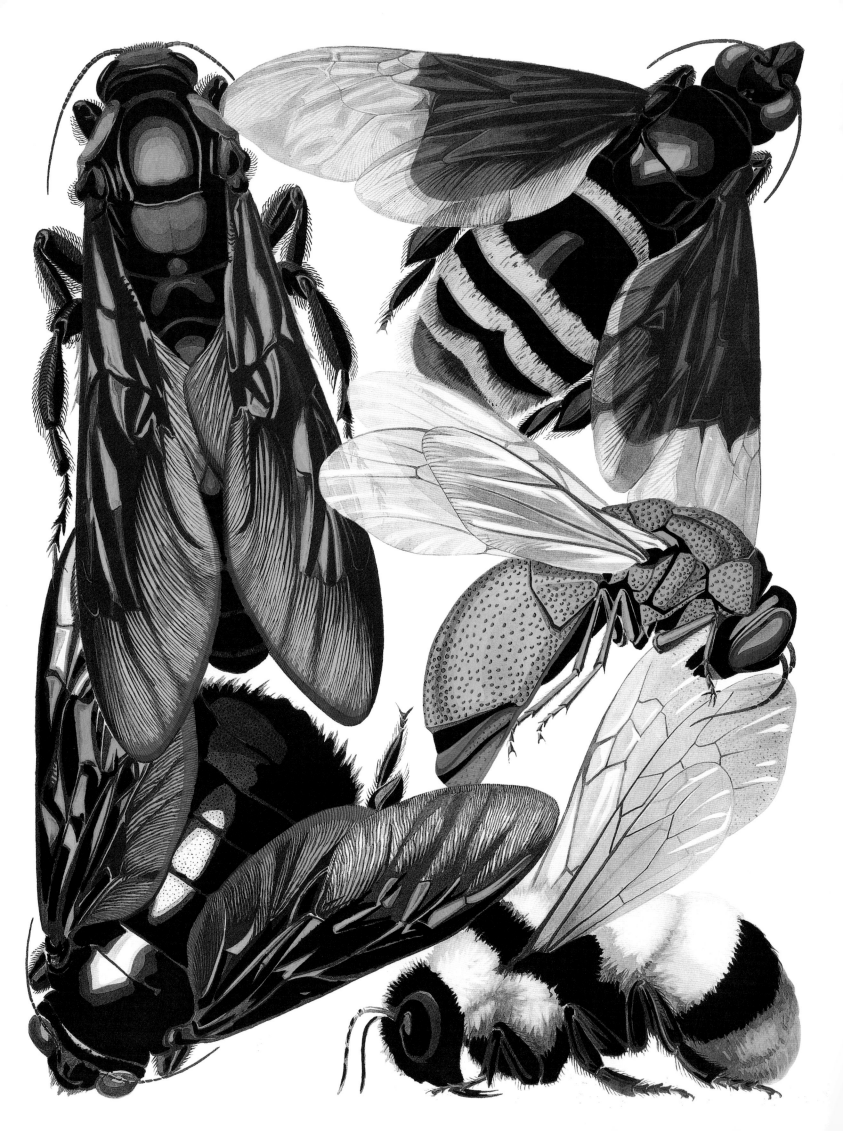

"The butterfly, an idle thing,
Nor honey makes, nor yet can sing…
And though from flower to flower I rove,
My stock of wisdom I'll improve,
Nor be a butterfly."

ADELAIDE O'KEEFE

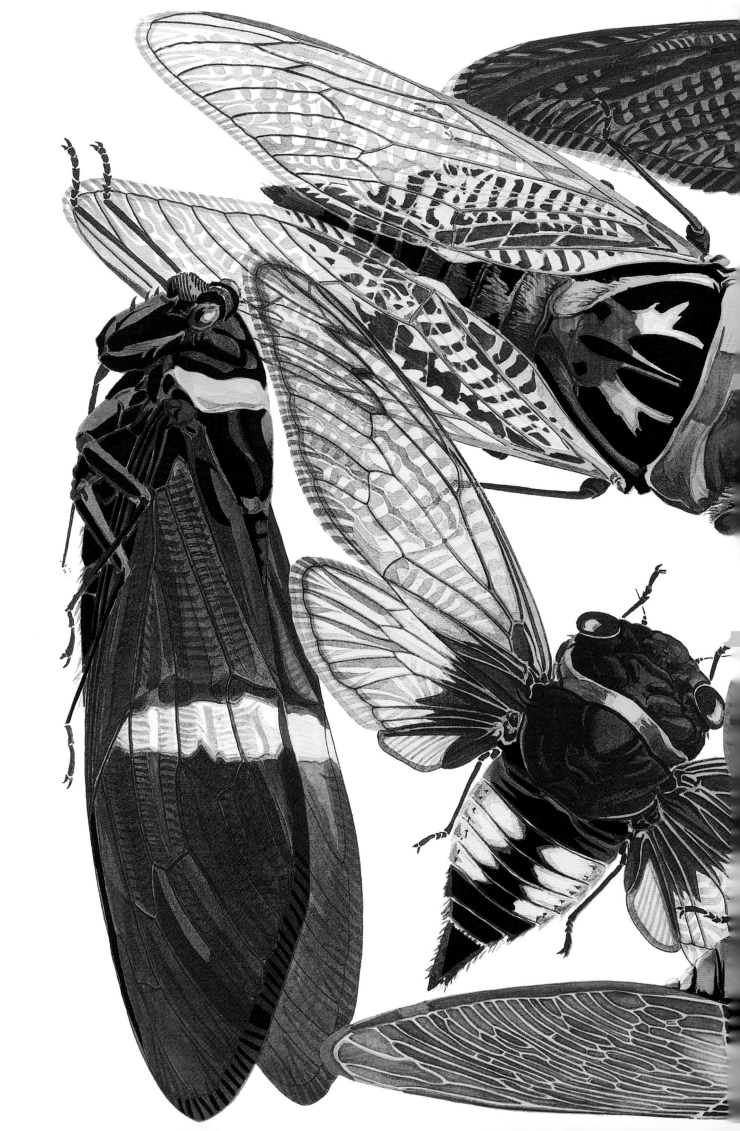

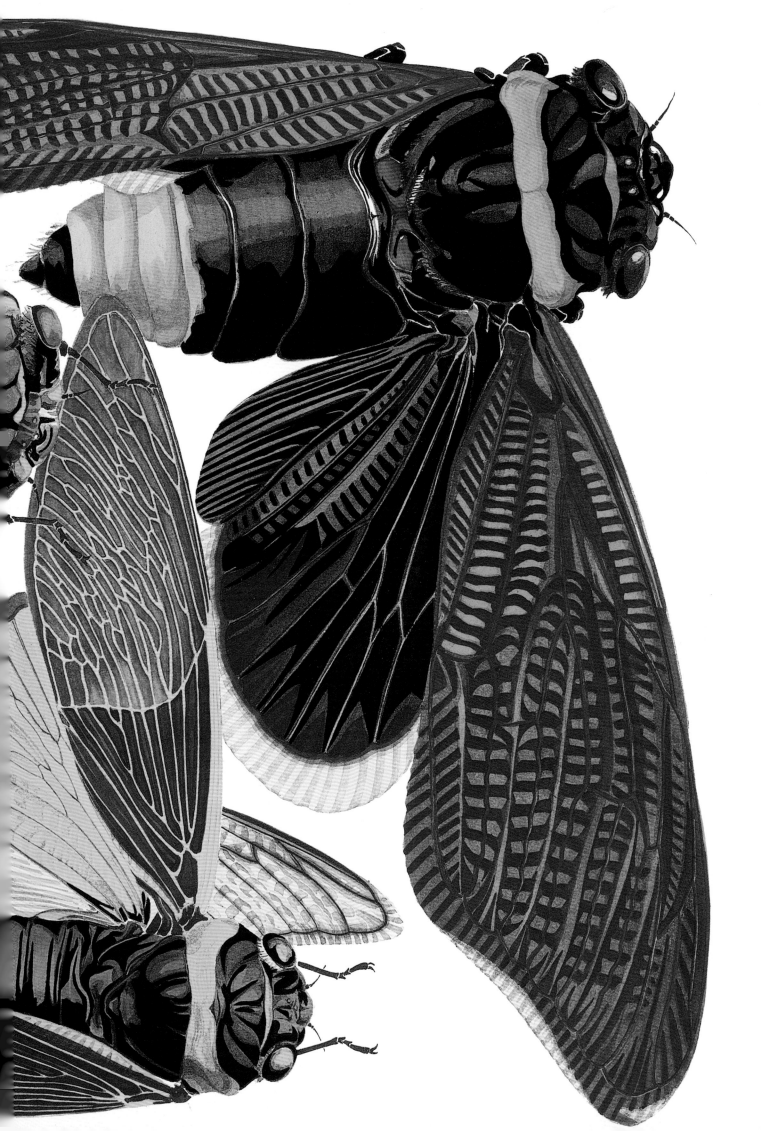

"When all the birds are faint with the hot sun,

And hide in cooling trees, a voice will run

From hedge to hedge about the new-mown mead;

That is the grasshopper's—he takes the lead

In summer luxury—he has never done

With his delights; for when tired out with Fun,

He rests at ease beneath some pleasant weed."

JOHN KEATS, *THE GRASSHOPPER AND CRICKET*

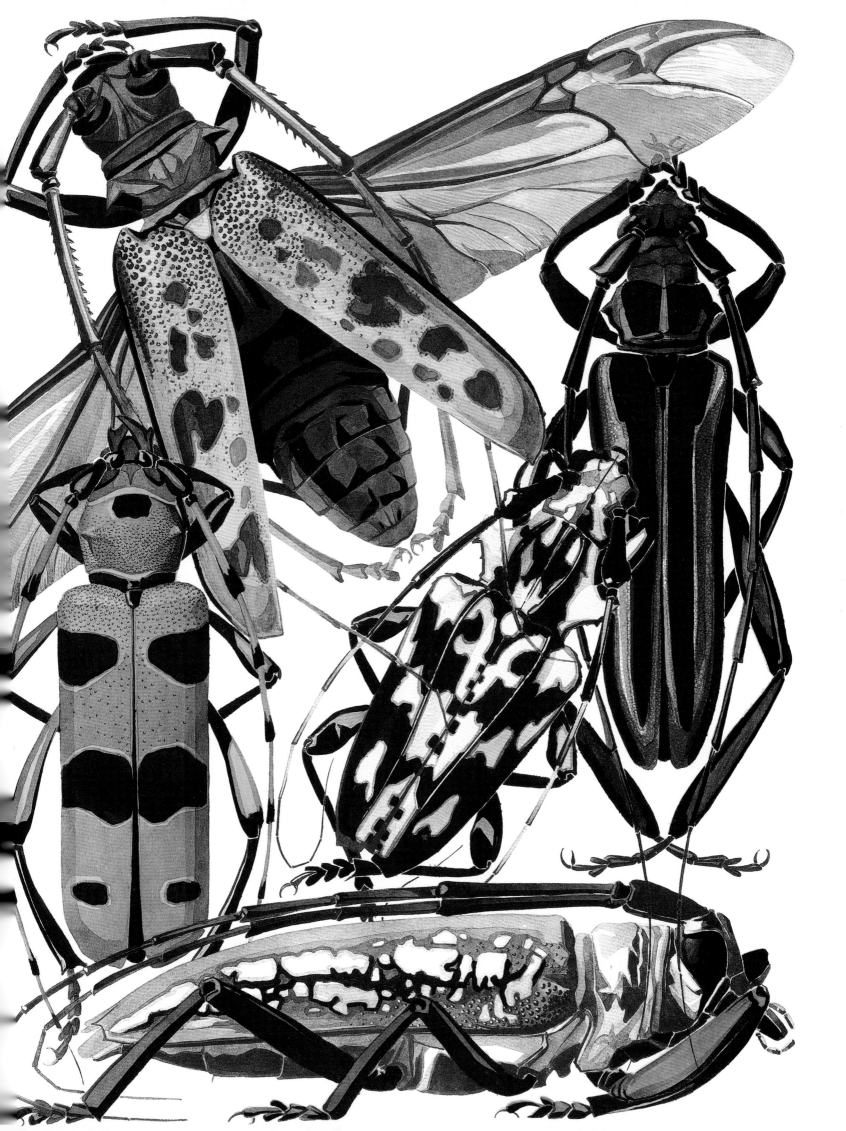

> **"The insect fable is the certain promise."**
> DYLAN THOMAS, *TO-DAY, THIS INSECT*

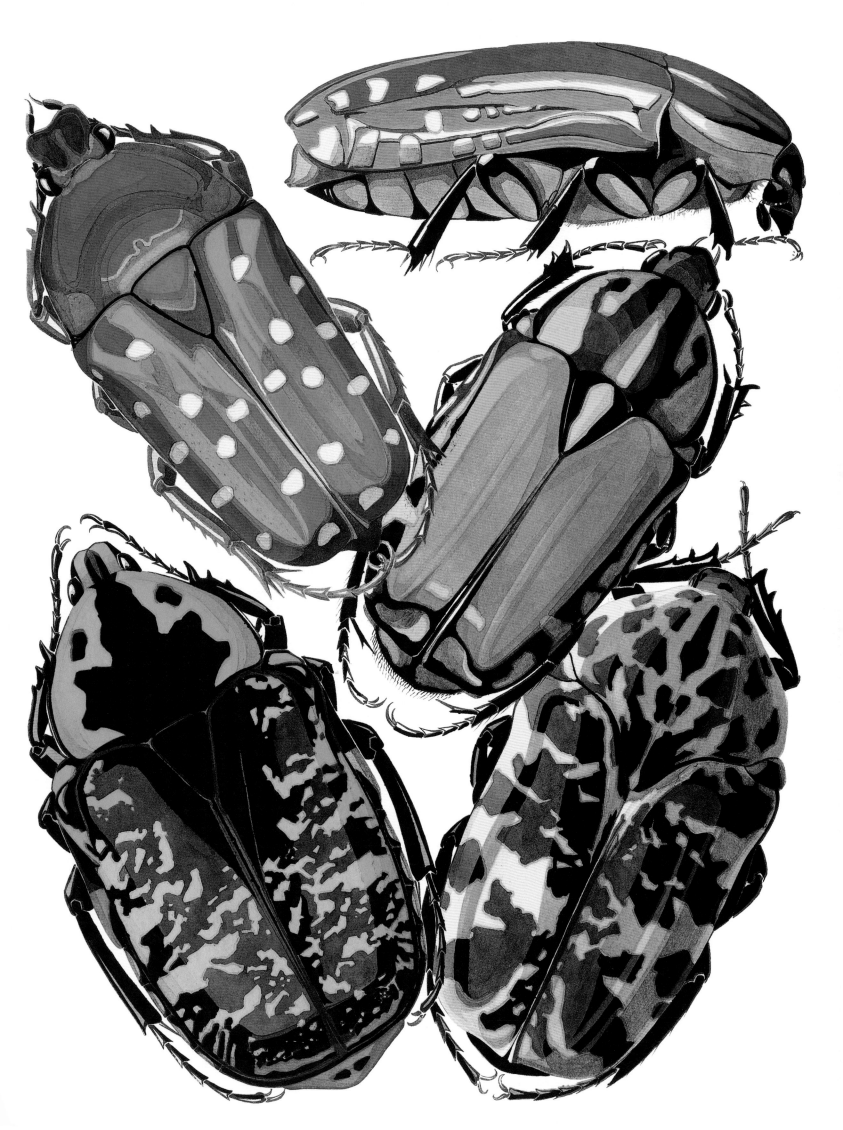

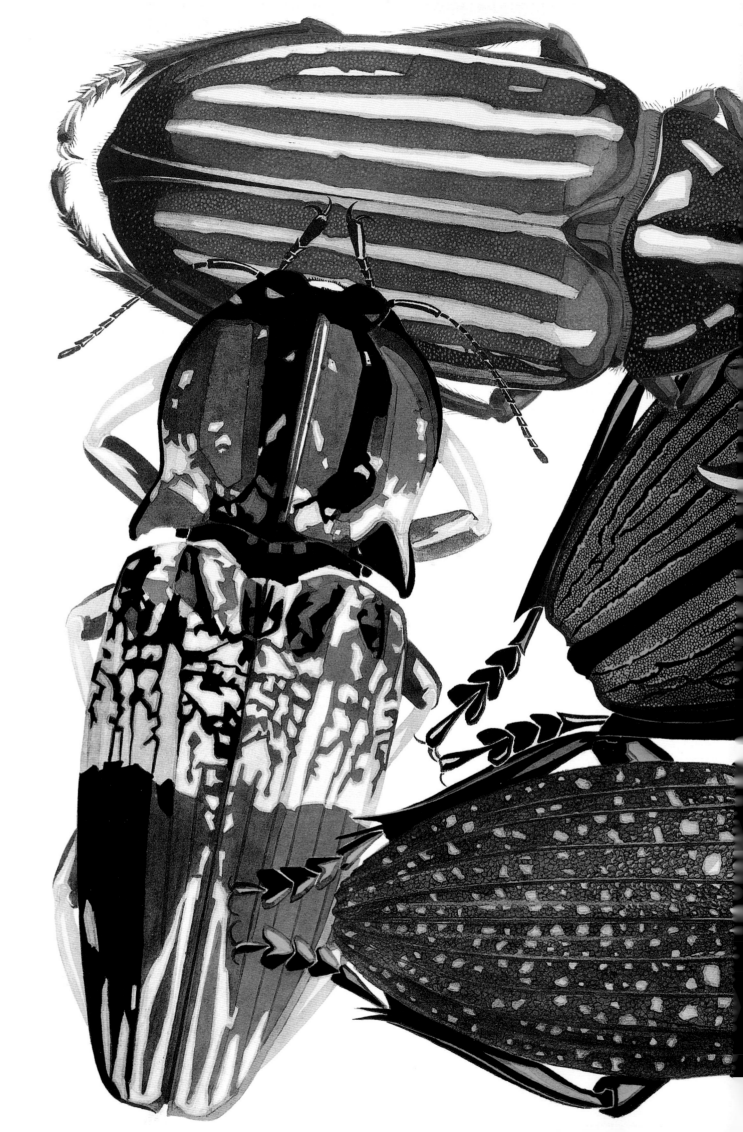

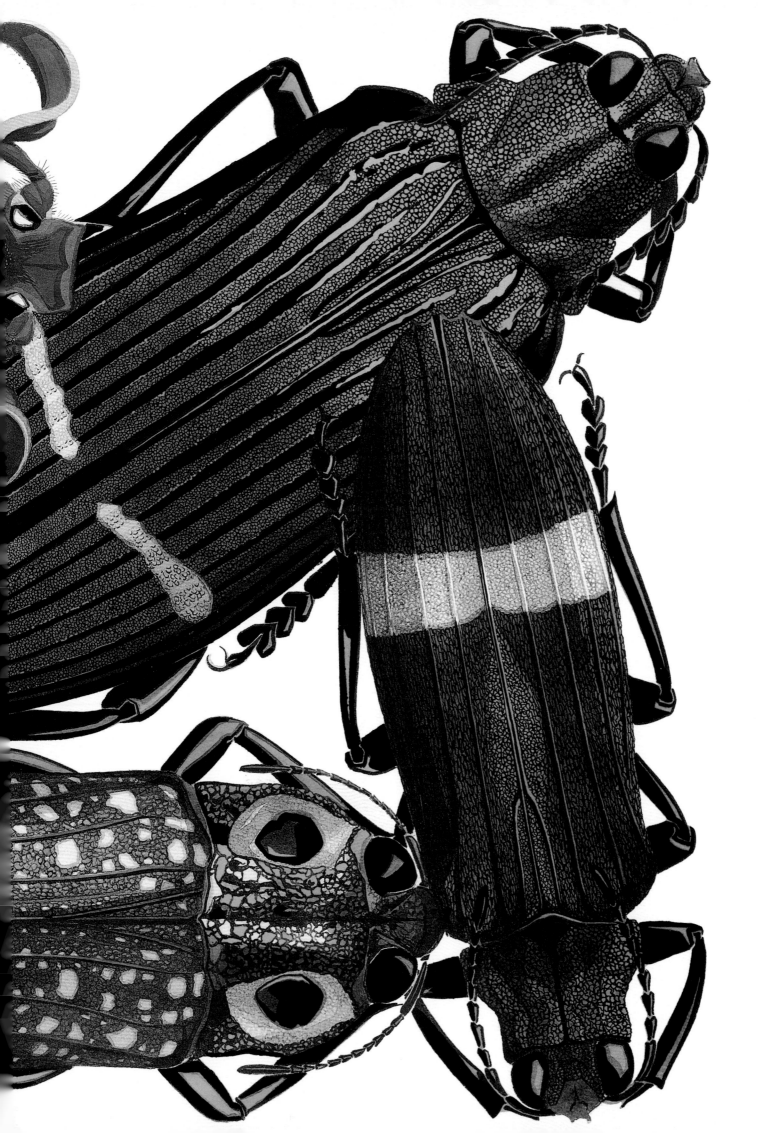

"Divine insect,
That sips of dew And sings!"
WILLIAM GRIFFITH, *GRASSHOPPER*

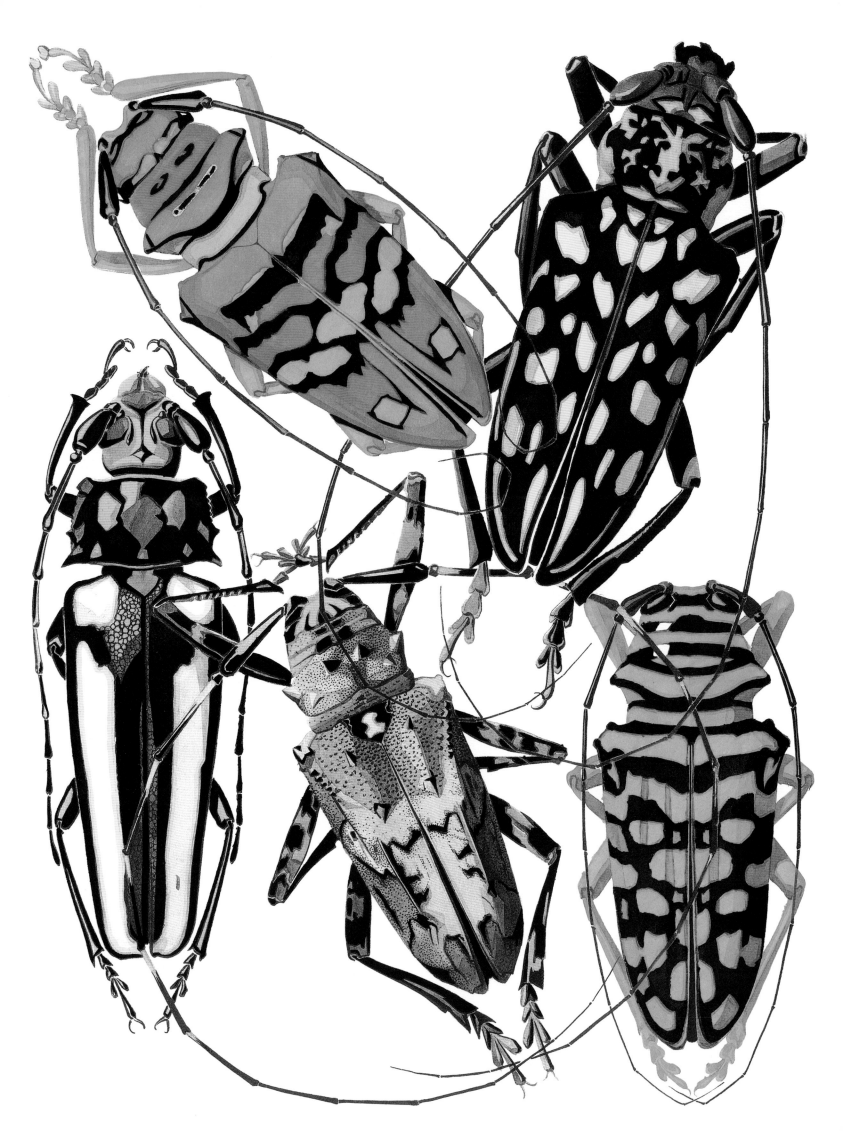

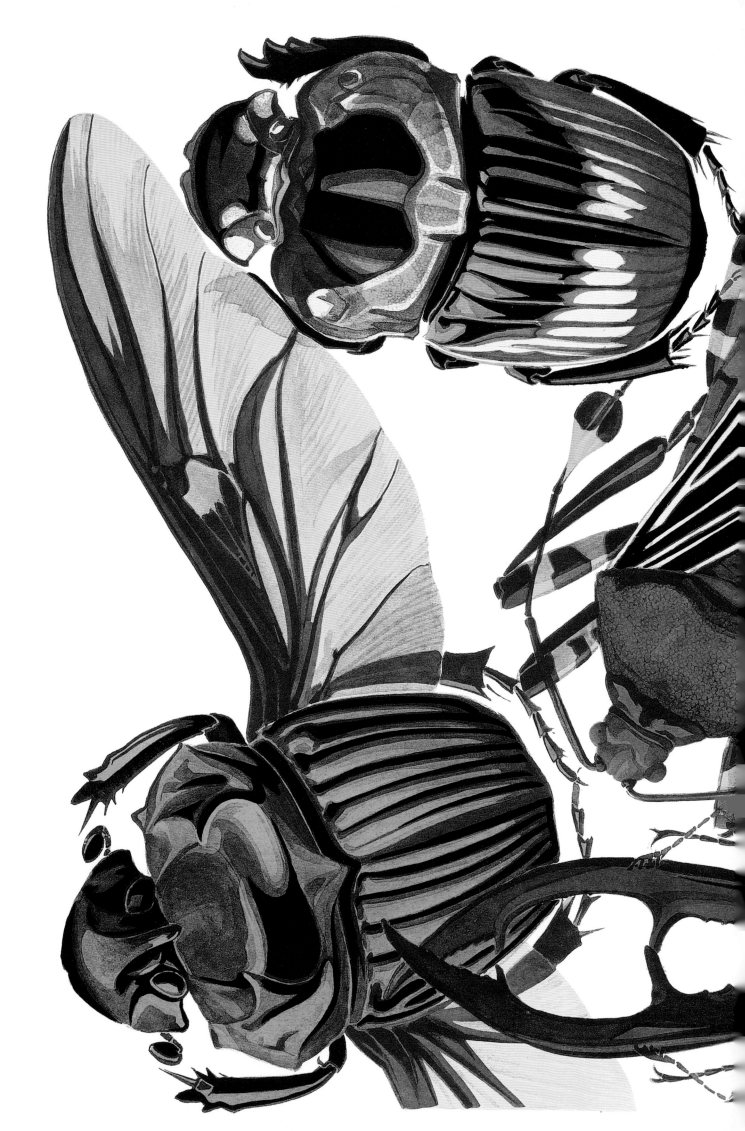

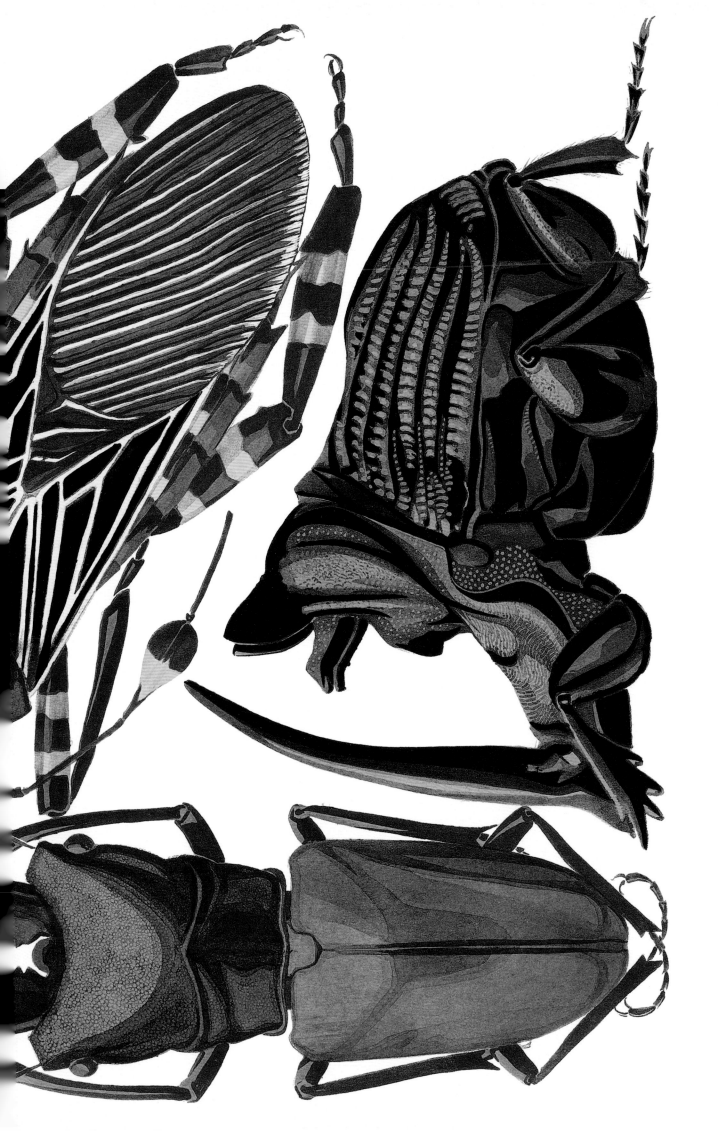

"Happy insect! what can be

In happiness compared to thee?

Fed with nourishment divine,

The dewy morning's gentle wine!

Nature waits upon thee still,

And thy verdant cup does fill;

'Tis fill'd wherever thou dost tread,

Nature's self's thy Ganymede."

COWLEY, *ANACREONTIQUES: THE GRASSHOPPER*

.

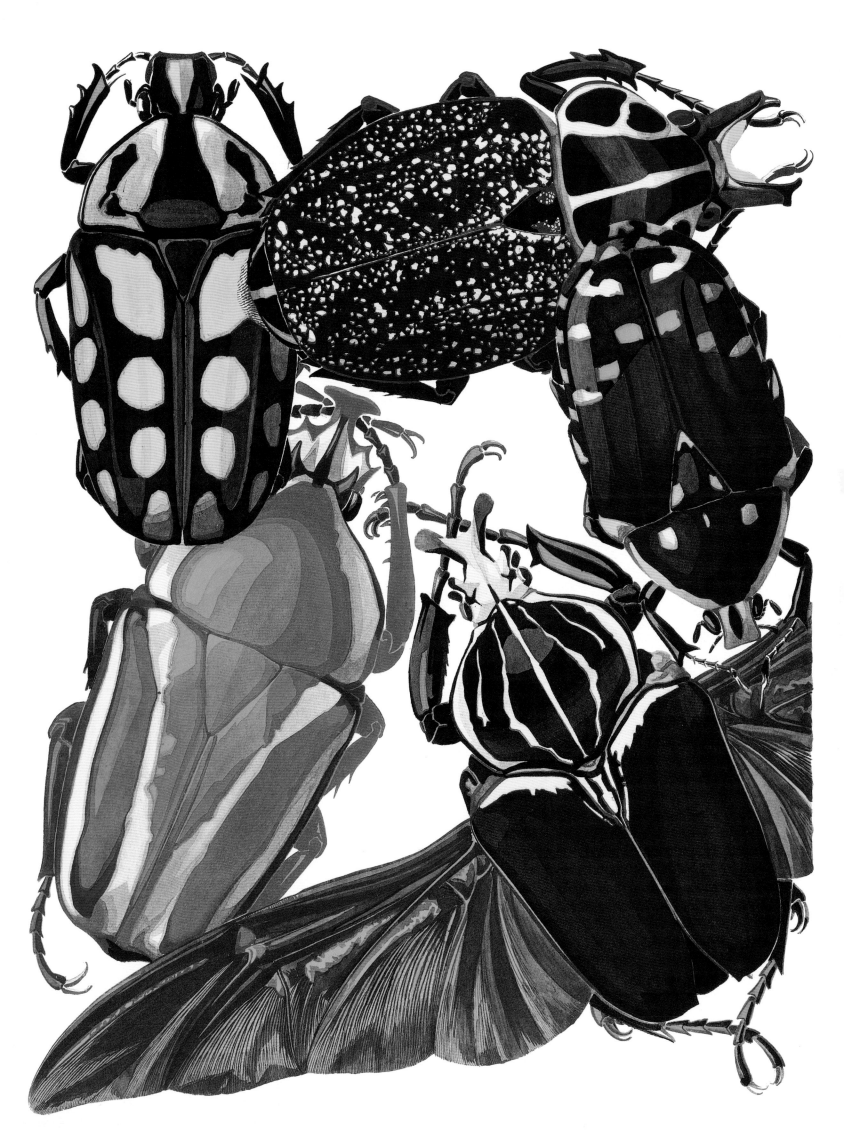

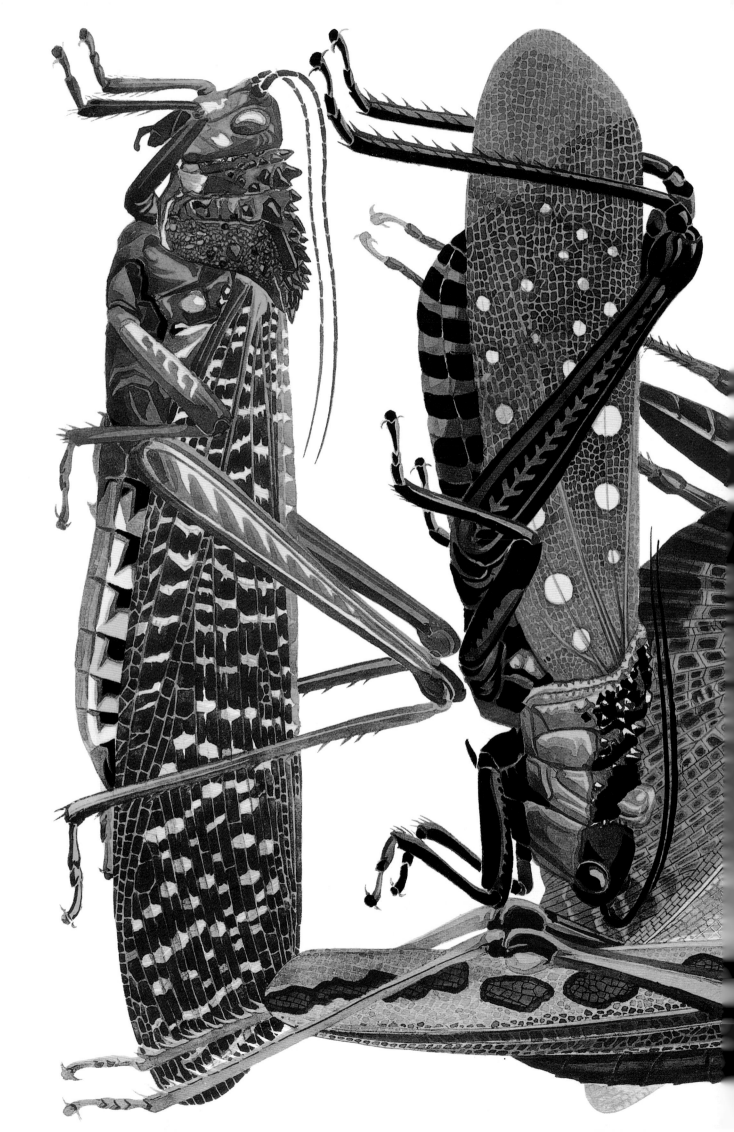

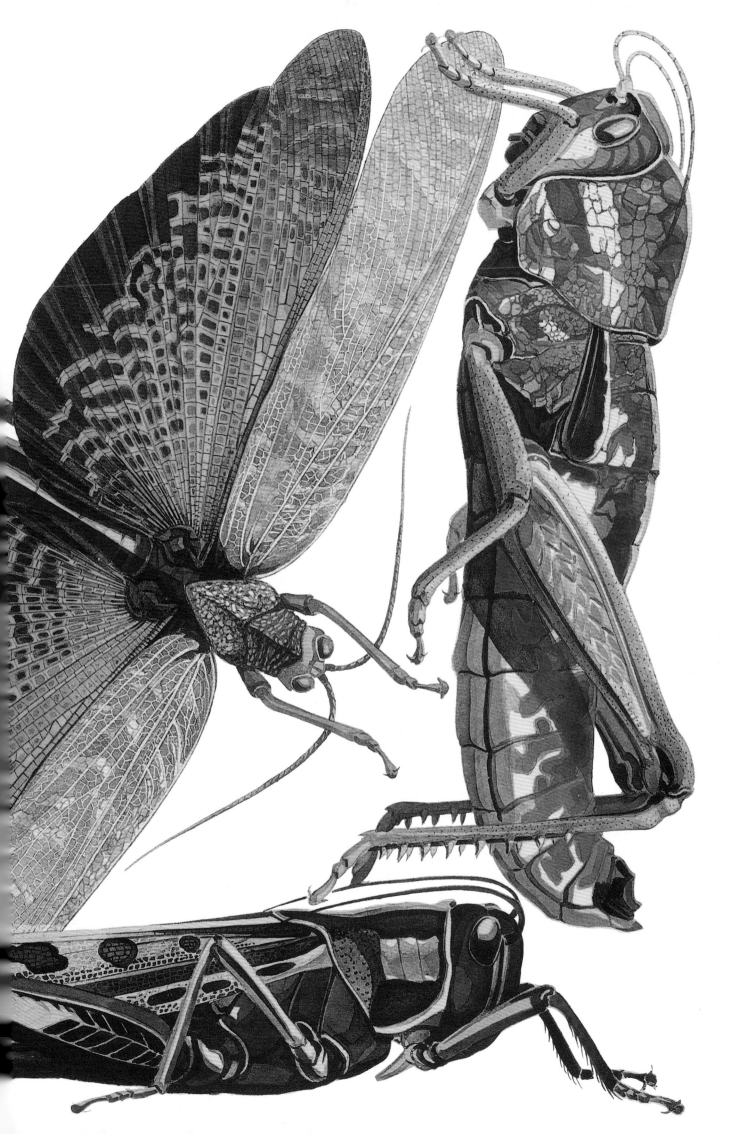

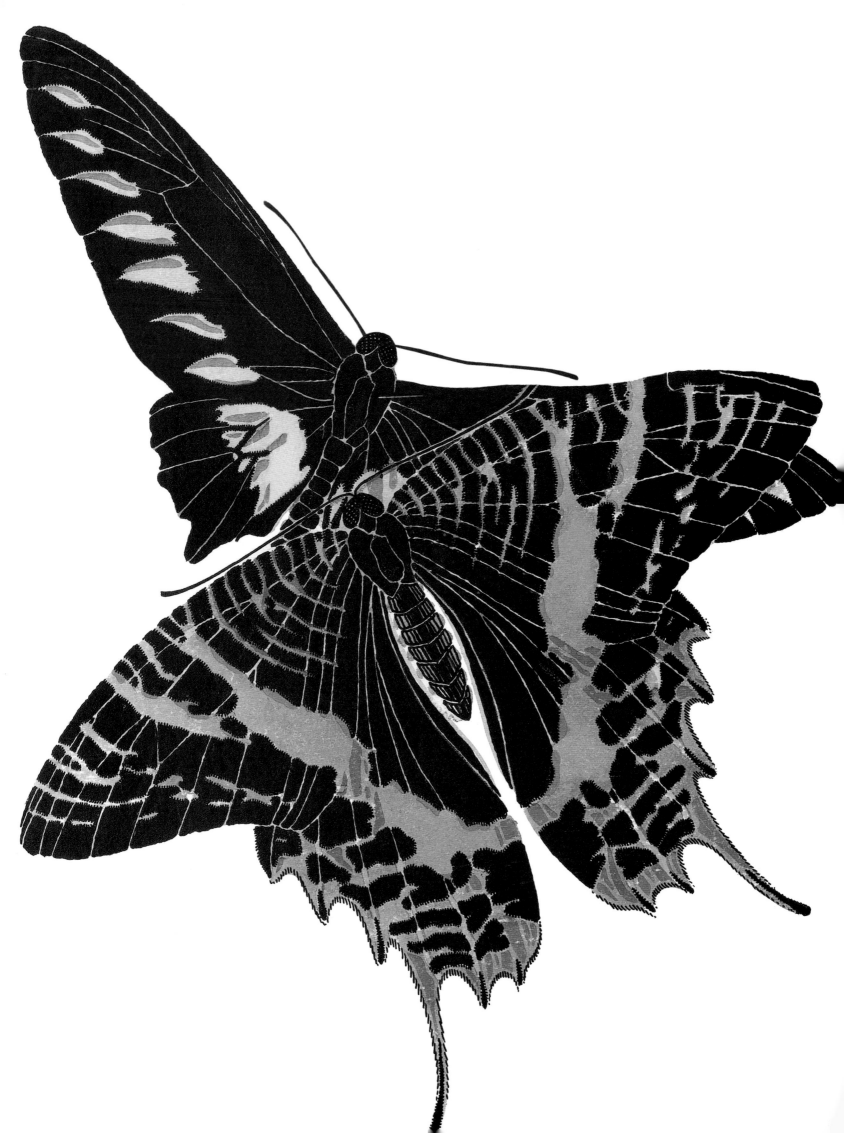

"What more felicity can fall to creature
Than to enjoy delight with liberty,
And to be lord of all the works of Nature?"

EDMUND SPENSER

MUIOPOTMOS, OR THE FATE OF THE BUTTERFLY

TEMPLE OF FLORA

ROBERT JOHN THORNTON (C. 1768–1837)

On the cusp of the nineteenth century, a popular literary, artistic, and intellectual movement called Romanticism swept through Europe. Deriving its name from the medieval literary genre of "romance," or heroic narrative in prose and poetry, Romanticism celebrated the individual imagination and emotional extremes—most frequently as an aesthetic response to an untamed natural world experienced as both awesome and awful, sordid and sublime. Pastoral idyll was held in a dynamic tension with horrifying mystery—this was the era of bestselling gothic novels such as Ann Radcliffe's *Mysteries of Udolpho* published in London in 1794, and later, in a less sensational mode, Charlotte Bronte's *Jane Eyre* (London, 1847). Permeating all was a

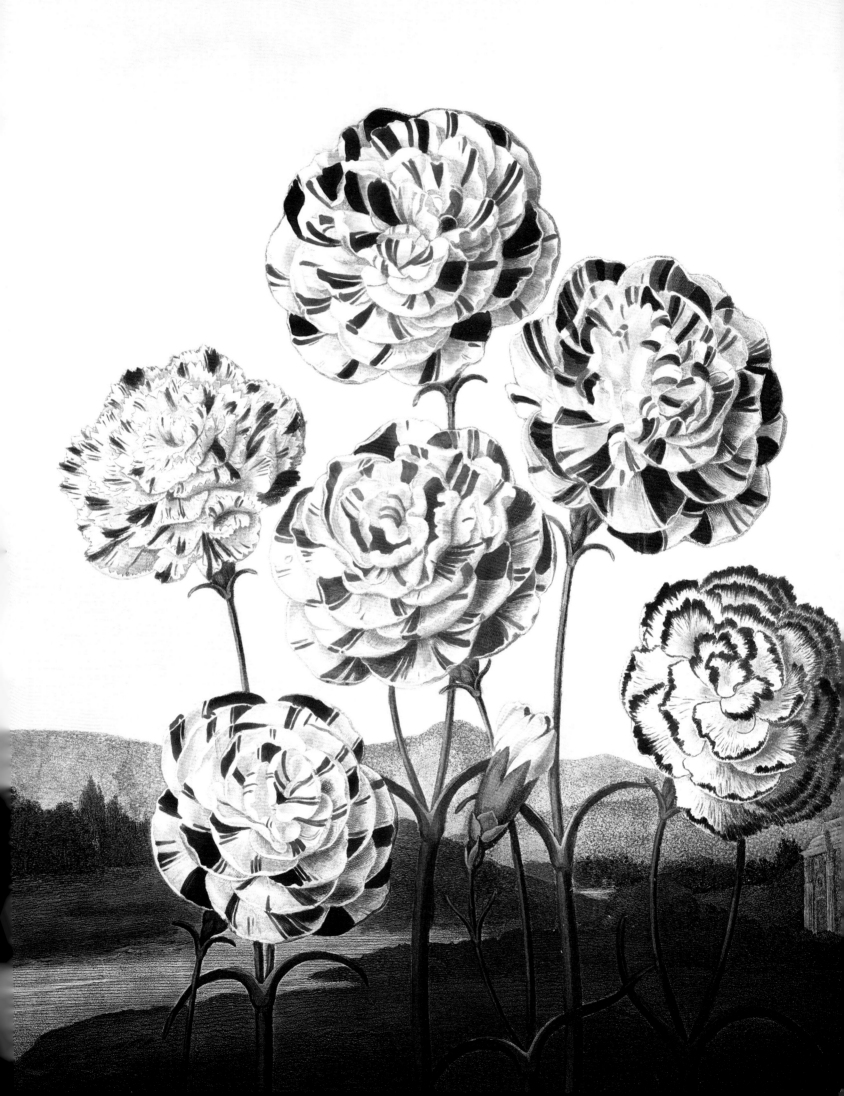

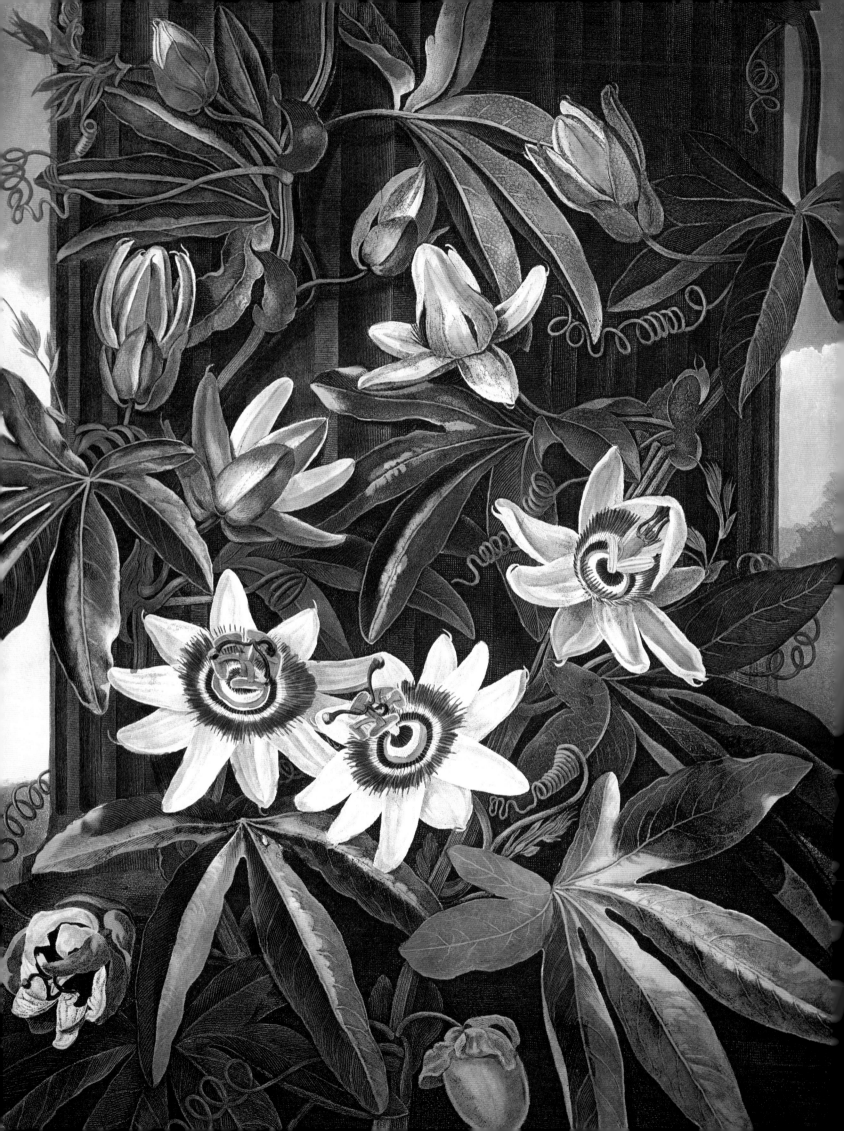

religious belief in the vanity of worldly things and a sense of temporal menace and doom.

A book published between the years 1799 and 1807 by an almost-middle-aged Dr. Robert Thornton (c. 1768-1837) was the unlikely medium for some of the most unusual botanical prints ever made. Ostensibly, Thornton's *New Illustration of the Sexual System of Carolus von Linnaeus* discussed the reproductive cycle of plants and the classification system of Carl Linnaeus, the Swedish naturalist who established the modern system of scientific nomenclature. But the book's third and final section, titled *The Temple of Flora*, contained the remarkable, elaborate prints that embodied the spirit of the time period and made the work famous.

Thornton's wealthy family intended him for the church, but he chose instead a career in medicine. With degree in hand he established a practice in London, where he became fascinated with Linnaeus's works on botany. Thornton had found his passion. Using his large fortune, he embarked on an ambitious—some would say extravagant, if not grandiose—project to explicate the new theories of Linneaus and illustrate them with the most

beautiful pictures of plants that could be devised. Numerous respected and renowned artists and engravers were engaged, among them Peter Henderson, who ultimately produced fourteen of the illustrations, including the *Blue Egyptian Waterlily*; Philip Reinagle, who contributed eleven illustrations, including the *Night-blowing Cereus*; and Abraham Pether, who created two illustrations as well as the moonlight effects in Reinagle's *Cereus*. At least five of London's top engravers and etchers joined the project as well. No expense was to be spared.

The folio prints for this project were produced variously by aquatint, mezzotint, stipple engraving, and stipple with line engraving—all intaglio processes for incising lines or dots into a copper plate. These techniques were used both separately and in combination to produce more than one version of an illustration. The plates were then printed with colored, rather than solely black, inks (a very exacting and expensive process that visually softens and rounds the figures' edges); the prints were meticulously finished by hand with watercolors.

Each illustration depicted a plant in a deliberately dramatic composition, purporting to place it in its natural habitat, though

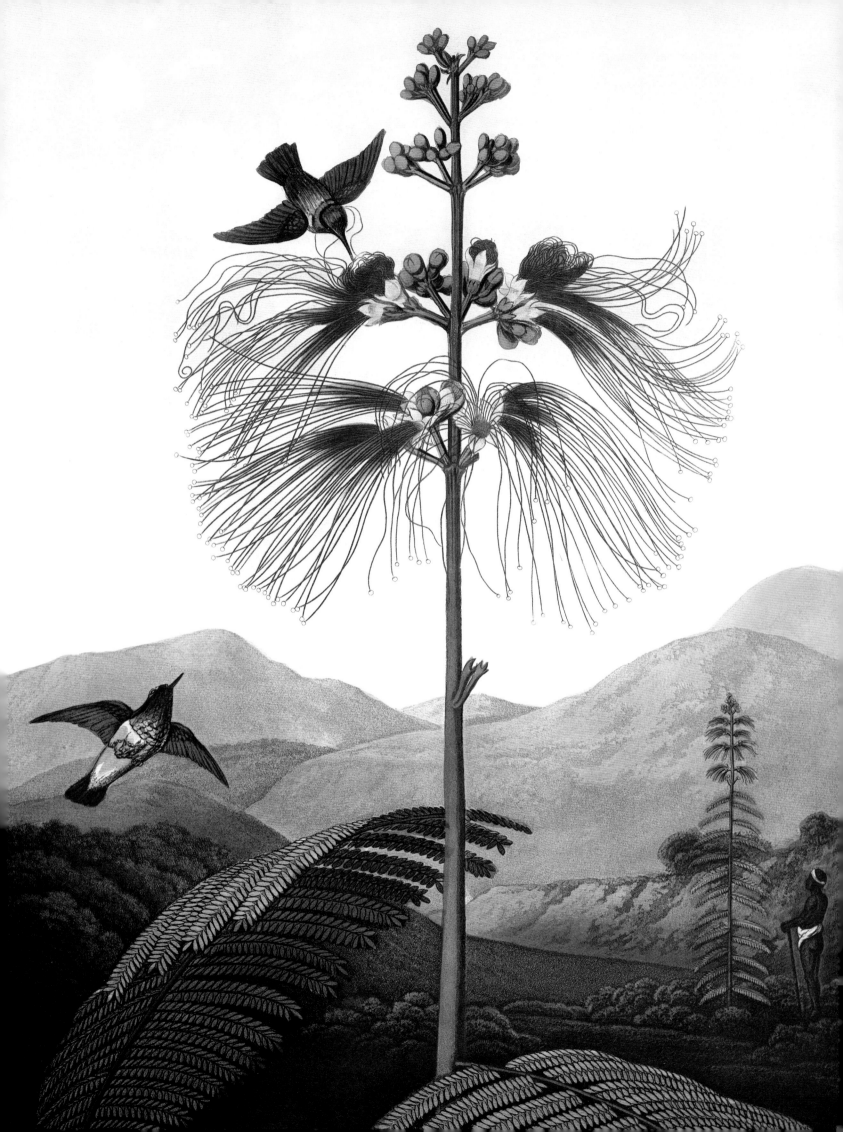

frequently erring in this regard. Most strikingly, Thornton's direction and oversight of the production process ensured that the images were consistently imbued with the dark and brooding atmosphere of Romanticism. An enthusiast of that genre, Thornton envisioned the book as a grand union of science and art. In addition to the botanical illustrations, the book included multiple allegorical title pages, calligraphic engraved half-titles, and elaborately engraved portraits of botanists (including two of Linnaeus and three of Thornton himself) and other eminent men such as Charles Darwin's grandfather, Erasmus Darwin, whose book of poetry *The Botanic Garden* (1789–1791) was very popular at the time. These and other embellishments adorn a text in which the science is lost amid florid poetry, fervent flights of nationalistic rhetoric, and lengthy digressions on subjects as varied as ancient Eastern mythologies and contemporary European political events and battle strategies.

Ultimately, however, the costs of producing the extraordinary and fantastical illustrations mounted beyond even Thornton's fortune, and the undertaking eventually bankrupted him. Like many illustrated

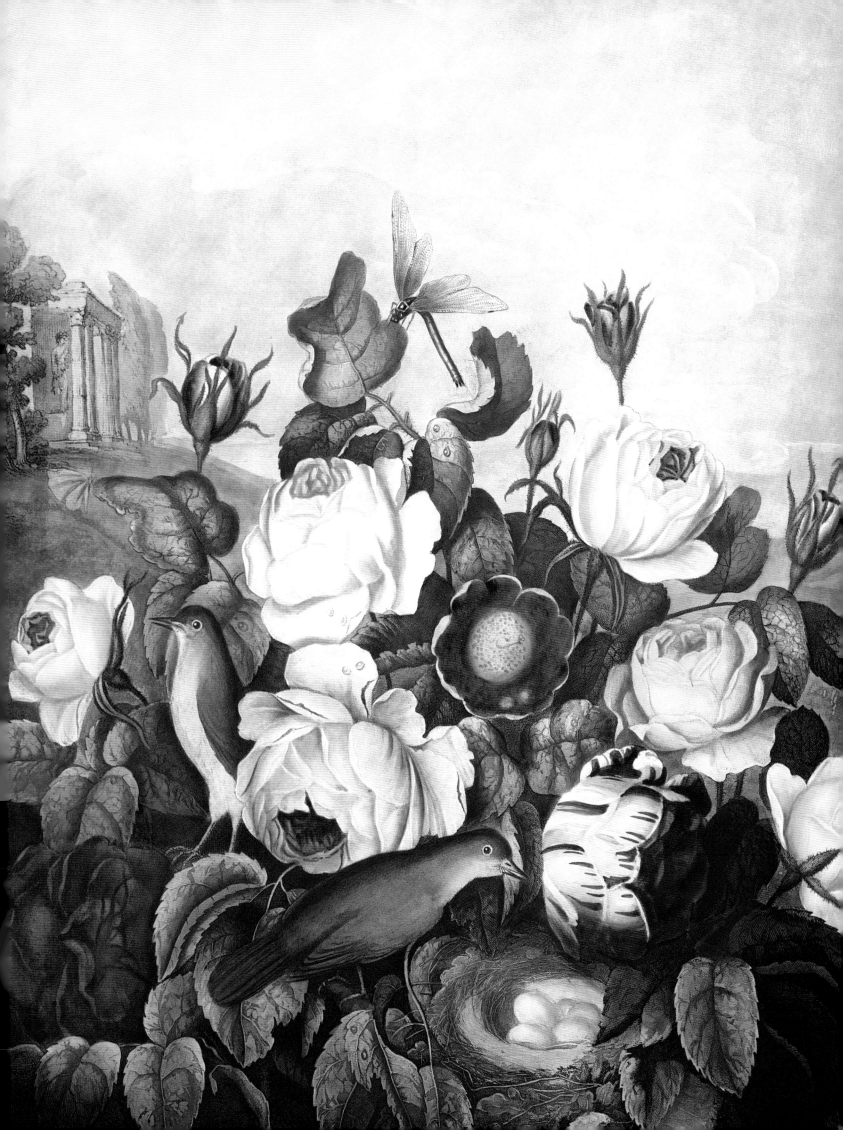

books of the time, Thornton's *New Illustration* was originally issued in parts by subscription, but it did not sell well, and only about thirty of the projected seventy illustrations were ever completed. Thornton tried in various ways to revive the public's interest and raise money for the work—including an exhibition of the original paintings; a lottery with the paintings, copies of the book, and unbound sets of the prints as prizes; a reissue of the work in 1812; and the production of a smaller octavo edition—but all his efforts failed. Reduced to poverty, he continued to write and publish books on botany, and his death in 1837 left his large family virtually destitute.

Although Thornton's book is of no scientific value, today *The Temple of Flora* is highly prized as perhaps the most magnificent florilegium, or book of plant portraits, ever produced. Appropriately for a work whose illustrations have been described as disquieting, eerie, and macabre, the book is a bibliographer's and collector's nightmare. No two copies are exactly the same, thanks to the multiple, experimental versions of each print; the subsequent alterations that often produced numerous variations; and the

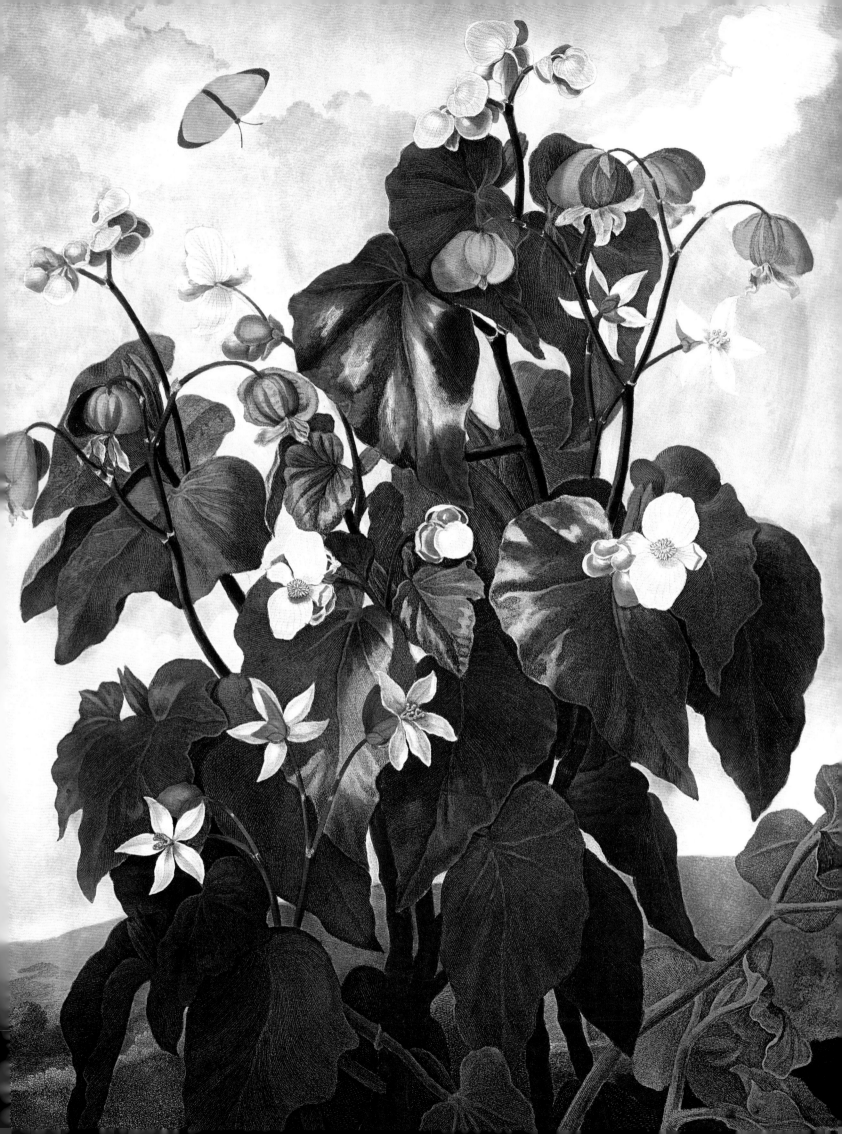

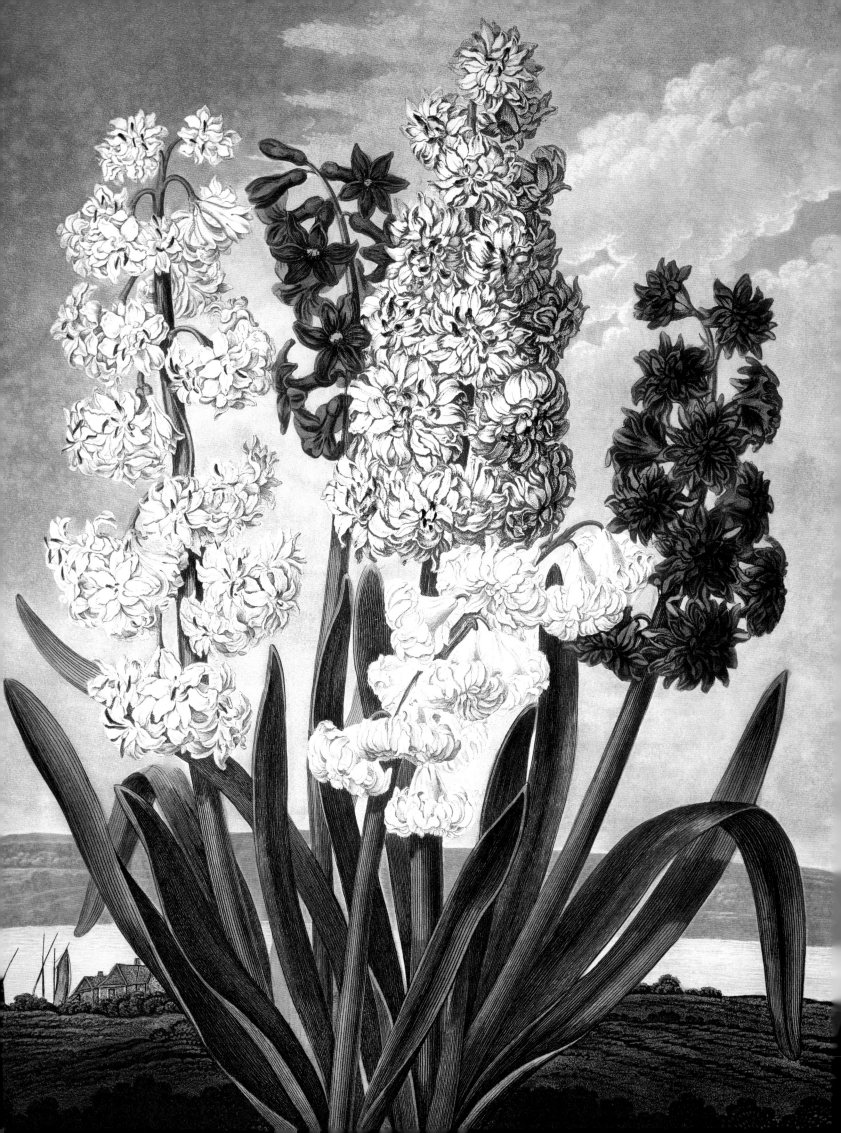

several issues of variant sets. Even the number of prints differs among copies of the first edition, from twenty-six to thirty-two. However, such disparities serve further to imbue the prints with the aura of their creator—a man whose undying, all-consuming passion lives on in the eloquence of delicate petals and supple leaves, of storm-clouded skies, and of vibrantly colored ink on paper.

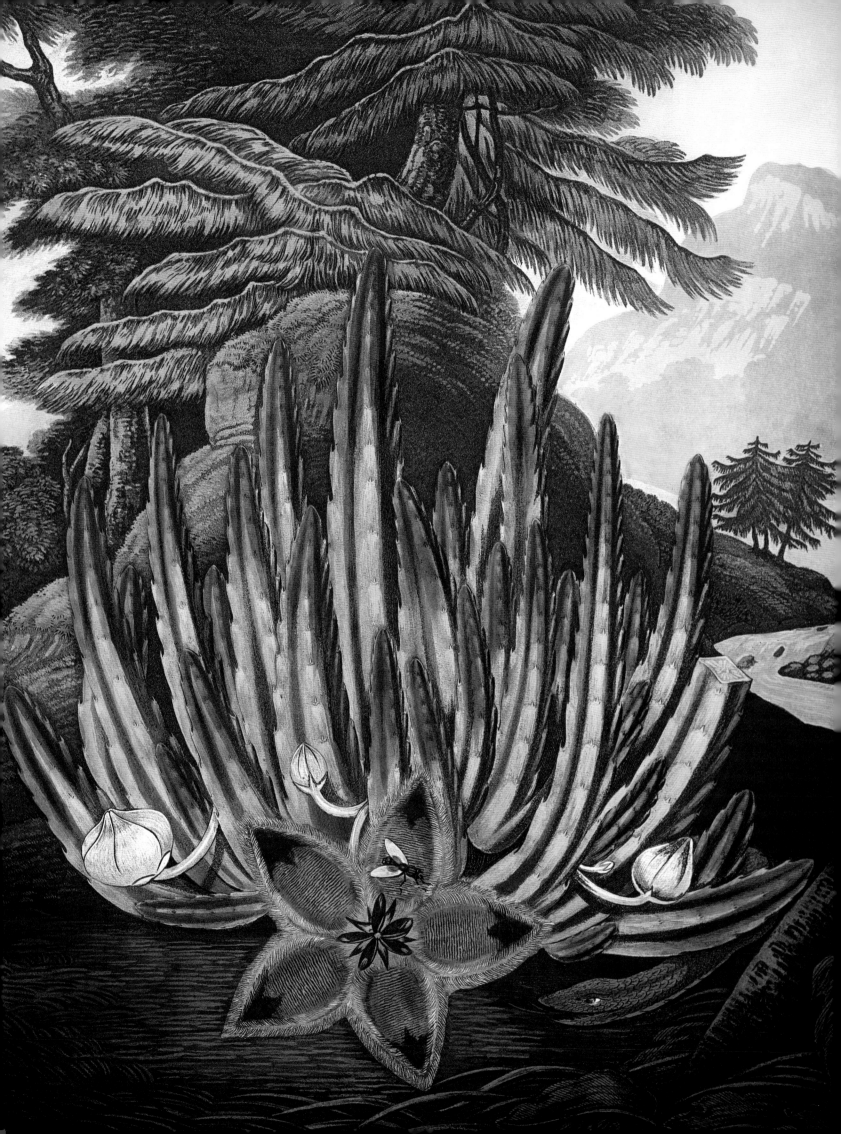

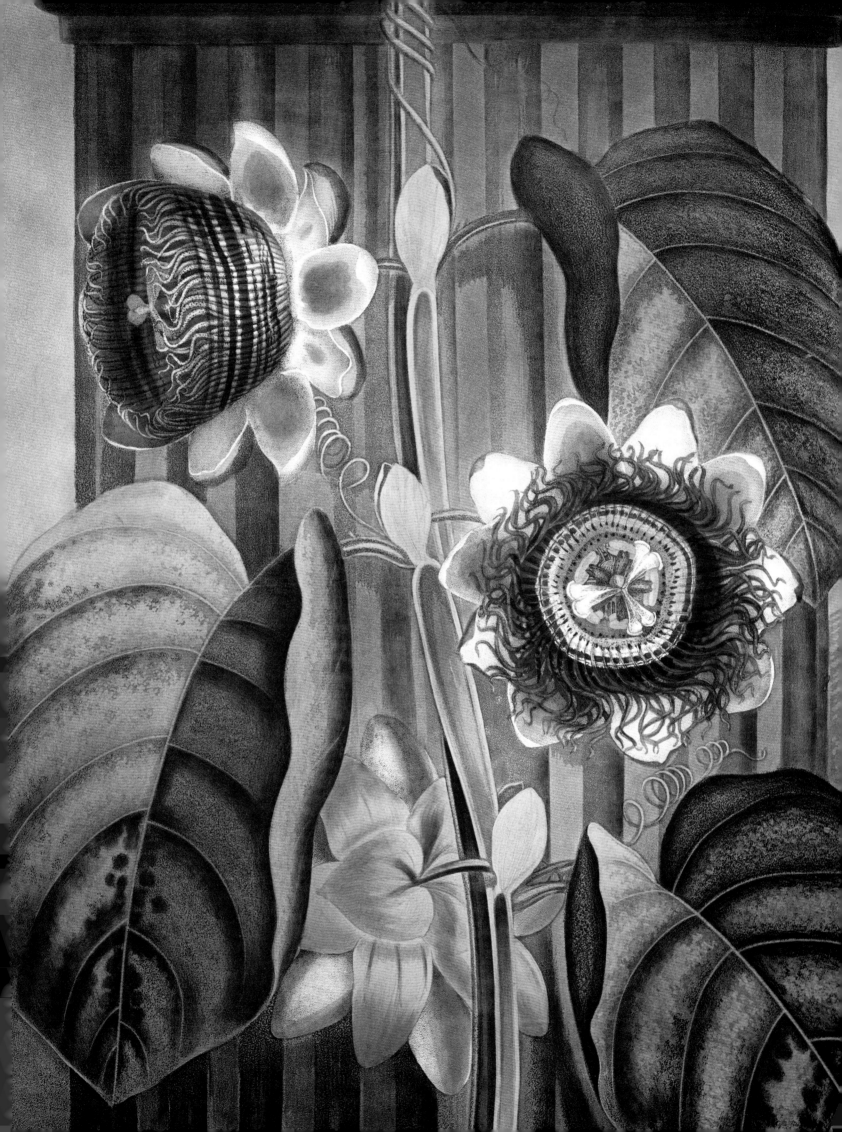

66 Clean as a lady,
cool as glass,
fresh without fragrance
the tulip was. 99

HUMBERT WOLFE, *TULIP*

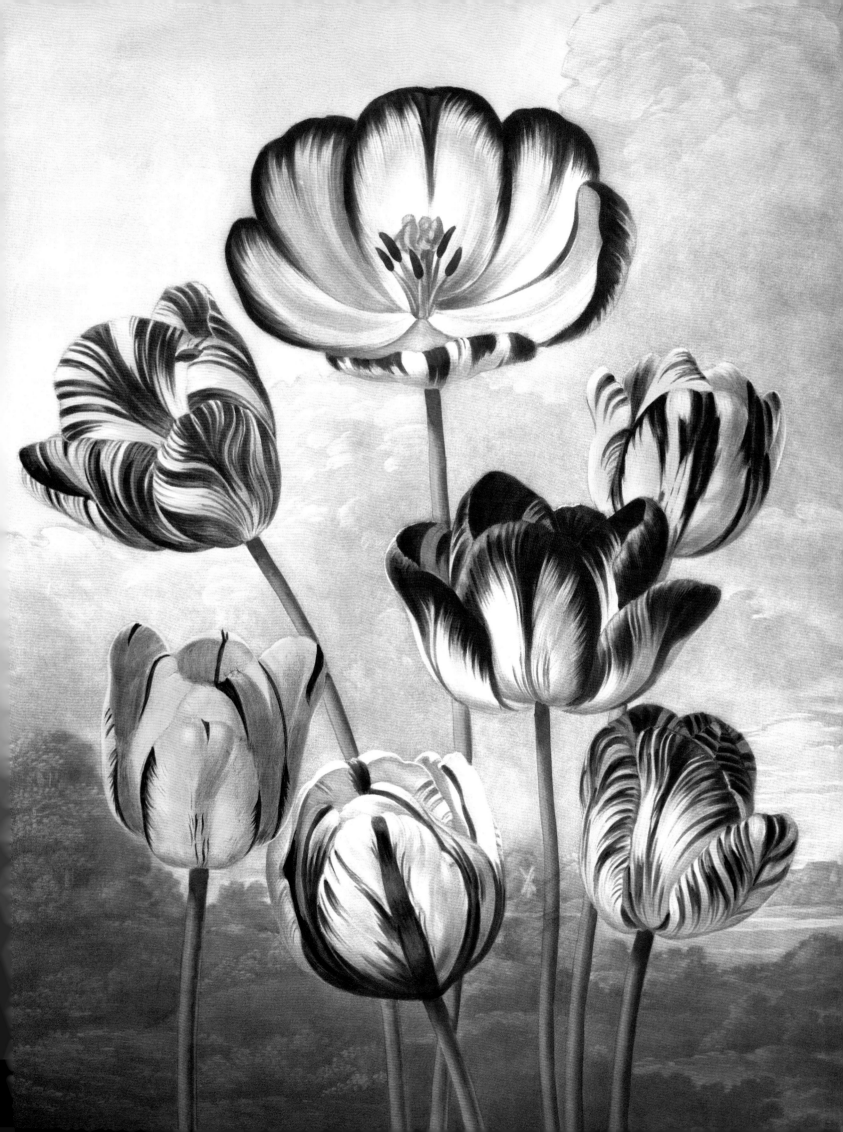

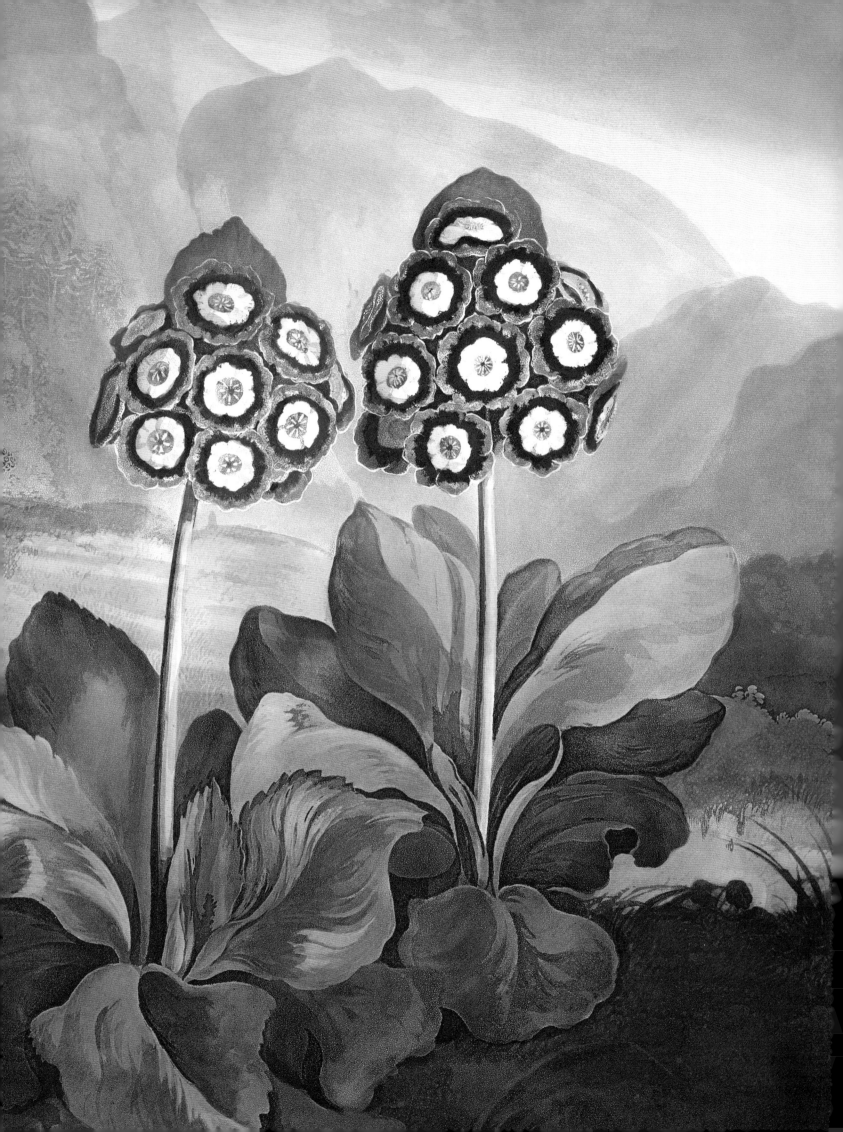

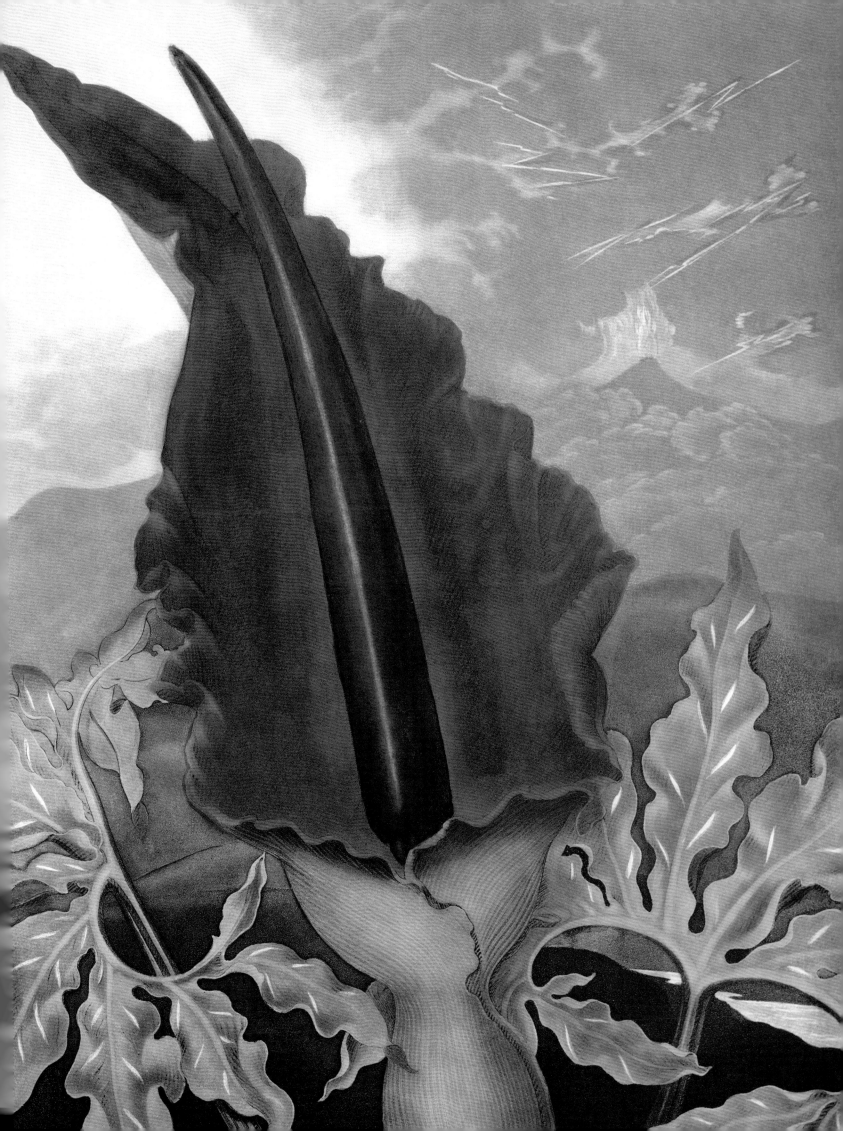

66 Meadia's soft chains five suppliant beaux confess,

And hand in hand the laughing belle address;

Alike to all, she bows with wanton air,

Rolls her dark eye, and waves her golden hair. 99

CHARLES DARWIN

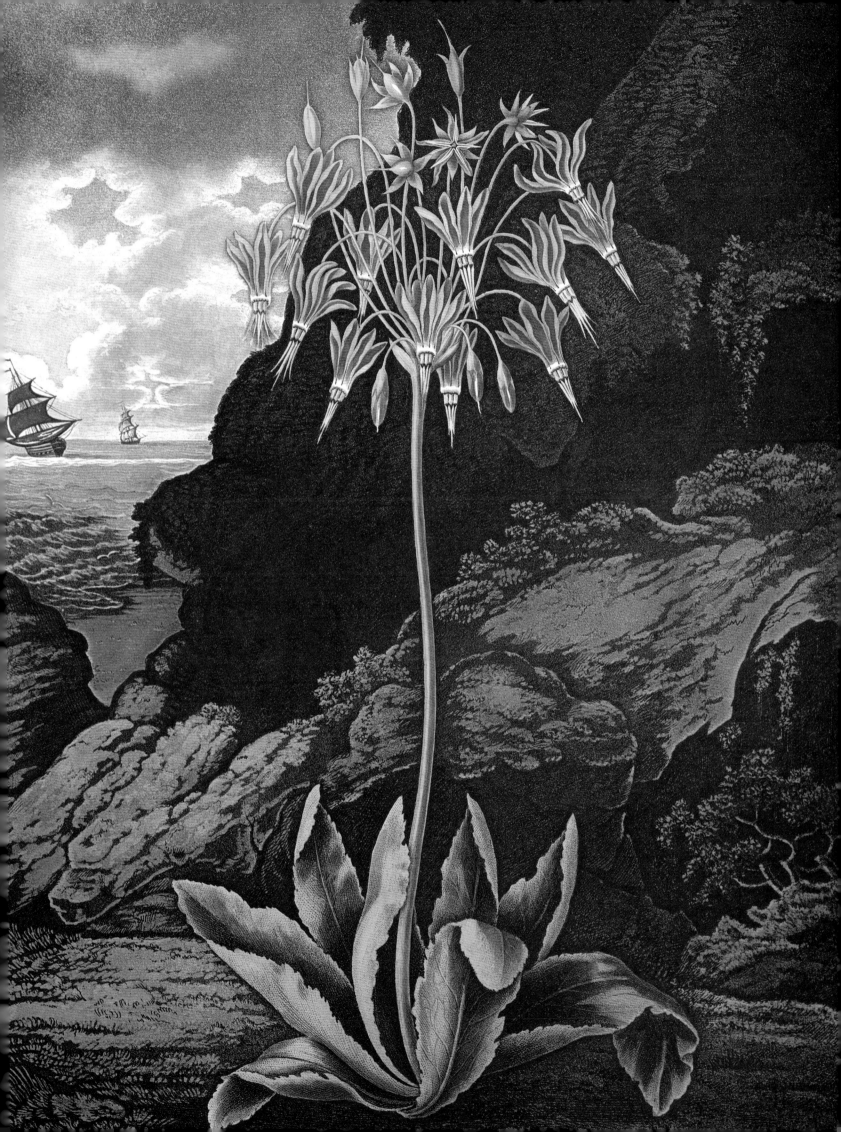

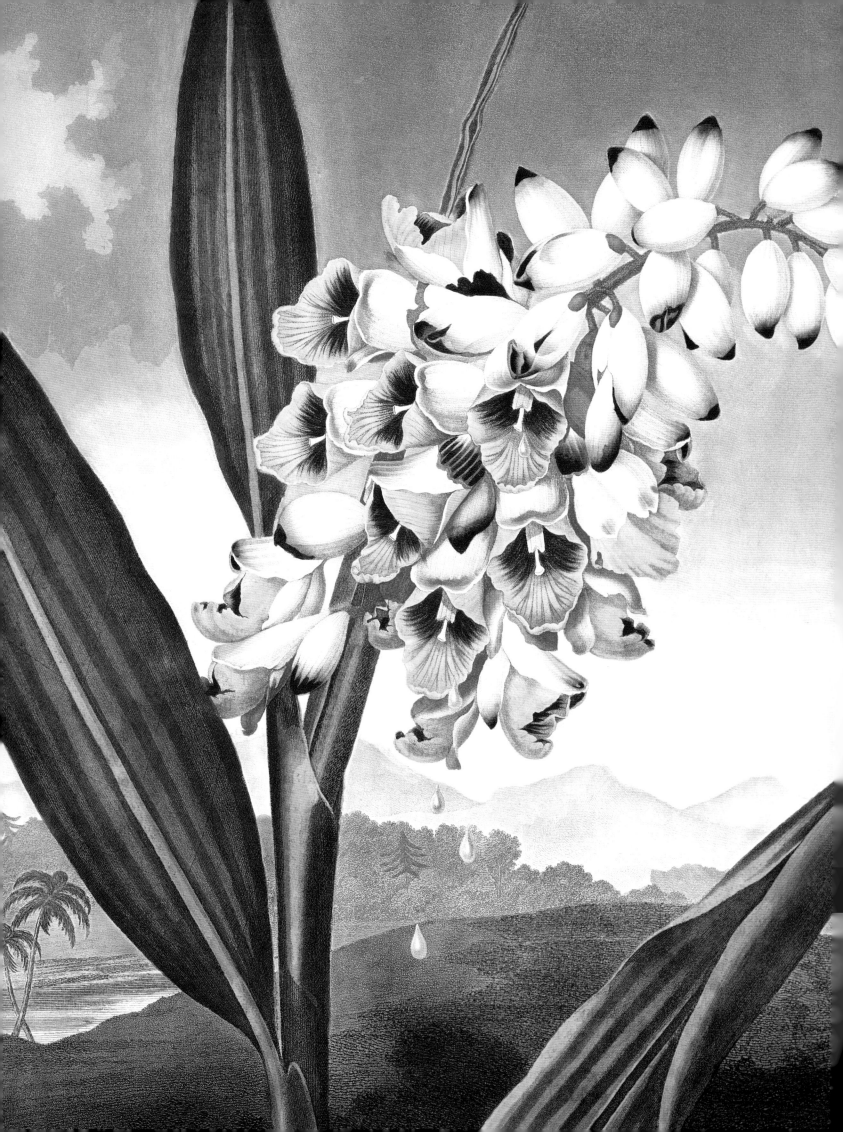

"I die, I die, young Hyacinthus said,
Sunk on the earth, and droop'd his lovely head.
Quick to his aid distress'd Apollo flew,
And round the hero's neck his arms he threw.
But whilst he held him to his throbbing breast,
And all the anguish of his soul exprest,
His polish'd limbs by strange enchantment's pow'r
Shoot into buds, and blossom into flow'r;
His auburn locks in verdant foliage flow,
And wreaths of azure florets shade his brow."

OVID

" And the Spring arose on the garden fair,
Like the Spirit of Love felt everywhere;
And each flower and herb on Earth's dark breast
Rose from the dreams of its wintry rest. "

PERCY BYSSHE SHELLEY, *THE SENSITIVE PLANT*

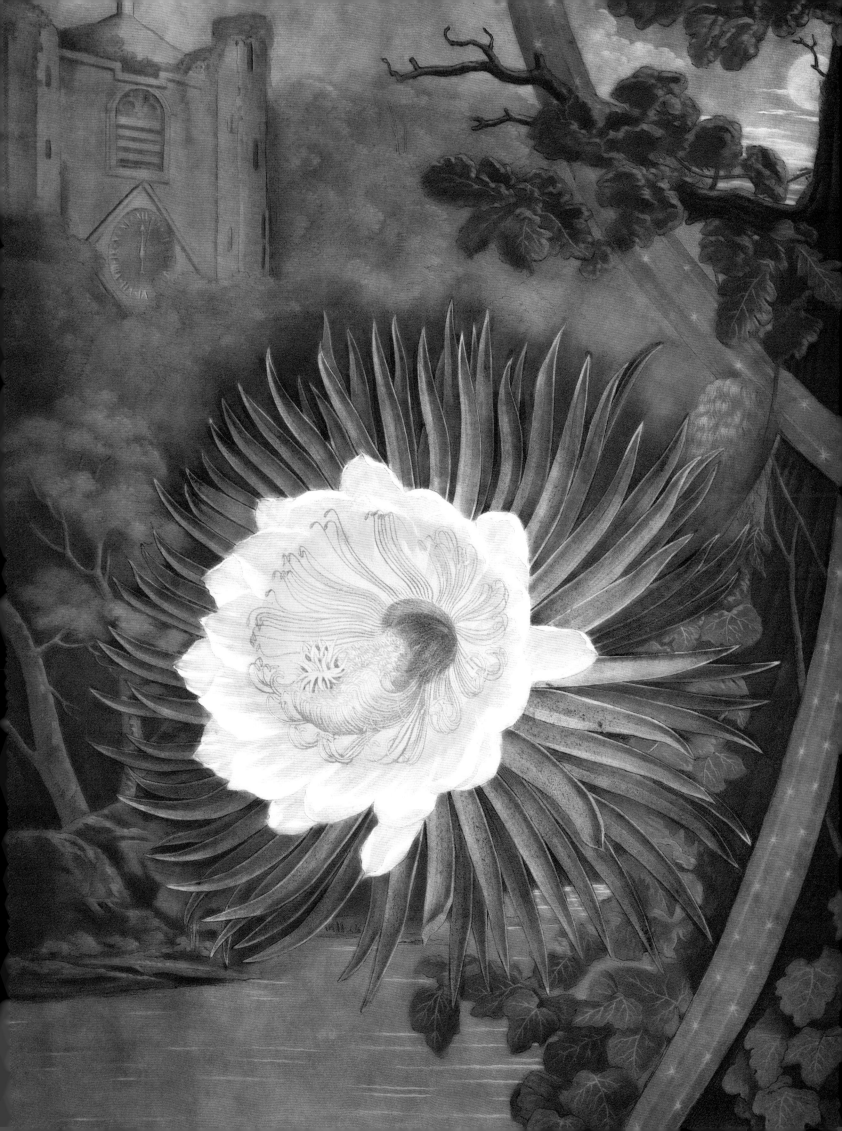

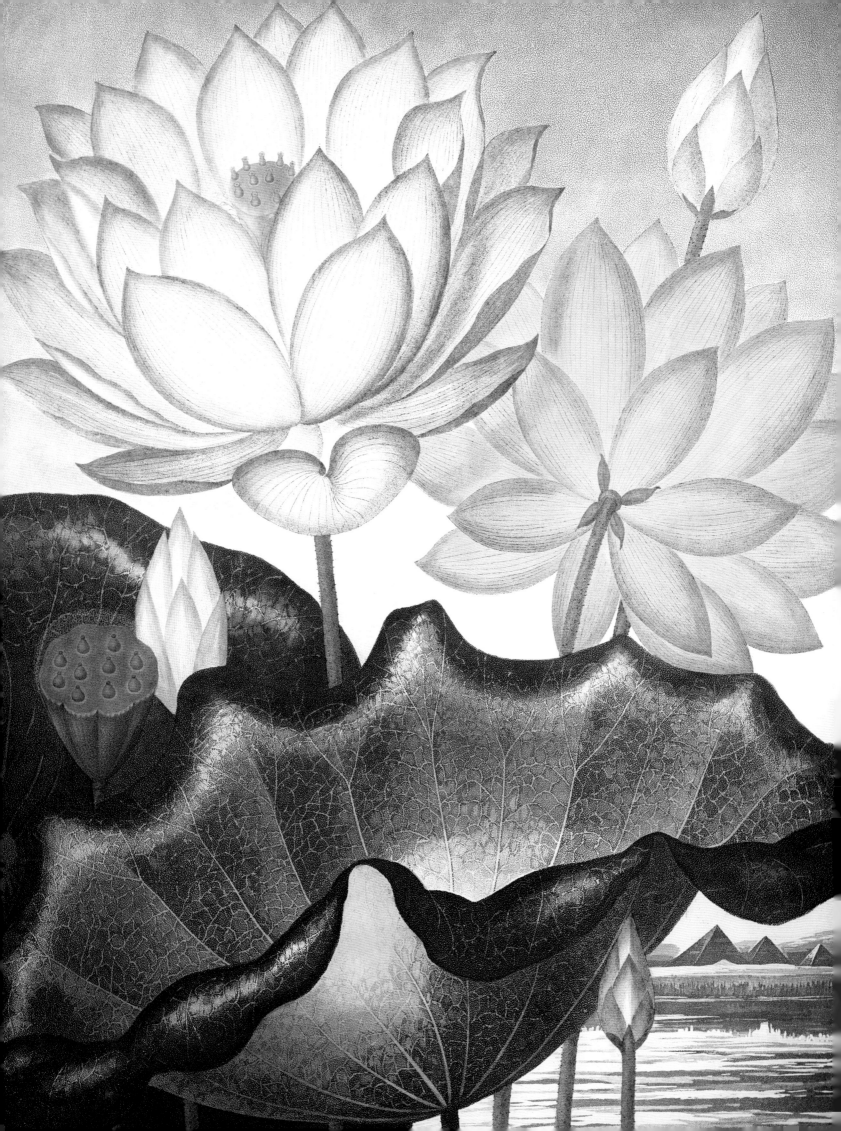

66 And every rose and lily there did stand
Better attired by Nature's hand. **99**

ABRAHAM COWLEY, *THE GARDEN*

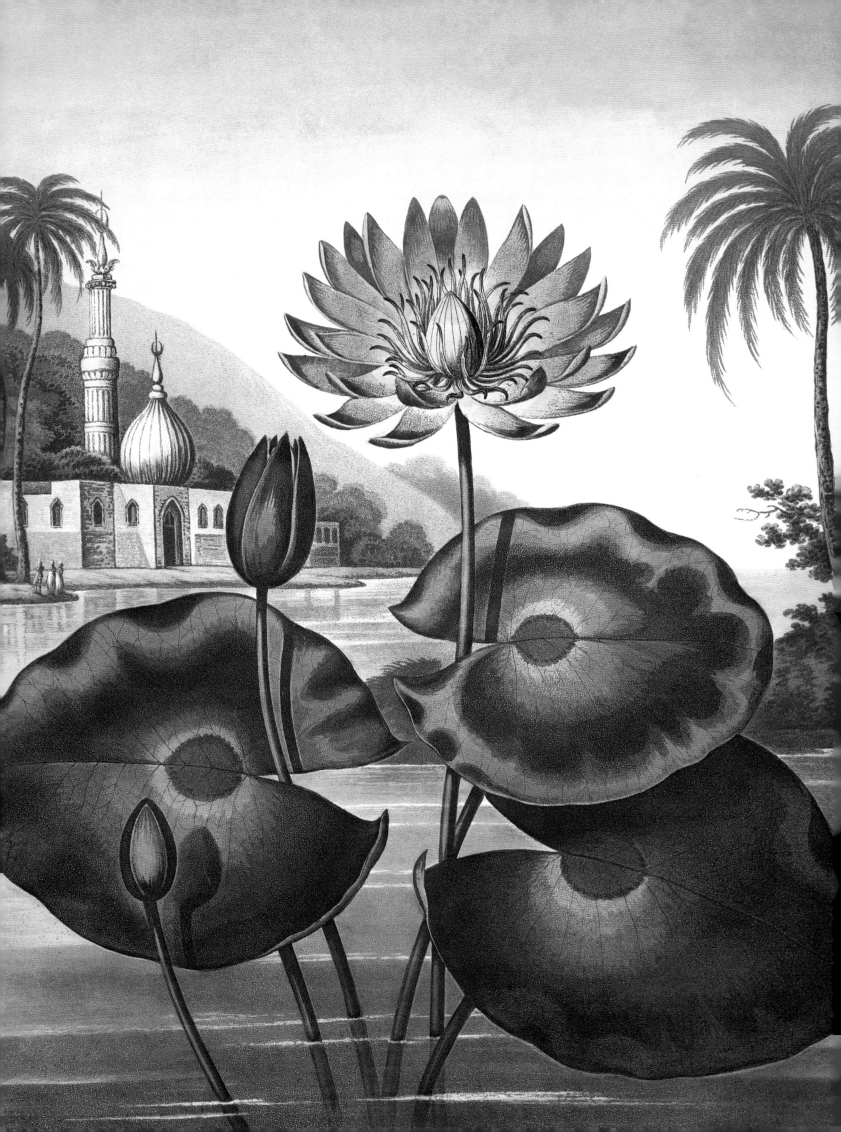

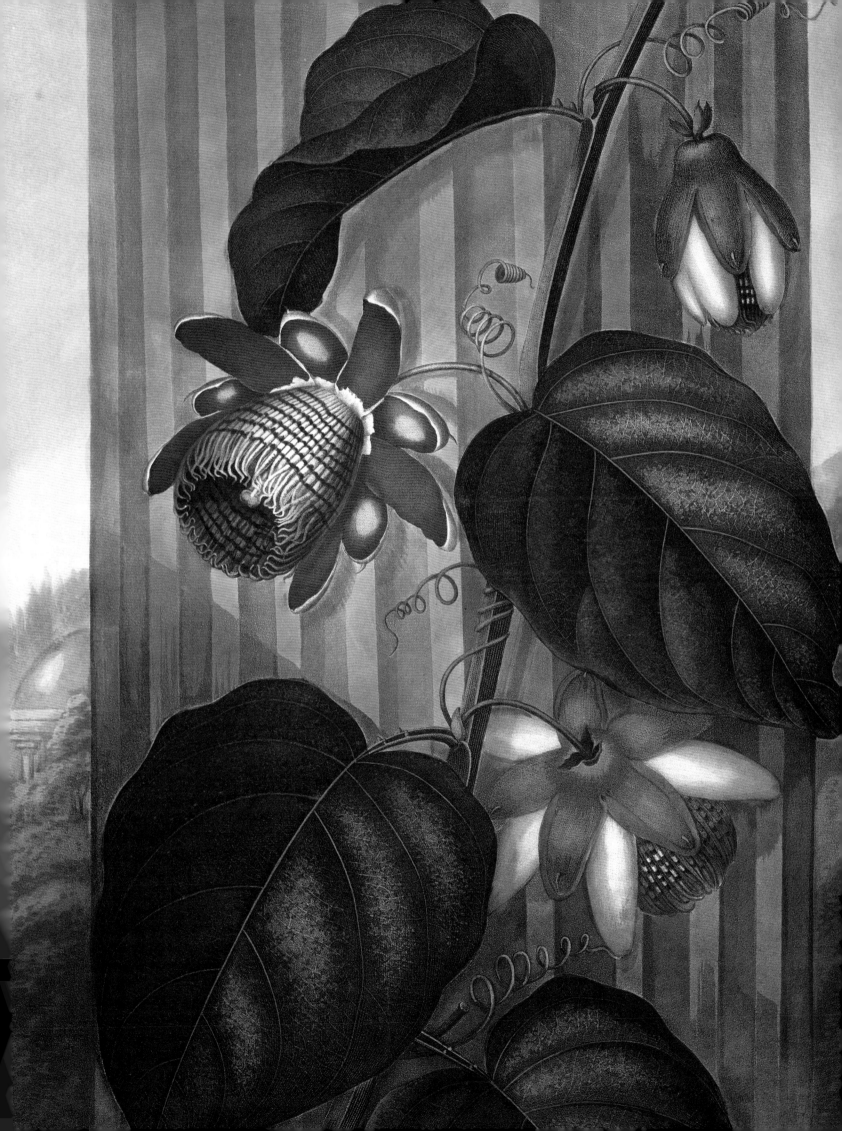

"Beneath the crisp and wintry carpet hid
A million buds but stay their blossoming
And trustful birds have built their nests amid
The shuddering boughs, and only wait to sing
Till one soft shower from the south shall bid
And hither tempt the pilgrim steps of Spring."

ROBERT SEYMOUR BRIDGES, *THE GROWTH OF LOVE*

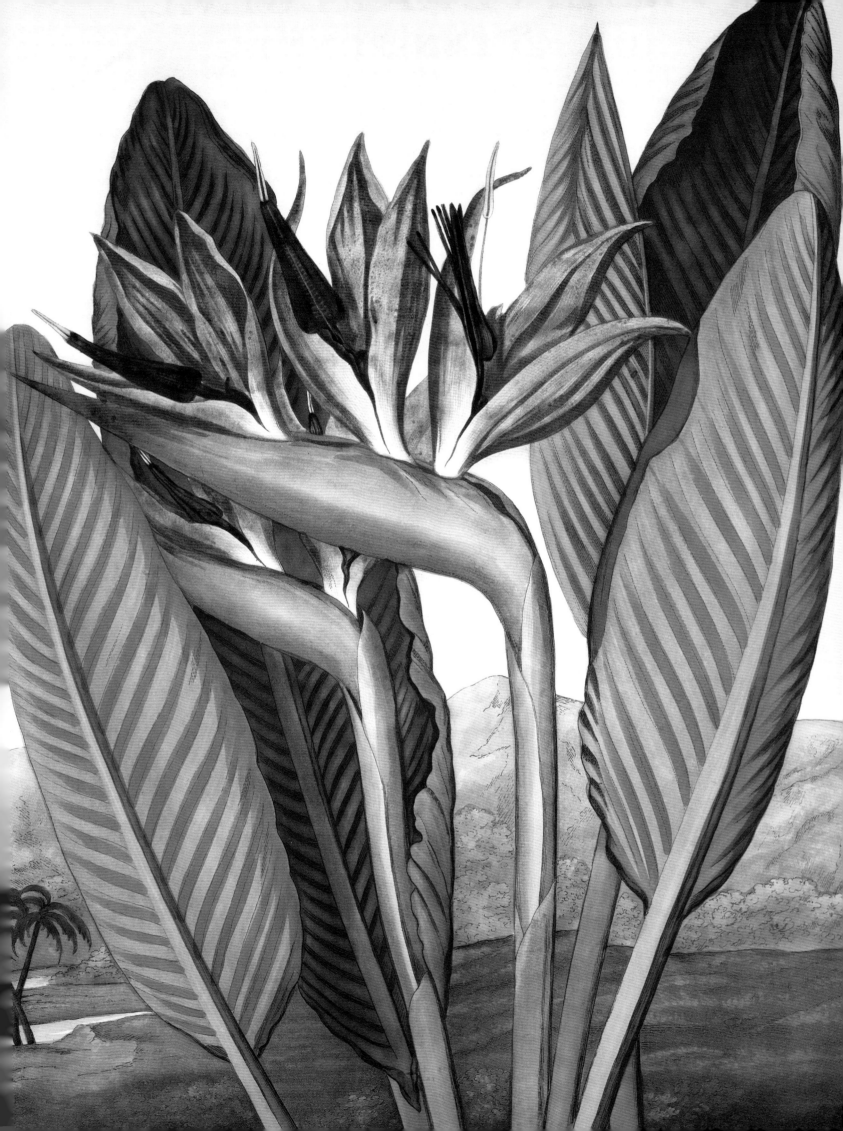

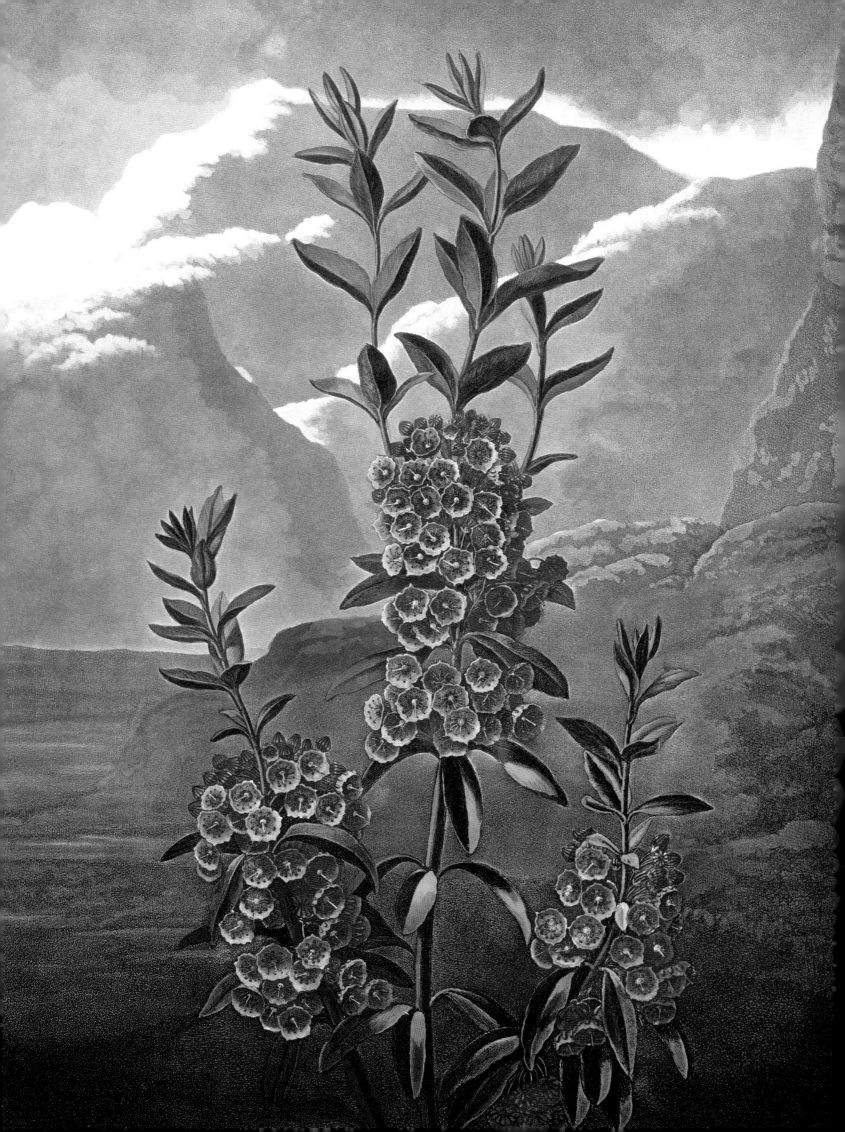

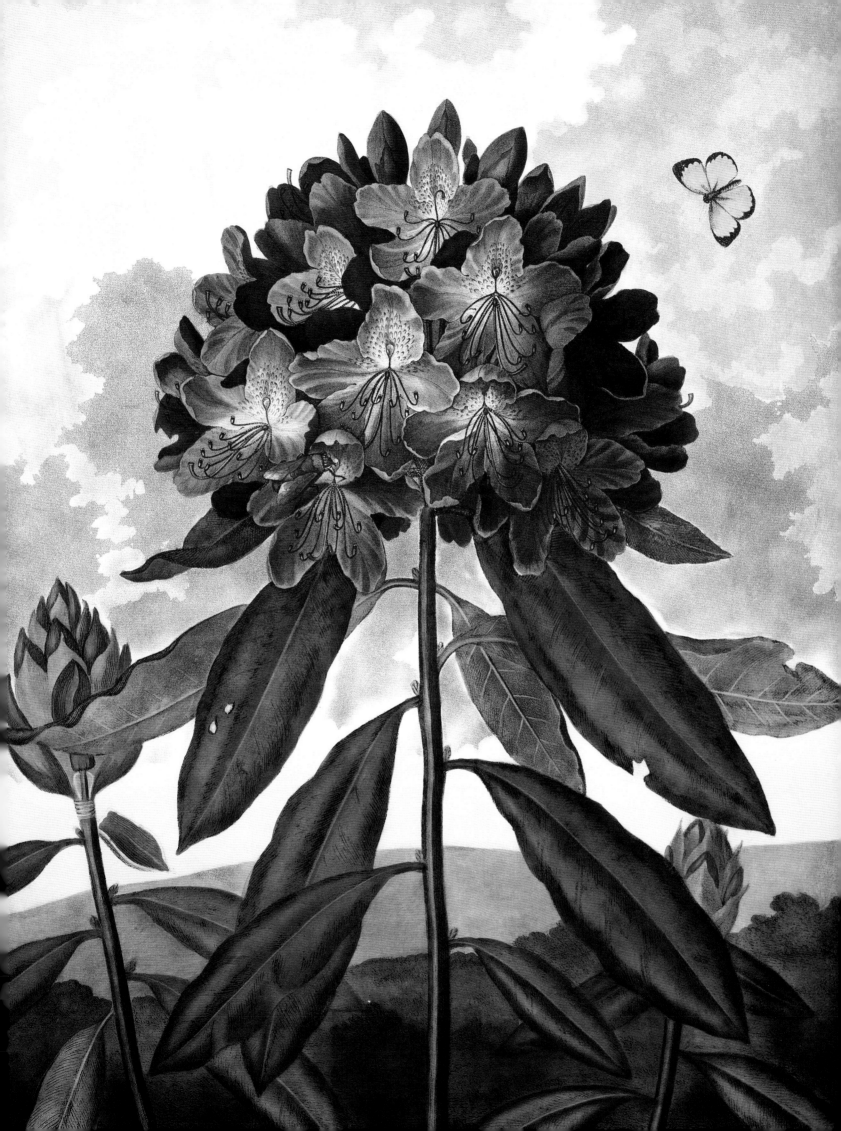

ORCHIDS

JEAN JULES LINDEN (1817–1898)

Through centuries of exploration from the 1400s through the 1800s, Europeans delighted in the discovery and introduction to their gardens and hothouses of innumerable exotic plants from previously unknown parts of the globe. One of the first and most famous such enthusiasms was "tulip mania" in Holland in the late 1500s and early 1600s.

The early French naturalist Pierre Belon may have been one of the first Westerners to call attention to the flower, when he traveled to the area of the Middle East called the Levant as an apothecary to a French ambassador in the 1540s. Belon first saw the tulip in the gardens of Constantinople. The flowers that he described as a kind of lily were given the name "tulip" probably through a linguistic misunderstanding, and within just a few years bulbs had been brought from Turkey to Vienna and Augsberg, then to Antwerp, and, by the 1570s, to Holland, where the flower became a national obsession.

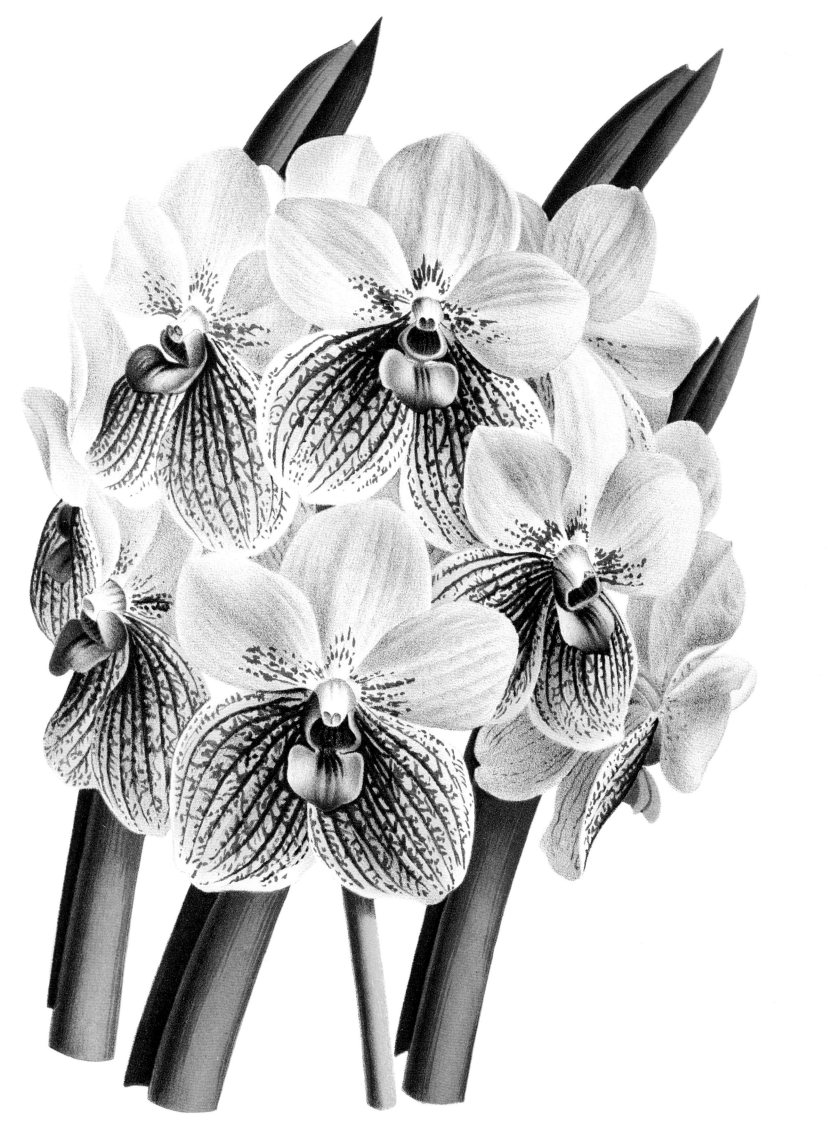

Gardeners soon discovered that the cultivated Turkish tulips could "break" and give rise to myriad variegated forms. Each new variety fed the growing craze, as did such illustrated works as Crispijn van de Passe the Younger's *Hortus floridus* (*Flower Garden*), published in Utrecht, in the Netherlands, in 1614. At the height of tulipomania in the 1630s, the market had become a dangerous frenzy of speculation and economic chaos, with entire houses and estates mortgaged for a single bulb. Prices were so high that everyone wanted to sell and no one to buy. With the market flooded, the bubble burst, as if everyone suddenly awoke from a dream. (The tulip subsequently enjoyed lesser waves of collective fascination in England and in Turkey and remains, deservedly but more reasonably, a popular garden flower today.)

Slightly more than two hundred years later, during another century of concerted scientific exploration and popular interest in new discoveries, a new mania emerged for the lush exotic blooms of orchids. It was the Victorian heyday of natural history, and beautifully illustrated books such as Sir William Hooker's *Century of Orchidaceous Plants* (London, 1849) and James Bateman's *Second Century of Orchidaceous Plants*

(London, 1867), *The Orchidaceae of Mexico and Guatemala* (London, 1837–1843), and *A Monograph of Odontoglossum* (London, 1874) again spurred on enthusiasm for exotic blooms. Orchid mania swept Europe from the 1860s through the end of the century. Expeditions to the jungles and mountains of remote continents specifically searched out and brought back new species of the mysterious and beautiful flower. Competition was so fierce that collecting localities were tightly guarded secrets, and prices for the plants soared.

One of the more enterprising and successful of these orchid-hunters was Jean Jules Linden (1817–1898), a Luxembourger by birth who undertook three expeditions to Central and South America for the Belgian government between 1835 and 1844. He subsequently established himself as a commercial horticulturist in Brussels and Ghent, specializing in orchids and palms. Linden sent out further collecting expeditions to make new discoveries as well as to ensure a supply of breeding stock. He is thought to have introduced more than eleven hundred species of orchids into the European market, several of which were named for him and his collectors, most notably by the British

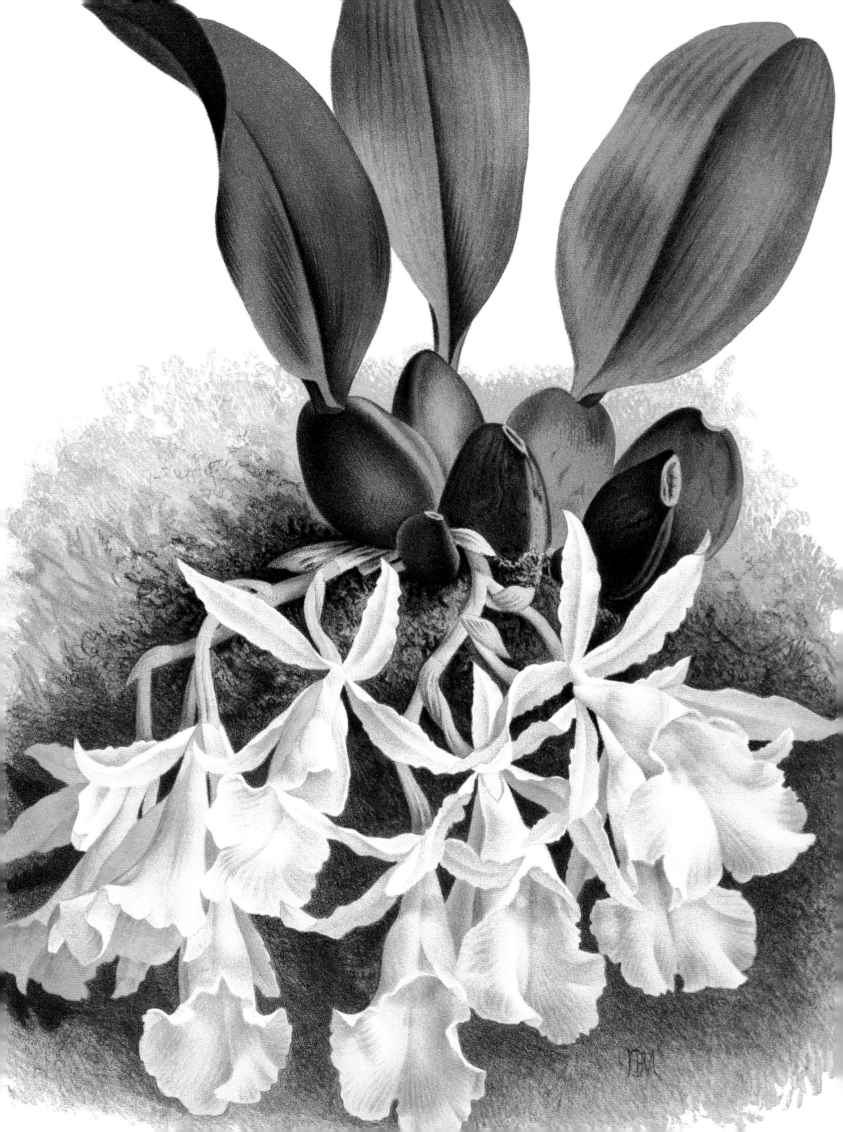

botanist John Lindley. Of equal importance to finding new species was knowing how to keep them alive outside their native habitats, and Linden was among the first to recognize that different species of orchids require various climates and environments to thrive—not the uniformly hot and humid conditions prevailing (and failing) in orchid culture at the time. In support of science—and not unmindful of the advertising value to his business—Linden published catalogs and periodicals about orchids, a few of whose beautiful lithographic illustrations are reproduced here.

Lithography is a planographic printing process, meaning that the ink lies on a solid, flat surface rather than in grooves that are cut into that surface (as in intaglio processes such as engraving and etching) or on raised lines created by cutting away blank areas from the surface (as in relief processes such as woodcut). Instead, lithography requires a specific kind of porous limestone and a special grease pencil to which the ink adheres after the stone has been wetted. Developed in the 1790s by the German Alois (Aloysius) Senefelder, lithography not only enables the artist or illustrator to draw directly on stone without the

intermediation of a technical craftsman but also produces a softer line and more subtle gradations of shading and tone than earlier intaglio or relief processes allowed. Furthermore, from a technical standpoint at the time of its development, lithography provided a relatively inexpensive way to color illustrations in the printing process itself. Multiple stones with the same design would be blocked out for different ink colors. The new technique proved popular, and by the end of the nineteenth century chromolithography was used to mass-produce cheap, garish greeting cards and newspaper supplements. However, the process could also be used for artistic effects (distinguished as "color lithography"), as Linden's work shows.

Lithographed from original paintings and delicately colored both in the press and afterward by hand, Linden's prints were issued four at a time in monthly installments of the journal *Lindenia: Iconographie des Orchidées* (*Iconography of Orchids*), each accompanied by a knowledgeable description of the species and references to the relevant scientific literature. The complete set of seventeen volumes, published in Ghent, Belgium, between 1885 and 1906 comprises 813 plates (though

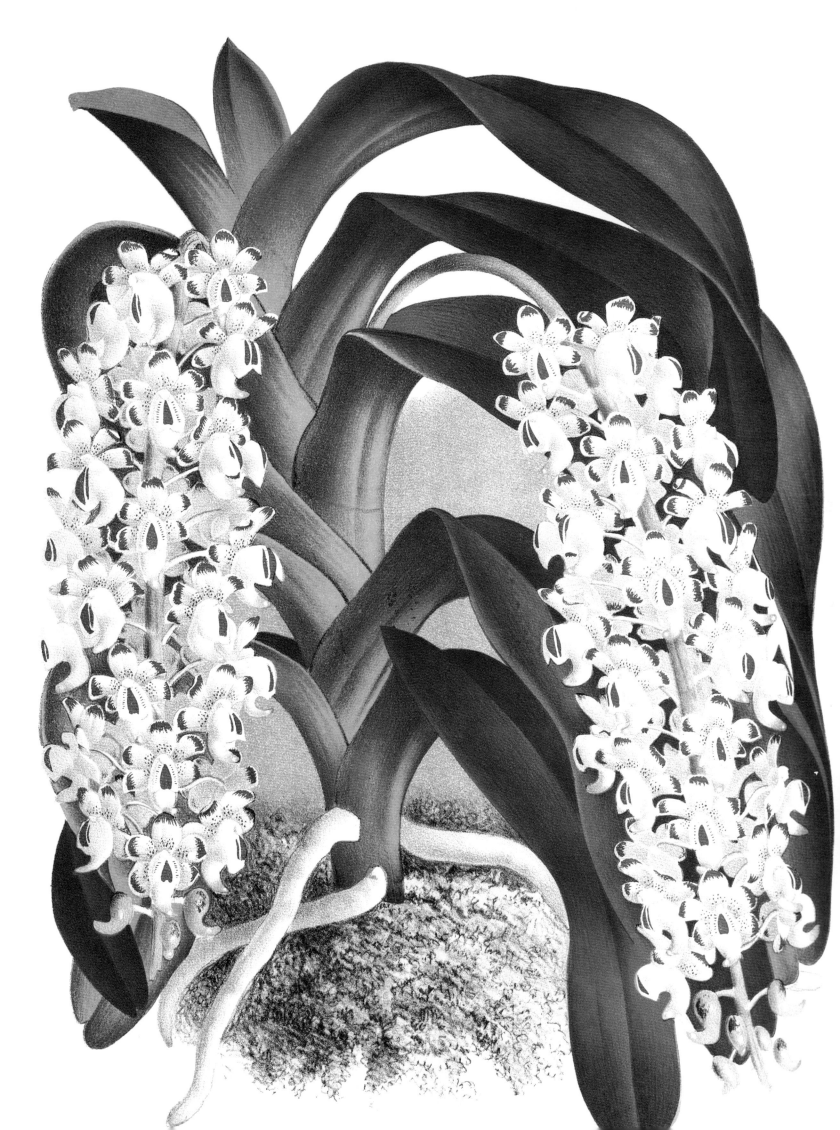

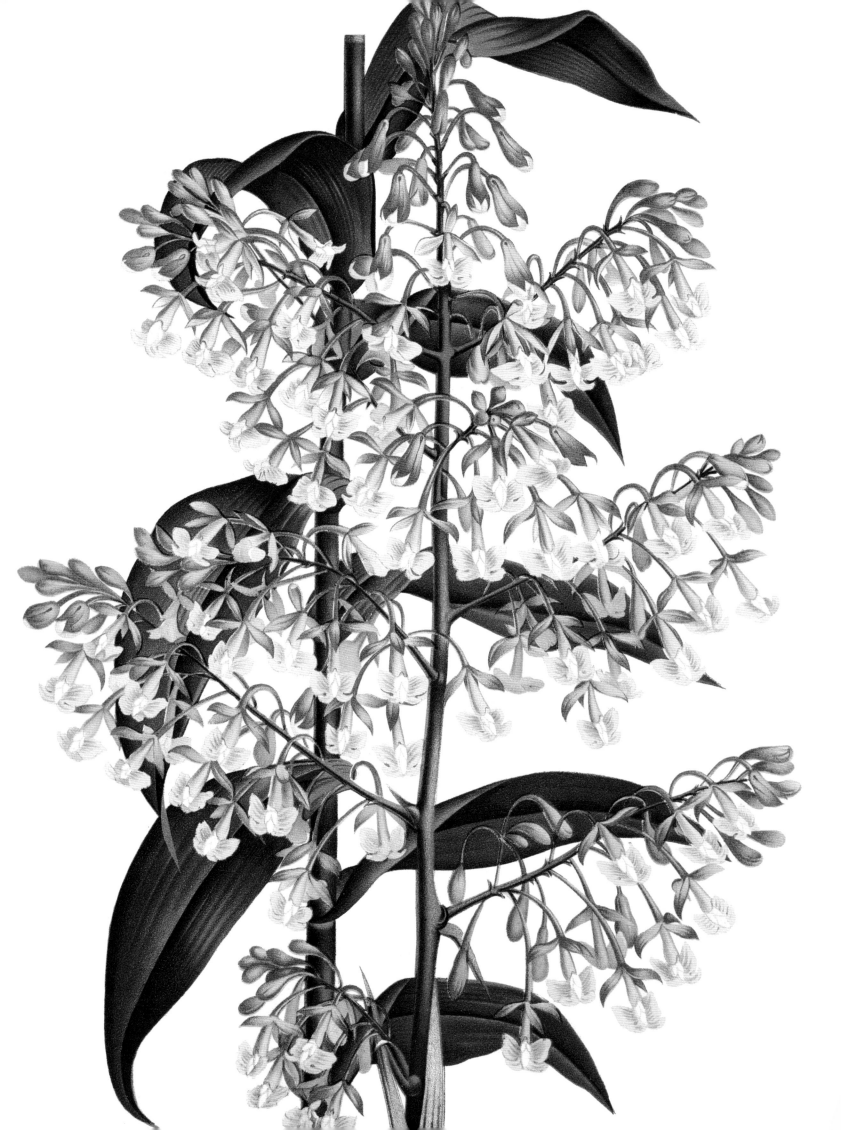

through a quirk of numbering, No. 795 was skipped). A partial English translation followed (thirteen volumes, 359 plates; Ghent, 1891–1898). Today, *Lindenia* remains quite scarce in libraries and private collections and is not currently available on the market. Fortunately, individual prints are more accessible, and a modern reprint of the complete work was published in five volumes in 1993.

Through the reproductions here, we glimpse how exciting it must have been to live during the nineteenth-century era of adventure and exploration—when the cultivation of a single bloom could represent a voyage to new worlds.

"Sweet letters of the angel tongue,

I've loved ye long and well,

And never have failed in your fragrance sweet

To find some secret spell—

A charm that has bound me with witching power,

For mine is the old belief,

That midst your sweets and midst your bloom,

There's a soul in every leaf!"

MATURIN MURRAY BALLOU, *FLOWERS*

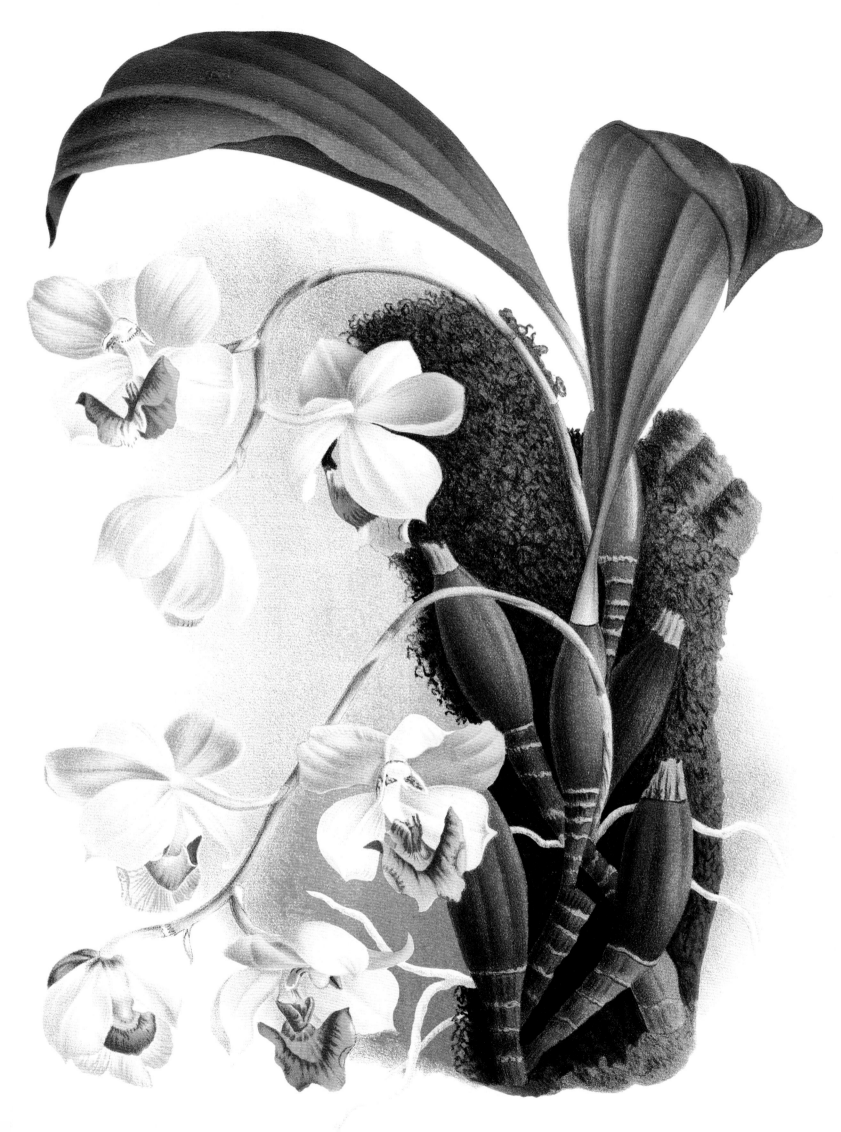

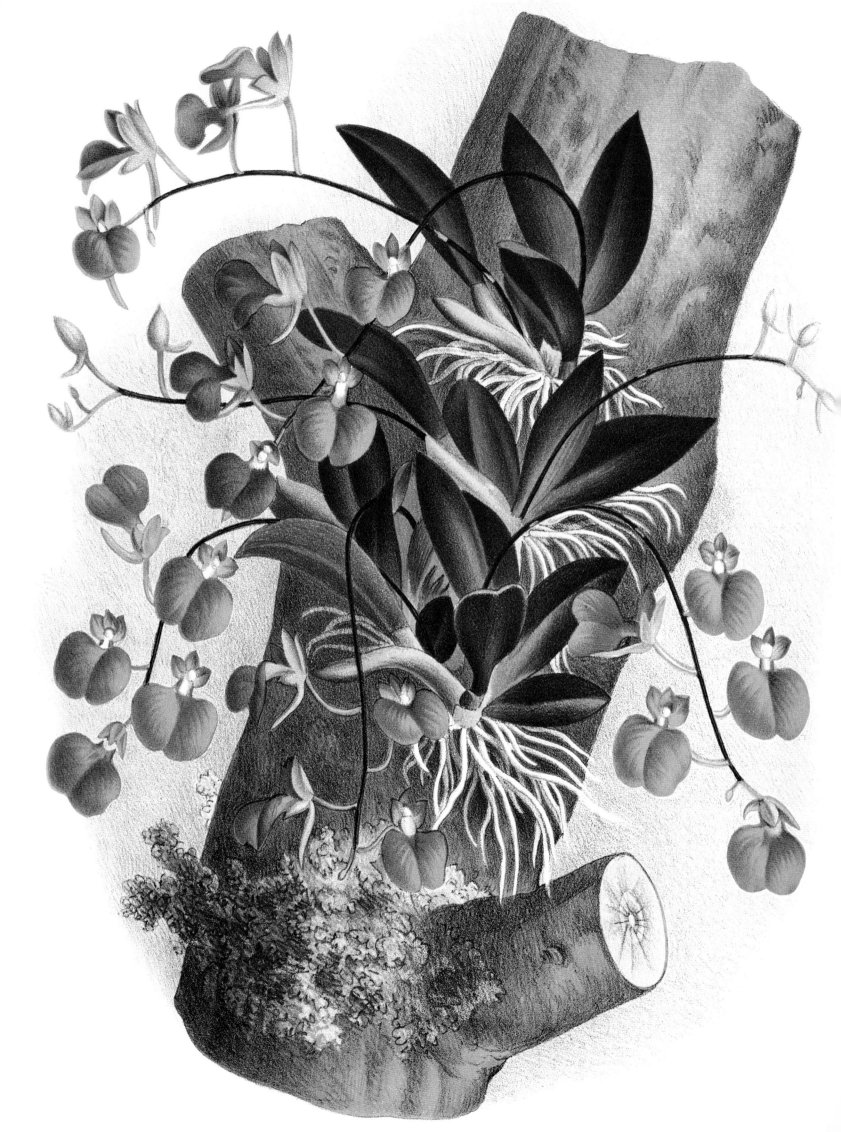

"Flowers are Love's truest language."

PARK BENJAMIN

"Which May had painted with his softe showers.
This garden full of leaves and of flowers."

GEOFFREY CHAUCER

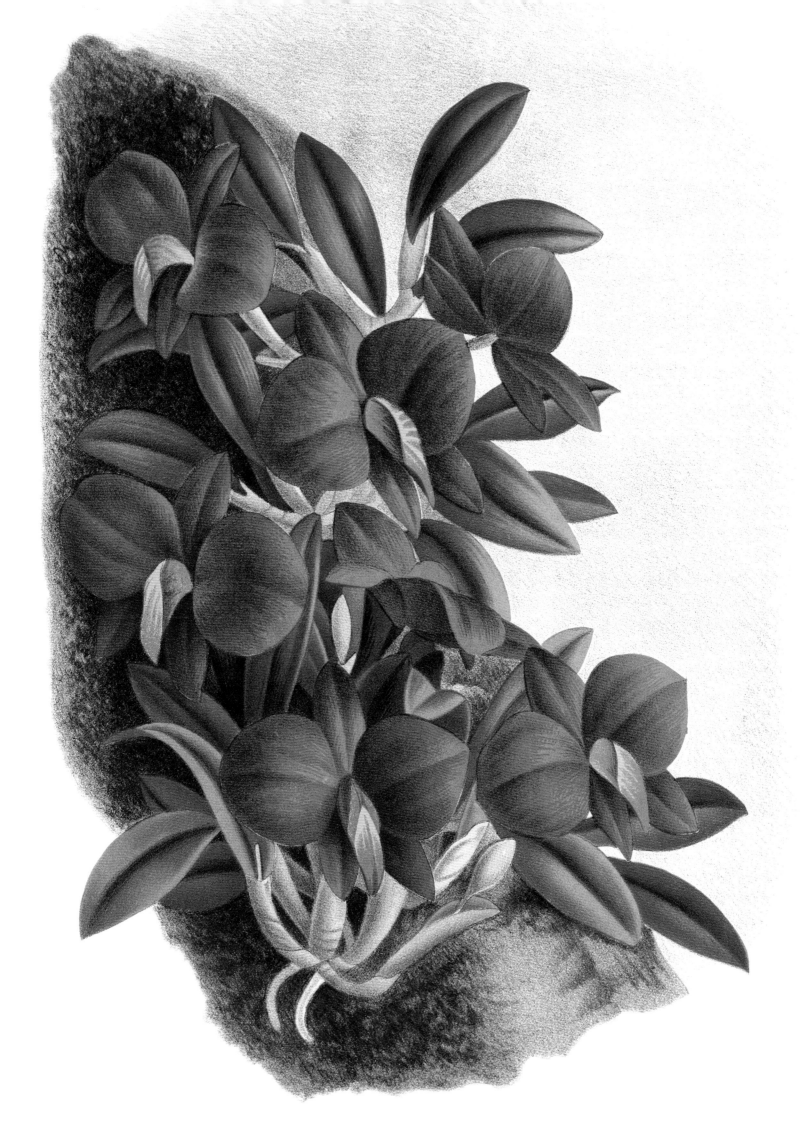

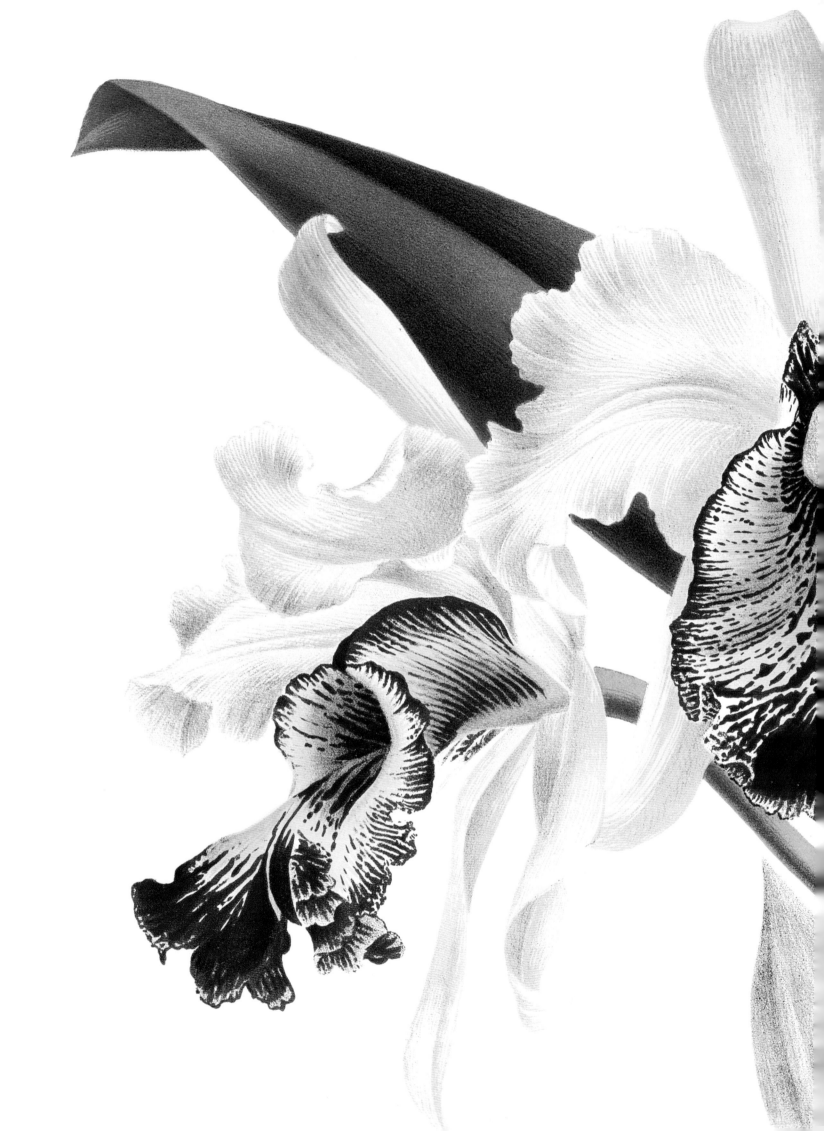

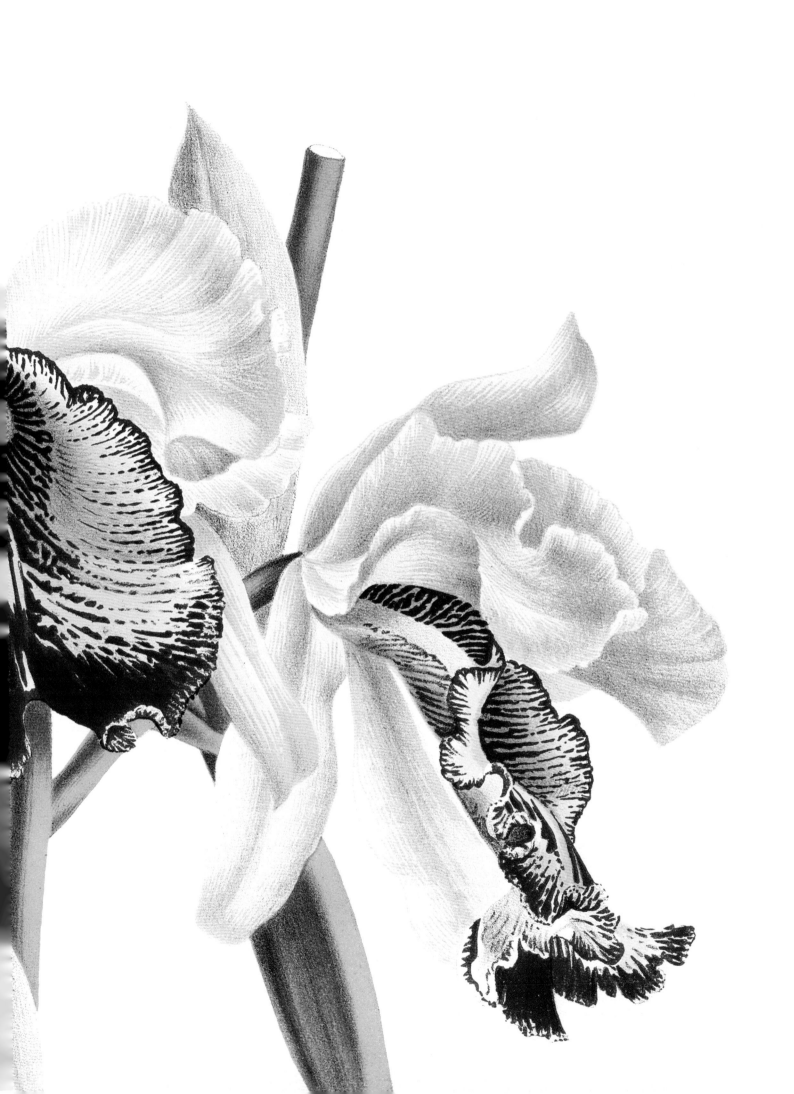

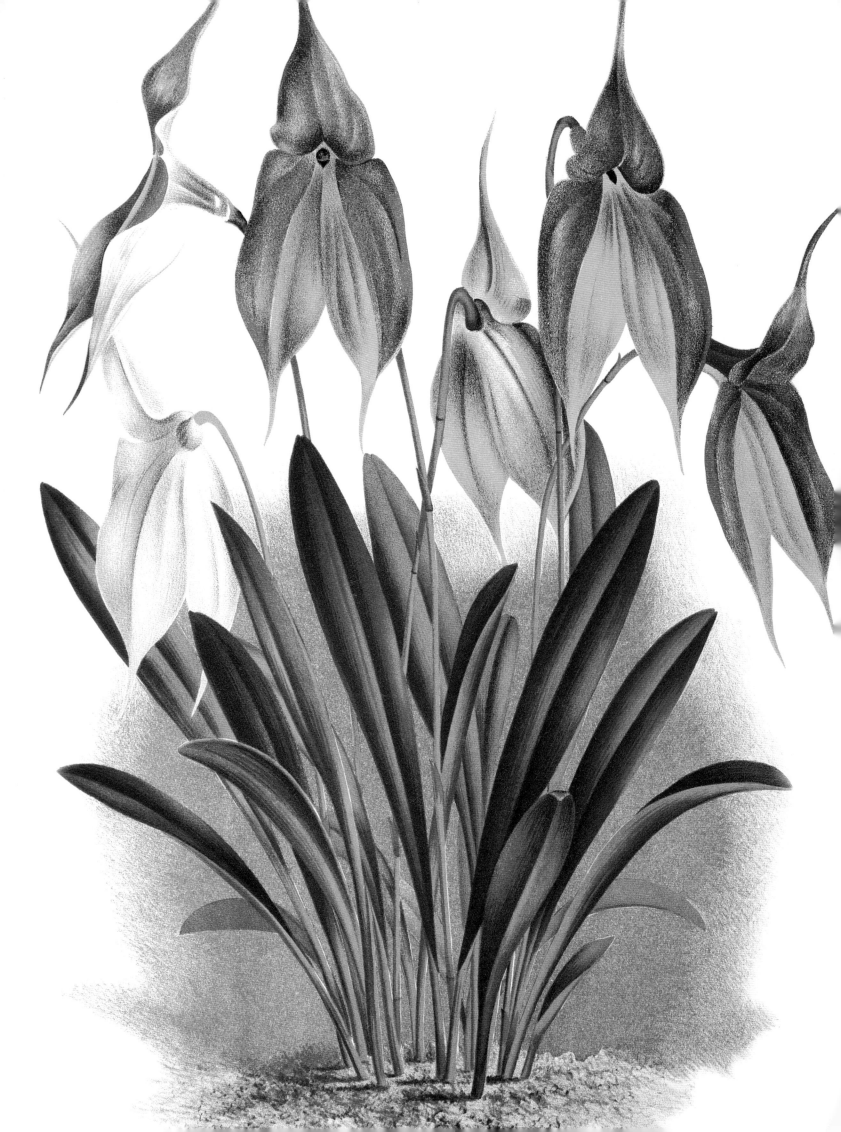

"No dainty flower or herb that grown on ground,
No arborett with painted blossoms drest,
And smelling sweet, but there it might be found
To bud out fair, and her sweet smells throw all around."

EDMUND SPENSER, *FAERIE QUEENE*

"You take a pink,
You dig about its roots and water it,
And so improve it to a garden-pink,
But will not change it to a heliotrope."

E. B. BROWNING, *AURORA LEIGH*

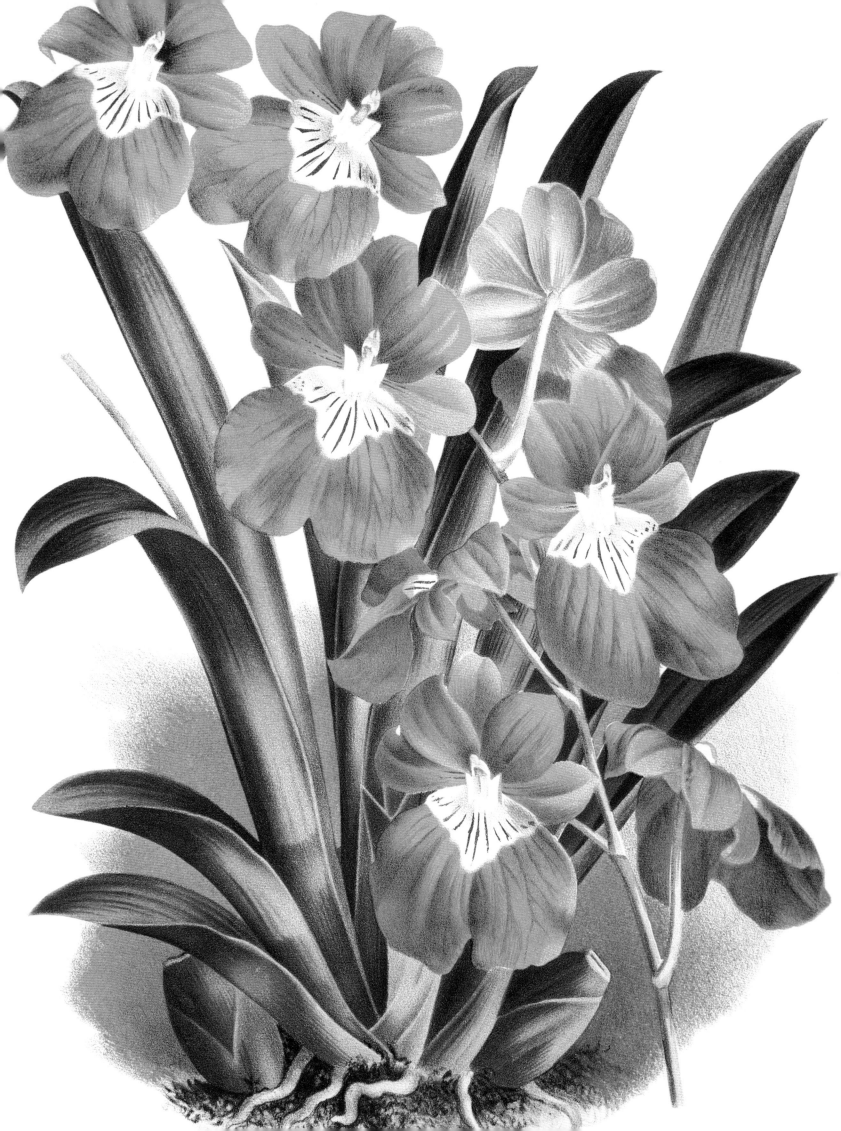

"In all things of nature there is something of the marvelous."

ARISTOTLE, *ON THE PARTS OF ANIMALS*

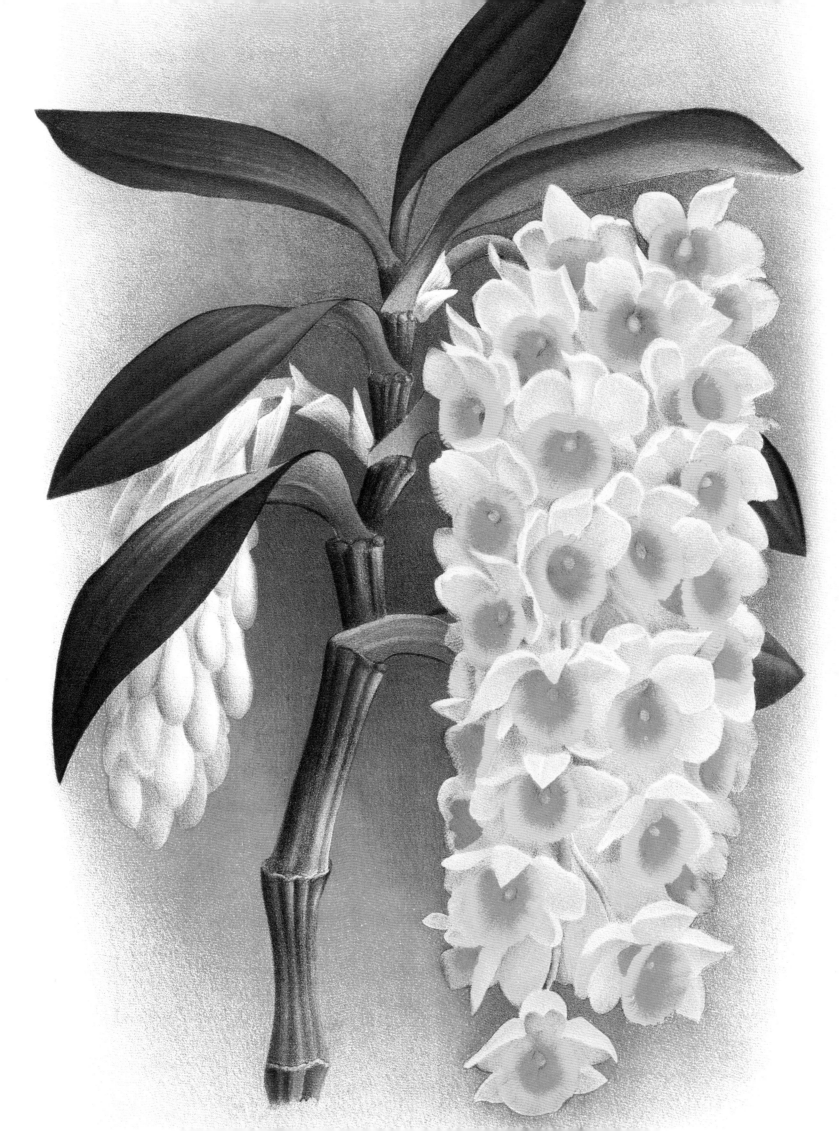

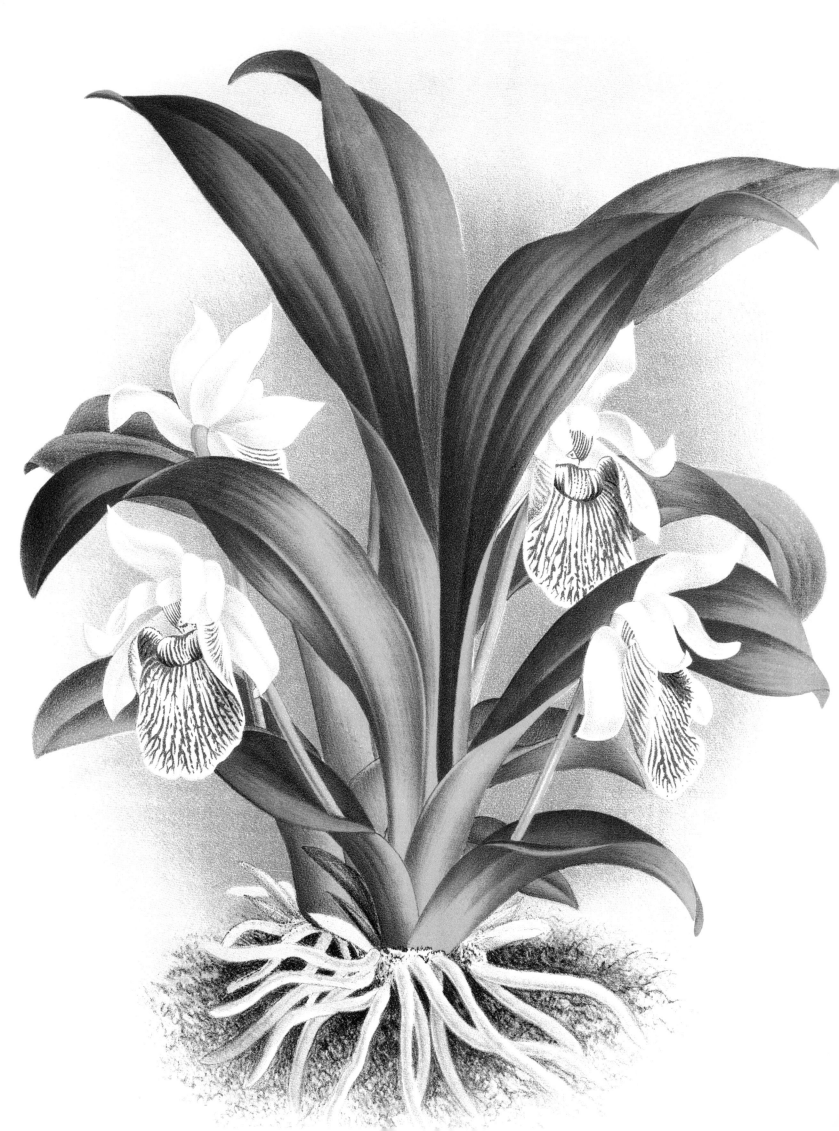

"I know not which I love the most,
Nor which the comeliest shows,
The timid, bashful violet
Or the royal-hearted rose:
The pink with cheek of red,
Or the faint, fair heliotrope, who hangs,
Like a bashful maid her head."

PHOEBE CARY, *SPRING FLOWERS*

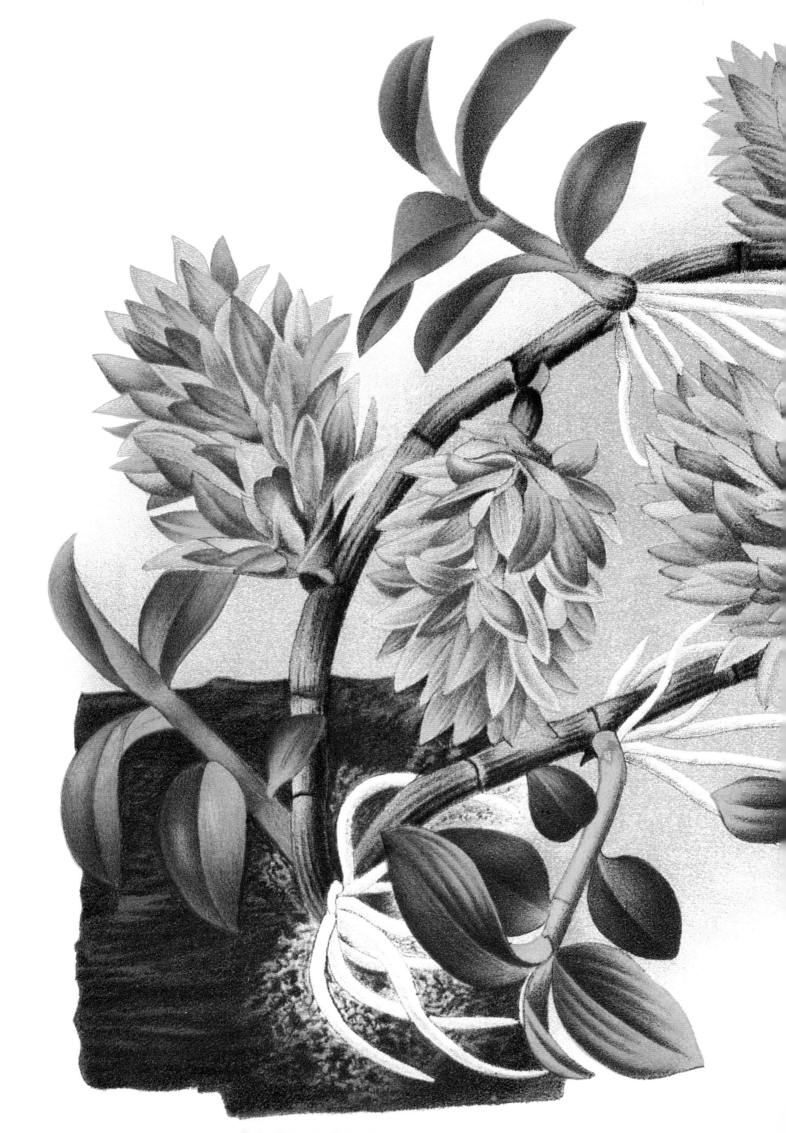

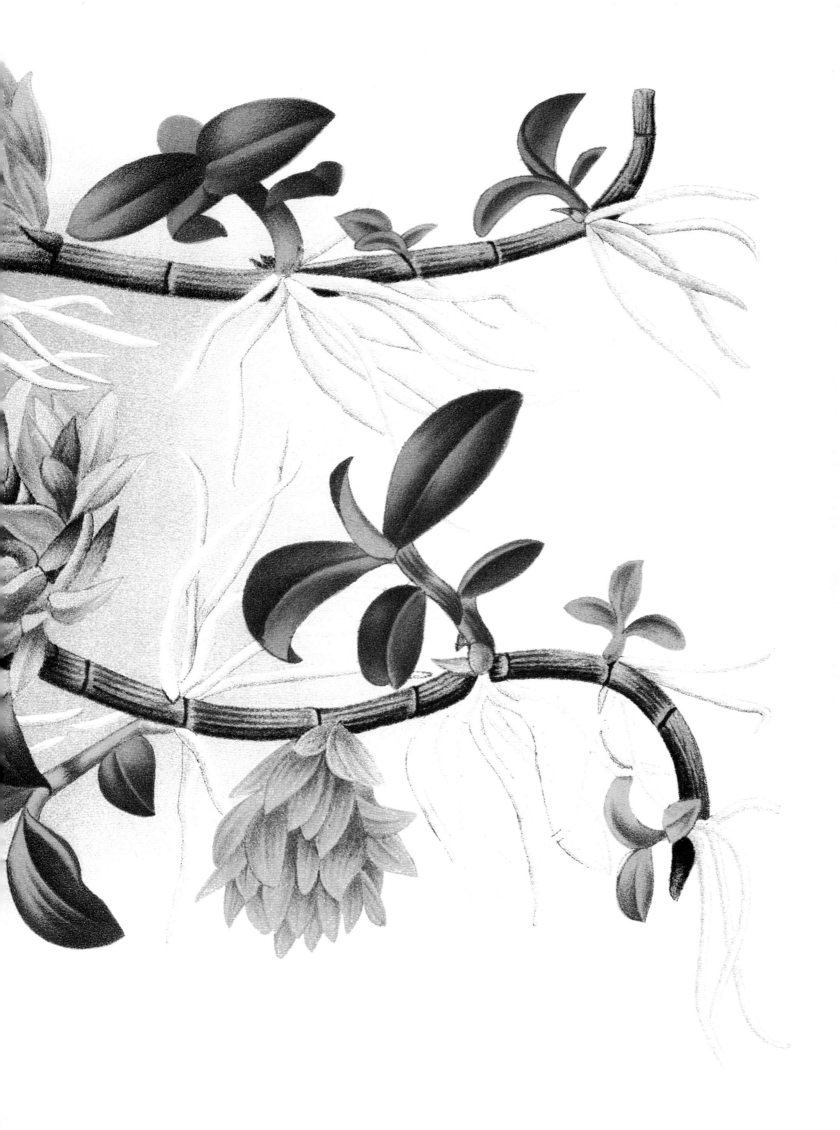

“ I waited alone, in the company of orchids, roses and violets who—like people waiting beside you, but to whom you are unknown— maintained a silence which their individuality of living things rendered more imposing and in their chilly manner received the heat from an incandescent coal fire, preciously placed behind a crystal glass, in a white marble tub where it dropped, from time to time, its dangerous rubies. **”**

MARCEL PROUST, *A REMEMBRANCE OF THINGS PAST*

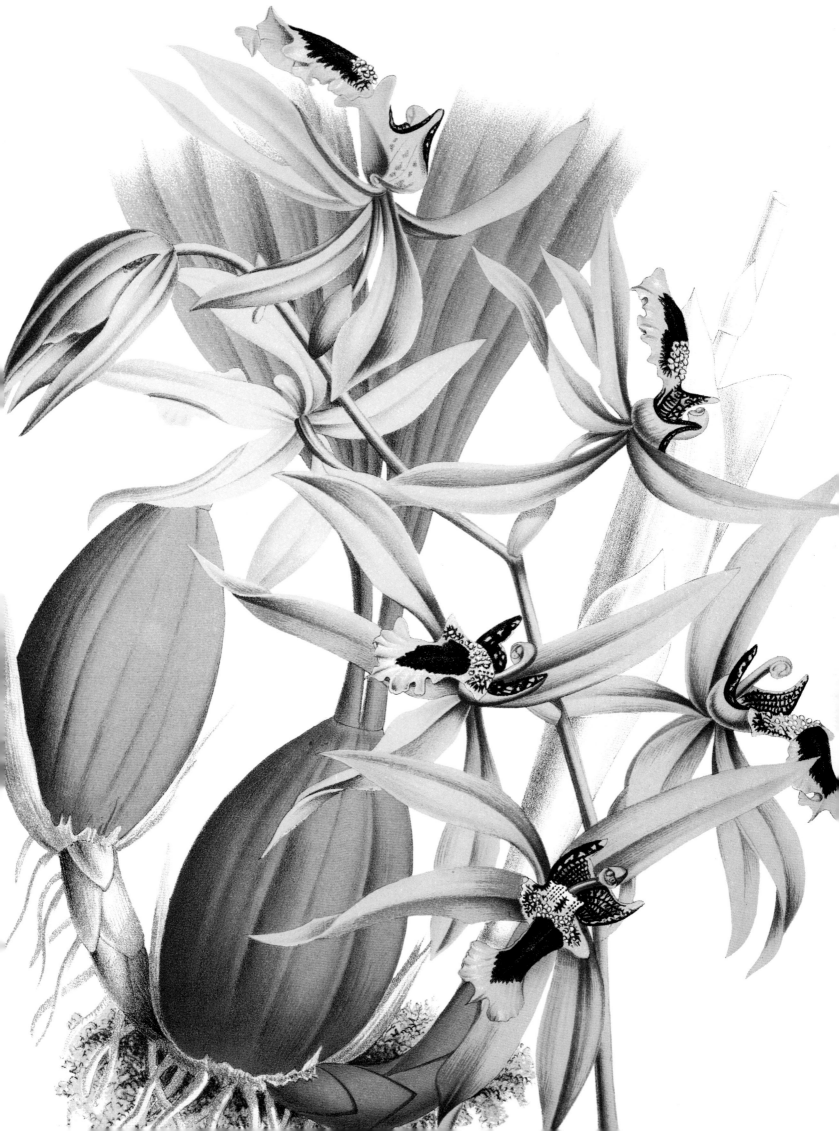

"It seemed as if the breezes brought him,
It seemed as if the sparrows taught him,
As if by secret sign he knew
Where in far fields the orchids grew."

RALPH WALDO EMERSON

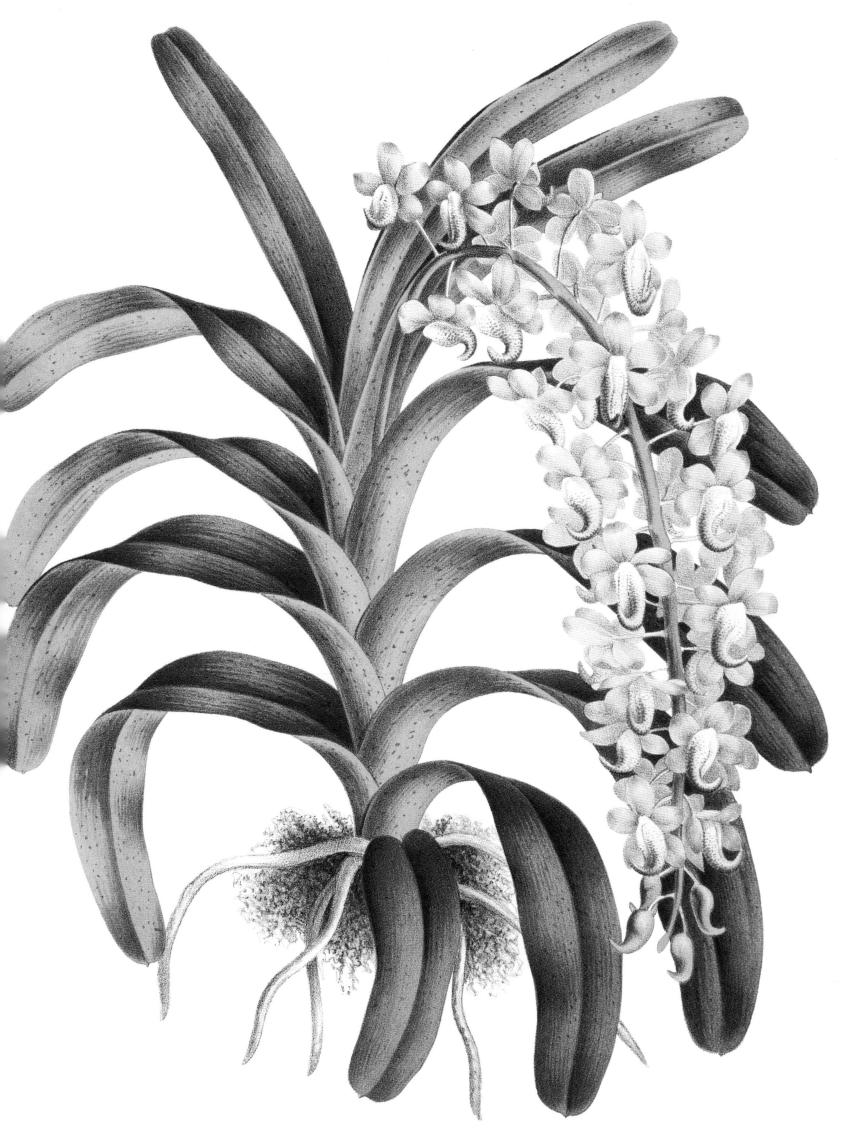

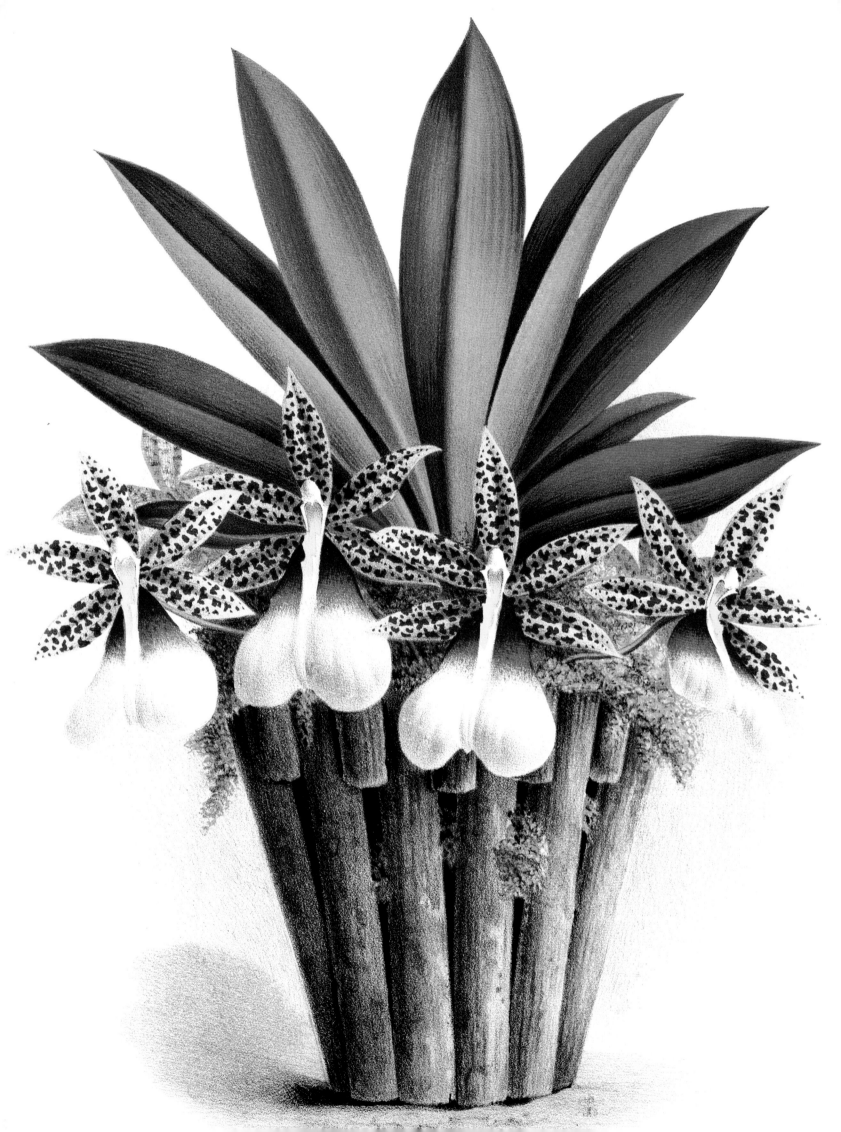

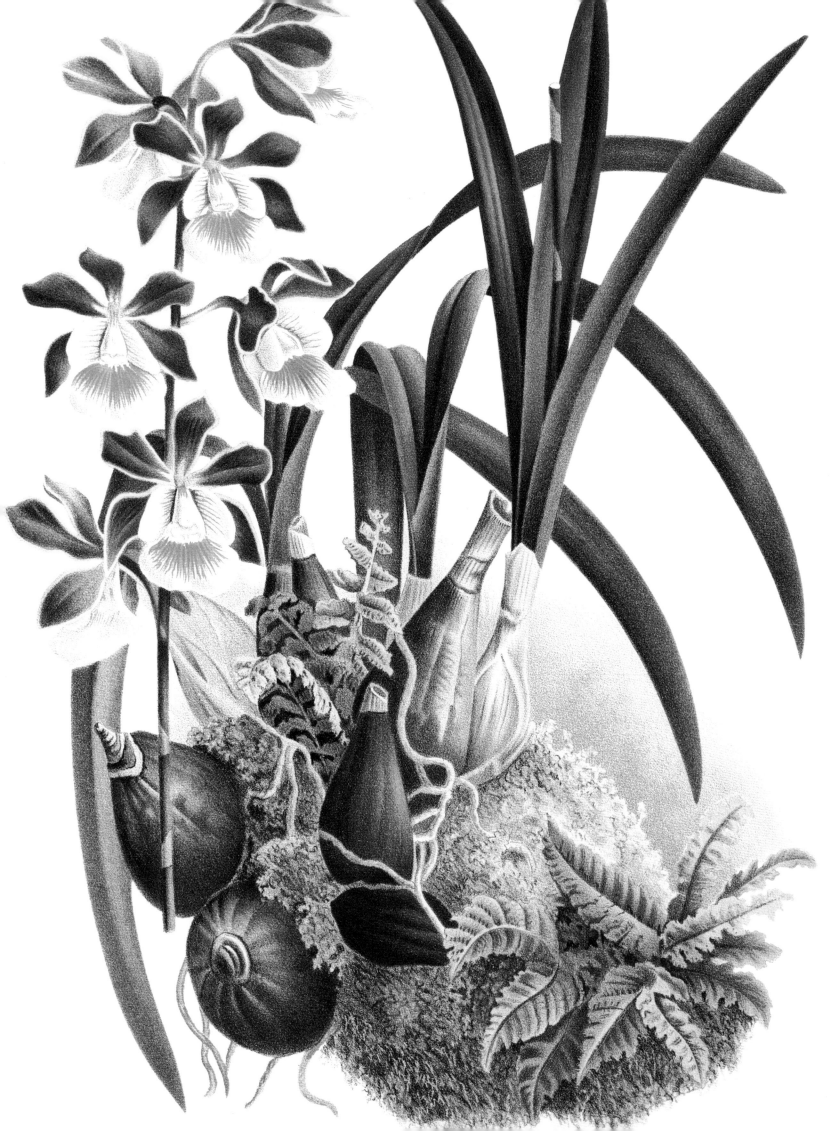

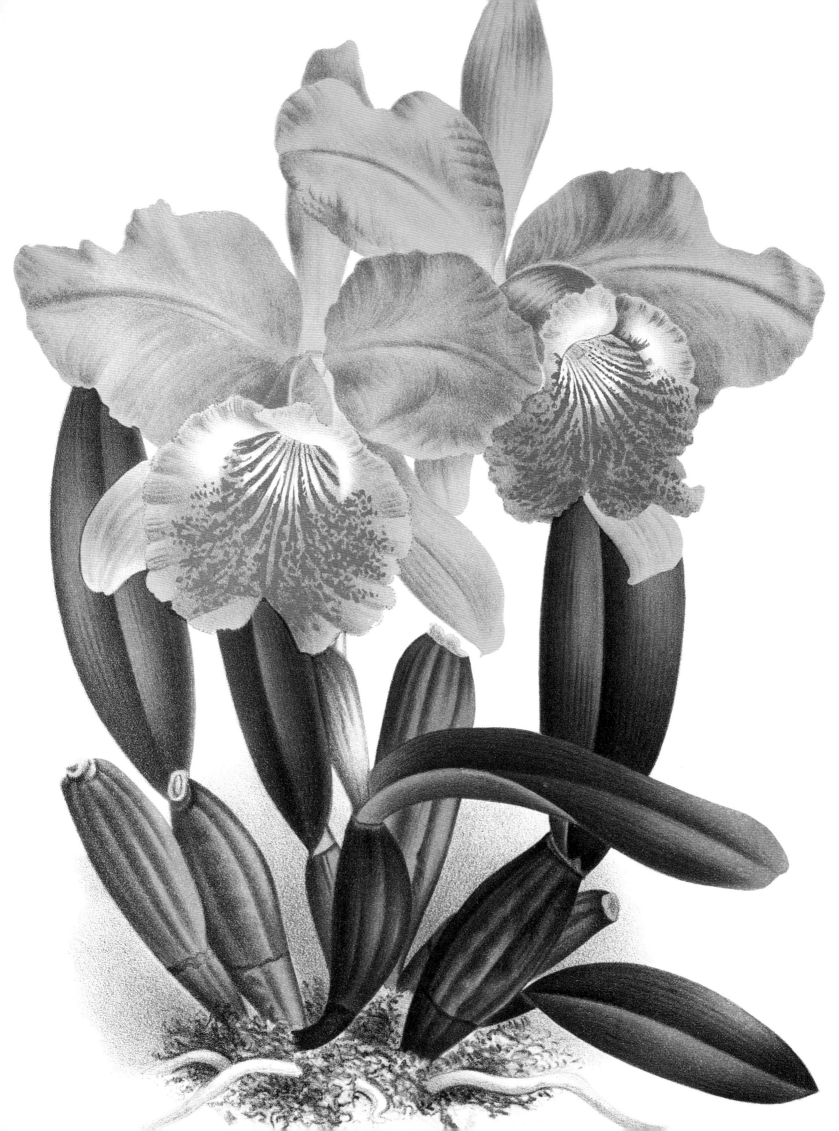

"Flowers of all heavens, and lovelier than their names."

LORD ALFRED TENNYSON

"Yet, no—not words, for they
But half can tell love's feeling;
Sweet flowers alone can ways
What passion fears revealing.
A once bright rose's wither'd leaf,
A tow'ring lily broken,—
Oh, these may paint a grief
No words could e'er have spoken"

THOMAS MOORE, *THE LANGUAGE OF FLOWERS*

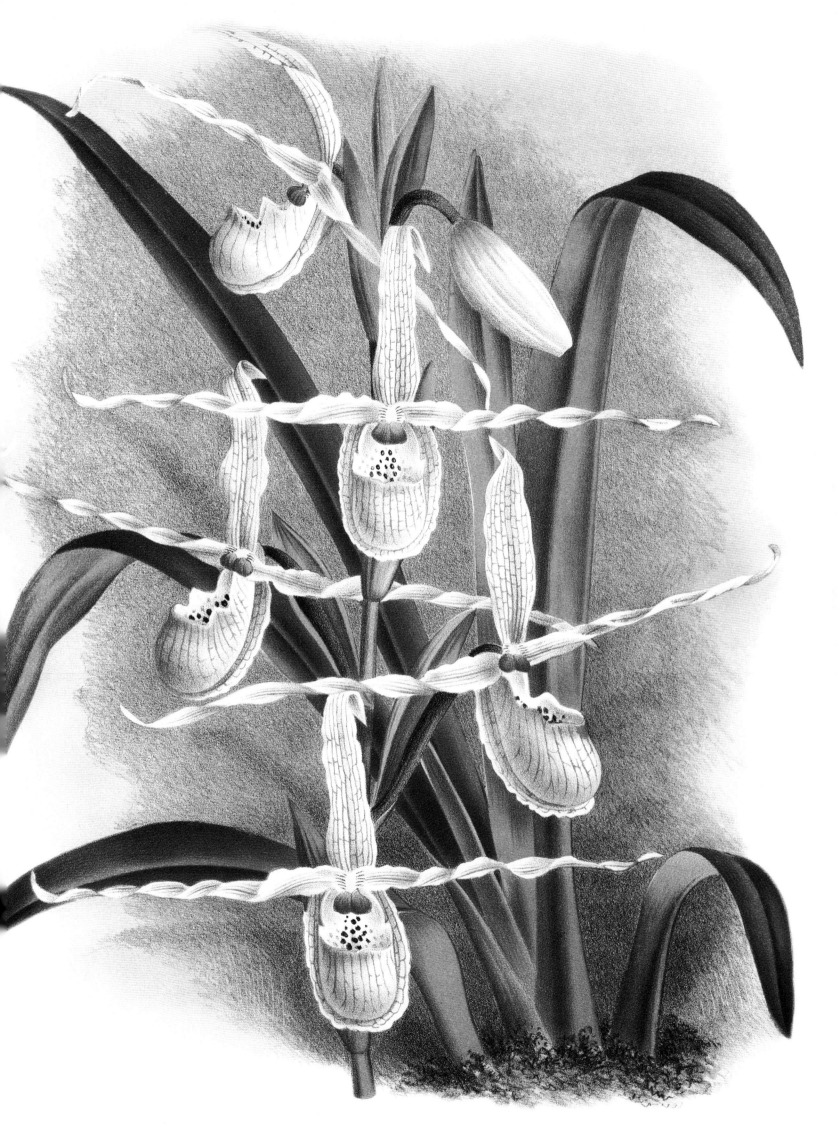

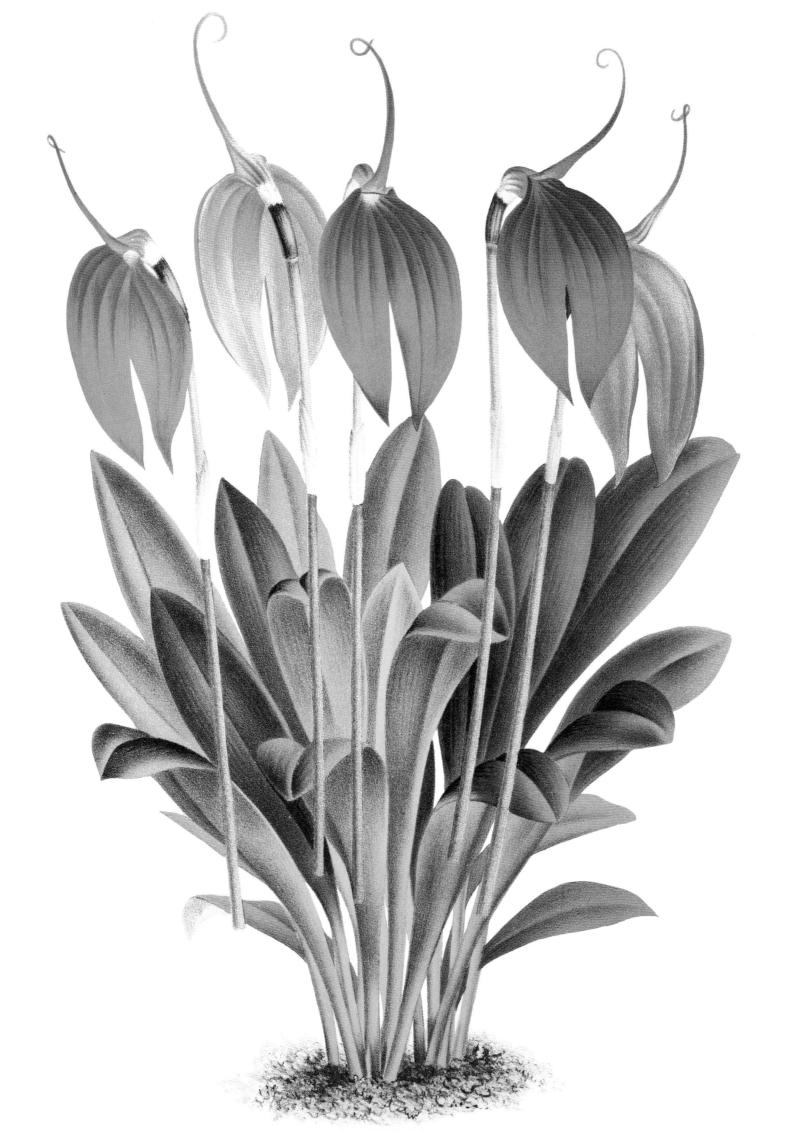

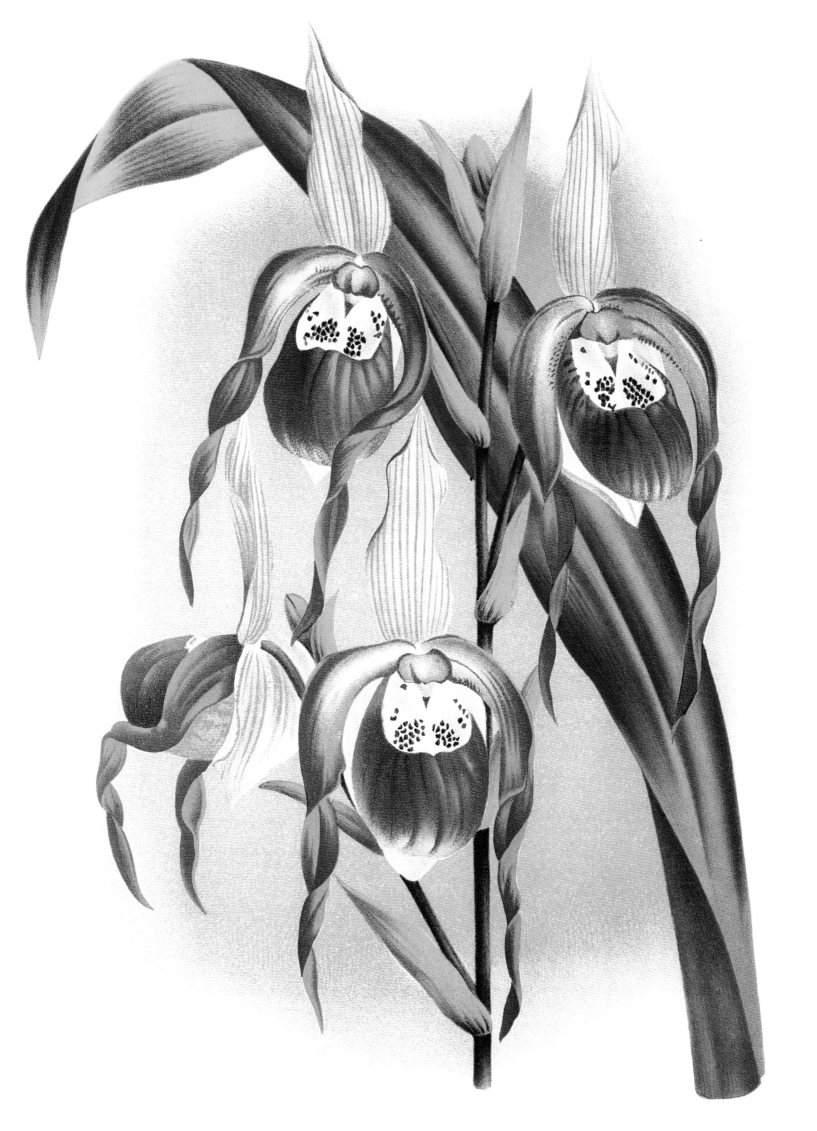

FURTHER READING

BOTANICAL ILLUSTRATION—GENERAL

Blunt, Wilfrid, and William T. Stearn. *The art of botanical illustration.* London: Collins, 1950.
There are several subsequent editions (New York, 1951; London, 1967; New York, 1994; etc.), as well as a revised edition, Woodbridge, Suffolk, U.K.: Antique Collectors' Club Ltd. in association with the Royal Botanic Garden, Kew, 1994.

Bridson, Gavin D.R., and James J. White. *Plant, animal and anatomical illustration in art and science: A bibliographical guide from the 16th century to the present day.* Winchester, U.K.: St. Paul's Bibliographies; Detroit: Omnigraphics, 1990.

Dance, S. Peter. *The art of natural history.* New York: The Overlook Press, 1978.
Later edition, New York: Arch Cape Press, 1990.

Dunthorne, Gordon. *Flower and fruit prints of the 18th and early 19th centuries: Their history, makers and uses with a catalogue raisonné of the works in which they are found.* Washington, D.C.: The author, 1938.
Other editions, London, 1938; New York, 1970.

Nissen, Claus. *Die botanische Buchillustration: Geschichte und Bibliographie.* Stuttgart: Anton Hiersemann, 1951.
Second edition, with Supplement: Stuttgart: Anton Hiersemann, 1966.

Rix, Martyn. *The art of the plant world: The great botanical illustrators and their works.* Woodstock, N.Y.: The Overlook Press, 1981.
Published in Great Britain as *The art of the botanist.* Another edition, titled *The art of botanical illustration*, New York: Arch Cape Press, 1990.

Sitwell, Sacheverell, and Wilfrid Blunt. *Great flower books 1700-1900: A bibliographical record of two centuries of finely-illustrated flower books.* London: Collins, 1956.
Revised edition, New York: The Atlantic Monthly Press, 1990.

BOTANICAL ILLUSTRATION—INDIVIDUAL ARTISTS OR WORKS

(in addition to the commentaries included with facsimile editions mentioned in the chapter texts)

Grigson, Geoffrey, and Handasyde Buchanan. *Thornton's "Temple of Flora" with plates faithfully reproduced from the original engravings.* London: Collins, 1951.

Hollman, Eckhard, ed. *Maria Sibylla Merian: The St. Petersburg watercolours.* Munich: Prestel Verlag, 2003. With natural-history commentaries by Wolf-Dietrich Beer. Translated from the German by Paul Alston.

King, Ronald. Introduction to Thornton's *Temple of Flora.* Boston: New York Graphic Society, c1981.

Pieters, Florence F. J. M., and Diny Winthagen. "Maria Sibylla Merian, naturalist and artist (1647–1717): A commemoration on the occasion of the 350th anniversary of her birth." *Archives of natural history* 26(1) (1999): 1–18.

Wettengl, Kurt, ed. *Maria Sibylla Merian, 1647–1717, artist and naturalist.* Ostfildern, Germany: Verlag Gerd Hatje, 1998. Translated from the German by John S. Southard.

PRINTING TECHNIQUES

Bridson, Gavin D. R., and Donald E. Wendel. *Printmaking in the service of botany.* Pittsburgh, Penn.: Hunt Institute for Botanical Documentation, 1986.

Gascoigne, Bamber. *How to identify prints: A complete guide to manual and mechanical processes from woodcut to inkjet.* London, New York: Thames and Hudson, 1986.
Reprinted 1991, 2004.

Glaister, Geoffrey A. *Glossary of the book: Terms used in paper-making, printing, bookbinding and publishing...* London: George Allen and Unwin Ltd., 1960.
First American edition, titled *Encyclopedia of the book,* Cleveland, [1960?]. Second edition, titled *Glaister's glossary of the book,* Berkeley, Calif., U.S.: Univ. of California Press, 1979; revised edition, titled *Encyclopedia of the book,* New Castle, Del., U.S.: Oak Knoll Press, 1996.

ACKNOWLEDGMENTS

Assouline would like to thank Stephen Van Dyke, librarian at the Cooper-Hewitt, National Design Museum, who introduced us to the wonderful editions published in this volume and conceived of our partnership. Elizabeth Broman, reference librarian at the Cooper-Hewitt, National Design Museum graciously opened the museum's archives to our editorial staff. Sincere thanks are also due to Erin Rushing of the Smithsonian Institution Libraries New Media Office, who managed the project on behalf of the Smithsonian and ensured that all the works featured were photographed in record time and with utmost quality; Jennifer Arterburn, contract negotiator/attorney for the Smithsonian Institution; photographer Matt Flynn; digital imaging specialist David Holbert;and the very talented curator of natural-history rare books at the Smithsonian Institution Libraries, Leslie K. Overstreet, who authored the texts.